FOLK ART OF THE AMERICAS

FOLK ART OF

THE AMERICAS

General Editor: August Panyella

Photographer: Francesc Català Roca

Harry N. Abrams, Inc., Publishers, New York

This work was primarily conceived, planned, and executed by Editorial Blume, Barcelona, who wish to acknowledge the following:

General editor and director:
August Panyella
Director and co-founder of the Museo Etnológico of Barcelona, Secretary of the Centro Peninsular de Etnología del Consejo de Investigaciones Científicas of Spain.

Photographer:
Francesc Català Roca
Exclusive photographer of painters, including Miró, sculptors, including Chillida; potters, including Llorens Artigas; and architects, including Coderch, Sert, and Martorell-Bohigas-Mackay. Roca has traveled throughout the Americas in order to illustrate this work.

Graphic design:
Zimmermann Studio
Designer: Yves Zimmermann; design assistants; Joaquim Trías (layout) and Ramon Fabregat (maps).

Editor:
Marta Ribalta
Coordinator of production; carried out the field work and selected the photographs.

Authors:
Lelia Coelho Frota, specialist in folk art, and *Berta G. Ribeiro*, anthropologist, specialist in indigenous art. Curator of the Museo Nacional of Rio de Janeiro. They have written the texts on Brazilian folk art and indigenous art, respectively.

Carlos Espejel, former director of the Museo de Artes Populares of Mexico; author of *Cerámica Popular Mexicana* and *Artesanía Popular Mexicana*. He has written sections on handcrafts in the chapter on Mexico.

Ricardo Muratorio, professor of the Department of Anthropology and Sociology of the University of British Columbia in Vancouver, Canada. He is author of *Artesanía y Arte Popular de la Sierra del Ecuador, Mates burilados de Huancayo*, and *Retablos de Ayacucho*. He is the author of the Ecuador chapter.

Marta Ribalta, while doing the field work, wrote the texts on the Antilles, Costa Rica, Panama, Venezuela, Peru, Chile, Paraguay, Argentina, and Uruguay; the introductions to the chapters on Mexico, Guatemala, Colombia, and Brazil as well as the introduction and the sections on hatmaking and totora work for the chapter on Bolivia.

Pablo Solano, member of the Council on Creative Arts of Colcultura.|Member of Proarte (World Cafts Council). Author of the book *Artesanía Boyacense*. Author of the sections on handcrafts for the chapter on Colombia.

Hugo Daniel Ruiz, Director of the Museo de Etnología y Folklore of La Paz, is author of the sections on pottery, weaving, masks, and embroidery for the chapter on Bolivia.

Ricardo Toledo Palomo, Director of the Museo de Arte Popular of Guatemala. Author of the texts on Honduras, El Salvador, and Nicaragua, and the sections on handicrafts in Guatemala.

Lucy W. Turner, curator and lecturer of the Department of Anthrogology and Sociology of the Museum of Anthropology of the University of British Columbia, Vancouver, Canada. Author of the texts on the United States and Canada.

Many persons from many different countries have supplied an abundance of information about folk art. We should like to give special thanks to: Roberto Villegas, Peru; Francisco Rodríguez Rouanet, Guatemala; Carlos Bardin and Ana Reyes de Heredia, Argentina; Nancy Bacelo, Uruguay; Hermes Oróstica Maureira, Chile; and Aníbal Rodríguez, Puerto Rico.

Editor, English language edition: Joan E. Fisher

Library of Congress Cataloging in Publication Data
Main entry under title:
Folk art of the Americas.
 Bibliography: p. 328
 Includes index.
 1. Folk art—America. I. Panyella, August.
II. Català Roca, Francesc.
NK801.F64 745'.09181'2 80-20602
ISBN 0-8109-0912-X

Contents

INTRODUCTION

It is the intention of this book to present an overview of folk art and crafts as they now exist in the countries of the American continents. It has not been possible to include either all the arts or all the countries, mainly because of the method that has been followed in preparing this text. This book does not contain summary statements or secondhand information. All the graphic documentation contained herein is the work of the eminent photographer Francisc Català Roca. To get these unique photographs Català Roca traveled to each country accompanied by the chapter author and a technical team.

Until recently these methods have been used only in preparing a certain few books on selected countries. This work, therefore, is genuinely original in providing firsthand, on-the-spot documentation of the folk art of many countries along with interpretative texts on each country's culture and history.

Increased interest in travel and in folk art has made such a book necessary. People want to know in exactly which cities, towns, or markets they can find folk art of good quality and which groups are engaged in producing it. We have tried to use the pictures and the texts to show meaningful sequences: objects and styles; craft materials and work settings; people who sell craft items and those who buy them. A deliberate effort has been made to exclude from this text the kind of article usually sold in souvenir shops as well as items made specifically for tourists.

The process of documentation has proved to be fascinating, and direct contact with craftsworkers of different countries has provided a wealth of information. This is not to say that the task was easy; on the contrary, many seemingly insurmountable problems were solved in order for this work to be completed.

Life—Culture—Art

Modern man experiences a certain uneasiness when he thinks about what life is or ought to be. With the exception of those who have dogmatic conceptions, most people today have great difficulty in integrating their knowledge with their actions and way of life.

We live in a world that is constantly sending us tiny shreds of information: encyclopedic knowledge is fragmented into minisciences and specialties so ephemeral that they sometimes expire in a single generation.

Human life is very complex; it carries with it history and tradition —life of other eras —yet it has a concrete existence in the here and now; that is, in the collective life of human communities and in the individual life of each human being. In short, we might say that culture is the contents of the life of a society of individuals. The synthesis of life and culture is unique to the human species with respect to other forms of life, although we really know very little about this contrast.

Most anthropologists consider art a component of culture. Art dwells not only within culture and society but also within every individual. The arts do not merely include the familiar categories of plastic, verbal, music, and dance, among others, but reveal themselves all around us in the form of furniture, textiles, clothing, and other useful and decorative objects, as well as in such fleeting phenomena as a flag floating on the breeze or a dream sequence that can be transformed into a play, novel, or film. The movements of an acrobat, a trapeze artist, or a child at play have their share of beauty and art.

This view of life-culture-art leads to the conclusion that there are no absolute boundaries between the most sophisticated, professional art and folk art, handcrafts, and the manifestation of the individual in any detail of culture. Let us consider these concepts a bit further.

Art and Folk

In the expression "folk art," it is not only the word "art" that is difficult to understand; the word "folk" is equally problematical. It means two quite different things: first, people of the lower social classes, including rural and urban artisans, and second, the idea of *etnia,* a people, tribe, or nation with a well-differentiated culture.

The advance of egalitarian attitudes continues to level social and cultural differences; this process has had an effect on folk art. Folk art is less and less an art of the "lower" classes; a growing number of folk artists

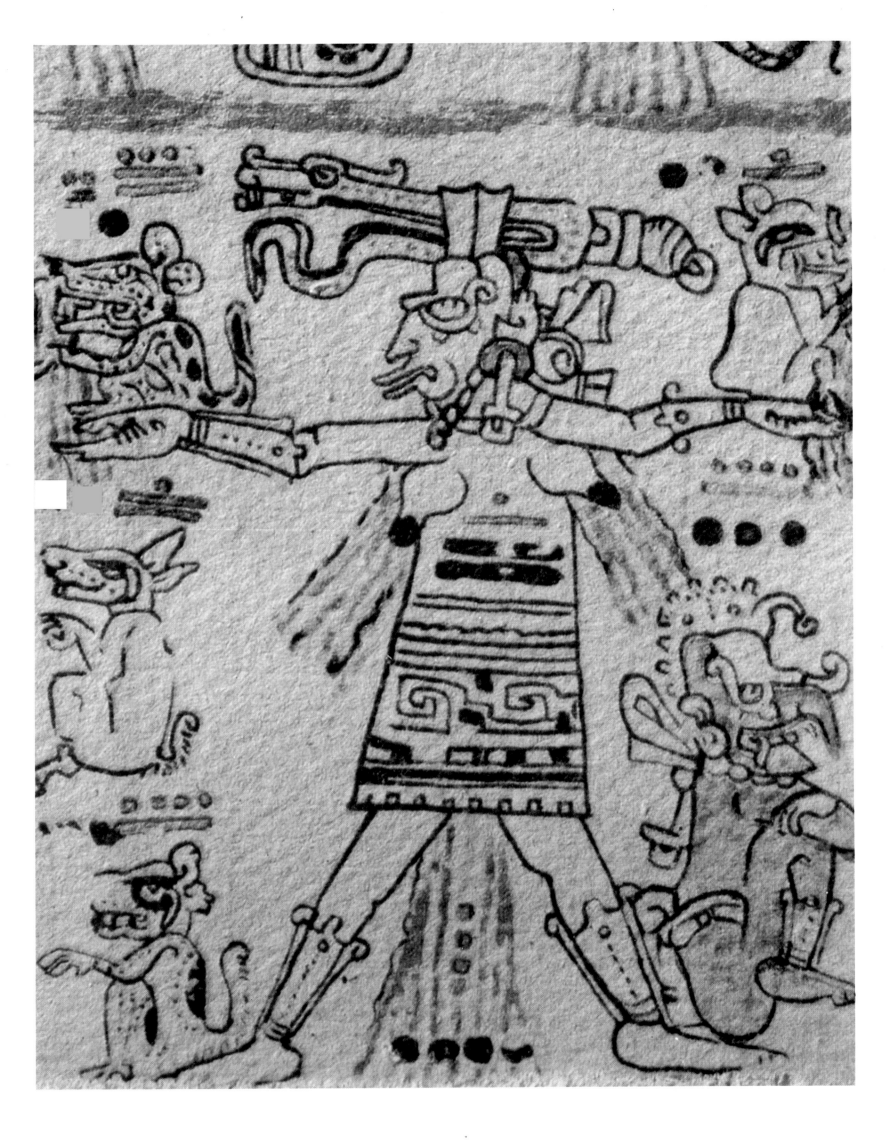

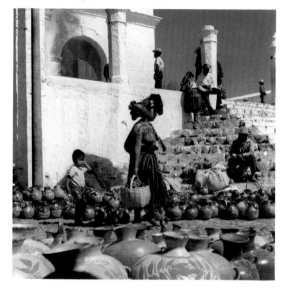

1 Pottery market at the foot of the steps of the church in Chichicastenango. Quiché, Guatemala

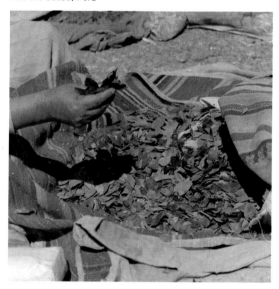

2 Sale of coca leaves; the surrounding cloths are hand woven. Cuzco, Peru

are attending art school, leaving fewer of them uneducated. We are ever more aware of our existence as folk and no longer find the term condescending.

Whether we are speaking in a national or a tribal sense, the notion of folk art suggests the existence of a distinctive creativity—the so-called style of . . .—the use of certain more or less specific techniques, and, usually, the reflection of the various manifestations of a specific culture.

The new appreciation of national or tribal cultures has led to the virtual disappearance of phrases like "Indian crafts" or "shepherd crafts"; what we look for now is the quality and, above all, the style of the individual object.

In short, the cultural development of the various groups classified as "folk" tends to improve folk art by permitting it to evolve, by bringing it into the mainstream of contemporary life; the affirmation of national cultural values will favor its continued development, giving rise to new periods of renaissance comparable to those that have occurred so frequently in other cultures throughout the course of history.

The complex relationship between folk and art is difficult to analyze because it depends on many factors, such as the relative cultural levels—including the social and economic structure—the weight of tradition, the assimilation of traits of other related cultures throughout the historical process, and the level of creativity of each successive stage of cultural development.

Tradition and Modernity

Recently, although certainly not for the first time in history, a pseudoproblem has arisen in the consideration of folk art: that of opposing the traditional to the modern and denying that anything modern can be considered truly "folk." These two tendencies are always a part of what we call art: the preference for traditional styles—which sometimes turn out to be old styles somehow cut off from the mainstream of an artistic tradition—and the preference for modern, contemporary, or avant-garde styles. This is a fairly well-known cultural phenomenon to which we are only now beginning to apply the analytical methods of social psychology.

Both classes of style, traditional and modern, are valid, and their relative proportion at each stage of cultural development depends both on the rhythms of the culture in question and on its creativity.

Mexico provides a good example of this play of tradition and modernity. It neither abandons its excellent traditional styles nor binds itself to them. Each new generation of artist-craftsmen takes what it chooses from traditional styles and techniques, partially or wholly modernizing what it borrows from the past. The pheno-

3 The sandal of Amerindian tradition, comparable to the Spanish alpargata, is being sold in a stall in the Los Filuos Market. Zulia, Venezuela

4 The Mapuche have retained their ethnic personality; they come to market not only to trade but also to socialize. Temuco, Cautín, Chile

5 Group of Aymará who have come to the annual feast of Taraco. La Paz, Bolivia

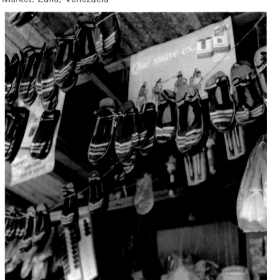 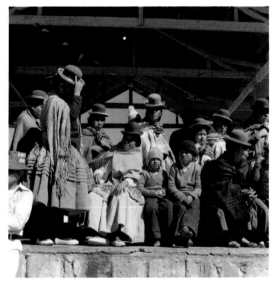 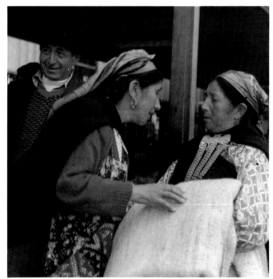

menon is reminiscent of the modernist period of European art that gave rise to an extraordinary renaissance of what were then called Arts and Crafts. This combination of traditional and modern seems to be the result of a general cultural process rather than of a tendency exclusive to folk art.

Tradition remains so long as it is pleasing to the groups that acquire it and make use of it. In reality, tradition is that which was once modern and new and which became such a deeply rooted part of the culture of a people as to be a component of its heritage. One of the characteristics of the truly traditional is its facility for reappearing, for coming back into style.

Art and Technology

All artistic works are executed by some means of technical procedures, which may vary from the very simple to the exceedingly complex. Contemporary art has a large repertoire of technical procedures, some developed recently and others long ago.

It is widely held that folk art must restrict itself to purely manual techniques. Nevertheless, this is not the case even within the category of traditional folk art, which makes frequent use of machines, albeit simple ones. Although it is admittedly possible to define such broad categories as manual production, production aided by simple machines, and that aided by advanced technology, this categorization according to technology seems less important than functional or aesthetic classifications.

We are experiencing a protest similar to that heard in Egypt when the potter's wheel was introduced amid the objections of defenders of hand-modeled ceramics. Similarly the accusation of industrialization must certainly have been hurled at those who introduced the use of molds in the production, in series, of Greco-Roman sigillate pottery.

It should be remembered that the techniques of artistic production have a progressive tendency, that it is not always necessary to abandon the simplest, oldest, and most elementary techniques in favor of the most modern and sophisticated ones. Folk art quite frequently reintroduces some traditional technique that has fallen into disuse. In Catalonia there are any number of potters working today who have revived techniques of hand modeling, ignoring the potter's wheel whenever they want to shake off the yoke of the wheel.

Restoring a forgotten technique is not so difficult as it might appear, one good reason being that many of these techniques are relatively simple. The same is true of the development of production skills that we usually call craftsmanship. It is really easier to acquire these skills through modern pedagogy than it was to acquire them

9

6 Bus decorated with a scene depicting the story of Noah's Ark, reflecting the influence of missionaries, in front of the market in Port-au-Prince. Haiti

7 The House of Mosquito Nets displays a good example of its product decorated with lace. João Pessoa, Paraiba, Brazil

8 The potter's lathe has an antecedent in the potter's wheel and later in the wheel or hand lathe. A potter of Checca. Cuzco. Peru

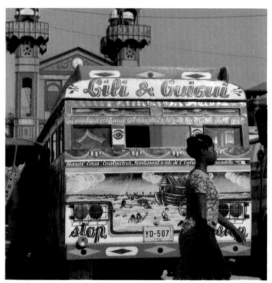
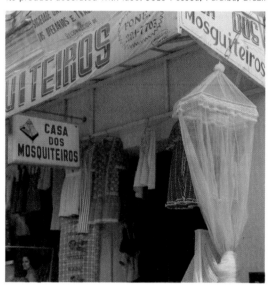
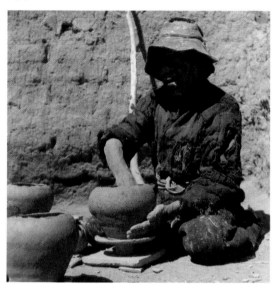

through traditional apprenticeship based on stepwise advancement, particularly since the apprentice all too often ran up against the master's insistence on keeping secrets, on not sharing all his knowledge.

Our age, having rediscovered the educational value of manual training, makes it easy for us to understand the relative artistic worth of handmade articles. Their creative, aesthetic value remains in a category apart, to be judged independently, for we understand that "handmade" does not necessarily mean "good." It is hardly necessary to add that not all the articles presently bearing the label "handmade" have actually been made entirely by hand.

Having clarified the concept of manual or simple-machine production, we can go on to consider the relationship between model and design, material and technology. The craftsworker struggles with materials and techniques until he or she is able to achieve the envisioned harmonic relationship. When this is achieved, he creates contentedly so long as he senses that his work retains its vigor and has not passed out of style. When this happens, the good craftsworker seeks new models, changing the materials and techniques as necessary. Thus we see that folk art has at its disposal a very wide range of production techniques.

Hand and Machine

Along with the workings of the mind, the function of the human hand has been a factor of capital importance in the development of culture. In prehistoric periods the human hand began to carve in stone, reaching such degrees of delicacy as the silex carvings of the Solutrean epoch and the carvings of various American cultures of the Paleolithic period—work that reached its culmination during the Neolithic period in such great ancient cultures as those of Mexico and Egypt.

In Paleolithic times man invented the first simple machines: tools. In order to work with stone he made use of other stones, employing them as hammers or anvils, and before long he developed the chisel as a means of transmitting and modifying the force of the hammer blow.

The lever is another simple machine, and it is so useful that it is probably used more frequently today than any time since its invention. The same is true of the drill, used originally to start fires and to make holes in stone beads or in human skulls in the primitive surgical procedure called "trepanning."

The study of the tools and instruments used to achieve a certain effect is illuminating in the process of appreciating any kind of artwork. To observe the complete set of implements used by an artist is to reach a deeper understanding of his craft. Nowadays there are a number of professional crafts—that of odontologist, for ex-

10

ample—that make use of a multiplicity of ultraspecialized tools and machines; these reveal the process of transition from the work of the skilled hand to that of the sophisticated machine.

We should also make note of the supplies and machines that are in and of themselves works of art. Machines are always technological instruments, but they interest us here because of the role they play in folk art. The bellows used by a smelter or blacksmith is a machine that in no way detracts from the manual dimension of metalcraft, but the treadle loom does represent a higher degree of mechanization than the horizontal ground or vertical manual loom. Pedals, separators, and shuttles—modified to an extent—have all become part of the textile machinery used in modern industry. Although the products of these three types of looms vary considerably, we should keep in mind that there are looms that are wholly mechanical, constructed and designed expressly for the machine production of decorated fabrics that could formerly be made only on treadle looms operated by individual craftsworkers.

It should be clear by now that the intention here is to clarify and define the concept of manual work and to put in proper perspective the role of machines, whether elementary or sophisticated. Many machines have been designed to carry out a series of tasks originally performed by hand; what should concern us is the artistic quality of the finished product. Moreover, the hand of the artisan always has the freedom to bestow upon an object something that insures the individuality we associate with folk art: the unique stamp of the artisan's personality.

9 The invention of netmaking has its origins in the art of spinning and ropemaking. Traditional system for twisting a cord. Secoia, Cundinamarca, Ecuador

Design

In a broad sense everything people produce has design; that is, plan, form, composition. Even when we speak we design the form of sentences and phrases. It is natural for objects produced to obey the norms of traditional design, modified to a degree by current styles or production techniques. We do not invent language when we speak, but rather choose our words to reflect our culture and personality. Artisans, when they neither invent nor modify, reproduce some traditional design. The utensils of prehistoric man were elaborated according to designs that from time to time were modified, perfected, or created anew.

An important advance occurred when the designer ceased to be the artisan or executor. A new profession was born, and new applications for the design process were discovered. We can appreciate the aesthetic dimension of even such designs as those of industrial machines—beauty of design is readily apparent in traditional machines, especially those dating from the Renaissance to modern times.

At present there are many artisans who execute designs made by someone else; artisans and artists occasionally work in collaboration, sometimes in the actual execution of an object. It is a common phenomenon for an artisan to be inspired by fine art or decorative designs and to then popularize them by adapting or modifying. This popularization is effected in two ways: the design is either adapted to the taste and resources of the consumer or is simply brought to the attention of a larger public.

Reproductions of religious images, temples, buildings, even toys that attempt to represent important or famous events, people, or places with some degree of accuracy are part of the same process. Popularization of a craft or design also occurs when an item originally made of costly materials is reproduced in cheaper materials. Mexico's intricate papercraft, for example, transfers to paper and to another technology the craft of the lacemaker. Embroidery may take the place of jewels applied to cloth; glass beads can replace precious or semi-precious stones; and so forth.

It is difficult for design not to be traditional. Even the most current models, though generally responsive to modern styles, borrow traditional designs, sometimes those of other countries. Renovation and tradition are the design basis of the folk art of the future. In many eras and in many cultures we have seen that ancient designs have been reintroduced whenever popular taste was ready to receive them.

One-of-a-kind and Series Production

The sociology of art concerns itself with replicas, copies, and reproductions of works of art as well as with the special problem of production in series. We should begin by recalling the common procedure in sculpture which requires that the original, if made of clay, be destroyed when the mold is opened, and the number of copies that can be made from the second original in plaster be fixed at four.

Once again we see an area in which the technological component of what we call folk art has special prominence. The artisan who executes one-of-a-kind pieces or who produces in small quantities is very imaginative. In Totolá, Mexico, potters make one-of-a-kind pieces inspired by topics of their society; they see no reason to repeat themselves. Technological advances such as the potter's wheel and the use of molds make series production easier. Series production is frequently used in making everyday domestic pottery and cast items. These series are not precisely the same but vary quite easily in response to current fashions or designs. Another kind of variation occurs as a result of the maturing of an apprentice or the declining energies of an older craftsworker.

The real problem is the relative worth that should be attributed to one-of-a-kind pieces versus series production. The price difference—quite another matter—really should reflect the difference in cost. Working out a design is arduous, but if it is used for a series, the cost can be divided among the individual pieces in that production, as is the case with copper engravings or etchings, which can yield fairly large numbers of prints with no deterioration of quality, or of woodcuts, which can be used on traditional printing presses.

The true value of a piece is determined by the quality of its design, execution, materials, the technology employed and, therefore, in the overall result, the artistic level achieved.

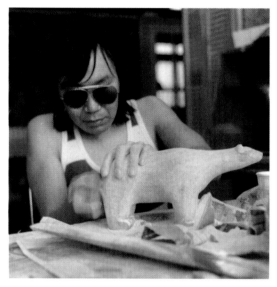

10　Eskimo sculptor from the Northeast Territory carving a bear in steatite. Canada

In general, series pieces that stand up well over the passage of time without undergoing significant changes are those that give pleasure and that speak to deeply rooted popular tastes. These designs are usually functional and well defined. Quite frequently they appear to be difficult to improve upon without radical modifications.

From the above it should be clear that there is no breach separating craft production in series and mechanized production. What differences there are tend to be in the design; finishing, which may enhance or detract from the piece when done by hand; subtle effects that a machine may be incapable of achieving; quality of materials, since industrial products are sometimes introduced; and price, which may be higher or lower for handmade goods.

One last observation. In some highly developed countries that are trying to revitalize their folk arts one notices the following trends: a new awareness of the importance of design in folk art; a clear-cut distinction between one-of-a-kind and series production; a recognition of differences in quality; an increase in the price commanded by folk art as a result of the normalization of salaries and work schedules. These trends show the direction of folk art of the future.

The Importance of Folk Art in the Americas

The American continent is a part of the world clearly delimited by its geographic boundaries. From a cultural perspective we should really always refer to it as the Americas. The main value of its folk art lies not only in the high level of achievement but also in the variety and number of themes, forms, and materials. The illustrations in this book serve as a fair sample of this rich variety.

The advanced development of folk art in the Americas is a result of a number of operating factors, some of which should be noted here. The first of these is the broad base of lands, peoples, and possibilities that America comprises, from the variety of terrain, climate, and raw materials to the many ethnic groups of pre-Columbian origin, whose numbers far surpass those that existed in fifteenth-century Europe.

An astonishingly high level of development had been reached by autochthonous American cultures, a phenomenon that amazed the first European observers. The amount of handwork being done in Mexico, Central America, and the Andean region was truly amazing, comparable to that done in Egypt prior to the introduction of the horse and the use of iron. These cultures had certain characteristics that encouraged the development of folk art and handcrafts. They were by and large not mechanized to any degree; because of their

11 Trunks or bride's chests of painted wood with repeated design. San Francisco El Alto, Totonicapán, Guatemala

relative isolation and their traditions they had not discovered the effective use of either the wheel—the basis of most machines—or of iron, the metal most commonly used in making tools. The understanding of metallurgy and the use of molds to cast metals and to make ceramic vessels and figures were important advances in the development of folk art in the Americas. The wide range of activities performed by artist and artisan in these cultures and the almost total lack of distinction made between their roles help explain the high artistic level of many examples of folk art.

The ancient agricultural peoples of the Americas organized their societies so that the artist, when his labors were not needed for farming, had time for handcrafting; weaving, pottery, the making of religious images and of jewelry, etc., were recognized also as work having a social function. This was possible because of the relatively high agricultural yield resulting from irrigation techniques, and also because excessive time was not devoted to military activities nor to supporting the luxuries of the royal court, both of which made heavy drains on the time and energies of the common man in the Old World during the same period.

Amerindians and Immigrants

Before the arrival of Europeans, the population of the Americas comprised various groups of the Amerindian trunk. The enormous extension of the territory, the relative lack of population, the isolation of less numerous groups, and the great distance separating the northern and southern extremes explain the cultural and linguistic diversity and the relative endogamy of various groups.

These factors were gradually modified over more than four centuries by the arrival of groups of immigrants and led to the development of a mestizo population that has yet to be carefully studied. The process of racial blending went relatively smoothly, although during the first three centuries the social, economic, and educational infrastructure of many countries set the mestizo in a social status generally inferior to that of his European forebears. The nationalism of new American states has helped improve the status of the mestizo, and in the last few decades it has also raised the social and cultural level of other groups within the population, such as blacks and mulattoes.

For folk art and handcrafts throughout the Americas the net effect of the ethnic mosaic that exists today has been one of constant enrichment. Two clearly defined groups of immigrants are the criollos and the foreign groups that have maintained their ethnic unity. The word criollo refers to a person descended from Spaniards who settled permanently in an American country and who is not a mestizo.

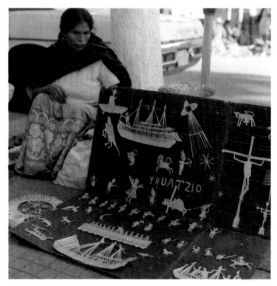

12 Woven straw figures, showing considerable Western influence, in a great variety of shapes at the market in Uruapan. Michoacán, Mexico

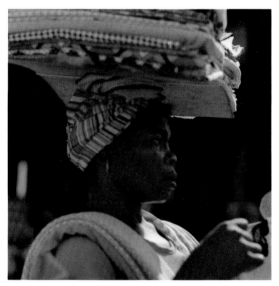

13 The black and mulatto population is of significant proportion in many areas of the Americas. This woman is from Port-au-Prince. Haiti

Transplanting their culture and traditions to a new environment has in some cases borne a rich harvest for criollos, owing to the greater number of economic and social options available to them in the new country. In addition, the fact that they were not mestizos afforded criollos certain social advantages.

The second group of immigrants is composed of a number of subgroups that seek to maintain their individual ethnic unities, cultural coherence, traditions, techniques, and folk art. The Germans and Swedes who emigrated from the United States, especially those who settled in rural or jungle areas, are good examples.

The great mobility of individuals and families in many countries of the Americas today is another factor that favors the blending of diverse groups within the population.

Cultural Mestizaje

The most surprising aspect of twentieth-century American folk art is probably the wide range of cultural mestizaje it presents. The panorama of form and content between the extremes represented by Amerindian art, on one hand, and European, on the other, is extremely broad.

The phrase "cultural mestizaje," used to denote the crossing of races and the resultant culture, is not altogether satisfactory. It has been chosen because it suggests a cultural process analogous to what occurred with respect to the population.

It is not possible to speak of influences arriving from Spain, Portugal, France, or Ireland through direct or even nearly direct channels. The process of cultural "delivery" brought a mixed bag of beliefs, life-styles, customs, and material objects from the Old World. Having transported all this, people then attempted to live as if they were still at home.

Another kind of activity that led to this mestizaje was the imitation of new forms of culture, especially in the new cities created according to Renaissance and Neoclassic models. Soon urban and rural ways of life came into direct contact with each other, the former having been introduced by Europeans and the latter American in origin. The development of the cattle and farm industries in the form of ranches also increased the contact and intensified the exemplary force of new ways of life. These phenomena had appeared previously at various historical stages in the Old World and are reappearing in our century in many African countries.

Cultural mestizaje, then, is broad and varied and occurs in different degrees. Its impact is most visible in such areas as dress and domestic utensils, in the introduction of new trades —blacksmith, tinsmith, etc. — and especially in the modification of the common beliefs of a given group.

14 The leucoderm or white race of America is composed of a number of subraces, which in turn are mostly composed of hybrids of these subraces. Santa Fe, New Mexico, U.S.A.

15 The long white dresses for girls of marriageable age are European in origin and are still used in the dances of European or hybrid origin. Villa de Leyva, Boyacá, Colombia

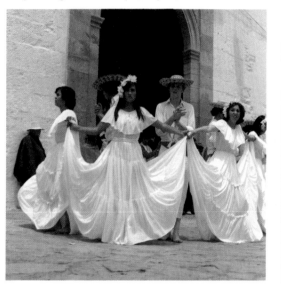

16 Sourdough breadmaking and the custom of making little bread figures, derived from Europe, have fused with American traditions. Calderón, Pichincha, Ecuador

Exactly as had occurred in the Old World, Christianity was introduced into cultures that had been animist or polytheistic; not only was Christianity influenced by these beliefs and the people who held them, but there was a development of those beliefs that coincided with both religions.

The specific process by which the cultural elements that have had an impact on folk art in the Americas were actually transported is not well understood. What happened during the sixteenth through nineteenth centuries in this respect has scarcely been studied, primarily because of the scarcity of reliable documentation. What we know most about is the result of this great process of cultural mestizaje, and it is this result we should like to have this book reflect.

Amerindian Cultures and History

American folk art cannot be understood independently of its cultural and historical context. Just as the study of folk art is inseparable from the process of art taken as a whole, so is it from the general historico-cultural process of a people. In most of the introductions to the chapters in this book, brief historical sketches of the country's cultures are provided, since it is from these that present-day folk art has sprung.

Beginning with the immigration from Europe and other parts of the world, the history of the Americas has constituted a human phenomenon having great transcendence, whose proper study has unfortunately been ignored or distorted as a result of biased perspective. The extensive fieldwork done throughout the Americas in connection with this book has led to the belief that the American melting pot has not succeeded in amalgamating all autochthonous cultures with those of European origin.

In order to write a balanced history the interpreter must ignore certain widespread suspicions of ancient traditions and the tendency to think of them as inferior or as pagan. An example of such a suspicion is the fear many people have of the Amerindian languages. An exception to this is the instruction that is presently being given to children in some of the native languages. One can hardly appreciate a culture without access to its language.

There are few immigrants or descendants of immigrants who speak an American autochthonous language at home. The emphasis on the indigenist movement that has been a part of the political program of so many American countries as they have achieved their independence has, in most cases, been a matter more of rhetoric than of substance.

In the face of the historico-political process of constraint and isolation practiced against non-European

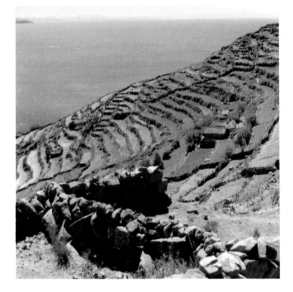

17 Terrace farming, of great importance in the Far East, was also an achievement of the advanced civilizations of the Americas. Terraces of Taquile, Lake Titicaca, Peru

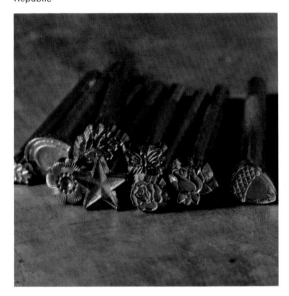

18 Awls for decorating tin. The use of the stamp to decorate leather, paper, copper, brass, and tin is found nowadays throughout the Americas. Santo Domingo, Dominican Republic

cultures in the Americas, the survival of a native artistic tradition, of crafts so rich and so varied in nature, demonstrates the enormous energy, the great resiliency of many native cultures. Nevertheless, the future, from an anthropological standpoint, is not very promising.

New Materials and New Techniques

The Europeans who came to the Americas from the time of the high Renaissance until very recently had to make the trip by boat. Their notion of colonies, in earliest times, was inspired in part by the Greek and Roman colonies, as reevaluated during the humanistic studies of classical Greek and Roman histories. It is for this reason that for these colonists "settling" meant building fortified towns and cities.

The immigrants, as we have said, came by boat and had to carry with them not only goods for trade, but also seeds, tools, cattle, small machines, etc., all of which enabled them to introduce new techniques and materials. Many of the colonists knew a traditional trade that they had practiced in their country of origin, and they knew how to work with materials as yet unfamiliar to Americans. Here we must make an effort to imagine the Americas without oxen or horses, and consequently without plows or carts, without the means of transportation provided by the combination of saddle horse and draft horse.

The forging of iron is an example of the use of a European technique that made available a new material; its introduction was to constitute an authentic technological and economic revolution in the New World. We should bear in mind that the rural forge is a relatively simple affair, easy to set up and transport by cart. One only has to recall the figure of the blacksmith who appeared in so many wild west films from the United States.

Another technological advance was the introduction of the lathe, which was used for ceramics, woodworking, and later for ironworking. Of great cultural importance was the introduction of the printing press used for reproducing texts and illustrations.

Other techniques and materials were introduced one by one—glassblowing, tin and coppermaking, use of the treadle loom, methods of boat and ship construction, use of new dyestuffs, methods of tanning ox- and horsehides, shoemaking, and all of the mechanical experiments that culminated in the development of the steamship. Folk art makes use of nearly all these advances, as we shall see.

19 Copperware market in Santa Clara. Michoacán, Mexico

20 Living room/workshop with a treadle loom in the home of a family that loves handcrafts. La Española, New Mexico, U.S.A.

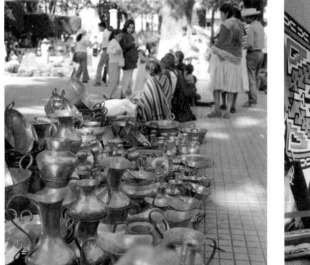

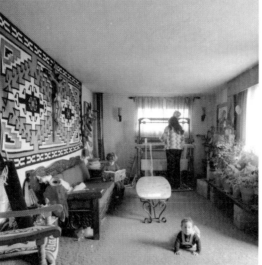

The Future of Folk Art

The peoples of the Americas are presently experiencing a consolidation of various nationalities and cultures that parallels the modernization which is incorporating them into the mainstream of contemporary society. Mexico City is an example, on a large scale; it includes everyone from former peasants to industrial and financial magnates. In this city—one of the largest in the Americas—there is traditional folk art, both Amerindian as well as criollo and mestizo; contemporary folk art of a very high level of artistic quality; and many objects made by hand by nonprofessionals—that is, by people who are not in the trade.

We should not forget that the term "folk" can be applied to everything that is used by people—many people—with certain differences according to the social class in question. This means that many "folk" elements are not necessarily craft items but are products of an industrial process. These objects—toys are a good example—have a promising future in that they will be more and more widely distributed and will eventually become very popular. It is important to analyze the design of such items, which may or may not be of folk origin, as well as the way in which the items are used. In many cases they are nothing more than industrial reproductions of traditional models that have been modernized.

Clearly in evidence is the growing appreciation for handcrafted items that require special skill; there is a demand for quality of form and design as well as materials.

We might consider another aspect of the new interest in folk art. At the present time traditional housing is being replaced by apartments designed and executed with standard elements, impersonal in the extreme. At the same time there are more and more residences and studios that have a particular ambience that expresses the personality of the people who live there; this individualism is revealed in the design, use of space, and interior decoration, all of which are at a high level of aesthetic awareness and are often folk oriented or folk inspired.

The purpose of these brief notes has been to suggest that folk art includes much more than the purely traditional and that future folk art will flourish not so much because of the efforts of artists and artisans as because of the enjoyment of people who admire it and who want to make it part of their daily lives. We should remember that bibelots have always been and still are popular.

Pessimists say that folk art is on the wane. We optimists, who have confidence in people, believe that the twentieth century will see a great upsurge in the appreciation of folk art, especially in the Americas.

CANADA

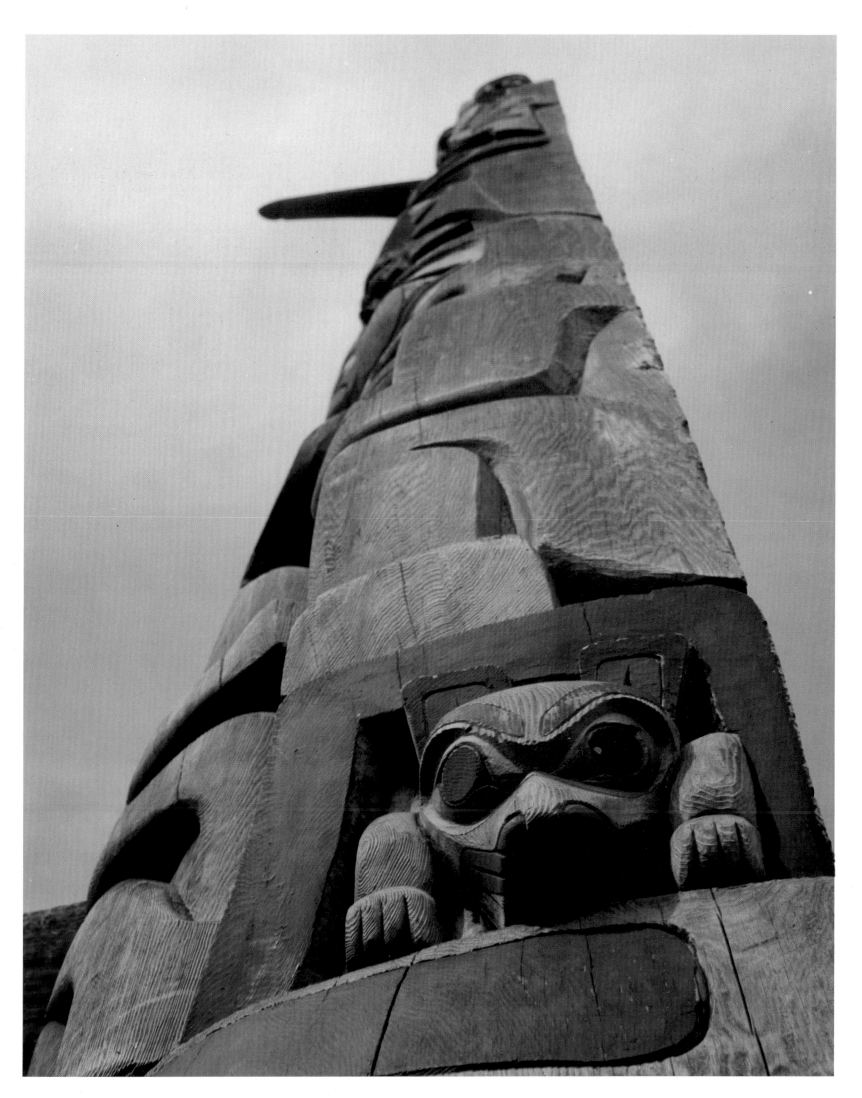

21 Magnificent Kwakiutl Indian cedar totem pole; the carved
figures represent crests of the family for whom it was made.
Victoria, British Columbia

Introduction

To some people it may seem that Canada and the United States must be similar merely because English is the dominant language in both countries and the majority of the early immigrants came from the British Isles. The fallacy of this thinking is made obvious by looking at their folk art traditions. Each country of the Americas has developed its own unique cultures with different political systems, customs, mores, and folklore.

The French and English explored, settled, and vied over who would control Canada, in the process involving various Indian groups. At the end of the War of Spanish Succession in 1713, France ceded some of its territories to England, and by 1763 French power in the New World ended.

The legacy of France continues today in the French-speaking minority of Canada, who make up 25 percent of the population. Many residents in the Métis are the offspring of French *coureurs de bois* who explored the wilderness, and of Indians who helped them. In Quebec, the French have had special status since 1774, when cultural rights, such as French civil law, and the Catholic religion were first guaranteed in an attempt to stem the domination of the British. Many of these were the one hundred thousand Loyalists who, distrusting republicanism, fled the American colonies to settle in Canada. Today the Canada government is a constitutional monarchy modeled after England's with the queen of England as the titular head of Parliament. The ten provinces and two territories are bound together in a federation more loosely tied than the republic states to the south, and this serves to accentuate the regionalism that is characteristic of Canada.

The waves of immigrants from other parts of the Old World fled the hardships of nineteenth-century Europe not only to the United States but also to Canada. There are, for example, Canadians of Ukrainian, German, Italian, and Greek descent. In addition, there are immigrants from all members of the Commonwealth, as well as groups who fled religious oppression, such as the Mennonites, whose communities dot the Ontario landscape.

Although Canada is the largest contiguous country of the Americas, its population is one-tenth that of the United States and one-fifth that of Brazil, the next two largest countries. This low population density, coupled with a harsh climate in the northern reaches, has meant that many of the native peoples have been able to maintain a cultural uniqueness, perhaps even more so than those in the United States. Canada thus offers a mosaic of subcultures that politics, geography, and demography have accentuated.

Canada's folk art will be represented here mainly through some of her oldest inhabitants: Indians of the East, Northeast, and Northwest; the Inuit (the preferred term for the Canadian Eskimo); and the French Canadians, who are perhaps less well known than the majority.

After vying with Russia and Spain for control, the English established a booming fur trade along the coast of British Columbia in the late eighteenth century. Within one hundred years, the province's Indian population had been reduced by 60 percent, but on the Queen Charlotte Islands, the Haida had lost 86 percent, mostly due to the ravages of smallpox. Today, the Haida Indians are making a comeback, and so are their argillite carvings, which were first made in the 1820s as souvenir items with designs based on scrimshaw. Present-day carvers, using symbolism often understood only by them, apply traditional motifs drawn from Haida mythology. The large cedar totem poles erected to mark a special family event are often commissioned by museums who have

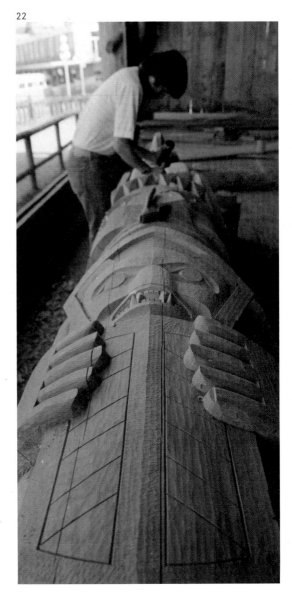

22

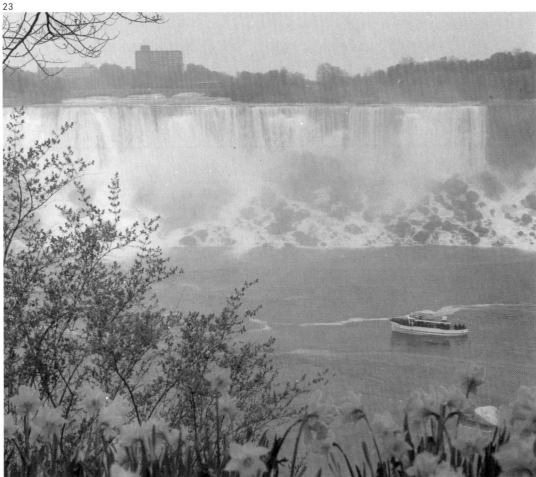

23

22 Coming from a family of carvers, this artist works on a cedar pole that will display his family's crests, given to the Kwakiutl by mythical ancestors, for the Provincial Museum. Victoria, British Columbia

23 View of Niagara Falls. The river of the same name separates Canada and the United States

24 Snowy scene of a boat at the dock showing the cold northern spring. Cape Dorset, Northwest Territories

the space to display these magnificent works. Other folk arts seeing a revitalization among Canada's native peoples are baskets, woodcarvings, textiles, and beadwork. The craft that created the giant poles of the Northwest Coast, possibly dating back thousands of years, is witnessing a renaissance. Master carvers are training apprentices in this ancient art, and it is becoming evident that this is also happening in other crafts.

In the eastern Canadian Arctic, where the full impact of the western world has been even more recent than on the Northwest Coast, the Inuit are producing crafts that involve more than one worker, such as embroidered parkas and jewelry. Other folk arts, such as ivory rings and weavings, are done by individuals who are using old motifs with new materials, or new motifs with old materials. The native peoples across Canada have shown an ingenious talent for synthesizing the old and the new, the indigenous and the introduced.

The dominant culture of Canada is also seeing a folk art revitalization. For example, stained-glass work that was imported from Europe during the colonial period's beginning and then later influenced by Louis Comfort Tiffany's adaptation of Art Nouveau designs in the late nineteenth century has become very popular in Canada. Many of the folk arts of the French Canadians, however, have had a continuous history, such as the weaving in the folk art centers along the upper St. Lawrence River in Quebec. So not only in the work of the native peoples but also in that of various other groups do we see a blending of the old and new as well as a pride in heritage that is contributing to the revival and growth of folk art in Canada.

24

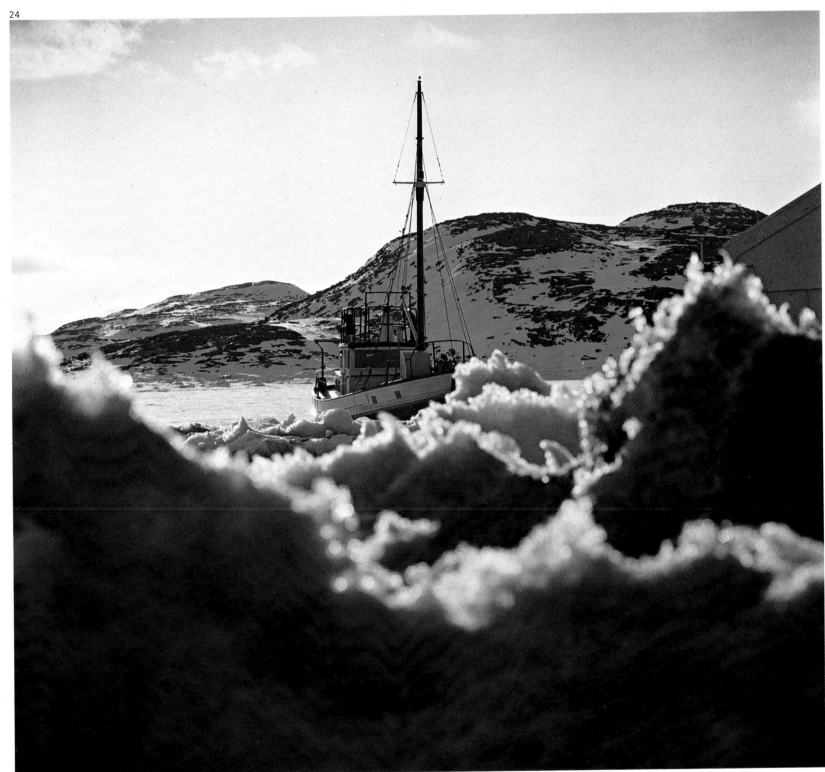

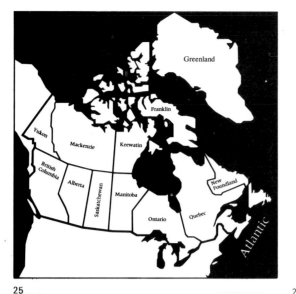

25

26

27

25 Stained-glass work here follows a tradition greatly influenced by Victorian England that has had a recent revival in North America. London, Ontario

26 Argillite carving of a totem pole being done by a Haida Indian. Queen Charlotte Islands, British Columbia

27 A religious carving by François Guernondit Belleville in 1775 being carefully reproduced in wood relief. St.-Jean-Port-Joli, Quebec

28 Basket of ash and sweet grass made by Micmac Indians, who now live in New Brunswick, Nova Scotia, Prince Edward Island, and on the Gaspé Peninsula in Quebec

Basketry

Basketry was a well-developed craft across North America, but among the Indians of the Northwest Coast it reached its zenith. It was also among these coastal tribes that the technique of twining was perfected. So closely woven were the strands of cedar bark, spruce root, tule reeds, and grasses that the baskets were used to hold water into which hot stones were placed, a cooking technique called "stone boiling." Baskets were also used for carrying, storing, and as eating vessels, and basketry techniques were used in making mats, bags, and blankets.

The Micmac of eastern Canada, who live on the Gaspé Peninsula in Quebec as well as in the Maritime Provinces, were among the first Indians to have contact with the white man in the sixteenth century. Traditionally, the Micmac made containers of birchbark, and it is not known when they learned to make the splint or plaited baskets that replaced them. However, they probably learned the new techniques from other Indians who, like the Micmac, were Algonquian speakers (a language family) and lived to their south, or from the Iroquois to their west. The baskets are made from a combination of black ash and sweetgrass, which gives them a distinctive and pleasant odor. Like most baskets in North America, they are usually made by women, sometimes in organized shops where each person makes one part of it. Some of these fancy baskets are made to resemble acorns or strawberries, and are used by the Indians themselves as well as sold to a wider market. Larger, less elaborate baskets are used to hold fish and potatoes, two industries in which the Micmac have been involved.

Finally, the Salish Indians of British Columbia, who live both on the coast and inland, use a technique

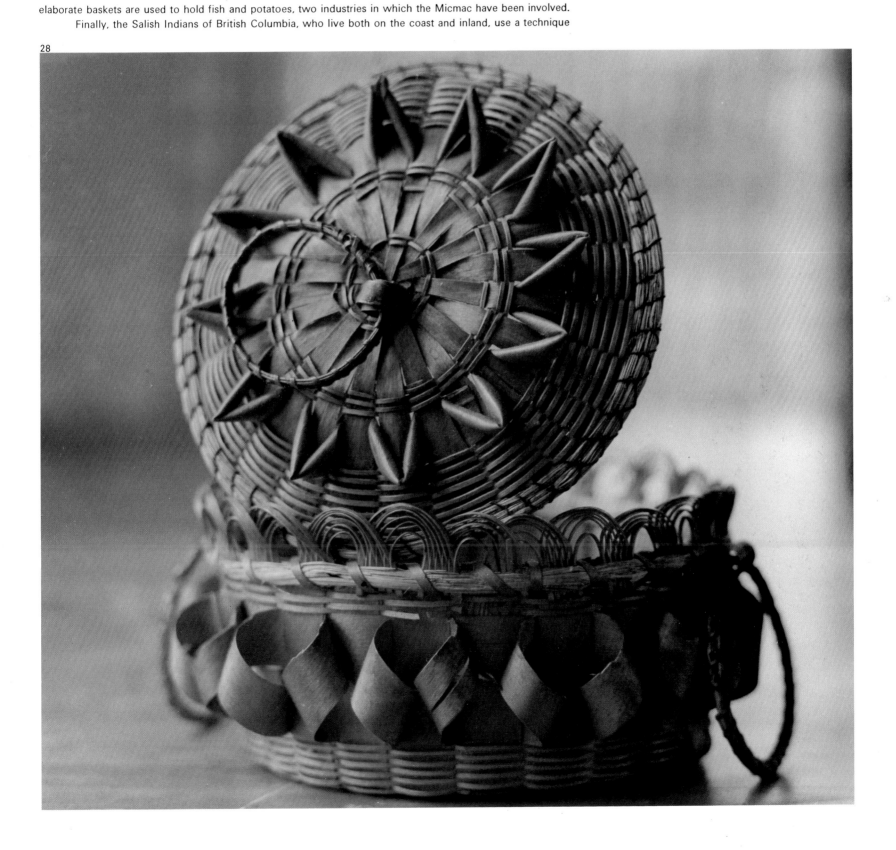

in their baskets not found among the coastal groups until recent times: the coil. Rings of flat fibers or reeds are sewn together rather than woven as in the plaiting and twining techniques.

Far from the Micmac, the Nootka, and the Salish live the Cree Indians of the central and eastern Canadian subarctic. These Indians were a vital link in the early fur trade and acted as suppliers of the desirable beaver and as middlemen between the whites and more remote Indian groups. According to an archaic law currently under review, the offspring of an Indian woman and a non-Indian man are not Indian, and in fact the Indian woman ceases to be Indian herself upon such a marriage. The result is that many of the crafts made by Canadian Indians are also made by the Métis, especially those having to do with hunting. Decoys made of spruce twigs (used to lure the Canada goose as it flies north to its nesting grounds in the spring and again when it flies south to its feeding grounds in the fall) are examples of the kind of craft shared by the Métis and Cree.

The Naskapi Indians of the eastern Canadian arctic and subarctic also hunt migratory birds to supplement their diet of caribou, bear, beaver, and fish. In a special feast, called a *mokoshan*, grease is skimmed off boiling meat with a special spoon made from spruce. This elegant utensil, ending in a goose or duck head handle, has not been successfully marketed, partly because although handmade it looks machine made. However, the Naskapi continue to use the utensil because of its ceremonial importance. These spoons, along with other wood items, are carved by men who achieve the nearly perfect lines without the use of rulers.

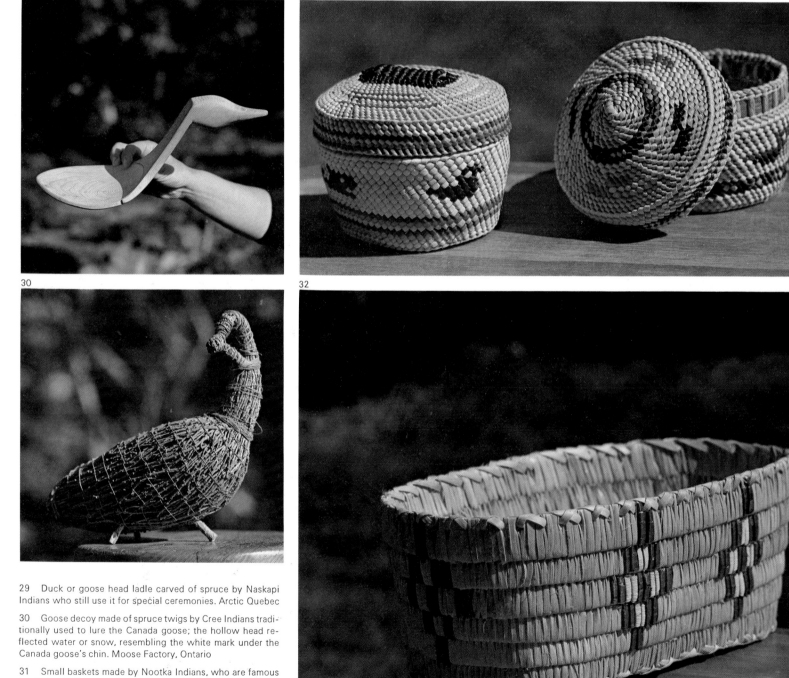

29 Duck or goose head ladle carved of spruce by Naskapi Indians who still use it for special ceremonies. Arctic Quebec

30 Goose decoy made of spruce twigs by Cree Indians traditionally used to lure the Canada goose; the hollow head reflected water or snow, resembling the white mark under the Canada goose's chin. Moose Factory, Ontario

31 Small baskets made by Nootka Indians, who are famous for their whaling expertise and who often picture whales on baskets. West Vancouver Island, British Columbia

32 Traditional coiled cedar basket made by Salish Indians. Northeast Canada

33 Beaded necklaces made by Cree Indians. Although none of the designs is traditional, necklaces have long been important to them, and some of the beading styles are unique. Fort George, arctic Quebec

Beadwork

While men usually work in wood, women have always done the beadwork in the eastern part of Canada. Although Christopher Columbus introduced glass beads into the New World, the Indians had manufactured their own shell beads centuries before. They also used various bird, mammal, and fish bones as well as seeds and porcupine quills to create the designs the glass beads would copy. Beadwork is a very tedious process, and some of the old museum pieces that are literally covered with beads —dresses, carrying bags, shirts, and so forth— are heavy and must have required an adjustment in their users' gait. There are several stitches that are used in beadwork; in one, several beads are sewn in a line with one needle, and a second needle returns to tack each bead in place. While geometric and curvilinear designs were popular, representational ones such as the thunderbird (a clan symbol among the Mohawks) also appeared. Beadwork continues to be made and worn by Indians across Canada, and to be sold to an increasing market. However, there has been recent intrusion by machine-made items from the Far East, so Indian-made items are marked with a special card issued by the Canadian government.

An interesting interaction has occurred in recent years, spurred on by the media and the Pan-Indian movement, in which different tribes have adopted designs and symbols that were not part of their traditions. Thus we find that such items as the necklaces made by Cree Indians of Quebec have designs that do not relate to their aboriginal culture. Feathered headdresses, however, have been adopted by many Indians as an iden-

33

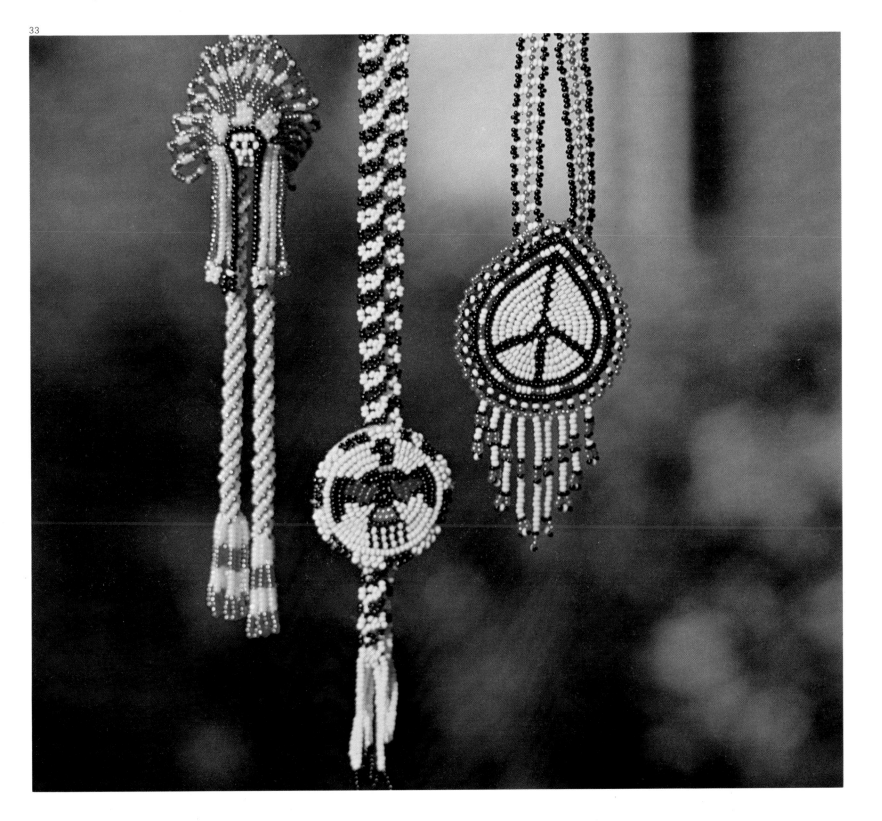

tity marker, although it was only used by Plains Indians in a culture that developed after the advent of the white man, who introduced horses and guns. Nor was the peace sign aboriginal, nor the thunderbird for this tribe. The techniques of beading are traditional, however, as is the use of necklaces. Pendants are done on moosehide and birchbark backing. Another group that has adopted the feathered headdress is the Mohawk, part of the Six Nations of the Iroquois Confederacy who sided with the British during the French and Indian Wars and the American Revolution, a fact which is acknowledged every year in a special ceremony.

Beadwork is still used to decorate certain clothing items, such as mitts and boots made of a combination of traditional colors, designs, and materials of the white man. These items are influenced not only by whites but by Inuit. Both mitts and boots are still worn in the subarctic climate inhabited by the Cree, although fancy ones are usually reserved for special occasions or sold to visiting whites. Thus beadwork presents us with an introduced manufactured item that has been integrated into a traditional folk craft, and recently used as both a marker of Indian identity and a commercial product.

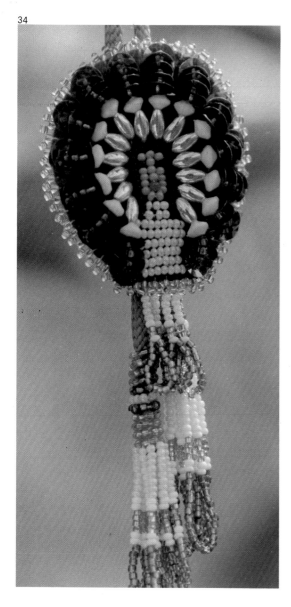

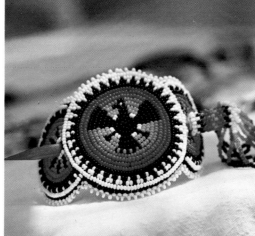

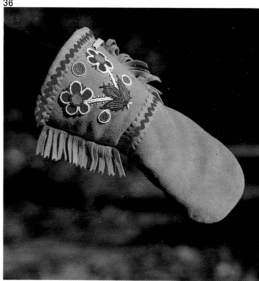

34 Elaborate Mohawk Indian necklace depicting a feathered headdress not worn by them aboriginally

35 Mohawk Indian hair ornament depicting the thunderbird, an important figure among the Algonquian-speaking Indians of the northeast. Algonquian is a language family; however, the Mohawks speak Iroquoian, another language family. It is not known who originated the design

36 Beaded mitt by a Cree woman for a subarctic settlement with bilateral design typical of this area. Winisk, Ontario

37 Mohawk Indian woman demonstrates beadwork; porcupine quills and shells were used before whites brought beads in the seventeenth century. Six Nations Reserve, Ontario

38 The merging of three dominant cultures can be seen on this boot: the cloth is from the whites; the style of the use of vertical bands comes from the Inuit; and the execution and beadwork were done by a Cree woman. Winisk, Ontario

Another introduced technique that has been integrated into the traditional is the Cowichan knitting industry of the Salish Indians of British Columbia. In precontact times, the Salish worked in goat and dog wool, weaving blankets that have recently been revived. They did not, however, knit until early Scottish settlers in Vancouver taught them. The resulting sweaters, worn today by Indian and white alike, are made from raw wool, which is left untreated and thus is water repellent. Some of the designs are similar to the ones on baskets, but a popular one today is the eagle, a family crest symbol.

Another introduced handicraft that has been integrated into traditional skills is that of embroidery among the Inuit of Frobisher Bay on Baffin Island. Inuit all over the arctic, both men and women, were skilled at sewing, for in such a climate even the smallest tear in clothing can mean freezing to death. Before contact with whites they made decorative designs by inlaying caribou and seal of different colors. This sewing industry is not too far removed from their traditions, which they picture in their work: camp and hunting scenes, some mythological, are used in many of these embroidered works, which resemble paintings. A popular motif, which is an Inuit identity marker, is the woman's *amautik* worn by mothers to carry their babies, and is distinguished by its white color and the tail that almost reaches the ground in the back.

Typical of Inuit work, great attention to detail is exhibited in the embroidery, which decorates most of the parkas worn in the north. At the Pitavik crafts shop in Frobisher Bay, the women work together designing,

39

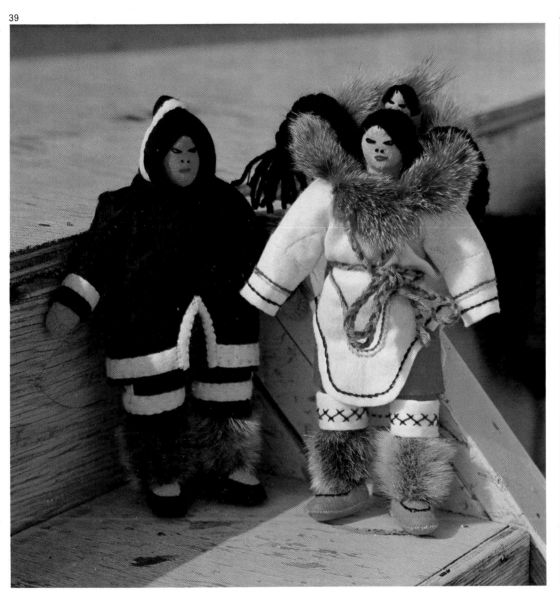

40

41

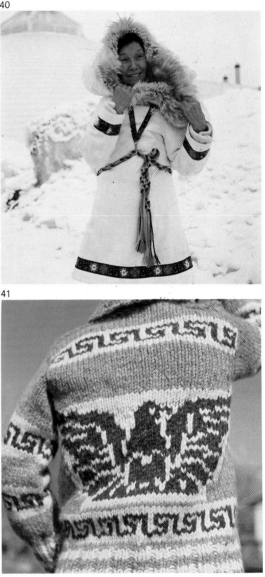

39 Dolls imitate a typical family on Baffin Island. Meticulous attention to detail is typical of Inuit crafts. Cape Dorset, Northwest Territories

40 Inuit woman wearing an *amautik*. The hood is often used to carry a baby. Frobisher Bay, Northwest Territories

41 Salish wool sweater with a popular eagle design. Originally, wool from specially raised dogs, now extinct, was used. Vancouver, British Columbia

sewing, and, with the help of an Italian tailor, putting together a line of parkas and jackets to be marketed in the south as well as the north. The parkas are made of duffle, a warm wool imported from Scotland, with a wind-proof cotton outer shell.

Attention to detail can be seen in the dolls made by women in such settlements as the ones on Cape Dorset. The dolls, which are stuffed with grasses that grow on the tundra, often have little knitted toques under the parka hoods, as well as clothing under the coats. The outer clothing is trimmed in seal and fox or wolf fur to imitate real clothing. In a landscape that may seem barren to the outsider, the Inuit survival often depends on close scrutiny of the details of their environment. Although most now live in settlements, it has only been in the last twenty years that the white world has encroached on the Inuit way of life, and they have adapted to rapid change admirably. They have also had a great deal of government backing in the development of various arts and crafts that had been lacking among other native groups. Nevertheless, as in the case of dolls, some things have not succeeded in the outside market and are made mostly for their own use.

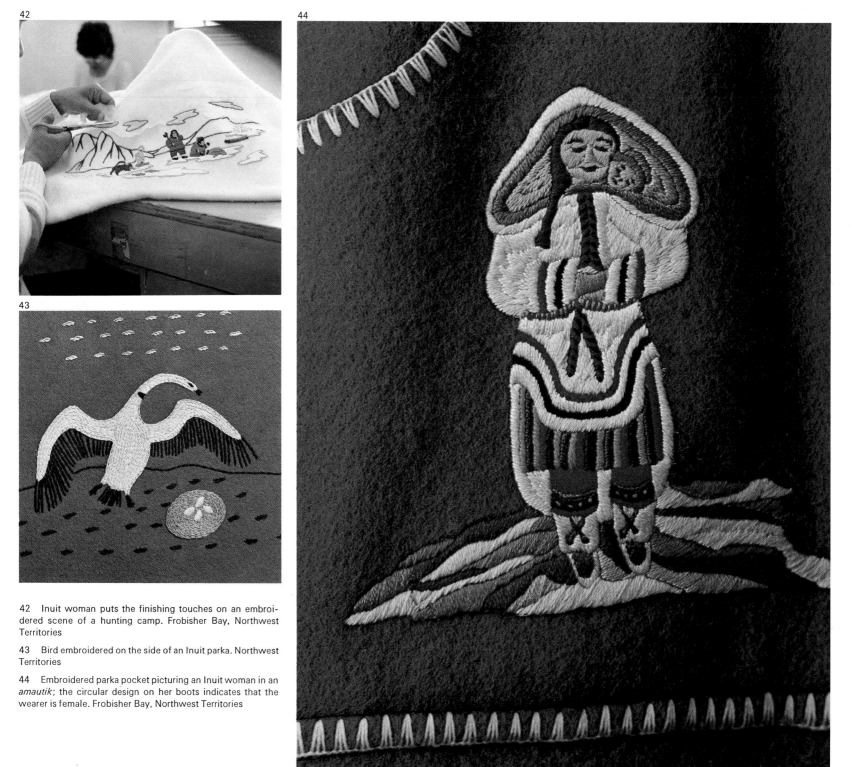

42 Inuit woman puts the finishing touches on an embroidered scene of a hunting camp. Frobisher Bay, Northwest Territories

43 Bird embroidered on the side of an Inuit parka. Northwest Territories

44 Embroidered parka pocket picturing an Inuit woman in an *amautik*; the circular design on her boots indicates that the wearer is female. Frobisher Bay, Northwest Territories

Jewelry

A new craft that combines old motifs with traditional and introduced materials is the jewelry making now underway at the Ikaluit Cooperative in Frobisher Bay. The work is distributed among several craftsworkers, some doing the designs, others the molds, others the shaping of the soapstone backing used in a few of the works. Once again, identifiable motifs like the woman in an *amautik* are used. Soapstone was traditionally used to make lamps and is now the medium for fine arts, but, as here, it is also used for a folk craft. Jewelry has become more important to the Inuit in their personal dress as life has become easier, but many of these pieces are being produced for an outside market. Some fine artists produce folk crafts on the side, as is often the case among potters in the United States. For example, an artist in Cape Dorset carves ivory rings for the craft market, and for the fine art market does soapstone carvings. Ivory is also used in the Ikaluit jewelry, usually in the presentation of animal motifs.

Whether or not this cottage industry will be a commercial success, it is an example of an adaptable group's presentation of itself to both insiders and outsiders in a new medium; it is perhaps the beginning of a new folk art created by an ethnic group that is being integrated into the larger Canadian society through technology.

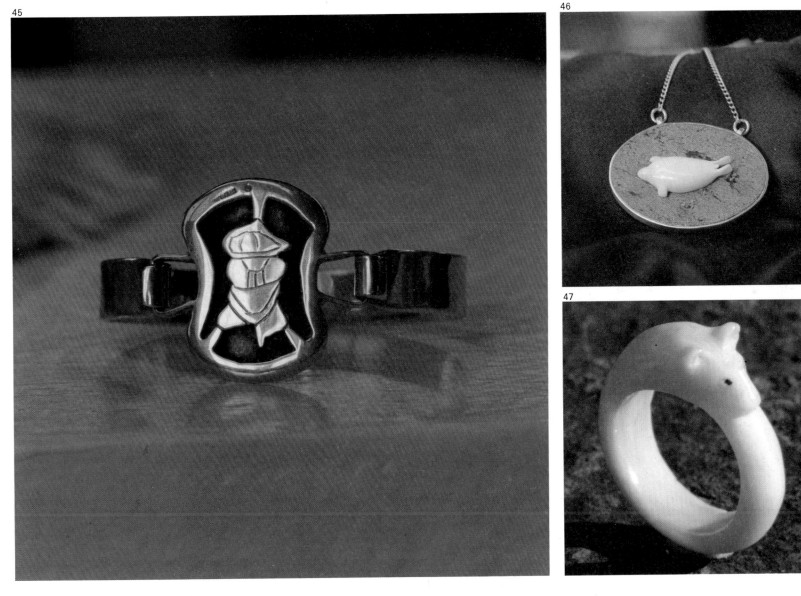

45 Silver bracelet showing a woman in an *amautik*. Silver is often combined with ivory and soapstone. Frobisher Bay, Northwest Territories

46 Soapstone, ivory, and silver medallion; the animal is a seal, an important food of the Inuit. Frobisher Bay, Northwest Territories

47 Ivory ring, made of a walrus tusk, in the form of a bear or fox. Rings always represent animals important to the Inuit.

Weaving

In Sardis, British Columbia, the Salish Indians are witnessing a revival of a craft that is centuries, perhaps thousands of years old. Unlike other Indian tribes in British Columbia, the Salish learned the craft of spinning, dyeing, and weaving long before contact with whites. They used upright looms not unlike the ones imported from Peru to the Southwest several thousand years ago, although the better-known Salish loom uses two bars instead of one. Under the impetus of Oliver Wells, an interested white man, this weaving has been revived since the late 1960s.

Oliver Wells went to Europe to search for old rugs that had been taken or traded from the Salish during the early period of contact, and the traditional patterns on those he found are the basis of the designs now used. He also found that some designs had been named for the place in which they were discovered. For example, one of the nobility blankets, worn only by the upper class in the old stratified society, was found in Perth, Scotland, and the design on this complex blanket is called the Perth design. Sometimes new designs are incorporated, for, as in most crafts, change is important and does not necessarily detract from its meaning.

We know from drawings made at the time of the first contact with whites, and from tribal legends, that the Salish raised a special breed of dog whose fur, along with goathair and various plant fibers (cedar, milkweed, cattails, nettles), was used in weaving blankets. Today sheep's wool is used and is handspun on modern machinery. The old spindle whorls, carved with designs of possible symbolic importance, are no longer used

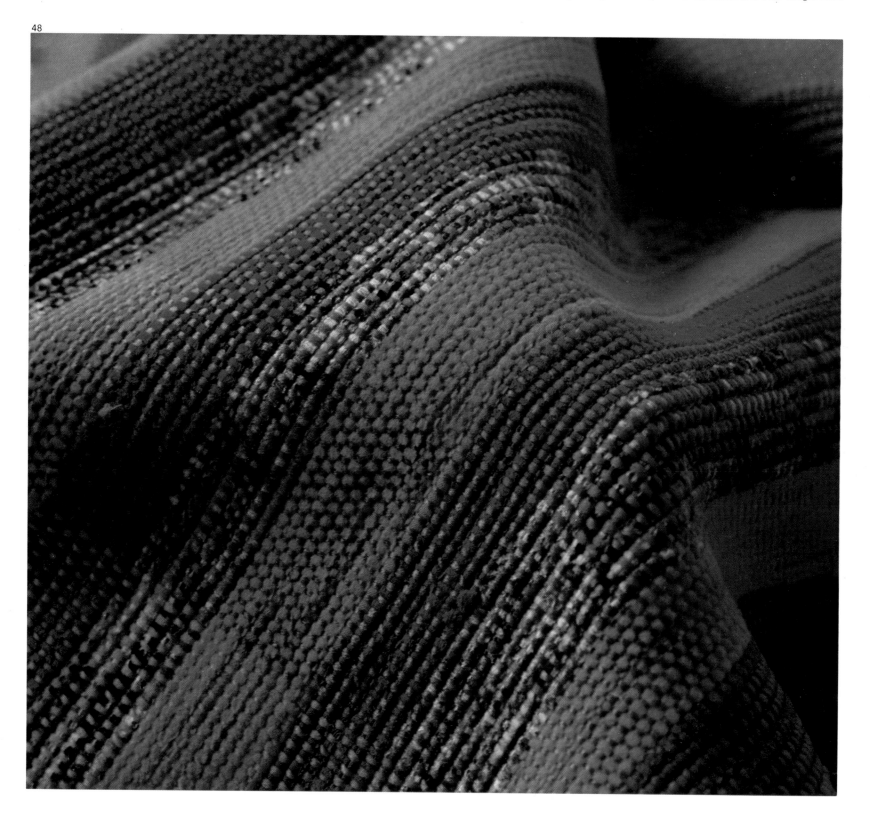

because the drop spinning method is not as efficient. The spun yarn is then colored with traditional dyes made from hemlock bark, fern roots, and birchbark, as well as alder bark, wolf moss, and oregon grape. The colors have been broadened by experimentation with different mordants, and different plants and roots.

Traditional weaving techniques include twilling and twining. Twilled fabric does not sell well, which somewhat limits the weavers' range of choices. Blankets were used not only for warmth but as trade items and for prestige in precontact times; the marketing of the weavings today is not far removed from traditional uses. Each of the designs has a name and meaning and incorporates ancient, traditional symbols. There are some forty weavers involved in making the blanket, and the work is divided among preparing, spinning, dyeing the wool, and weaving—some of which is done in the shop for the benefit of tourists—and some knit the Cowichan-style sweaters.

Another Canadian weaving tradition with a long history is to be found in Quebec, along the upper St. Lawrence seaway. North of Quebec City, on both sides of the river, live the descendants of the oldest Europeans to settle in Canada. Separated by the terrain from the rest of Canada, the French Canadians of this region have maintained many of their folk arts and are well known throughout the country for them. In particular, their weaving, which uses twill, twining, and other techniques, is proudly spoken of as being real "Canadiana." It is recognizable by the use of gay colors and play with textures.

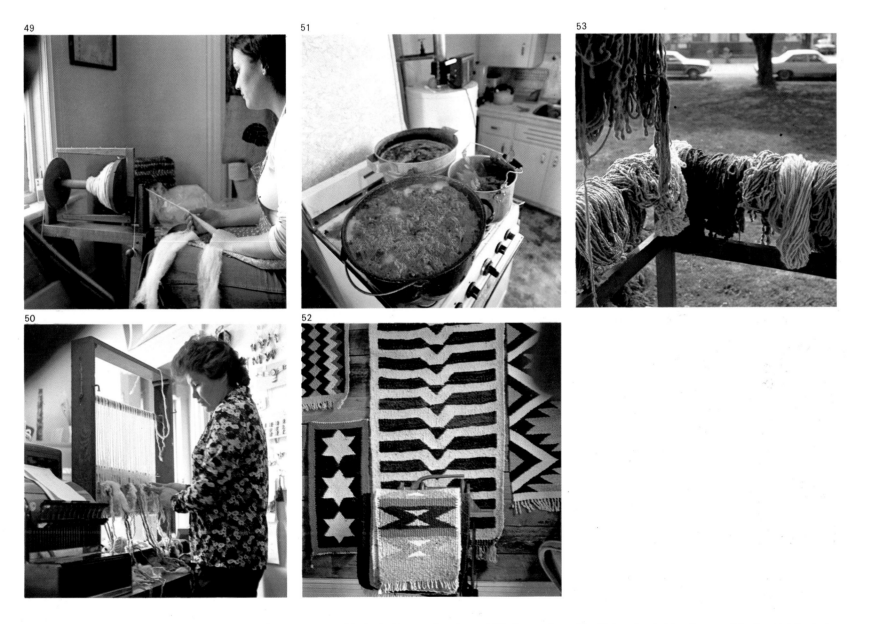

49

51

53

50

52

48　Weaving from the Charlevoix region. This area was long isolated by the Laurentian mountains and has pioneering roots that date back to the first settlers in Canada. Baie Saint Paul, Quebec

49　Salish woman handspinning wool. There is a revival of the old weaving techniques used by her ancestors for centuries. Sardis, British Columbia

50　Salish woman working on an antique vertical loom. Sardis, British Columbia

51　Wool is dyed with natural products: dahlia flowers (for yellows and golds, shown), elderberries, and Oregon grapes are just a few

52　Handwoven blankets by Salish Indians. The designs all have meanings: the large work in the center shows the flying goose, symbol of the revival of weaving as well as of plenty; the smaller tapestry in front uses the butterfly, symbol of everlasting life, combined with the half-diamond, which represents the passage of time. Sardis, British Columbia

53　Skeins of carded, handspun, and dyed wool drying in the sun. Sardis, British Columbia

Recently, in the arctic settlement of Pangnirtung on Baffin Island, loom weaving has been introduced to the Inuit. Using bright colors they have designed traditional pictorial motifs, in addition to the more muted geometric designs, for hanging tapestries. It will be interesting to see if this introduced folk art, like the jewelry, succeeds in the open market, and also to see how integrated into the homes of the Inuit it becomes.

Another example of handiwork in Canada is that of patchwork appliqué. Based on the sewing techniques used in making quilts, which were imported from England and France during early colonial days, this folk art incorporates the old with the new in that these pieces are actually tapestries. Most of the subject matter is drawn from folk songs and folktales sung and told to children. Much like the crafts from the southeastern United States, these appliqués have a nostalgia for the past, for the pioneering days that were so important to all North Americans.

54

55

54 Appliquéd piece depicting a scene that has recently become popular. St. Lambert, Quebec

55 Inuit women are expert weavers, and often use animal motifs as well as nonpictorial designs. Pangnirtung, Northwest Territories

The apple-faced doll also appeals to the "good old days" in subject matter, dress, and detail. They are simply made, using dried apples that have been carved and decorated with pin eyes to form the head, and wire and wood to form the body. The amount of work involved in replicating the dress indicates a love of the subject by the craftsperson. These dolls are sold individually, but they are actually made in pairs. Although they are played with by some children, they are mostly purchased by adults who display them in their homes, as do the makers.

It is hoped that this brief survey will stimulate interest in the folk arts of Canada. Although the crafts presented here may not be what some people think of as folk art, having changed so much from the traditional forms, they are nonetheless examples of what is happening in the real world.

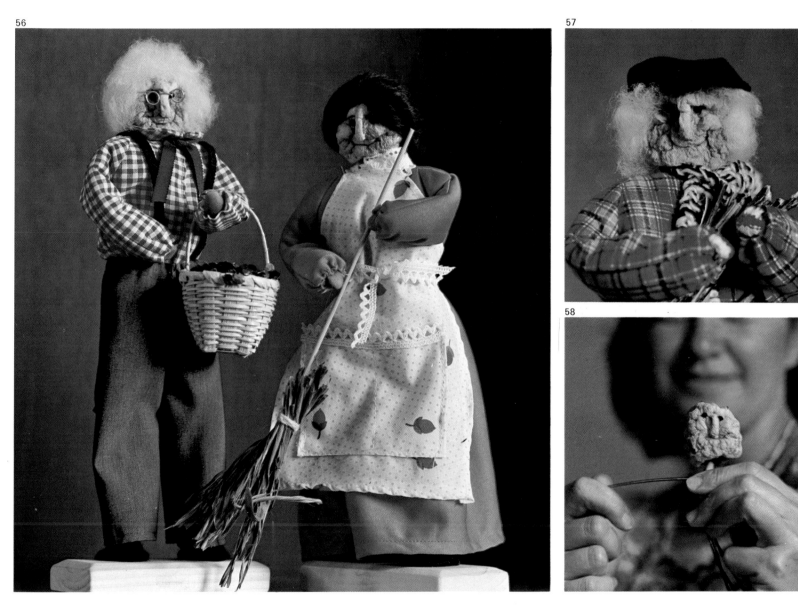

56

57

58

56 Elderly French Canadian couple replete with details; the basket holds tiny clams and the man's glasses are made with wire. St. Lambert, Quebec

57 Apples cored, peeled, and dried for two months create such expressive faces as the one on this old man. St. Lambert, Quebec

58 The arms and legs of the dolls are made with wire and the body and base with wood. St. Lambert, Quebec

Catalogue

59 Carved cedar eagle dish. Nootka Indians

60 Totemic figure of cedar. Squamish Salish Indians

61 Miniature totem in the form of a stylized eagle. Squamish Salish Indians. British Columbia

62 Close-up of the Kwakiutl totem pole in front of the Provincial Museum. Victoria, British Columbia

63 Kwakiutl carved cedar mask. Vancouver Island, British Columbia

64 Pine sculpture of a young girl; the wood was salvaged from an old house. St.-Jean-Port-Joli, Quebec

65 Marble figures; the middle one is a seal sticking its head up through the ice. Frobisher Bay, Northwest Territories

66 Cribbage is a popular game in the arctic. This cribbage board is made of walrus tooth. Frobisher Bay, Northwest Territories

67 "Strawberry" basket of sweet grass. Micmac Indians

68 Splint basket possibly based on an ancient baby carrier. Micmac Indians

69 Old basket made of sweet grass and splint ash. Micmac Indians

70 Basket of sweet grass and cedar bark. Micmac Indians

71 Typical Charlevoix-style weaving with bands of muted colors. Pointe au Pic, Quebec

72 Typical Charlevoix-style weaving. Île aux Coudres, Quebec

73 Tapestry done by an Afro-Canadian who used bright colors with traditional designs. London, Ontario

74 Hooked rug with an owl design, a symbol of Inuit work. Cape Dorset, Northwest Territories

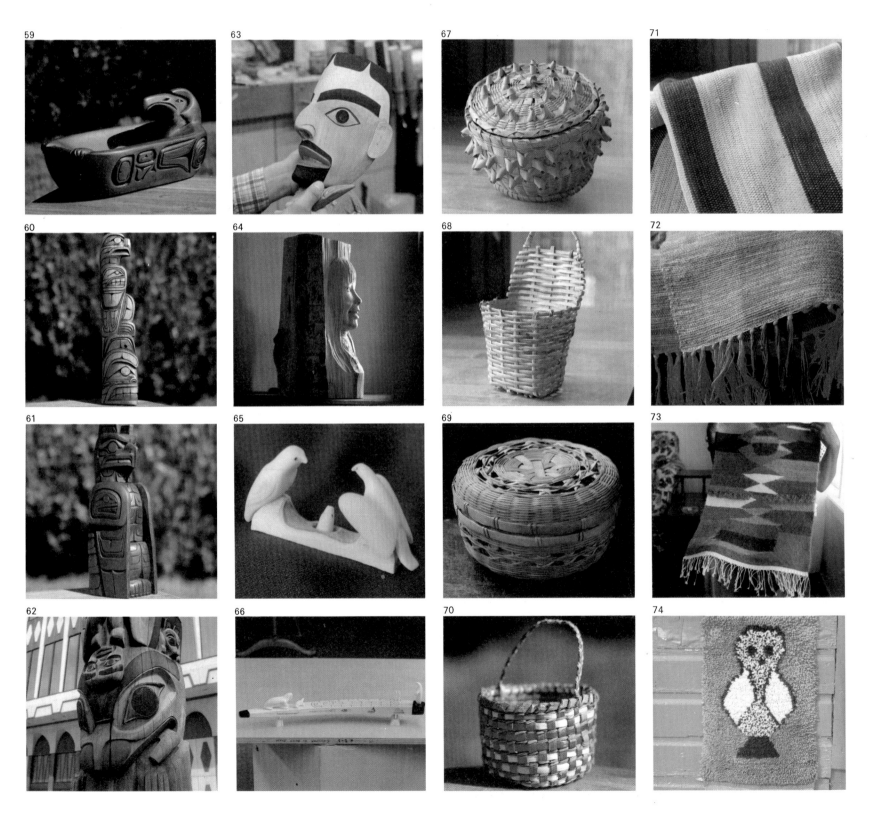

59 63 67 71

60 64 68 72

61 65 69 73

62 66 70 74

75 Appliqué work. St. Lambert, Quebec

76 Wool, arctic-style toque. Cape Dorset, Northwest Territories

77 Miniature sealskin boots used as a zipper puller. They are exact replicas of those worn in spring. Frobisher Bay, Northwest Territories

78 Apple-faced dolls with late nineteenth- and early twentieth-century costumes. St. Lambert, Quebec

79 Mocassin of caribou hide with wild mink trim. Cree Indians. Winisk, Ontario

80 Puckered mocassin of caribou hide trimmed in beaver fur

81 Embroidered slipper of Scottish duffle. Sugluk, arctic Quebec

82 Stained-glass window in the Victorian style. London, Ontario

83 Medallion and chain combining steatite and silver

84 Beaded necklace inspired by fish nets. Inuit. Cape Dorset, Northwest Territories

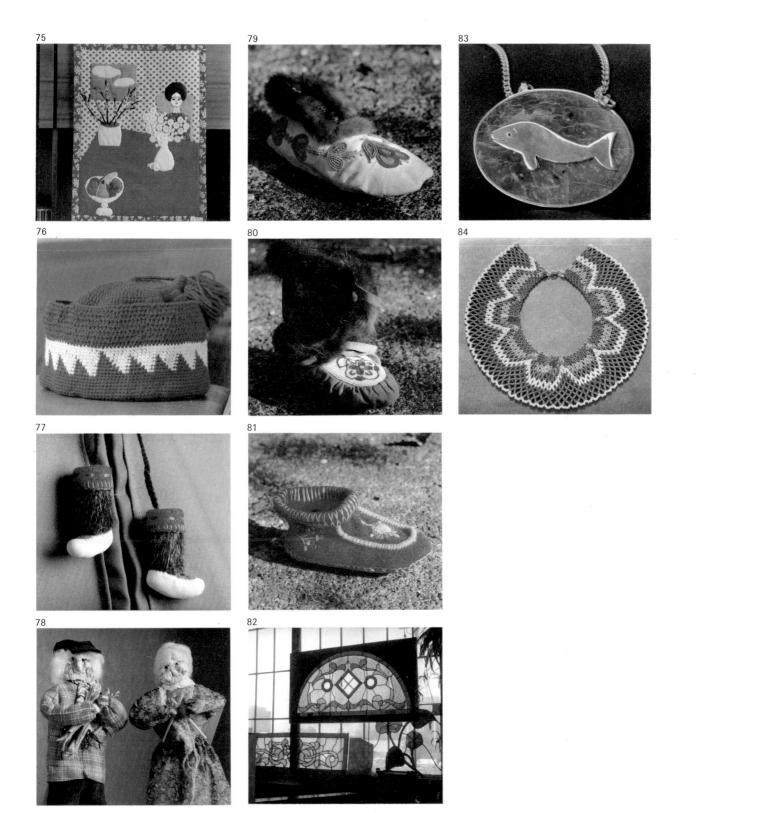

U.S.A.

85 With an invitation to buy on credit, shoppers decide on
traditional Pueblo woven belts at the Eight Northern Indian
Crafts Fair. Santa Fe, New Mexico

Introduction

The folk art traditions of the United States and Canada differ from those of the other countries of the Americas — at least in content if not in form. This is largely due, as one would suspect, to the historical development of these nations, both of which were populated in the seventeenth and eighteenth centuries by immigrants drawn mainly from the British Isles and northern Europe. In the United States the populace was supplemented by the forced immigration of black Africans. The full impact of Spanish culture, which so influenced the other countries of the Americas, was not felt until the nineteenth century when Florida, Texas, and the Southwest, all former Spanish possessions, were annexed. It was also during the nineteenth century that great waves of immigrants from all over the Old World, Middle East, and Asia arrived on the shores of the United States. Each succeeding wave brought with it ethnic traditions, customs, beliefs, mores, and outlooks that have filtered down to the present day, some changed substantially, others only slightly. And of course, the original inhabitants, the Indians and Eskimos, were culturally as varied as the newcomers, with whom they mixed to varying degrees. In theory, all of these peoples were supposed to have melted in the great population pot, but as anyone who has traversed the width and breadth of this enormous country can attest, there are not only striking regional differences but also strong pockets of ethnic groups that have maintained ancestral traditions to different extents.

For today's folklorist, this heterogeneity is both a burden and a delight, as is the concomitant homogeneity caused by the increasingly technocratic nature and mass-media domination of United States society. In the past decade and a half, folklorists in the United States have been forced to come to grips with the problems of defining folklore so as to take into account the character not only of contemporary America, but also of an increasingly pluralistic world. The general public, and indeed some older folklorists, particularly those working in outdated traditions prevalent in Europe fifty years ago, will be surprised at whom these younger folklorists consider to be the folk (anyone), and what they consider to be their lore (shared traditions that give a group a sense of identity). Rather than seeing folklore as a rapidly vanishing cultural phenomenon, the American folklorist sees it as an ongoing, viable aspect of everyday life, incorporating change.

Due to space and time limitations, not all folk groups of the United States are represented in this chapter; indeed, that would be an impossibility even in a single volume. We have tried instead to give a flavor of different types of folk art found in three regions of the country: the Southwest, as represented by New Mexico; the Southeast, as represented by Tennessee; and the Northeast. In so doing, we have focused on the folk arts that are rooted in the Spanish and English colonial and southwestern Indian heritages, as well as the more contemporary developments of immigrant groups in these areas. It is unfortunate that we are unable to show specific examples of the black heritage as well, but this presented a special case too complicated for this chapter. There are increasing numbers of specialized books that focus on the folklore of specific folk groups to which the interested reader can turn. However, many of the works shown here are blends to which many, including blacks, contributed. This interaction among the many groups in the United States is evident today at crafts fairs where members of different groups buy, sometimes on credit, from each other. In earlier bartering days, these exchanges led to crafts that represented several traditions melded together, a process which continues today.

This merging process is particularly characteristic of the Southwest. For example, the Ortega family of

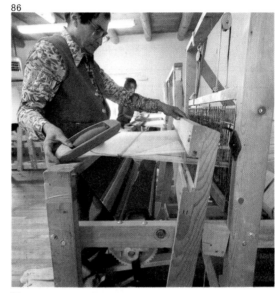

86

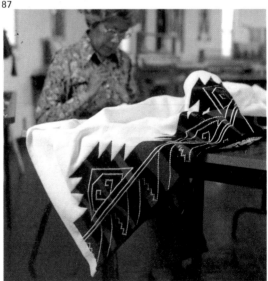

87

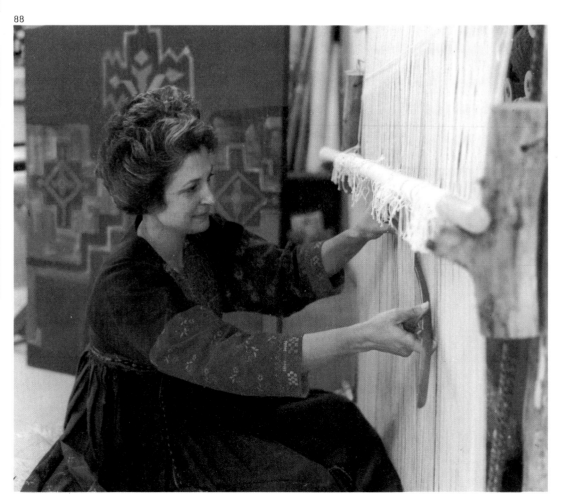

88

86 Weaving shop where bright aniline dyes have replaced natural ones. Chimayo, New Mexico

87 Embroidered manta for ceremonial Pueblo Indian dress at Oke Oweenge Crafts Cooperative at the San Juan Pueblo, which conquistador Juan de Oñate declared the first capital of North Mexico

88 Artisan at her traditional upright Navajo loom, which was made by Navajo carvers. The painting in the background is used as a guide for the weaving

Chimayo, New Mexico, incorporates into its weaving Mexican dyes, Spanish looms and techniques, and, at times, Pueblo Indian designs. Another example of intergroup borrowing is found in the adobe architecture, so well adapted to the hot summers and cold winters in this predominantly treeless land and used by all the cultural groups here. This housing style originated with the Pueblo Indians, embodied in the famous many-storied apartments of the Taos Pueblo, which has been continuously occupied for over five hundred years. The Spanish colonials also adapted the use of outdoor bread ovens from the Indians. The ones still used at the "living museum" of Rancho de las Golondrinas south of Santa Fe were originally constructed in 1650.

The Pueblo weavers, whose craft originated in northern Peru two to three thousand years before Christ, continue to produce traditional clothing that dates back some fifteen hundred years and that is still worn in religious ceremonials. From them, the Navajo Indians adapted the upright loom in the late 1700s, and today Anglos, as the English speakers are called, sometimes weave in the Navajo style, using tools, techniques, and designs of the Indians. The Southwest thus presents an interesting and distinctive example of cross-ethnic borrowings, and yet each of the three major groups — the Indian, the Anglo, and the Hispano —has developed its own folk arts.

In the Southeast, the influence of Indian cultures is also felt, although it is more subtle than in the younger West. In Appalachia, a region noted for its folk arts, the various immigrant groups were as isolated as were the

89

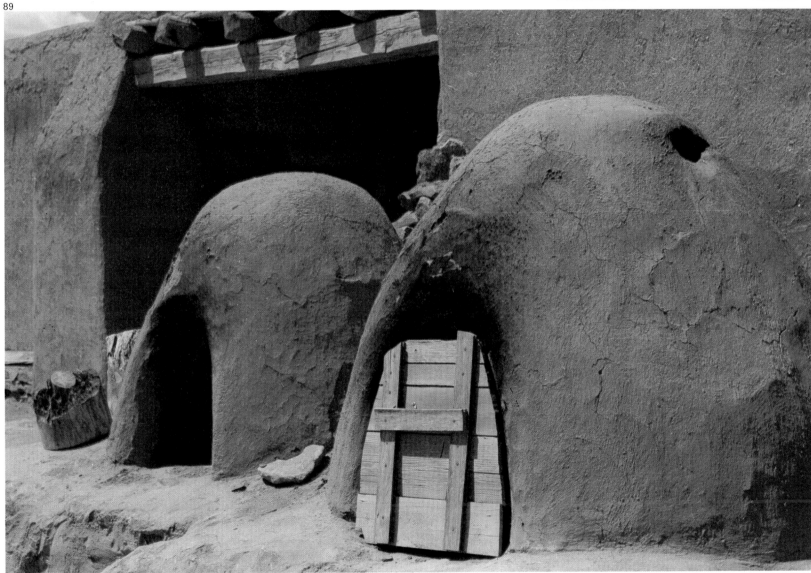

89 Outdoor adobe bread oven, first used in 1650, at the Rancho de las Golondrinas. The walls are over three feet thick, and are made of a clay and straw mixture. South of Santa Fe, New Mexico

groups of the Southwest, although more from geography than from the cultural and religious barriers presented to the English Protestants by the Spanish Catholics. A woodcarver demonstrating the folk art of puppet making, which dates back to the eighteenth century when parents made their children's toys, may sport a headband made by Cherokee Indians, from whom Tennessee got its name. Unlike the southwestern Indians, who continue to live on their ancestral land and have maintained their customs, beliefs, and to a great extent their traditional way of life despite European intrusions, the Indians of the Southeast were decimated by disease, warfare, and forced migration from their land. The few remaining in this area are descendants of those who evaded the "Trail of Tears," a forced march to Indian Territory in the nineteenth century, by which time their way of life had already changed substantially.

It is difficult to tell exactly which crafts were of Indian origin, so great was the interplay between the colonialists and the natives. For example, the Cherokee and Creek tribes were known for their basketry at the time of contact, and today splint basketry is considered an Indian craft. Yet there is evidence that it was introduced by Swedish settlers, although of course the canework seen among the white craftsworkers of Tennessee was greatly influenced by the Cherokee. On the other hand, the potter's wheel is known to have been introduced into the New World from the Old, and there has been a recent explosion of pottery making in the United States, particularly among the young. Partly a rebellion of youth, and partly a statement against technology,

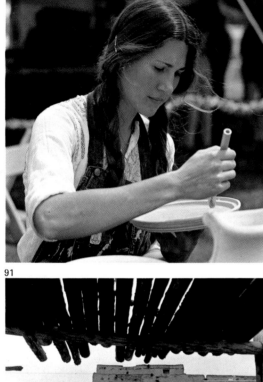

90 Potter painting a design on hand-thrown plates at the Tennessee State Crafts Fair

91 Five-hundred-year-old Taos Indian pueblo still rejects much of the white man's world. For example, electricity still is not used, and traditional Indian bread is eaten. Taos, New Mexico

92 Eighteenth-century stoneware wine keg

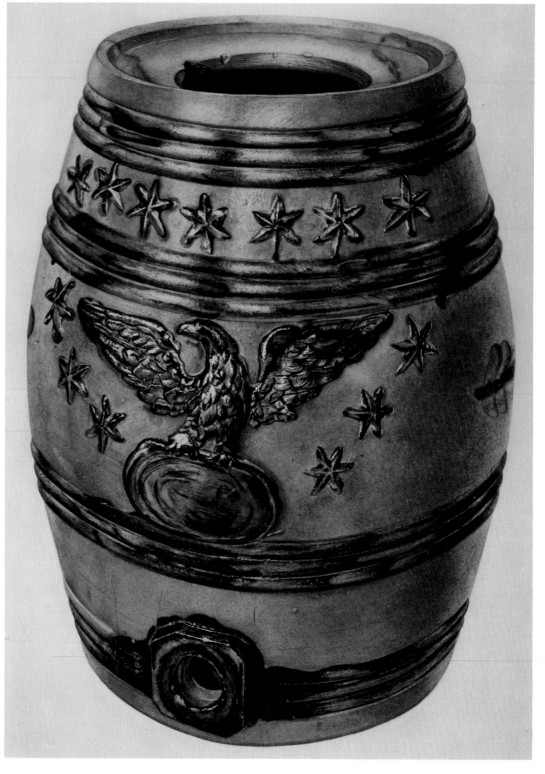

the last fifteen years has seen a return to the handmade, especially to the pioneer crafts exemplified by those made in the Appalachian region for the past two hundred years.

The flavor of the Northeast is different again, reaching back to English colonial and northern European immigrant roots. The two oldest crafts in this area are woodwork and pottery, which continued to flourish after the American Revolution forced the former colonials to fall back on their own resources rather than to rely on imports. As the population expanded, specialized craftsworkers emerged, so that by the nineteenth century woodcarvers were creating fanciful figureheads for the new shipbuilding industry in Maine, as well as carousel horses and cigar-store Indians. The shortlived Shaker communities at this time produced beautifully crafted furniture expressing their religious beliefs, becoming so well known that a mail-order business of replicas was established. The pottery industry expanded from creating functional stoneware to refined porcelain, while metalworkers added brass to iron and copper items, made for the house, which were increasingly decorative. During the colonial era itinerant painters called "limners" produced decorative, flat portraits that were often ridiculed as being out of place in the austere colonies. Following the Revolution, landscapes, historical scenes, and still-lifes were produced by "folk" or "primitive" painters who lacked academic training in the use of perspective and showed a fascination for repetitive patterns similar to the limners.

In Pennsylvania, German religious sects that had fled intolerance in their homelands established pros-

93

94

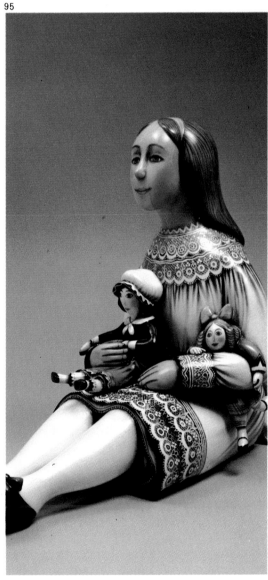

93 Cut pieces used in constructing the bed below, put together without a nail

94 Imaginative and sturdy elephant bed for children. New York City

95 White pine box, hinged at the waist, carved, painted, stained, and waxed; 1979. New York City

perous farming communities with lavish folk arts apparent everywhere. The Amish, Moravian, and Mennonite blended English craftsmanship with their Rhineland traditions, painting fanciful motifs on pottery, "Fraktur," tinwork, and woodwork. The Amish quilts, distinguished by the use of bright colors in stark geometric designs, contrasted with the blander hues and intricate patterns found in New England. Women in the Northeast learned sewing as girls by making samplers, which included folk sayings done in various stitches they would use later. The textile mills in the nineteenth century heralded America's first industry, and women were freed from time-consuming spinning and weaving to indulge in hooking rugs and making pieced quilts. There is evidence that men in some Pennsylvania "Dutch" (German) communities were not adverse to working on the quilts.

The Southwest represents, in a sense, the heterogeneity of the United States, while both the Southeast and the Northeast represent a yearning for homogeneity as expressed in the pioneer roots of the former and the colonial roots of the latter.

96

96 Pet portrait by Mimi Vang Olsen, a modern-day itinerant folk painter. New York City

97 Fine handcrafted table, chairs, sideboard, and tall cabinet
reminiscent of Shaker furniture in its spare, uncluttered look.
New Gloucester, Maine

Woodwork

When Don Juan de Oñate arrived in what is now New Mexico at the end of the sixteenth century, he was not looking for the mythical Seven Cities of Cíbola that eluded Coronado in 1540. Rather, he came, along with soldiers, settlers, and Franciscan friars, to extend the colony of New Spain. The harsh and arid land matched the life in the early colony, which was ruled with a ruthless hand that extended to the Pueblo Indians, whom the Franciscans tried to convert. Churches were built and in them placed sacred images brought from Mexico, since the colony lacked specialized artisans. The Indians revolted in 1680, and during the short twelve years before they were reconquered, they destroyed most of the material evidence of the early Spanish occupation. Spain wanted to keep the church and colonial life unchallenged, and to control trade. Thus, until Mexican independence in 1821, followed in 1846 by annexation of New Mexico to the United States, the influence of Anglo-America was minimal, and Hispanic-American culture was born. Thrown to their own resources, the settlers not only farmed the land and built their homes, tools, and furnishings, but they also became carvers and painters of sacred images for the home and the church. These "santos" were of two kinds: the "bultos," or fully rounded figures; and the "retablos," or painted and/or relief-carved wooden panels. The creators were called "santeros." At first copying Spanish models, the santeros eventually developed their own style, which the newly arrived Anglos scorned as crude and medieval. Today there is a flourishing of this folk art coupled with the resurgence of ethnic pride among Hispanic-Americans.

98

99

100

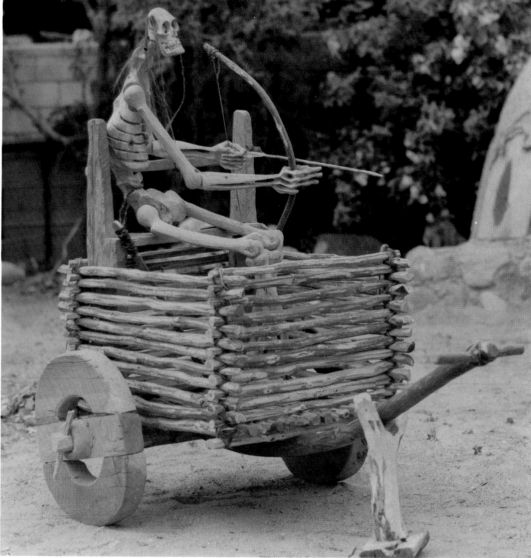

98 Retablo of Our Lady of Guadalupe, the patroness of Mexico since 1531, when she appeared to an Indian named Juan Diego. Santa Fe, New Mexico

99 Artisan working on a cottonwood bulto. Note the expressive face that is traditional in these images and that the Anglos rejected as crude in the nineteenth century. Santa Fe, New Mexico

100 Muerte or death cart. Observe the hair added as a touch of realism, and the exaggerated hands and limbs. Española, New Mexico

The early golden age of the santos was 1750–1900, when the New Mexico Hispano style asserted itself. The bultos, carved from cottonwood, varied from ten inches (25 cm) to life-size. Sometimes dressed in actual clothing, they often had detachable arms, even movable fingers, real hair, tears of glass beads, and so forth. Many bultos had exaggerated hands and limbs. Glued rather than nailed, the joints were not only movable but were sometimes removed as a form of punishment if the saint represented failed to fulfill its duty. Sometimes they were turned to face the wall as a form of punishment. It is not uncommon for old santos to have the wrong saint's attributes, probably because they had been "punished." Earthen and vegetable pigments were used in painting the bultos, although some were unpainted, and the retablos. The usually flat retablo was often carved in bas-relief or was molded with gesso. Retablos ceased being made when lithographs were imported, shortly after annexation, but bulto production, although lessened, continued. There was a resurgence of bulto making in the 1920s, which slowed down after World War II, but today both forms of santos proliferate. The resurgence in the 1920s had been spurred on by interested Anglos, who mediated to a large extent the style, fitting it to their tastes rather than to the santeros'. Today, however, the santeros are reaching into the past, and the folk art has become a vehicle for the expression of a proud identity by Hispano-Americans in New Mexico. Women are also participants in these folk arts, and, in fact, one interesting aspect is that today entire families are involved.

Wood was also the medium of religious expression for the Shakers in the Northeast. Actually a Quaker

101

102

101 Tin shrine of Saint Anthony. The painting technique is very different than that used for Pennsylvania Dutch tinwork. Santa Fe, New Mexico

102 Hollow frame construction of Our Lady of the Skies (Nuestra Señora de los Cielos) made from cottonwood, muslin, gesso, and paint. Each santo is identified by his attributes that he or she holds or those incorporated into the clothing. Santa Fe, New Mexico

sect that originated in England, they followed a doctrine of celibate Christian communism on their small farming communes, which flourished from the late 1700s to the mid-1800s. Ordered by the precepts of harmony, equality, utility, and simplicity, the functional furniture they produced, finished with oils that emphasized the wood grain, influenced much of the handcrafted work done today. The white walls of their spare rooms sported a single horizontal wood strip with pegs for hanging chairs, clothes, and other items when not in use. Oval boxes made of maple strips steamed around a mold were often tinted red, green, or blue, but colors were used sparingly.

In contrast, the secular woodcarving of the Northeast was colorful not only in the use of paint but also in subject matter. The young nation carved its symbol, the eagle, on everything imaginable, from chairs to ships. Ships were also proudly decorated with figureheads, actually torsos of women, placed on the prows. These gaily painted sculptures were often dressed in the latest fashion. On land, shops advertised their wares with carvings placed outside, such as the bakery's sheaf of wheat, the toy shop's rocking horse, and the smokeshop's cigar-holding Indian, which appeared in the nineteenth century. Today, small shops in many eastern towns have returned to the use of these carved symbols, or painted imitations. Late in the nineteenth century, carousel animals appeared with elaborate saddles and bridles that recalled the jousting tournaments of the Middle Ages. While horses were the usual subject matter, it was not uncommon to see fanciful creatures such as the griffin, or even large birds such as swans carved for the merry-go-round. Birds were also carved for the hunter, and

103 Pyramid of oval wooden boxes. Shaker, nineteenth century

104 Woodcarver, dressed in the traditional overalls of Appalachia, demonstrating his craft at the Tennessee State Crafts Fair

some craftsworkers carefully outlined each feather of the decoy in bas-relief, while others used paint. Finally, under the influence of Scandinavian and German immigrants, many household items were carved in decorative bas-relief floral and geometric patterns—butter molds, cradles, mangling boards, distaffs, and so forth.

105

106

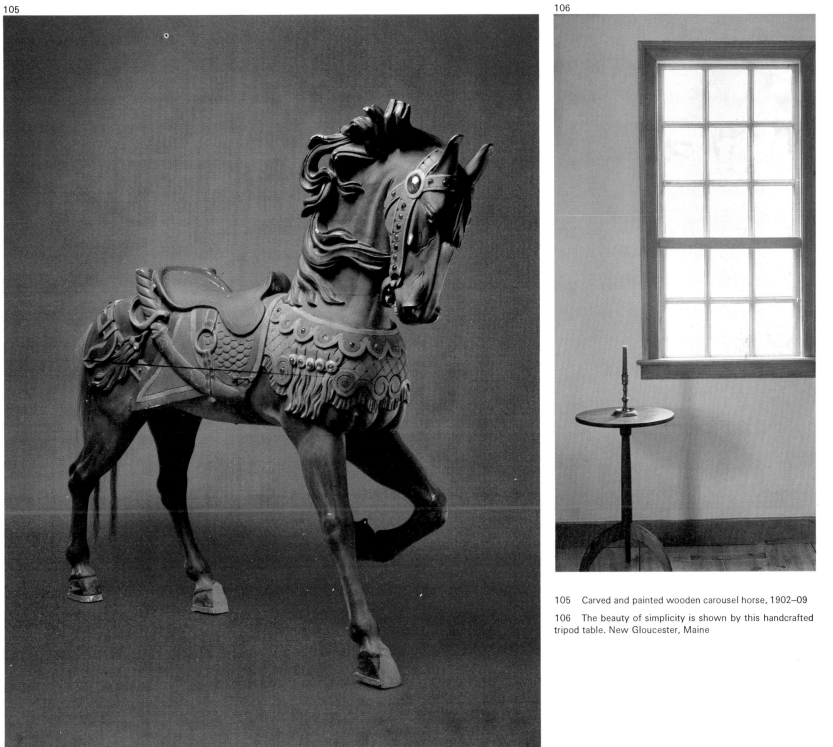

105 Carved and painted wooden carousel horse, 1902–09

106 The beauty of simplicity is shown by this handcrafted tripod table. New Gloucester, Maine

Metalwork

The tinwork of the Southwest originated with the Moors during their occupation of Spain and was brought to Mexico and New Mexico by Franciscan friars. In the 1800s the tinplate used was imported from Mexico, but after 1846, discarded army tins were used. The first decorated objects were religious, a tradition that continues today. In addition, tinwork adorned the home in the form of chandeliers, candlesticks, niches, wall sconces, frames, and boxes. The niches and wall frames often held bultos, the family saints. Unlike other folk arts in this area, tinwork has continued to be produced up to the present day without interruption. The tools are simple, consisting of hammers, nails, snips, and dies. Using snips and a minimum of soldering, elaborately shaped forms are occasionally created. Besides embroidery, wallpaper is also sometimes added under the glass panels.

Although a Hispano folk art in the Southwest, tinwork was also produced in the Northeast. It was imported from England in the colonial era, and in the post-Revolutionary period, produced by craftsmen called "whitesmiths." The Pennsylvania German form of this folk art is probably the best known. It actually used thin sheets of iron dipped in molten tin and then painted with motifs that originated in the Rhineland—bell-shaped tulips, fancy hearts, brightly colored birds (some double-headed), unicorns, mermaids, and geometric designs. Animal and plant forms were also used in other metalwork in the Northeast, in particular in ironwork. Footscrapers, andirons, log tongs were all embellished with traditional motifs. Copper was used to make weather vanes, which were often painted and gilded and shaped like birds—but sometimes even grasshopper shapes were used. Brass was a late arrival in the Northeast, so that many early pots and pans were made by melting down imported brass items. Practical and decorative objects continue to be made in this and other metals, and recently there has been a resurgent interest in brass buttons, and even mobiles are being constructed out of leftover cans by folk artists. Silverworkers, who in the early days of the colonies as well as later catered to the wealthy, also worked in other metals, producing everyday items in pewter for the common folk, along with copper warming pans and brass candlesticks. There has been an increasing interest in these metalcrafts in the Northeast, both in terms of collecting and in re-creating the old forms that are often given a modern twist by the folk artist.

107

108

109

107 Tinwork cross with wallpaper decoration also acts as a candleholder. The work of its creators has won many prizes in the Spanish Ma ket in Santa Fe, New Mexico

108 Elaborate mirror that can also be used as a candleholder. Embossed patterns are hammered in with the use of dies, similar to those used in leatherwork. Santa Fe, New Mexico

109 Artisans working in the kitchen of their home, producing not only religious tinwork but practical items like the letter-holder in the foreground. Santa Fe, New Mexico

Straw and Canework

Another New Mexican folk art that dates back to the Moors is straw inlay. Brightly colored wheat, corn, or oat stalks were cut into designs which were then applied to a darkened wood form—crosses, frames, boxes, candleholders, and so forth. Folk artists today use glue to apply the straw, but pine pitch was used in earlier times. Some place the cutouts on top of the wood, while others carve the design into the wood so that the straw is actually laid into it. The effect is similar to mother-of-pearl or gold inlay, both of which were lacking in the early colonial days. Although the materials used have changed somewhat in the past two hundred years, particularly in the use of paint and store-bought glue, straw inlay work maintains the sense of community to the New Mexican Hispano, particularly in its religious overtones. The Catholic church remains central to these young crafts-workers, as it did to their ancestors, giving their products a distinct flavor.

In the Southeast, corn husks are used to make dolls, some of which are placed in "pioneer" settings with miniaturized items that might include dried flowers. Corn had been domesticated in Mexico by 5,000 B.C., and by A.D. 700 agriculture was central to the way of life of the Indians in the Southeast, with corn as a major staple. Corn plays a central role in the shared folklore of American children, who are told that the early English colonialists were saved from starvation by being taught how to plant it by the Indians. Corn-husk dolls are found all over the East and Midwest, and always they are dressed in the pioneer long gown and bonnet.

Another important folk art learned from the Indians in the Southeast was the use of cane. In ancient

110

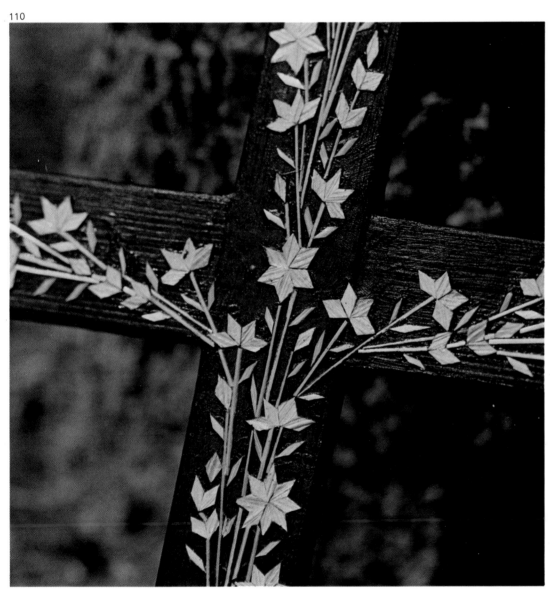

111

110 Detail of a cross decorated with straw. While the artisan prefers to glue the straw onto the wood, other workers in this traditional art prefer to carve out the design and inlay the straw. Santa Fe, New Mexico

111 Artisan cuts pieces from corn husks that she will use to form the lovely designs for both religious and secular wooden objects, such as the box in the background. Santa Fe, New Mexico

times, the Indians used the cane that grew along the riverbanks as building material, for mats, baskets, shields, torches—in as many ways as one can imagine. The art of caning, in which the seat of a chair is woven from strips of split cane that has been soaked in water, is being revived. When the strips dry, they tighten to form a solid and strong foundation. In some areas, as among the Shakers to the north, the cane is varnished to give it a high gloss, and different patterns are (or were) woven. Baskets are also made from river cane or from white oak splints in a style that is reminiscent of the Woodland Indians of New England and eastern Canada rather than the southeastern Indians. The pioneers who settled this area of Tennessee probably knew how to make baskets, which is an ancient craft.

112

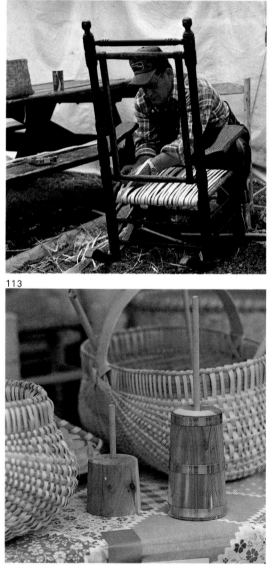

113

114

112 Artisan, wearing traditional overalls of the region, giving a demonstration of caning. Tennessee State Crafts Fair

113 Splint baskets with design medallions at the juncture of the handle with the body of the basket. Tennessee State Crafts Fair

114 Corn-husk doll placed in a scene, complete with miniature ax, meant to evoke the pioneer days of Appalachia. Tennessee State Crafts Fair

There has been a resurgence of weaving in the Southwest among young Hispano women, who have taken up the old Rio Grande Valley style, including dyeing their yarns from natural substances. At the same time, there has been a revival of traditional Pueblo weaving and embroidery. On the other hand, there is some evidence that Navajo Indian weaving is on the decline. The history of weaving in the Southwest has been one of rise, decline, and revival. The three traditions named above are fairly well documented so that the pattern can be traced. The Spanish colonials brought with them a weaving tradition that had been influenced by Turkish, Persian, and oriental designs. More important, they also brought sheep, the spinning wheel, and the treadle loom, and introduced new dyes from Mexico into New Mexico. These greatly influenced the Indian weaving, as did the demand by the Spanish crown of a great quantity of weaving as tribute.

By the mid-nineteenth century, when the three groups had diverged in style, the central medallion or diamond design on a background field of more diamonds or with zigzag borders was introduced from Mexico. By the late 1800s two Hispanic styles had evolved, both woven by men: the Vallero style and the Chimayo style, and it is the former that is being revived, while the latter has been dominant until now. A popular design is the eight-pointed Vallero star placed in the center with smaller stars along the border forming a frame. Another popular design of the Rio Grande Valley style involves alternating stripes of solid bands with strips of a beading design formed with little triangles, and strips of a chain stitch. This particular style of weaving is seeing a revival of sorts, and the tradition of families, and generations of families, participating in the folk arts repeats itself. This is particularly true of the other weaving styles of the Hispano-Americans, the Chimayo style. It differs from the former in the use of a solid background, the stylized lozenge in the center, the use of a stylized thunderbird taken from Indian designs, and the bright aniline-dyed Icelandic yarns.

The Navajo continue to weave with homespun yarn and a mixture of natural and aniline dyes, using the upright loom adopted from the Pueblo Indians two hundred years ago. This tradition has been greatly influenced by the Anglo-American market that has mediated the styles that have emerged over time, such as one point in 1890 when the use of garish colors was restricted. Different settlements have become known by their designs and use of color, but such things as the "spirit line," an imperfection in the rug "to let the evil spirits out" is a folk belief of the market, not necessarily the Indians. The Navajos themselves seem to enjoy pictorial blankets, but are constantly urged to weave traditional patterns.

Finally, the Pueblo Indians are seeing a revival of traditional weaving and embroidery among the Rio Grande groups. Weaving has never ceased in the Pueblo world, as evidenced by the continued use of traditional clothing in ceremonials. However, there was a shift from the Rio Grande towns to the Hopi towns, with the former trading for the woven items of the latter. This is now changing, however.

In the early colonial and post-Revolutionary days in the Northeast, until the textile industry took hold in the nineteenth century, women had to prepare their own wool and flax for weaving cloth, unless they could afford to buy imports. Fleece had to be cleaned, fibers carded, thread spun, and all dyed before weaving could begin. Like quilting bees, spinning was a social time for these hardworking women who had so many chores to perform that taking time for only socializing was impossible. Today, as in other parts of the country, there has

116

115
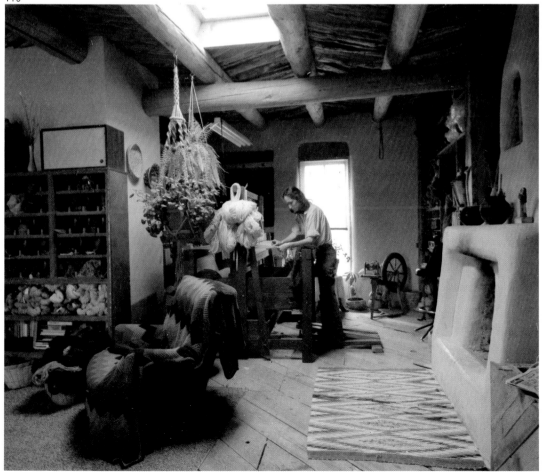

117

115 Artisan weaving in her own home, which like many in New Mexico was built of traditional adobe walls and vegas for the ceilings. The shelves are filled with hand-dyed yarns.

116 Before she begins, the weaver carefully designs her patterns, in colored pencils, based on the El Valle style. Española, New Mexico

117 Students who are learning the El Valle style keep a dye book in which are put samples of each batch with the formula and the plant used

been a revival of the craft of weaving in the Northeast, although few people make the cloth for clothing. Rather, rugs and tapestries, along with knitted sweaters, scarves, and babies' items, form the subject matter of some of these modern weavings.

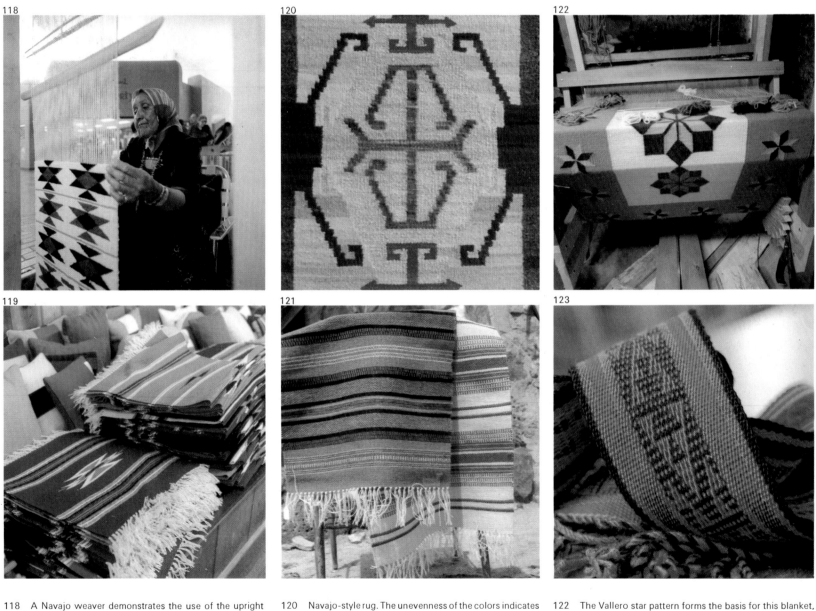

118 A Navajo weaver demonstrates the use of the upright loom adapted from the Pueblo Indians in the eighteenth century

119 Chimayo-style blankets incorporate an abstract design. Chimayo, New Mexico

120 Navajo-style rug. The unevenness of the colors indicates that the dyes are natural.

121 These weavings incorporate the El Valle (Rio Grand Valley) use of bands of color that alternate with designs of chains and beads. The wool is dyed using onions for brown, Indian tea (cota) for reddish orange, and sometimes indigo for blue. Española, New Mexico

122 The Vallero star pattern forms the basis for this blanket, which is woven on a treadle loom similar to the kind introduced by the Spanish. Each foot pedal moves a different set of threads, each of which must be put in place by hand. Española, New Mexico

123 Traditional Pueblo Indian sash, hand woven by men, and dating back several thousand years. The colors and designs each have a meaning

Handiwork

During the early days in the colonies it was imperative that women know the arts of the needle, which included embroidery, tatting, lacemaking, quilting, and appliqué. In the Northeast young girls practiced various stitches on a sampler, such as letters of the alphabet, proverbs or Biblical verse, and various pictorials, including landscapes, fruits, flowers, and animals. Specialized samplers were made as gifts after a friend or relative died, and following the Revolution, pictorial samplers of various heroes with appropriate verses appeared. The skills learned in sampler making were later applied on numerous embroidered items using silk, crewel, and linen—on chair seats, coverlets, pillows, dresses, and so forth. In the early 1800s Scandinavian immigrants introduced rug hooking, which involved weaving scraps of yarn or cloth with a metal hook through homespun backing. Despite commercialization, rug hooking today has become a popular pastime, with many folk artists returning to traditional designs.

Braiding rugs was a pioneer craft in the Southeast that continues today. It was one way of using scraps of precious leftover material. These rugs, sometimes called rag rugs, consist of long strips of rolled and sewn cloth that is braided in strips, which are then sewn in ever increasingly larger ovals. Another use of scrap material was in the quilt. These coverlets were very popular in England in pre-Revolutionary times, where imported Indian chintzes meant the covers were "more sophisticated." After the Revolution, Americans had to rely on their own homespun cotton, and this experience led to the development of distinctly American styles. The quilting bee

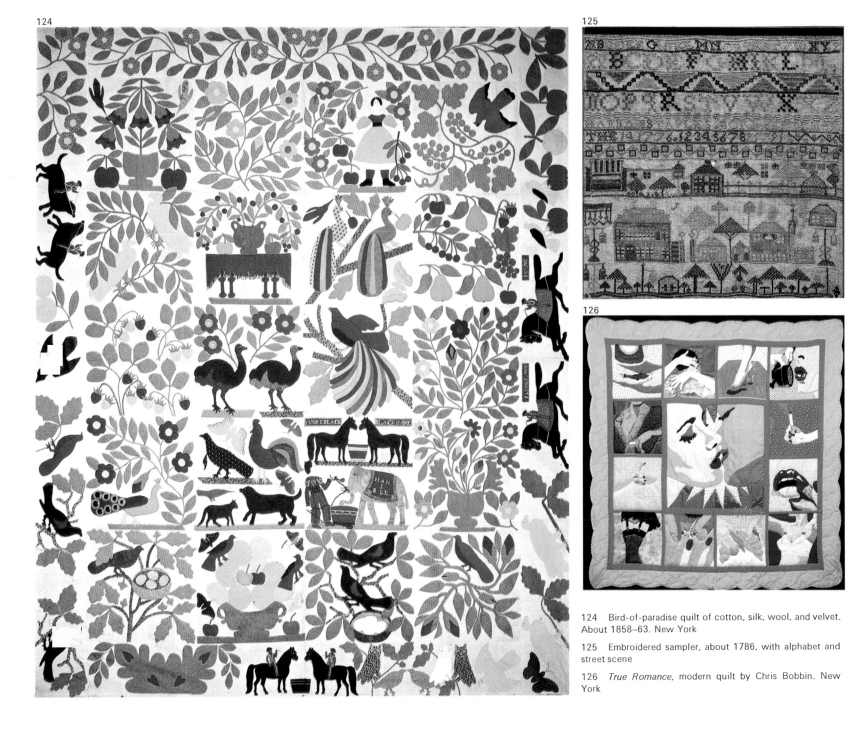

124

125

126

124 Bird-of-paradise quilt of cotton, silk, wool, and velvet. About 1858–63. New York

125 Embroidered sampler, about 1786, with alphabet and street scene

126 *True Romance*, modern quilt by Chris Bobbin. New York

became an important social function attended by women who worked as a team applying the patches that formed the design while sitting around a large frame. It was a good place to exchange gossip while at the same time adhere to the work ethic of the former colonies.

The names of the quilts are an interesting insight into the American experience. They reflect nature (North Carolina Lily), religion (Star of Bethlehem), politics (Lincoln's Platform), historical events (Free Trade Patch), games (Leap Frog), romance (Steps to the Altar), exotica (Arabic Lattice), and so forth. There were also sharp regional differences in the use of color, from the vividness of those of the Pennsylvania German to the somber hues of the New England Puritans, and from the simple geometric designs of the Amish, reminiscent of modern paintings, to the intricate patterns of Tennessee. Once thought to be a dying craft due to the invention of the sewing machine, the quilt is still being made not only in Appalachia and Pennsylvania but across the country.

127
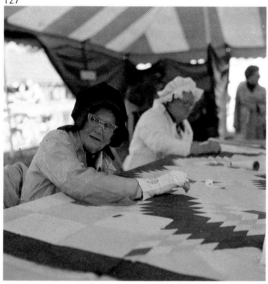

129

128
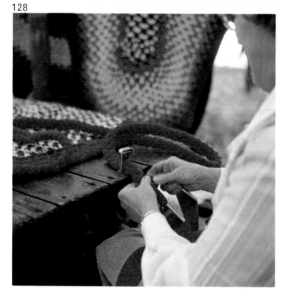

130

127 Although some of the members have passed away, the Jolly Dozen demonstrate the art of quiltmaking at the Tennessee State Crafts Fair. The oldest member (aged 85, in the foreground) learned to quilt as soon as she was tall enough to see over the frame

128 Demonstration of rugmaking at the Tennessee State Crafts Fair. First the yarn is braided and then attached in ovals that increase in size. Rags are often used instead of yarn

129 This quilt by the Jolly Dozen uses a favorite Pennsylvania pattern, the Star of Bethlehem, but it differs in the use of somber colors that reflect the Scottish and Irish heritage of region. Linden, Tennessee

130 Quilts made by the Jolly Dozen have diverse designs used according to the artisans' imaginations. Linden, Tennesee

131 Crocheted jacket. New York

132, 133 Embroidered denim. California

Toys and Instruments

Playthings for children, and sometimes adults, are an old folk tradition, and in the mountains of Tennessee one sees toys that date back to pioneer times, often reflecting the humor of the early settlers. The puppets recently displayed at the Tennessee State Crafts Fair are actually rag dolls with strings. While some reflect such media characters as the Tin Man from *The Wizard of Oz*, most were dressed in the overalls, caps, and bonnets of the mountain people of the region. The dancing hillbilly toy carved from native buckeye wood and painted to resemble a mountaineer taps out a rhythm played on the paddle he is held over. In the Northeast, wood was carved or whittled into dolls, whirligigs, rocking horses, and even sleds, all gaily painted. Unadorned wooden toys—blocks, trains, helicopters, Noah's ark complete with animals—are again being made and sold at crafts fairs and specialty shops.

Music was, and remains, an important part of the identity and community of folk groups throughout Appalachia so that the presence of a "musical" toy should not be surprising. However, the best-known instrument in this region, besides the banjo, is the mountain dulcimer. Its antecedents are ancient, and it probably evolved from the German *scheitholt*, the Swedish *humle*, and the French *épinette*—stringed instruments that are hammered with a small mallet while being held horizontally on the lap. The American variety is plucked with a quill or plastic pick, producing both the drone sound familiar in the European instruments, as well as a melody. Handmade, it is carved from such native woods as walnut, cherry, and butternut, although the pegs are made

134

135

134 To play this traditional Appalachian toy, one sits on the paddle and taps the tune with the fingers, and the figure then dances, creating rhythmic sounds with its feet. The overalls are typical dress of the region. Cookeville, Tennessee

135 Puppets' dress reflects the mountain image. Tennessee State Crafts Fair

with hard maple. Only a clear finish is applied to the instrument, no coloring. Wood clamps, up to eighteen on a side, are used to hold the dulcimer together while the glue sets. The heart-shaped holes are traditional, but the maker can design other holes. There has been an increased interest in the dulcimer, which is a simple instrument to play, with the resurgence of the folk music movement. Many folk and country folk singers come from this region of the country, and they, too, capitalize on the pioneer roots of their craft.

136

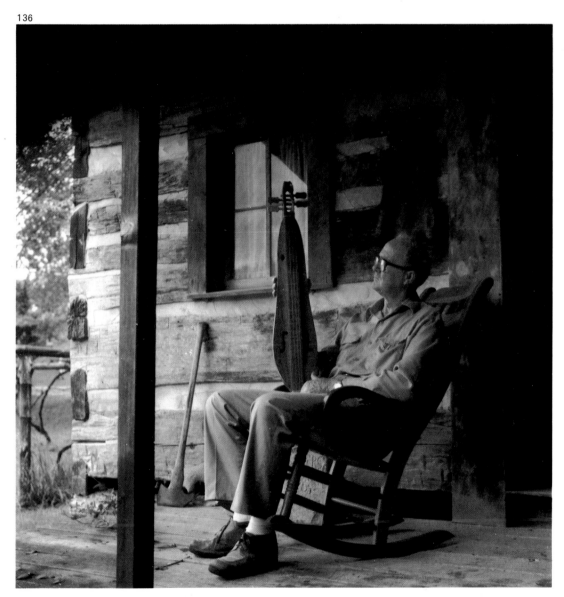

137

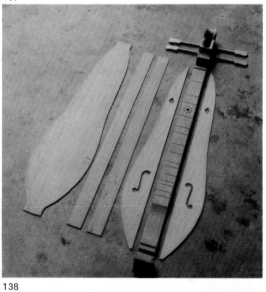

138

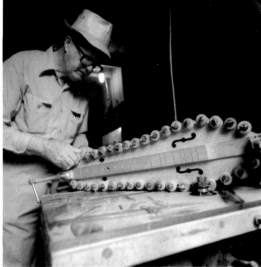

136 Log cabin, made completely by the artisan, furnished with handmade traditional furnishings reminiscent of the days of Davy Crockett. Cookeville, Tennessee

137 Dulcimer in parts. The back is split from one piece of wood and then glued together. These particular dulcimers come in three, four, or five strings. Cookeville, Tennessee

138 Each artisan specializes in making one part of the instrument. Cookeville, Tennessee

Pottery

There has been an explosion in the past fifteen years in the popularity of handmade pottery, particularly among the youth of America. Many young people prefer hand-thrown dishes, mugs, and pots to the traditional fine china of their parents' generation, or to machine-made imitations. This movement has been important to potters who work in the fine arts traditions, for many are now able to make a living selling to friends and at crafts fairs, while at the same time working on pieces for art galleries and museums. The crafts fair is an important disseminating place for these folk arts, whether in the Southeast, Northeast, or Southwest. Wheel-thrown pottery actually dates back to the founding days of the country. In the Northeast, the same red clay used to make bricks and tiles was used for dishes, pitchers, cooking vessels, mugs, and storage containers needed by every household. In the seventeenth century, stoneware made its appearance, and this heavy tan or gray ware, with decorative floral, bird, or animal designs applied with a blue slip, was used for syrup jars, jugs, pickling crocks, churns, and even plates. The Pennsylvania German made sgraffito ware, which involved scratching traditional designs and motifs through a white clay coat overlaid on the red clay.

The Pueblo Indian pottery in the Southwest has a much longer history, dating back several thousand years, and is not made on the potter's wheel. Each pueblo has its own distinct designs, colors, and patterns that are used by the Indians in their everyday life as well as being sold to outsiders. In some pueblos, clay figurines are

139

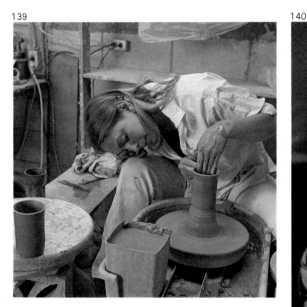

140

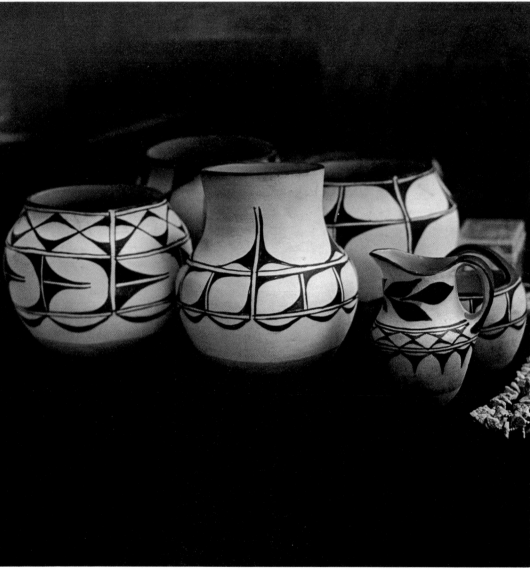

139 Potter throwing a mug on an electric wheel. Corrales, New Mexico

140 These vessels from Santo Domingo Pueblo are fine examples of pottery made without the wheel, as it has been for thousands of years here

made that depict characters in folktales and myths, such as the Storyteller from the Jemez Pueblo. Some of the Pueblo work in clay is fine art, and finds its way to museums and art galleries.

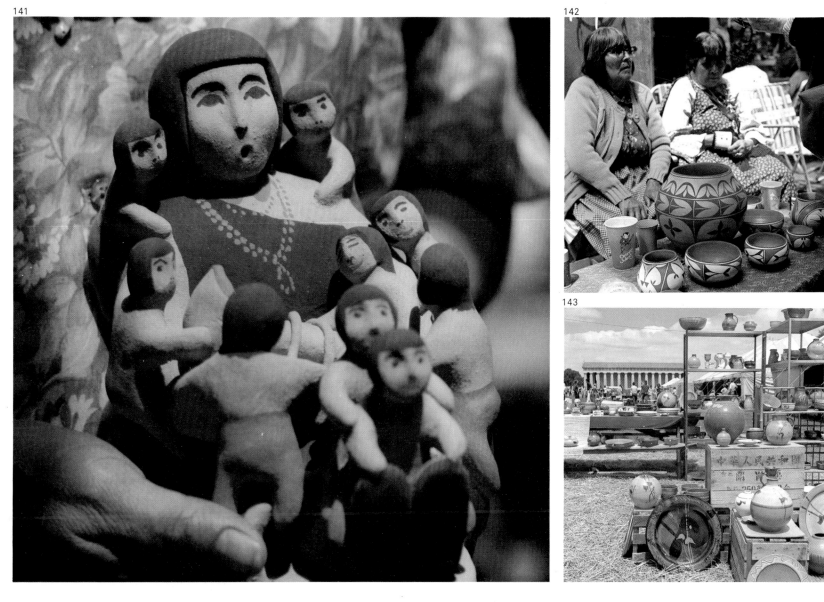

141 Lovely example of The Storyteller, a woman surrounded by children listening to her stories. Jemez, New Mexico

142 Patient women from one of the Eight Northern Indian Pueblos selling pottery during a crafts fair. The pueblos are Taos, Picuris, San Juan, Santa Clara, Nambe, Pojoaque, San Ildefonso, and Tesuque. Santa Fe, New Mexico

143 Pottery display at the Tennessee State Crafts Fair looks oddly international, with a replica of the Parthenon in the background and with some of the pottery resting on crates with oriental calligraphy

Folk Pictorials

Folk arts cover more than merely decorating utilitarian objects. From the colonial days when limners traveled about painting portraits, folk artists have created pictorials in various mediums. Although it is not true that the limners finished all their canvases except the heads during the winter, adding faces later, such folktales give charm to folk paintings. The first-known portrait in the United States was done in 1664, and the tradition of primitive painting has been continued—expanded to landscapes, still-lifes, and historical scenes—into this century by such notables as "Grandma" (Anna Mary Robertson) Moses. Another folk pictorial was scrimshaw, created by New England whalers, during the three to five years they spent searching the seas for their quarry, by carving and etching on ivory, bone, shell, and baleen. The samplers referred to earlier also incorporated scenes of daily life, and were hung like paintings. Portrait silhouettes cut out of paper, using the shadow of the subject, is an old pictorial folk art, as is tattooing, and also the traditional Biblical scenes displayed in homes at Christmas. Finally, the Pennsylvania German introduced a form of illuminated calligraphy, the Fraktur reminiscent of medieval manuscripts, which had highly stylized scenes enmeshed in the floral and animal motifs that formed the borders of baptismal certificates and bookplates.

This rather quick and brief survey of some of the folk arts produced in three regions of the United States will hopefully interest the reader to the point of searching out other forms of these arts of the common people.

144

145

144 *Our First and Last Leader of the Truth*, 1977, by Reverend Howard Finster. Summerville, Georgia

145 Family portrait, 1976, by Mimi Vang Olsen. New York City

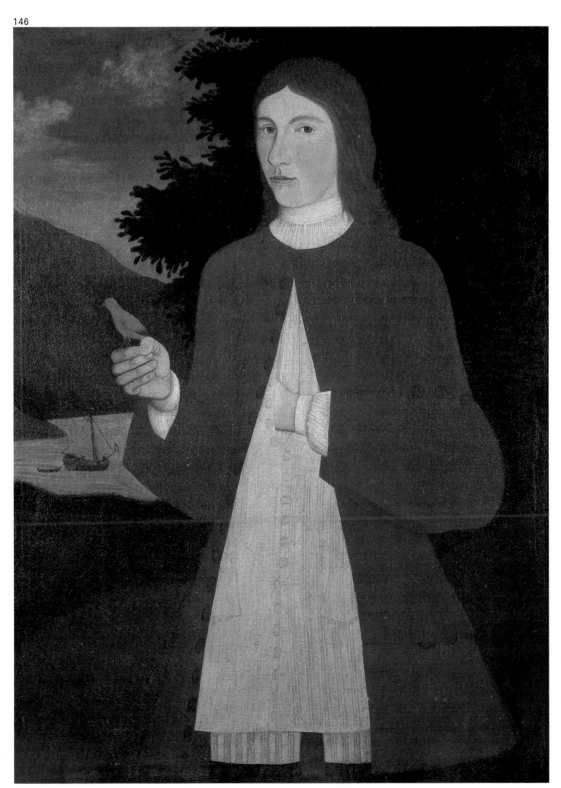

146 *Pau de Wandelaer* by the Gansevoort limner (possibly Pieter Vanderlyn, 1687–1778). c. 1730. Albany County, New York

147 Octopus sculpture by Miles Carpenter, modern folk artist. Painted tree root. Waverly, Virginia

Catalogue

148 Cedar crucifix. Santa Fe, New Mexico

149 Our Lady of Guadalupe, which has become a national symbol in Mexico. Santa Fe, New Mexico

150 Crucifix made of Russian olivewood. Santa Fe, New Mexico

151 Saint Francis of Assisi, patron saint of Santa Fe. Hand carved of wood. New Mexico

152 Simple but elegant flour scoop, hand carved from buckeye. Cumberland Mountains

153 Hand-carved mallard decoy. Cookeville, Tennessee

154 Saint Isidore Laborer, with oxen and yoke, in carved wood. Cordova, New Mexico

155 Natural hair in the tail of Saint James's horse adds realism to the bulto. Santa Fe, New Mexico

156 Two cottonwood bultos of the Holy Family. Santa Fe, New Mexico

157 Stages of decoy making: shape is blocked out of wood by machine, then hand carved and stained. Cookeville, Tennessee

158 Tinwork mirror with colcha embroidery in floral motifs. Santa Fe, New Mexico

159 Candle chandelier of tin in the Rancho de las Golodrinas. Many artifacts on the ranch are more than three hundred years old. New Mexico

160 Ceramic receptacles, some with lids. Corrales, New Mexico

161, 162 Glazed ceramic pitchers, Corrales, New Mexico

163 Hand-thrown ceramic plate. Corrales. New Mexico

164 Handmade clay pot. San Juan Pueblo, New Mexico

165 Ceramic pot ornamented with a lightning snake, a figure with ancient ceremonial meaning. San Juan Pueblo, New Mexico

166 Pot made by molding clay to the inside of a basket, an ancient tradition

167 Clay model of a Kachina, an important deity in the Pueblo Indian religion. Tesuque Pueblo, New Mexico

168 Painted clay figure of a Storyteller, made with real hair. Tesuque Pueblo, New Mexico

169 "Practice rug" used to familiarize new weavers with various designs such as the lightning snake below the fringe

170 El Valle-style weaving with a somewhat unusual step-terrace design. El Valle, New Mexico

171 El Valle-style weaving with alternating bands of color. El Valle, New Mexico

172 Old handmade loom with homespun yarns. Rancho de las Golondrinas, New Mexico

173 In this weaving the bands of diamonds and white beads are traditional, as are the natural dyes. El Valle, New Mexico

174 Goods in a weaving shop. Chimayo, New Mexico

175 Rain sash worn with ceremonial dress. The tassels, which may represent rain, are stuffed with dried corn husks. San Juan Pueblo, New Mexico

176 Homespun and hand-embroidered man's dance kilt; the colors and designs are of ancient origin.

177 Chimayo weaving with abstracted diamond from Mexico, and the New Mexico state bird, the roadrunner, made famous in cartoons.

178 Appliquéd skirt. Llanos, New Mexico

179 Willow basket. To obtain different colors, the willow has to be picked at different times of the year. Note the dark band and center. San Juan Pueblo, New Mexico

164 168 172 176

165 169 173 177

166 170 174 178

167 171 175 179

MEXICO

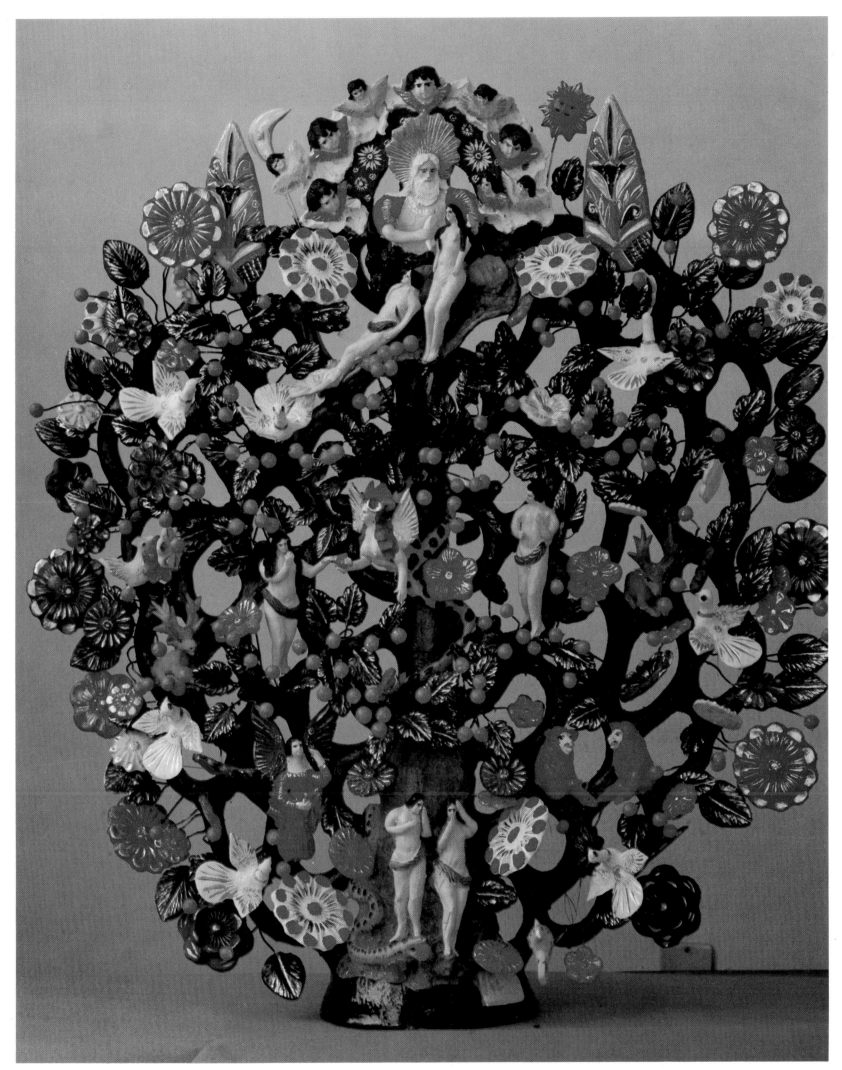

180 The Tree of Life represents the expulsion of Adam and
Eve from Paradise. Metepec, Mexico

Introduction

The great city of Temixtitán is founded in a lake and from Terra Firma to any part of the city, for anyone who would wish to go there, it is two leagues. There are four entrances, all of which are causeways as wide as two riders with lances. It is a city as large as Seville or Córdoba. Its streets, I speak of the main ones, are very wide and very straight, and are, along with some of the others, half land and half water, on which the people travel in canoes; all the streets are open at certain intervals to allow the water to pass from one to another, and at all these openings, some of which are very wide, there are strong and well-built bridges made with large beams joined together; on them as many as ten cavalry could pass at the same time.

Hernán Cortés, *Letters Relating to the Conquest of Mexico*. 1519

A chronology does not easily reflect the evolutionary dynamics of prehistoric man; there are, nevertheless, certain actions, landmarks, or inventions that determine the transition from one epoch to another more developed one. The problem in presenting a chronology of Mexico is especially complex because of the country's many diverse civilizations, which often have overlapping zones and relationships. Without doubt, one of the more important landmarks in Mexico's development is the abandonment of a nomadic life for a sedentary one; that

181

182

181 In some religious celebrations different faiths can be seen; there are Christian images as well as the costume and body painting appropriate for the worship of another religion. Jesús María, Nayarit

182 Mexico has a diverse orography; fertile volcanic mountains alternate with arid zones, offering a wide variety of landscapes. Oaxaca

is to say, the act by which, at a specific moment, man takes possession of territory, organizes himself, and creates an administrative and social system with rules and relationships that foresee the foundations of an urban center. Another important feature that marks the modification of man's way of life, more or less parallel to the previous one, is agriculture; this new life-style quickly places importance on pottery, vessels, and containers in which to store the fruits of the earth. In general, it could be said that these processes are common to nearly all civilizations and that this outline, in varying degrees, is applicable to all the cultural groups that developed during the pre-Columbian period in the present-day countries of the American continent.

The present-day ruins of Teotihuacán, the once splendid constructions of a flourishing culture, were the center of one of the oldest Mexican civilizations. The dating of pottery shard places the birth of this culture at about 300 B.C. and the end at A.D. 900. It has not as yet been possible to determine precisely to which ethnic group their creators belonged.

The Olmec (c. 500 B.C.–A.D. 1500) is one of the most important civilizations in Mexico, considered to have developed independent of the influences of others. More than one historian places them in the first century of the Christian era, but the high level of development the Olmec attained in about A.D. 200 suggests that the beginning of their growth was in an earlier age. At a later date the Zapotec and Mixtec made up a transitional civilization leading to the Toltec, who exercised a considerable influence over much of Mexico.

183

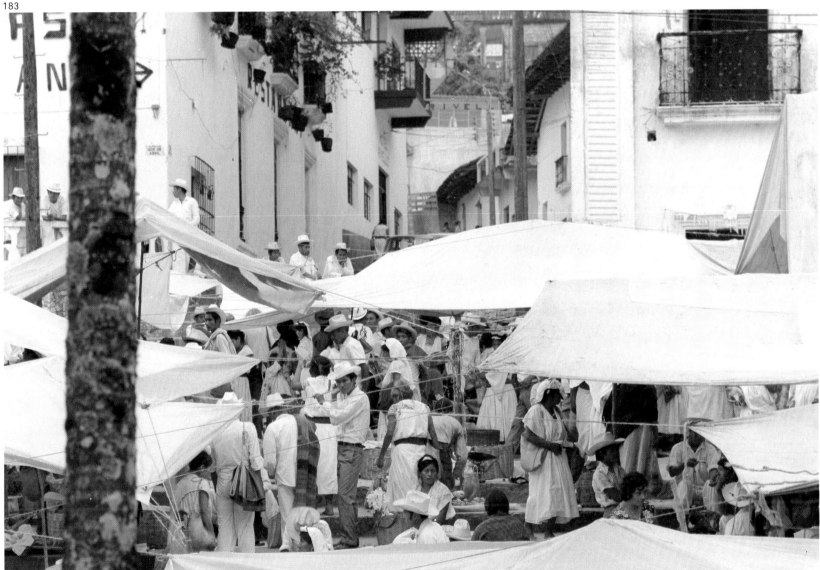

183 With its myriad crafts and costumes, Mexico is a land of vibrant color. It is surprising, then, to discover entire villages in which white is the only color

One of the Nahuatl-speaking groups, also called the Chichimeca, who originated in the north, invaded Mexico about 1200 and settled in the valley that bears their name; they were a bloodthirsty group of warriors who practiced cannibalism. Another of the Nahua tribes, called Aztec, founded the city of Tenochtitlán in the center of Lake Texcoco, whose site was that of modern Mexico City. The Aztecs, later called the Mexicas, were only a small group at first, but due in part to their military and imperialistic ideology, they became increasingly important. After settling in Tenochtitlán, they cultivated the arts and became expert weavers, potters, sculptors, builders, goldworkers, and silversmiths. The legend says that the Aztec warriors came from north of the Gulf of California. They were searching, as ordered by their gods, for a land in which they would find a large territory, and they were to identify the place by a sign —perched on a prickly pear would be an eagle with a serpent in its talons. This promised land was Lake Texcoco. The Aztec language, Nahuatl, is still spoken in some areas.

Since cultures did not follow each other chronologically, there is some difficulty in establishing the direction of their influences on each other. This fact is important when considering the Maya, a culture of great scope. In the origins of the Maya there are relationships with the Oaxaca culture (Zapotec, Mixtec) and the Valdiva culture of Ecuador, although other theories indicate a direct descent from the Olmec.

From the fourth to the eighth centuries A.D. the Maya built their most important urban and cultural centers, among them Tikal in Guatemala, Copán in Honduras, and Palenque in Mexico. The geographic distances involved give some idea of the power and territorial extent of the Maya. Their hieroglyphic writing, however, has not been deciphered, although the current interpretation of their numerical system has permitted several of their works to be dated. Their social structure was characterized by great class differences, which were upheld by the priesthood, the only people who knew all the codes of law. The cause of the first disintegration of the Mayan empire is not known for sure, but perhaps bad harvests created discontent in the great mass of peasants and started a social revolution that eventually destroyed the empire.

The Maya reappeared in the Yucatán Peninsula, where they still live today, and competed with the Toltec for supremacy. Their reciprocal influence is exemplified by the magnificent constructions of Chichén-Itzá, Uxmal, and Mayapán. The confederation of the three cities was named Mayapán. The Mayapán league was dominated by the Toltec, but it was overthrown by the Mayan uprising of 1441.

The physical geography of Mexico is very diverse: it ranges from the deserts bordering the United States to the tropical valleys of the south. The central area is the most rugged. When Hernán Cortés was asked what the Mexican landscape was like, he took a piece of parchment, crumpled it in his hand, let it go, and said, "Such is Mexico." The explanation was correct: the eastern and western ranges of the Sierra Madre mountains cover Mexico from north to south, enclosing the central uplands; lesser ranges of mountains form perpendicular spurs to them. The Pacific coast is steep, with great cliffs and difficult access; the Atlantic coast is more gentle, with sandy areas on the Gulf of Mexico, where the major ports are to be found.

The climate is as varied as the terrain: torrid in the region of the Atlantic coast; cold on the volcanic peaks, with their perpetual snow cover, which surround the valley of Mexico; temperate on the aptly named tableland. Mexico has about 67 million inhabitants and is the second most populous country in Latin America. Its terri-

184

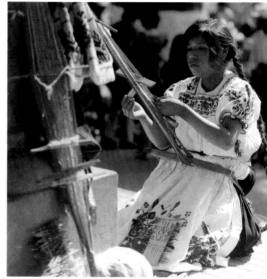

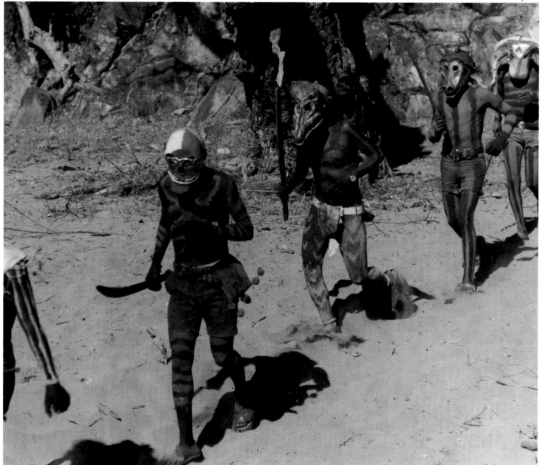

184 The Mexican woman, tireless in her work, uses every occasion (in this case while waiting for buyers in the market) to weave on her backstrap loom. Note that her costume is decorated with magnificent embroidery. Uruapan, Michoacán

185 A craftswoman decorating amate, paper made in a way that predates the Spanish Conquest. Strips of amate or jonote bark are boiled and later latticed and beaten to make very fine sheets of paper. Guerrero

186 The color and imagination of the participants make the popular Mexican festivals lively and unique. Jesús María, Nayarit

187 Monte Albán, the capital of the Zapotec culture, has well-preserved terraced pyramid constructions. Oaxaca

torial area is over 750,000 square miles (2 million sq km). The plateau, or central valley of Mexico (19 percent of its total area), contains the capital city and nearly 50 percent of the population. Sociologic and ethnologic studies show that the indigenous population, which is 25 percent of the total, comprises some fifty-six subgroups, each with its own characteristics and language. The conquistadors called this land New Spain, but eventually the country took the name of one of the groups of Aztec origin, the Mexica.

The variety of forms, materials, and colors found in Mexican craftwork is the result of this complex social and geographic panorama. If the mixture of cultures caused by the Spanish Conquest seems to presuppose a cutting off of traditions, it should be remembered that it also introduced new forms and techniques. Now underway is an attempt to recover the ancient techniques of craftsmanship handed down from generation to generation that make the Mexicans one of the most creative and prolific craftworkers on the continent.

Mexican textiles and embroidery are similar to those of Guatemala and are treated together. In order not to be repetitive, therefore, we have omitted them from this chapter, although there is a wide representation of them in the catalogue section. It is safe to say that the best fabrics and embroidery in Mexico are produced in Pantepec, Chachahuantla, Cuetzalan, and San Pablito in the state of Puebla; Venustiano Carranza in Chiapas; Uruapan in Michoacán; Pinotepa de Don Luis, Putla, Usila, Huautla de Jiménez, and Ixcatlán in Oaxaca; and Gualupita in Mexico.

187

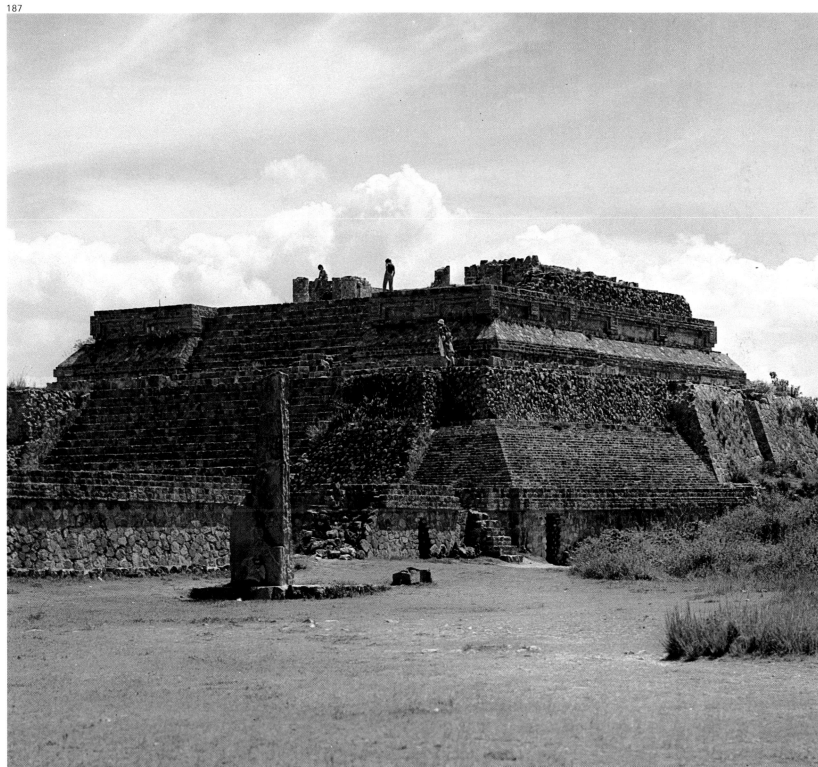

Laquerware

In the pre-Columbian era the technique of lacquering was widely known over Mesoamerica and was common among the native Mexicans, as is recorded in such ancient documents as *Código Mendocino* and *Matrícula de Tributos*, which contain the names of those communities that paid periodic tribute to the Aztecs in the form of small painted bowls. Sahagún and other chroniclers of the past also give credence to the existence of this craft with eloquent testimony that modern lacquerwork has a pre-Columbian background and that its origins are genuinely indigenous. Although lacquerware was once produced throughout Mexico, today it exists only in Olinalá, Temalacacingo, and Acapetlahuaya, Guerrero; in Uruapan and Pátzcuaro, Michoacán; and in Chiapa de Corzo, Chiapas.

Lacquering is the technique of decorating objects made of wood or gourd by grooving or incising and gilding, and coating with lacquer. The use of these two methods dates back before the Spanish Conquest began in 1519, but the motifs have changed with time. The decorated objects may be for daily use or for ornamental purposes. Some of the ancient pieces are no longer made, having been replaced with forms that better serve today's needs and the demands of tourists, an important economic factor in Mexico.

The first step of the process, which is common to both methods, is the preparation of the porous wood or vegetable surface with linseed or chia oil and ochre of limonite. (The material that gives durability to the lacquer is mixed later.) The surface is polished and the mixture with the base color is added immediately. It is im-

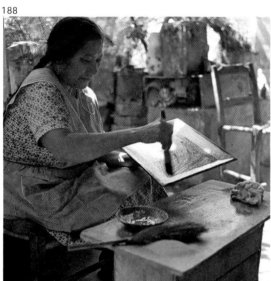

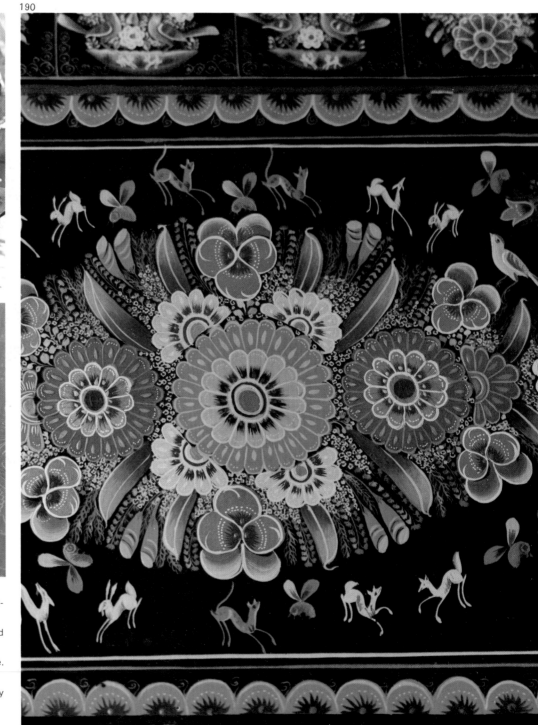

188 Expert giving a coat of *tecostle* to one of the most common objects of this craft, called a *charola*. Olinalá, Guerrero

189 The tools for doing lacquerwork are a turkey quill and thorn from a plant; the grooving is being done with the latter

190 Detail of a large chest made by the gilding technique. Olinalá, Guerrero

191 Tray with an application of gold leaf that is applied by means of a fixative. Pátzcuaro, Michoacán

torial area is over 750,000 square miles (2 million sq km). The plateau, or central valley of Mexico (19 percent of its total area), contains the capital city and nearly 50 percent of the population. Sociologic and ethnologic studies show that the indigenous population, which is 25 percent of the total, comprises some fifty-six sub-groups, each with its own characteristics and language. The conquistadors called this land New Spain, but eventually the country took the name of one of the groups of Aztec origin, the Mexica.

The variety of forms, materials, and colors found in Mexican craftwork is the result of this complex social and geographic panorama. If the mixture of cultures caused by the Spanish Conquest seems to presuppose a cutting off of traditions, it should be remembered that it also introduced new forms and techniques. Now underway is an attempt to recover the ancient techniques of craftsmanship handed down from generation to generation that make the Mexicans one of the most creative and prolific craftworkers on the continent.

Mexican textiles and embroidery are similar to those of Guatemala and are treated together. In order not to be repetitive, therefore, we have omitted them from this chapter, although there is a wide representation of them in the catalogue section. It is safe to say that the best fabrics and embroidery in Mexico are produced in Pantepec, Chachahuantla, Cuetzalan, and San Pablito in the state of Puebla; Venustiano Carranza in Chiapas; Uruapan in Michoacán; Pinotepa de Don Luis, Putla, Usila, Huautla de Jiménez, and Ixcatlán in Oaxaca; and Gualupita in Mexico.

187

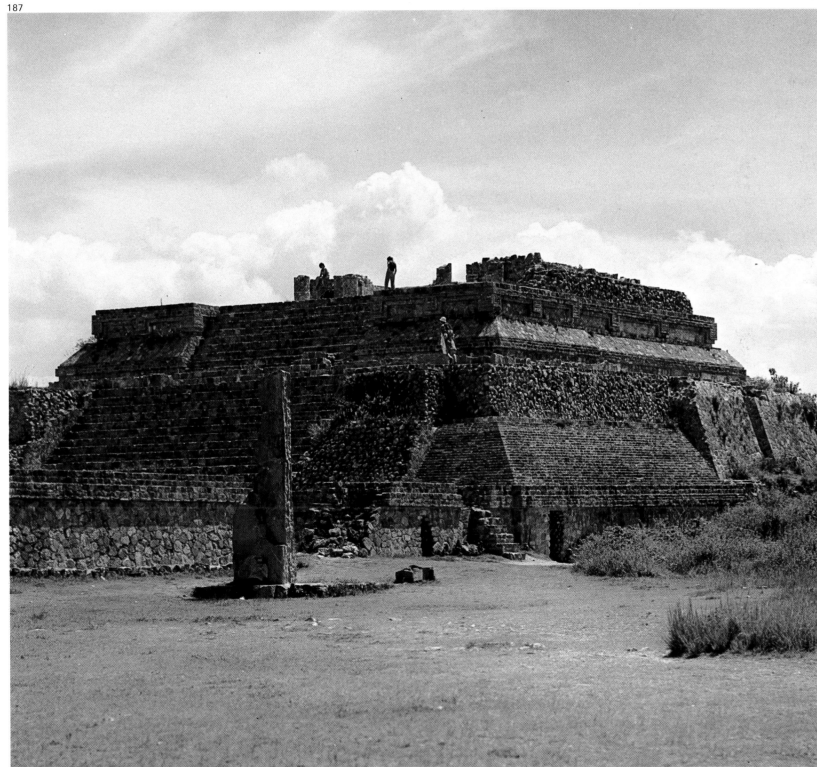

Laquerware

In the pre-Columbian era the technique of lacquering was widely known over Mesoamerica and was common among the native Mexicans, as is recorded in such ancient documents as *Código Mendocino* and *Matrícula de Tributos*, which contain the names of those communities that paid periodic tribute to the Aztecs in the form of small painted bowls. Sahagún and other chroniclers of the past also give credence to the existence of this craft with eloquent testimony that modern lacquerwork has a pre-Columbian background and that its origins are genuinely indigenous. Although lacquerware was once produced throughout Mexico, today it exists only in Olinalá, Temalacacingo, and Acapetlahuaya, Guerrero; in Uruapan and Pátzcuaro, Michoacán; and in Chiapa de Corzo, Chiapas.

Lacquering is the technique of decorating objects made of wood or gourd by grooving or incising and gilding, and coating with lacquer. The use of these two methods dates back before the Spanish Conquest began in 1519, but the motifs have changed with time. The decorated objects may be for daily use or for ornamental purposes. Some of the ancient pieces are no longer made, having been replaced with forms that better serve today's needs and the demands of tourists, an important economic factor in Mexico.

The first step of the process, which is common to both methods, is the preparation of the porous wood or vegetable surface with linseed or chia oil and ochre of limonite. (The material that gives durability to the lacquer is mixed later.) The surface is polished and the mixture with the base color is added immediately. It is im-

188

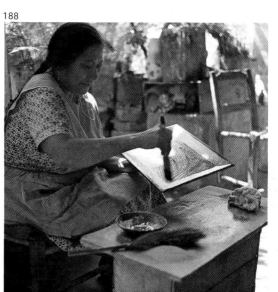

189

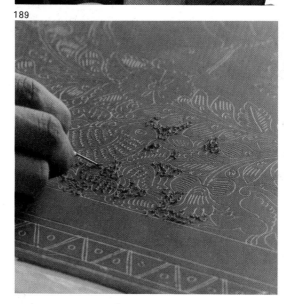

190

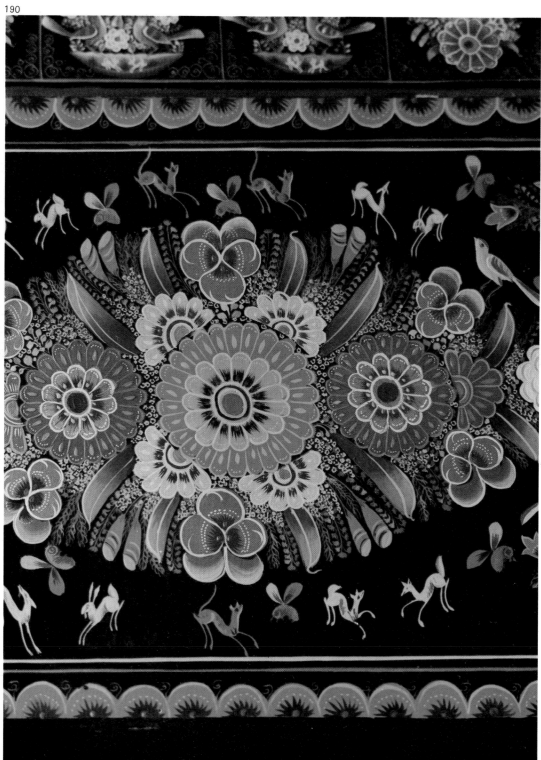

188 Expert giving a coat of *tecostle* to one of the most common objects of this craft, called a *charola*. Olinalá, Guerrero

189 The tools for doing lacquerwork are a turkey quill and thorn from a plant; the grooving is being done with the latter

190 Detail of a large chest made by the gilding technique. Olinalá, Guerrero

191 Tray with an application of gold leaf that is applied by means of a fixative. Pátzcuaro, Michoacán

portant to give luster to this coating before applying the next layer, so the object is left to dry for ten or fifteen days.

Grooving is done on top of a second layer of color, while it is still fresh, with a thorn mounted on a turkey quill. The motifs tend to be floral or animal, the most typical of the latter type being the rabbit. Tradition dictates the use of color, and combinations of a deep red base with black grooving and a blue base with white grooving are most common.

The gilding technique is attributed to earlier times when the objects were decorated with silver or gold leaf, in addition to designs made with a brush. The most distinctive feature of this technique is the preparation of the colors made on the spot. According to an old method, the basic ingredients, a mixture of minium, ochre of limonite (to help the drying), and oil, are put on the fire and cooked.

In general terms, these techniques are the same in all the centers of lacquerware production, with slight variations in the type of oil used or the way the colors are applied. The biggest difference among the craft centers is in the type of pieces that are made. In Olinalá, for instance, large chests, trunks, tables, trays, small bowls, boxes, etc., are made, while in Acapetlahuaya only small boxes are made.

Uruapan was the largest center for lacquerware in western Mexico, and although production has declined somewhat there is a definite movement to revive it. The characteristic technique is that of *embutido*, which

191

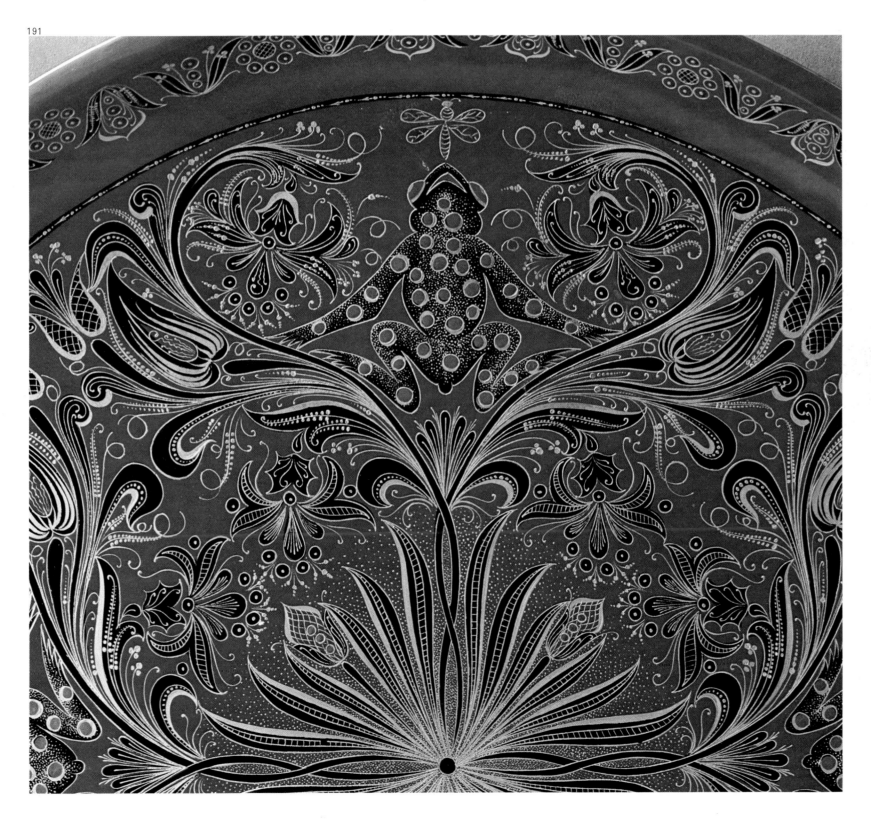

consists of drawing or inlaying decorative materials on a lacquer base. The design is copied or traced on a lacquer surface. Then some parts of the decoration are cut away to uncover the wood, and once this is done, the area outlined is inlaid or encrusted with a color different from the background. In Uruapan and Chiapa de Corzo oil of *aje* is used to fix the colors. The *aje* is a parasite that develops in certain shrubs in the temperate regions. This minuscule animal is gathered in large quantities and boiled in water until a fatty substance results that floats on top of the water. This grease is gathered and left to dry wrapped in banana leaves.

192

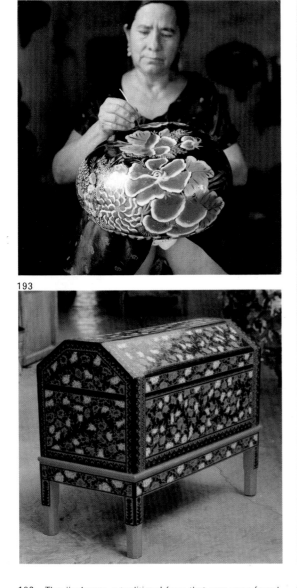

193

194

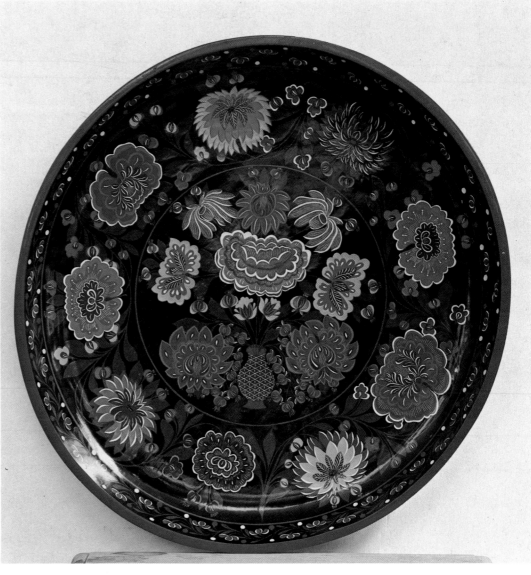

192 The *jicalpeste,* a traditional form that was once found all over the isthmus of Tehuantepec. Chiapa de Corzo, Chiapas

193 Large chest made using the grooving technique. Olinalá, Guerrero

194 Tray lacquered by hand using the inlay technique. The colors are natural and no artificial pigments have been used. Uruapan, Michoacán

Glassware

Although glassware is not of local origin, unlike other folk arts, it has received the sensibilities of Mexican craftsworkers, and it is securely established in its own style. The first producers of glassware in Mexico were Spaniards who came to the town of Puebla. Factories were later set up in Mexico, Guadalajara, and Texcoco. At present this craft is widespread and factories have been opened in Monterrey, Tlaquepaque, Guadalajara, Tonalá, and border towns such as Juárez City and Tijuana.

Blown glass is produced in nearly all the factories, but only in Puebla is pressed glass made. Blown glass may be given various finishes: quicksilver, fired enamel, blistered, or ground. Pressed glass is sometimes deccorated with emery in a decoration called *de pepita*.

Bottles, glasses, jugs, plates, goblets, and many other pieces are made in blown glass, some of which are finished in a mold. Pressed glass made in a mold has characteristically been in traditional forms, such as the receptacles that up to a few years ago were used to serve pulque (fermented juice of the agave or maguey plant). These forms, with such popular names as *chivos, catrinas, cacarizas, tornillos, macetas,* once reached a high volume of production that eventually fell into decline, causing factories to turn to other products.

195

197

196

198

195 Blown glass jug with leaves of a different color added

196 Horse of blown glass, treated with quicksilver

197 Demijohn of blown glass from the old glass factory in Avalos. Guadalajara, Jalisco

198 Jug of blown and frosted glass, used to chill wine. The handle is a rope of fluted and braided glass

Pottery

It is practically impossible to summarize in a few pages the vast panorama of Mexican pottery. In the majority of villages, everyday objects are made in a wide range of forms, decorative motifs, and uses. Pottery, then, is one of the most widespread of the craft activities. In addition to ordinary earthenware, more or less different from that in other countries, we can find pieces in Mexico that are unique in their form and finish and to which we must devote special attention. The glazed ceramics and Talavera ware, which is influenced by the earthenware from the Spanish city of that name, or pieces such as those produced in Metepec, San José de Gracia, or Río Blanco, are proof of the creative power of the potters.

Some of the finest ceramics in the country are made in Puebla de Zaragoza, called *Talavera poblana*. This Talavera ware was introduced into Mexico by the Spaniards and still retains the decorative motifs of Asian and Spanish influences, as well as the potter's individual style. The way in which it is made remains virtually the same. Two types of clay are used: one is called "black," and is found in the area, and the other is called "white," and comes from Valsequillo. They are combined in equal parts and submerged in large tanks of water to separate out the impurities. Each piece is thrown on a wheel and when completed is left to dry in a room with no ventilation. The piece is baked once before being decorated, which is then done over a base of white glaze. Although other colors are used, blue and yellow predominate. Nowadays the motifs are mostly floral designs that are applied with an artist's brush.

199

200

201

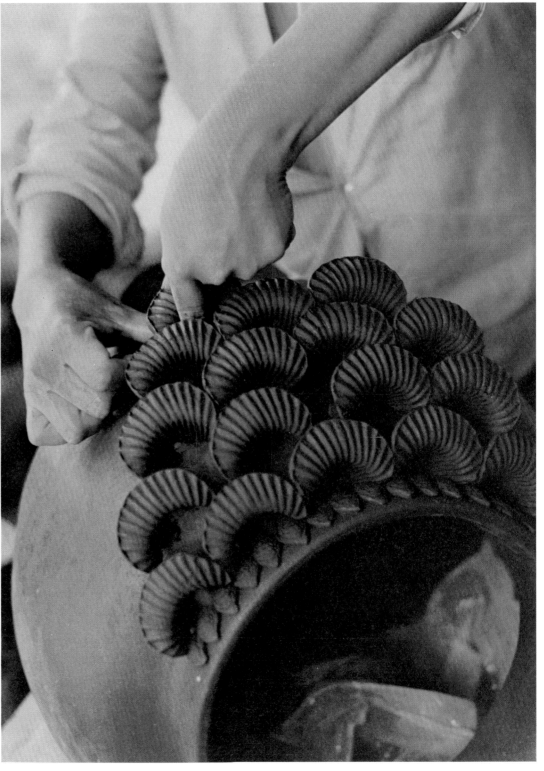

199 The making of "pineapples" of glazed clay is a modern style of pottery. Patambán, Michoacán

200 Pitcher with a dripped and splattered decoration made from an infusion of oak barks. Río Blanco, Oaxaca

201 "Pineapples" are decorated with small leaves made in a mold and then placed so that they overlap each other. San José de Gracia, Michoacán

At the end of the sixteenth century centers were ordered to be set up in the states of Guanajuato, Jalisco, Oaxaca, and Aguascalientes to preserve the manufacture of Talavera pottery. In these places the work took on a character of its own; the designs varied and only the use of the white background continued. These glazed ceramics have an excellent finish and are highly prized; although in some areas production has decreased, an attempt is underway to recover the old forms.

Metepec is famous for a piece called the "tree of life," which is more representative of Mexico today. It is an extended sequence of the beginning of life in the earthly Paradise; the representation is based on the figures of Adam and Eve, the serpent, and the Creator in the middle of a luxurious and colorful decoration of plants. Metepec is, without doubt, a major pottery center in Mexico, where a great deal of earthenware and polychrome figures are produced. This most important industry continues to encourage the creation of such imaginative works as the above-mentioned trees of life.

Another outstanding piece in the range of Mexican pottery is the famous "pineapple" of San José de Gracia; the craftsmen of this village, although not dependent on a tradition of pottery, have been able to create this luxury piece, decorated with mold-made leaves of a distinct design. The leaves are placed on top of one another to cover the entire body of the pineapple. The finish is done with green greta glaze, in the style of Patambán, where pineapples are also made today.

202

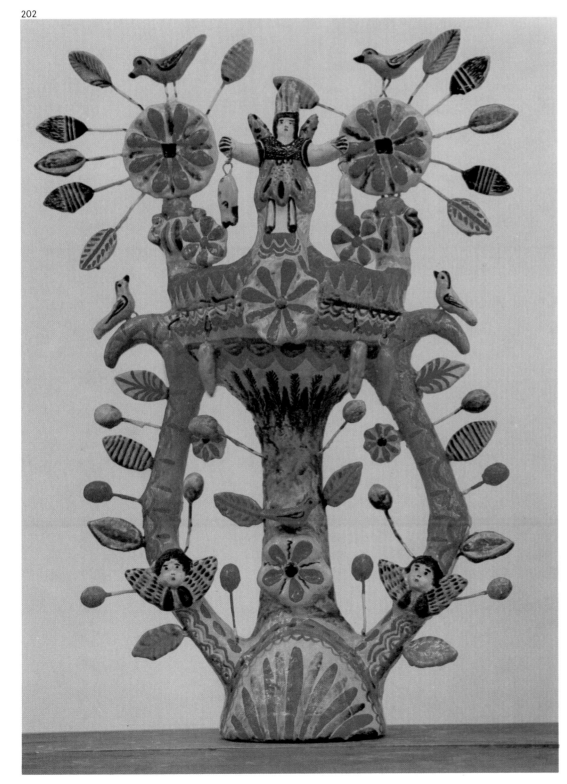

203

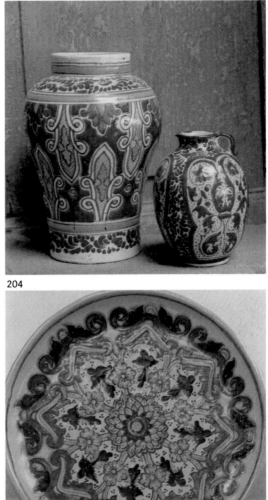

204

202 Polychrome clay vessel in which to burn incense and copal. Izúcar de Matamoros, Puebla

203 Talavera pottery jugs decorated in the old style. Puebla

204 Plate in the style called *Talavera poblana* with traditional design and color. Puebla

Unlike the ornate and decorated ceramics that have been mentioned to this point, the dripped and splattered earthenware of Río Blanco in the state of Oaxaca stands out among pottery for everyday use. Río Blanco is a small, inaccessible village where pottery is made exclusively by women (in most centers the woman is usually the assistant). The pitchers are started from a lump of clay that is hollowed out to form a bowl, then made larger by additional strips of clay placed on the rim until the right size is reached.

While the pitcher is being made, the potter is simultaneously polishing the outside of it with a scrap of leather, which also eliminates the impurities. The pitchers, which have a conical base and handles at the widest part of the body, are usually used for carrying water. An interesting aspect of the decoration is that the color is applied with a rag soaked in an infusion of oak bark after the piece has been fired and is still warm. In this way the color is fixed in the clay.

This short exposition on the most original pieces of pottery produced in Mexico must also include the polished clay candelabra from Acatlán, the cooling jugs from Ixtaltepec, and the original and widespread painted earthenware from Tonalá. It must be emphasized that Mexico is the country of the Americas where everyday earthenware has a great many forms of expression; the variety of plates, pans, pots, pitchers, etc., is limitless. Sometimes traditional form and decoration are used as a model, on other occasions the craftsworker introduces changes, resulting from observation or from the daily use of the pieces.

205

206

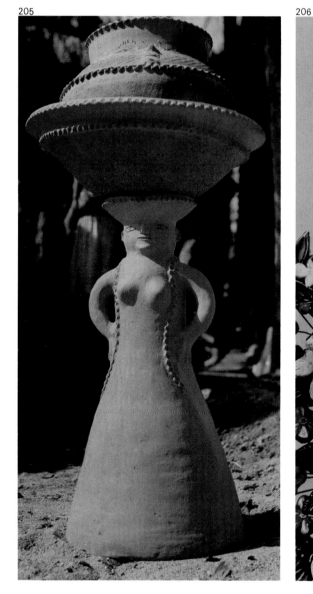

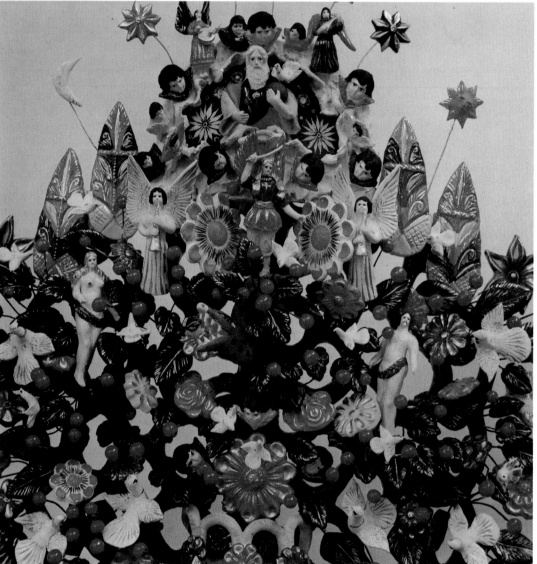

205 Water cooler with decorative elements. Hand modeled in the form of a woman. San Blas Atempa, Oaxaca

206 Detail from a Tree of Life, a popular version of Paradise that contains religious symbolism. Metepec, Mexico

Carving

Many utensils and popular craft objects are fashioned from wood. Practical objects such as bows for saddles, yokes, and plows are made from wood as well as nonpractical items, such as toys and masks. Nowadays furniture is made of ordinary, rather than fine, wood; the furniture produced in Cuanajo, Pátzcuaro, and Paracho de Verduzco is pine decorated with engraved floral motifs. Furniture for everyday use is also made in Santa Clara del Cobre, Guadalajara, Acatlán, Huejutla de Reyes, and other places. There is furniture of a regional type, such as the rustic chairs of Jalisco and Michoacán; there are also skilled craftsworkers in Cuetzalán (Puebla), Chiapa de Corzo, and Tlaxcala.

In Arrazola, San Martín Tilcajete, and other places in Oaxaca animals and figures are made in whitewood and painted with dyes. Retablos are also made which represent Virgins and Nativities. From the wood of orange trees combs are made by a primitive technique.

Animals and figures are made in the state of Mexico of whitewood carved in the form of spoons, sauce boats, and toothpick holders; these are sold in the market at Ixtapán de la Sal. Whisks for chocolate are made in Rayón and San Antonio de la Isla.

Near the city of Cuernavaca, in Tepoztlán, small houses, churches, and figures are made from Bombax wood, whose wrinkled bark and reddish color give a characteristic appearance to these pieces very similar to the mountains that encircle the town.

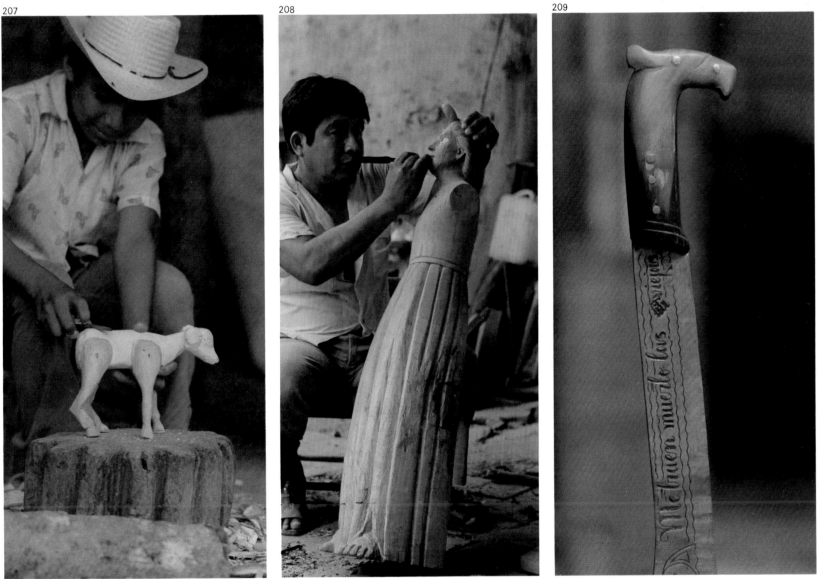

207 This young artist carves wooden animals and then paints them with dyes. San Martín Tilcajete

208 Wood is often used for the carving of religious figures, or *imaginería*

209 Machete hilt made of horn. Chiapa de Corzo, Chiapas

Walking sticks and molds (for decorating tortillas) are made in Chamacuero de Comonfort. At festivals, vegetable dyes are placed in a mold into which a hot tortilla is then laid; the dye is moistened by the damp heat, leaving an imprint on the tortilla of the designs, which are floral and religious motifs.

Traditional walking sticks are made in San Esteban Tizatlán Tlaxcala. They are hollowed out, grooved, painted, and then sold in the fairs and markets of the country.

Stone carving in the pre-Columbian era was an important activity, and even today stone continues to be used to make sculptures and garden ornaments, and in masonry for buildings and monuments. In utilitarian form stone mortars of native origin (a metate, a stone for grinding corn, and a *molcajete*, a stone mortar on a tripod) are used a great deal in homes in the rural areas.

Obsidian is worked in San Francisco Mazapa, San Martín de las Pirámides, and Taxco. It is worth noting that this is one of the materials most beautifully fashioned by the pre-Columbian craftsworkers; for example, *bezotes* (rings worn in the lower lip) and earrings were polished to a fine finish until they seemed translucent.

In Guerrero carving in hard stone has started again: serpentine, malachite, and amethyst are used to make small animals, rings, and figures in the pre-Columbian style.

The technique of hollowing and carving onyx is used extensively in the state of Puebla. Flower vases, goblets, and bowls, as well as a wide variety of boxes, bookends, ashtrays, jewelry, and ornaments in the forms

210

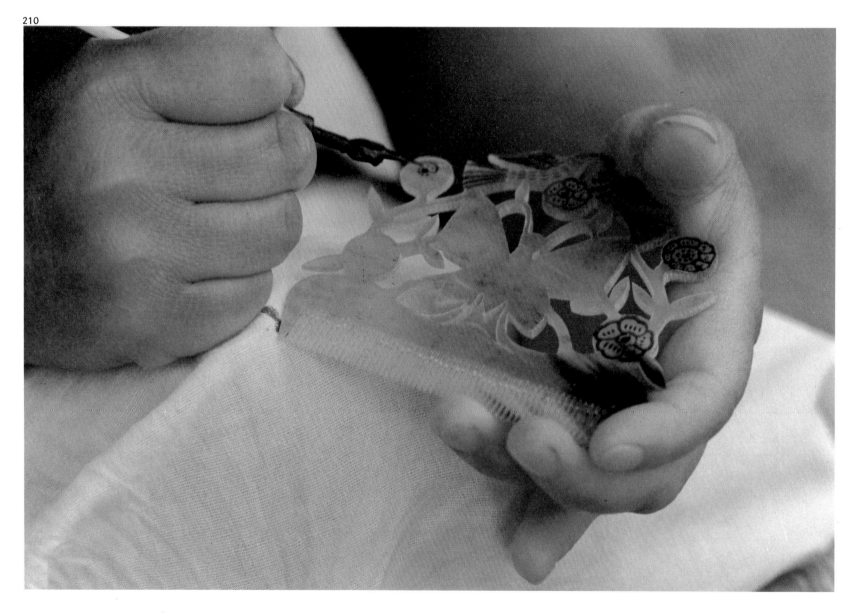

210 Once carved, the horn comb is decorated with permanganate. San Antonio la Isla, Mexico

of animals, fruits, etc., are made from onyx. Tecali has a high volume of production of carved goods. Almost all the inhabitants live by this industry, running the many workshops where this material is worked.

Craftsworkers all over use bone, horn, shell, and tortoiseshell to make objects of popular manufacture. The best works come from Teocaltiche and Guadalajara, where fine openwork bone chess sets and miniatures are made. Bone is also used in the state of Mexico to make small dominoes and buttons. In Guanajuato this material is used to make various small figures, weaving hooks, and other small handicraft pieces.

In the state of Mexico cow's horn is used to make buttons, chess pieces, and combs in the shape of animals. In Chilapa combs are also made—the traditional *escarmenadores* (combs for wool) and *chinas*—and are decorated with acid and polished with ashes. In Cualac and Ometepec small animal figures and the handles of machetes are made. Horn figures are also made in San Marcos, and in Tecpan de Galeana horn vessels are elaborately carved and painted with a permanganate mixture.

Seashells have been used since very early times, when native peoples wore them for adornment or used them for money. Nowadays seashells are used to make decorative objects: small boxes, toys, miniatures, and small pieces of furniture.

Tortoiseshell is used in La Paz, Campeche, Carmen City, and Isla Mujeres to make boxes, watchstraps, bracelets, letter openers, ornamental combs, clasps, earrings, and many other objects for personal adornment.

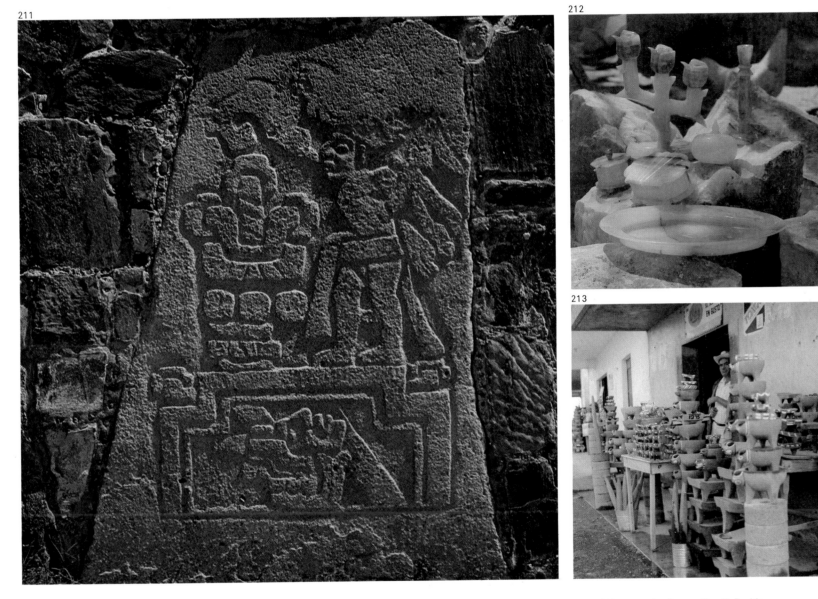

211 Carved stone found in the archeological ruins at Monte Albán, Oaxaca

212 Objects made of onyx. Tecali, Puebla

213 There are many types of objects made from stone. Among them are *molcajetes* and metates, stone wheels for grinding corn. San Salvador el Seco, Puebla

79

Metalwork

The use of metals in Mexico dates back to the pre-Columbian times, when native artisans worked in copper to make small axes, bells, tweezers, and other objects. Gold and silver were used for luxury items and for personal adornment and were fashioned with a beauty and technical perfection that astonished the conquistadors. The precious metals were obtained by the indigenous population from riverbeds and open cast placers, and it was only after the Spanish Conquest that work started in the mines, of which those in Guanajuato and Taxco were the most productive for the benefit of the Spanish crown.

The production of copper objects in Santa Clara del Cobre is important as much for Michoacán as for the rest of the country, as it provides a constant source of work for many families and represents considerable access to foreign currency, given that a large amount of the material is destined for export. It has been argued that, with the valuable copper beds in the state of Michoacán, the coppersmiths should be using waste material for their works. In fact, they are already using waste copper wire, because it is easy to smelt, but if this material, which is nearly always on a spool, contains even the smallest amount of tin, it loses its flexibility and the craftsworker can no longer hammer it, so that it has to be used to make handles for pots.

The coppersmiths smelt the wire using firewood in the forge, bringing the flames to life by means of a handmade bellows. The smelting is done in a hole in the earth, and the shrinkage of the metal is 6 to 10 percent. Once smelted the material is left to cool in sheets up to sixteen inches (40 cm) in diameter and about three

214

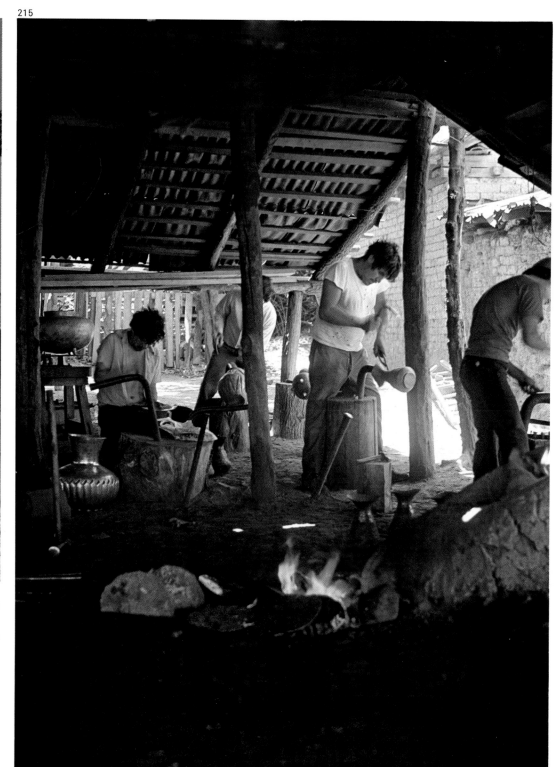

215

214 Objects of beaten copper displayed in the market of Santa Clara. Michoacán

215 Forge and workshop for making copper objects that are beaten when hot. Santa Clara, Michoacán

inches (8 cm) deep at its thickest part. A piece is cut with a chisel to the right size for making a pan, plate, pot, jug, etc. Each portion, or *tajo*, is put into the fire until it glows red hot, when it is taken out and beaten on an anvil to stretch it. These anvils are now made of metal, but once they were stone, some of which can still be seen in various workshops today.

When regular-sized pans and pots are made, the participation of as many as nine men is required to beat the piece while another turns it.

It is most interesting to see the work in a forge where, with very flexible movements, several men rhythmically beat a piece of copper, giving all their energies to the work, which on occasion lasts for hours. Sometimes up to sixteen turns are required to make the copper tortilla the right size; and when it is reached, one worker undertakes to finish the piece himself. When a pair of pots is being stretched and beaten, several hot leaves of copper are beaten at the same time, separated from each other by scraps of cardboard to prevent them from fusing. When they are the required size, the leaves are separated so that each pot can be finished separately.

The coppersmiths themselves make the tools they use from bits of iron, in addition to all those such as hammers and *candongas* (teasers), which are used to curve or deepen and round off the pieces.

Until recently, Santa Clara was considered the only place in Mexico where work was done in hammered copper, but other copperwork centers exist in the state of Hidalgo. In Tlahuelompa and Zacualtipán copper has

216

217

218

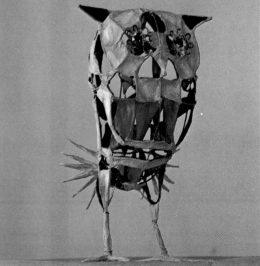

216 Rooster and bouquet of flowers (background) made from painted sheet metal. Mexico

217 Finishing some dark blue steel spurs with silver inlay. Amazoc, Puebla

218 Owl made of wire and paper. Mexico City

been worked since ancient times with almost the same technique as that used in Santa Clara. In addition, in these two villages casting is done on a large scale to make bells. One difference from the Santa Clara process is that the pots and pans are generally finished in two parts, which are worked separately and afterward soldered into one. Another basic difference is that in Hidalgo all the pieces for domestic use are tinplated. In general, the styles are less artistic than in Santa Clara, but they are more geared to the domestic needs of the population.

Handmade wrought iron is produced in many places throughout Mexico, mainly for use as machetes, knives, and tools for work in the fields. The machete is the common tool of the country people, and its production is widespread, above all in Guerrero. The classic *yahuales* (curved machetes) are made in Chilapa; in Tecpán de Galeana and Ometepec engraved and plain machetes are produced.

Given that the making of spurs is an imported craft, it has been done in various Mexican villages since colonial times, above all in Amozoc, where spurs are beautifully hand fashioned and inlaid with silver.

The art of blacksmithing dates back many years and has a great tradition of craftsmanship. The most beautiful examples of this still remain today in windows, railings, and balconies, as in the colonial city of Querétaro. Nevertheless, this craft has declined a good deal. In some parts of Bajío locks, nails, and other iron fittings for furniture and doors are still made. San Cristóbal de las Casas also produces this type of wrought iron, particularly

219

219 Acid-engraved knife blade. Oaxaca

iron fittings for furniture and decoration. The wrought iron and glass lamps made in Guadalajara and Mexico City are also noteworthy.

Finally we must look at the works made in tinplate and brass that are produced in Mexico City, Oaxaca, San Miguel de Allende, Puebla, Tlaquepaque, Puente de Ixtla, and other places, where there are enormous varieties of tinplate figures, either painted or plain: candlesticks, mirror frames, lanterns, plates, trays, niches for images, etc. The town of San Miguel de Allende, which has specialized in fine brass, is renowned for this type of work.

In Mexico City a variety of imaginative figures made of wire and covered with glued and painted paper are produced: horses, bulls, owls, skulls, bicycles, planes, small cars, etc.

220

221

220 Butterfly of sheet metal cut out and beaten. Oaxaca

221 Beaten copper pieces of recent design. Santa Clara, Michoacán

Toys

For many years folk toys have been famous for their variety, their vibrant colors, the simplicity and beauty of their forms, and for the notable ingenuity of their simple but efficient mechanisms that allow them to make noises or move in various ways.

Until recent years it was still possible to find toys, knickknacks, whistles, and small bowls, of a thousand forms and finishes, in the shops of the cities and towns, in the markets, fairs, and the *tianguis* (special marketplaces set up during certain traditional festivals). However, these toys have become increasingly difficult to find; fashioned from wood, tinplate, ragpaper, sugar, palms, and other materials, they were authentic examples of the ingenious skill of the Mexican artisan.

Nowadays, for example, cardboard masks are still made to old patterns and are given to children during the carnival celebrations, and rattles of batten wood have hand-painted decorations. Cardboard "Judases" are extraordinary grotesque figures of traditional paperwork that are sold in village streets during Easter Sunday. They are finely finished and smell of *cola*, as the dyes used in their decoration are mixed with this glue to give luster and firmness. The "Judas" sellers go through the streets with poles over their shoulders, from which hang clusters of skulls, devils, "he-men" with large mustaches, pot-bellied, sombreroed cowboys, and other small figures for the children.

In November the making of *muertos*, toys for the Day of the Dead in Oaxaca and Mexico City, delights

222

223

224

222 Toys of woven palm. Santa María, Chicmectitlán

223 Policeman, a figure made in the traditional way of the papermakers. These dolls, which always have a skull for a head, represent different prototypes of people. Mexico City

224 Cardboard dolls are made in a mold and painted with dyes. Small masks are made in the same method. Guanajuato

225 *Alebrijes* are fantastic cardboard figures decorated with a brush and varnished. Mexico City

everyone with the improbability of its theme. Since olden days, lost in the origins of the Mexican people, the theme of death has been one of the favorites for artists and craftsworkers. Obviously its representation cannot be missing from folk toys. Therefore the children of Mexico play with death; they make cardboard skeletons dance, they move little death figures made of metal paper and chick-pea heads, and they carry small coffins. Or else they eat sugar skulls, sugar-paste figures of the "bread of the dead."

During the last week of October and the first two days of November, the markets of Mexico City and Oaxaca are covered with vendors' stalls selling toys of clay and paper related to the theme (the Day of the Dead). Loaves of bread and sugar skulls are also used to decorate the "altars of the dead," which are customarily put up in the houses during this time.

For Christmas one can buy small toys for the Nativity in the markets: "mysteries" (figures of Mary and Joseph), the Magi, shepherds, small houses, devils, hermits, and angels, all in unimaginable quantity. The potters of Tlaquepaque work all year to satisfy the demands for these Christmas figures which although they are not all strictly toys are called so by the craftsworkers who make them. Those toys that are not intended as gifts to Mexican children nevertheless contribute to their happiness.

As well as toys made only for one particular festival, there are others that are produced for use all year. And, in addition, there are others which are produced for specific celebrations but which never reach Mexico

225

City, as their range of distribution is limited to the region or town where they are made. Such is the case with the clay toys of Teloloapán, which are given to the children on the eve of Palm Sunday; the small dolls called *tanguyus* of the Vishana district of Tehuantepec; the simple clay toys of Santa María Tatecla, which are sold in the market at Huatusco during the Day of the Dead.

Although many kinds of toys have become difficult to find, an enormous quantity of miniatures are being made. Mexican craftsworkers fall into true preciosity in the making of their objects, some of them almost to the point of mania for minuteness. The Mexicans like to make, buy, and keep these miniatures, which are generally not given to children; if they are given, they are not for play but to be kept as family treasures.

In nearly all craft centers there are miniaturists who reproduce tiny knickknacks and figures in clay and other materials. Notable among them are miniature weddings, Nativities, bullrings, and other pieces of wired clay from Tlaquepaque; diminutive animals and kitchens from Puebla; small copper objects from Santa Clara; horn miniatures from Jalisco; tiny musical instruments of wood with shell applications from Ixmiquilpan; spun-glass miniatures from Toluca and Guadalajara; woven palm miniatures from Chicmectitlán.

All together the toys form a rich craft inheritance and are a vital and important part of Mexican culture and the history of its people and its cities.

226

226 Clay miniatures painted with dyes

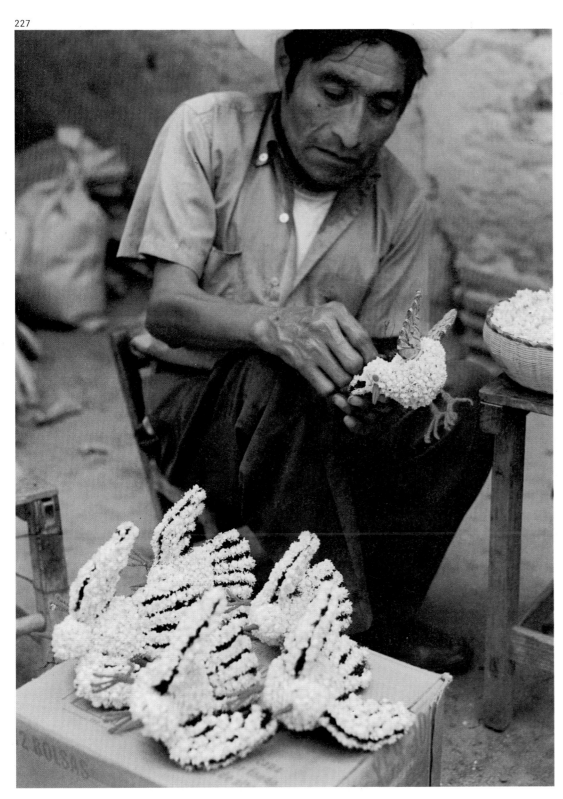

228

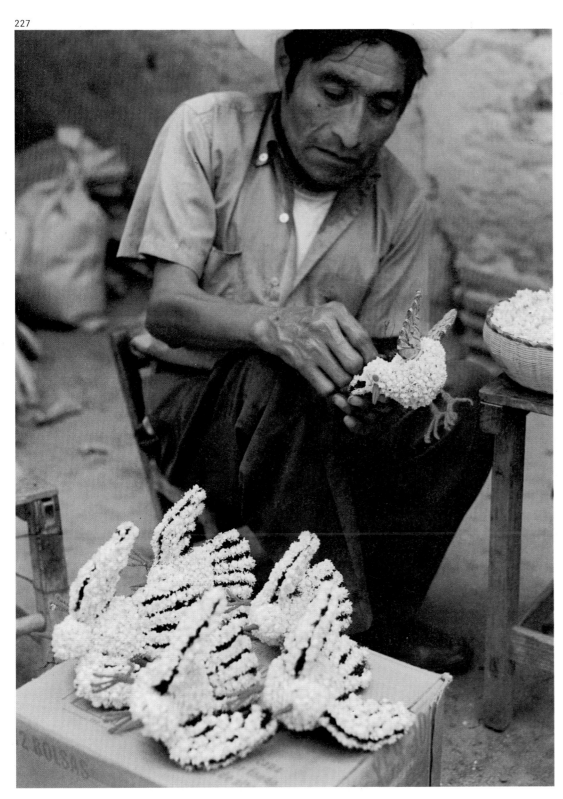

227 Doves made with the blossoms of strawflowers. San Antonio, Oaxaca

228 Truck in painted batten wood; toys of this type are found in nearly all the markets of the country. San Juan Chapultepec, Mexico

Catalogue

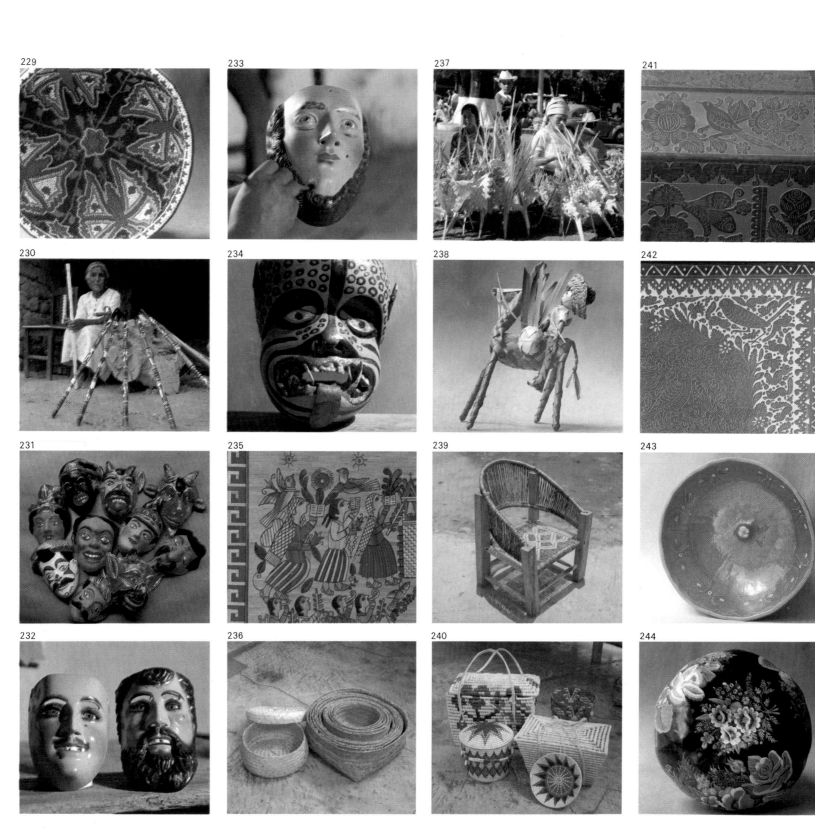

229

230

231

232

233

234

235

236

237

238

239

240

241

242

243

244

245 *Tole* with lacquered top and decorated with a brush. Chiapa de Corzo, Chiapas

246 Picture on amate paper. San Pablito, Puebla

247 Handmade wrought-iron cross. San Cristóbal de las Casas, Chiapas

248 Rice-paper ornament. Puebla

249 Rice-paper ornament. Puebla

250 Hand-worked clay figurines, painted and varnished. Ocumicho, Michoacán

251 Hand-worked clay figurines, painted and varnished. Ocumicho, Michoacán

252 Hand-worked clay figures, painted and varnished. Ocumicho, Michoacán

253 Miniature folkloric scenes. Tlaquepaque, Jalisco

254 Glazed clay toy. Tecomatepec, Mexico

255 Mold-made high-temperature pottery. Tonalá, Jalisco

256 Majolica of Guanajuato

257 *Granada*, vessel of ancient form. Tonalá, Jalisco

258 High-temperature pottery with traditional motifs. Tonalá, Jalisco

259 Majolica (a type of china typical of Majorca). Guanajuato

260 Glazed ceramic plate decorated by a brush. Tzintzuntzán, Michoacán

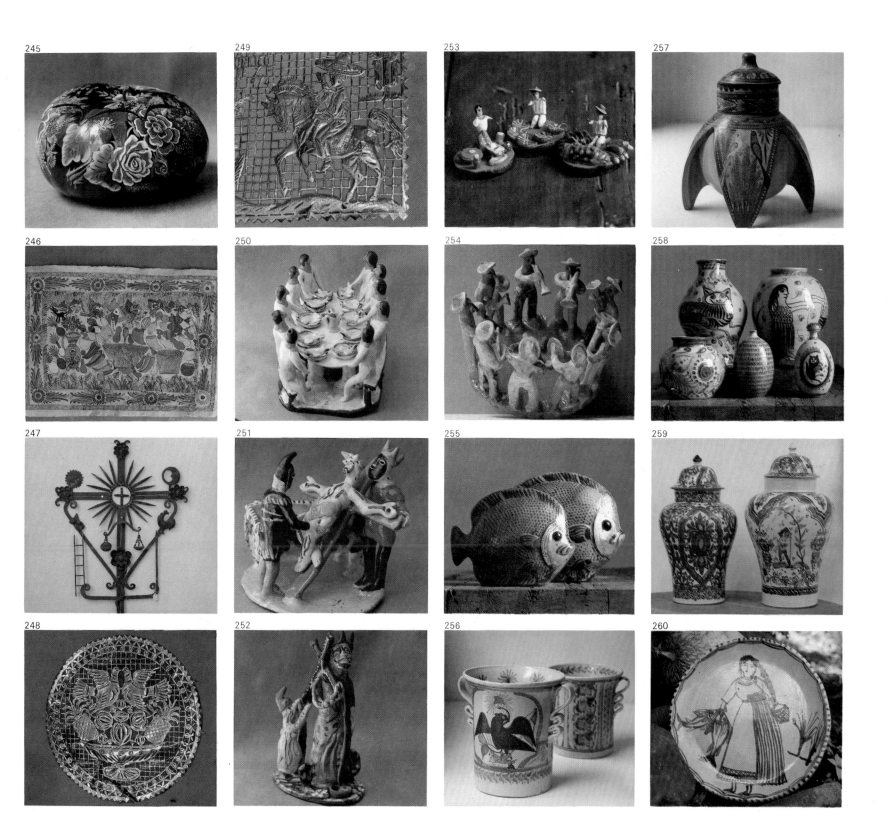

261 Clay figurines made in a mold, painted and fixed with egg yolk. Tlaquepaque, Jalisco

262 Polychrome clay figures. Ocotlán, Oaxaca

263 Painted clay whistle. Salatitán, Jalisco

264 Painted clay whistle. Salatitán, Jalisco

265 Fantastic figure of painted clay. Ocumicho, Michoacán

266 Tower with angel of painted and varnished clay. Santa Cruz de las Huertas, Jalisco

267 Small pavilion of painted and varnished clay. Santa Cruz de las Huertas, Jalisco

268 Polished clay candelabrum. Acatlán, Puebla

269 Openwork pot of polished black clay

270 Pitchers of polished black clay. Cayotepec, Oaxaca

271 Popular toy for All Saints' Day. Santa María Tatecla, Veracruz

272 Censer of spirits made from clay that has been baked once. Ocotlán, Oaxaca

273 *Comales*, plates for cooking tortillas. Santa Cruz Zautla, Puebla

274 Clay toys. Santa María Tatecla, Veracruz

275 Water vessel. Tzintzuntzán, Michoacán

276 Mold-made punch bowl, glazed with *greta*. Patambán, Michoacán

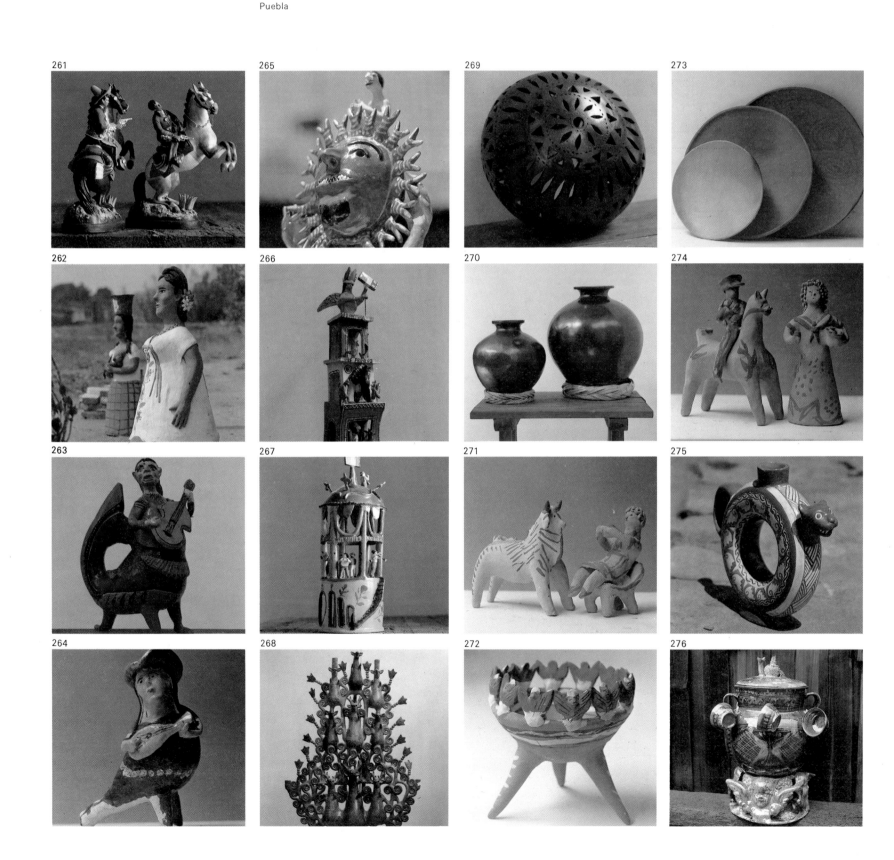

261 262 263 264 265 266 267 268 269 270 271 272 273 274 275 276

277 Clay punch bowl dyed red and polished. Tzintzuntzán, Michoacán

278 Vessels of traditional design decorated with a brush. Tonalá, Jalisco

279 Woman's shirt embroidered by hand and machine. Chachahuantla, Puebla

280 Hand-embroidered huipil. Huauntla de Jiménez, Oaxaca

281 *Quesquemetl* embroidered with traditional motifs. San Pablito, Puebla

282 Detail of a cotton *quesquemetl* embroidered with woolen yarn. Acaxochitlán, Hidalgo

283 Detail of the front of a woman's shirt. San Pablito, Puebla

284 *Quesquemetl* embroidered with woolen yarn. Pautepec, Puebla

285 Embroidery in cross-stitch. Acaxochitlán, Hidalgo

286 Detail of a woman's blouse. Chachahuantla, Puebla

287 Embroidered and hemstitched shirt. San Antonio, Oaxaca

288 Huipil. Usila, Oaxaca

289 Detail of a fringed shawl. Tenancingo

290 Striped warp on a backstrap loom. Pinotepa de Don Luis, Oaxaca

291 Cotton huipil. Copala, Oaxaca

292 Rugs and blankets woven in wool. Teotitlán del Valle, Oaxaca

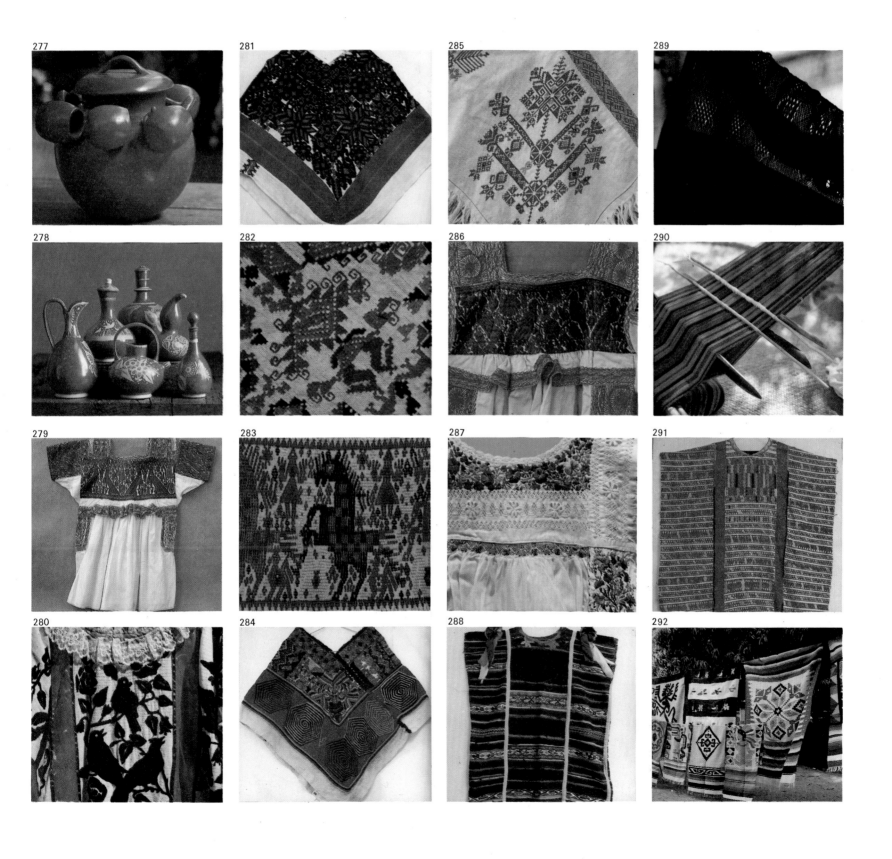

ANTILLES

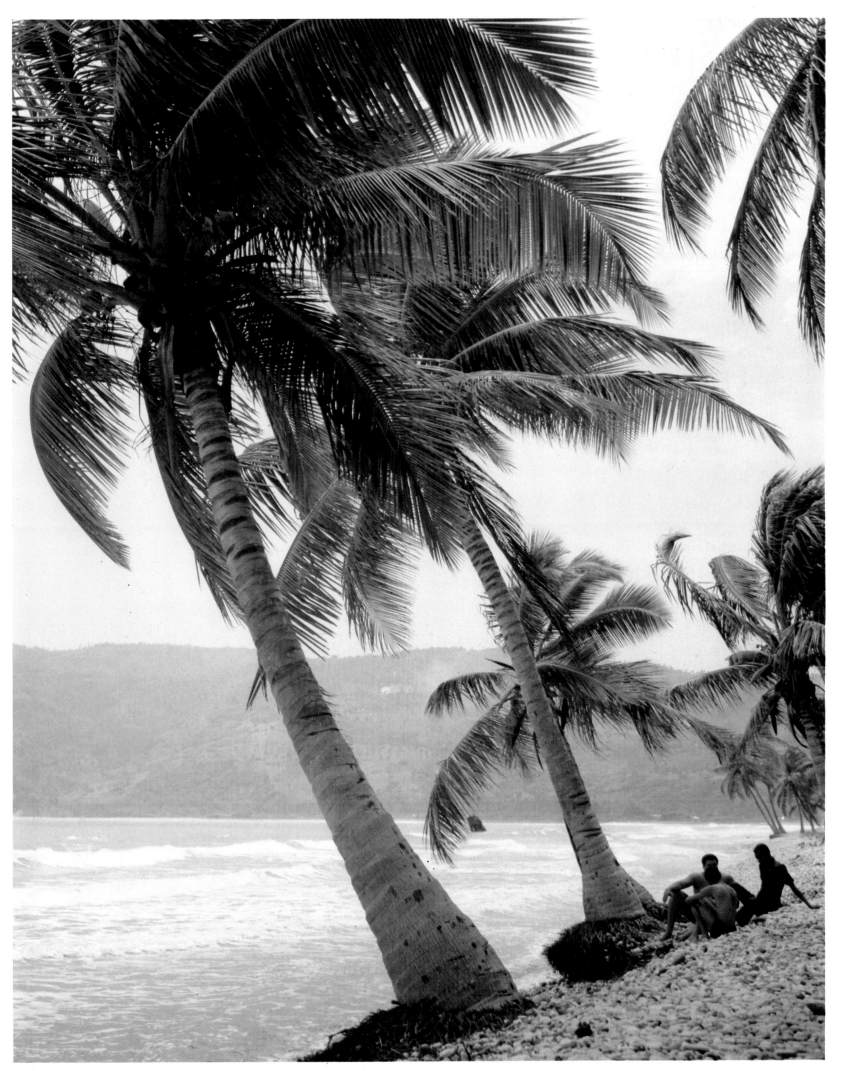

293 Common to all islands of the Antilles is a coastal land-
scape where coconut palms grow to the very edge of the water
and must correct their natural tilt in order to regain verticality.

The Dominican Republic, Haiti, and Puerto Rico are grouped here under the generic label of the Antilles. The selection of these three results from technical rather than preestablished criteria. In these countries are found the handicrafts that best illustrate the panorama of the Antilles in general.

Hispaniola—today known as Haiti and the Dominican Republic—was the first land settled in the New World by the conquistadors. Many aspects of the Spanish Conquest and colonization took their initial form here and were the model for subsequent conquests and explorations. In the name of a king and a religion, the Spaniards fought, to a certain extent, to leave the islands without native inhabitants. Although Columbus had been impressed by the beautiful flora and fauna of Hispaniola and he acknowledged the friendly welcome given by the natives, the Spaniards were not hindered from sacking the gold mines and native property. Contact with viruses against which the natives had no immunity, hunger (this was a society that had not yet discovered the possibility of storing food) as well as the military superiority of the conquistadors decimated the native population. At that time, the Antilles were inhabited by groups linguistically descended from Arawak. One of these subgroups, the Taino, left behind examples of beautiful sculpture in stone and well-made earthenware figures and vessels in both Hispaniola and Puerto Rico (earlier called Borinquen).

Once the conquest of the mainland had begun, the Antilles became valued for their strategic importance. For the Spaniards the islands were outposts that protected the occupation of the mainland, while for the English

294

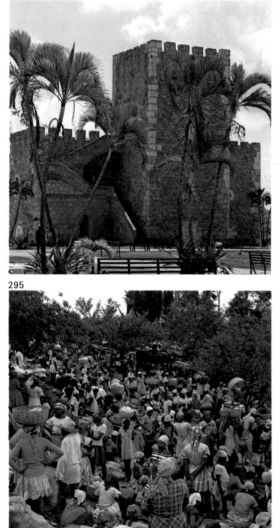

295

296

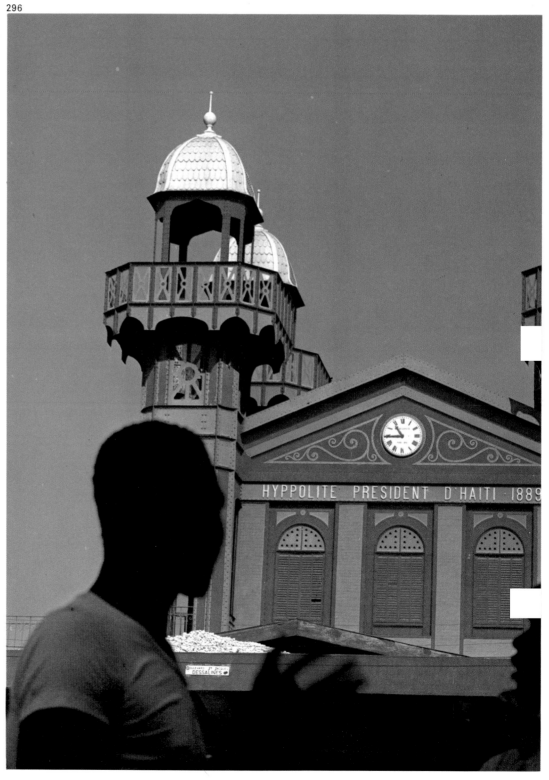

294 Santo Domingo is perhaps the city in the Antilles where the largest number of colonial structures are preserved. Dominican Republic

295 Kenscoff Market, located on the side of a mountain, is a meeting place for all the island's inhabitants. Haiti

296 Auction in Port-au-Prince at the Iron Market with its four painted towers. It is the most crowded spot in the city. Haiti

and French they were a place to take shelter and wait for the expeditions of commercial fleets carrying valuable cargoes to the mother country. With an eye toward colonizing, the Spaniards placed little importance on the islands—so little, in fact, that they recognized a group of buccaneers lodged in the western part of Hispaniola as a French colony. Thanks to the sugar trade, this French slave colony prospered and developed into the embryo— black and French—of what in time came to be the first independent country in Latin America. As a result of the French Revolution, the first black leaders arose. In 1804, after numerous military reversals, these black nationalists and liberationists proclaimed independence for one-third of Hispaniola under the name of Haiti ("mountainous land"). The Haitians later controlled the rest of the island for more than twenty years (1822–1844), but in 1844 the present boundary with the Dominican Republic was established.

In broad outline, the history of Puerto Rico is similar to that of the other islands. The French, English, Germans, and even the Dutch attempted to invade it. Given the island's strategic importance, Spain fortified the capital, San Juan, but the city nevertheless was subjected to various governments. The Spanish prohibition against Puerto Rico's trading with any country but Spain increased smuggling, on the one hand, and contributed, on the other, to a certain agricultural development of the island. In 1898, after invasions, wars, pillaging, and other incidents, Puerto Rico was ceded to the United States by Spain, which signed the Treaty of Paris. Since 1951, Puerto Rico has had its own constitution and is a Free Associated State of the United States.

297

298

299

300

297 Business sign made of cut sheet metal. Jacmel, Haiti

298 Catholic and mythological symbols are often intermixed in the metal figures. Croix de Bouquets, Haiti

299 Detail of two pieces of cut iron sheet metal. Port-au-Prince, Haiti

300 Rear view of a "tap-tap." Although the practice of Voodoo, a religion with African roots, is widespread in Haiti, the themes of popular painting testify to a peculiar interpretation of Catholicism. Port-au-Prince, Haiti

Haiti

Haiti is an exceptionally colorful country, with its peddlers, patterned fabrics, and "tap-taps" (minibuses painted over with religious themes, mostly taken from the Bible). The singular qualities of its people—90 percent of the population is black—add to this impression.

One of the traditional handicrafts of the country is metalwork with strips cut from discarded tin cans. Once the strip is flattened, a design is sketched on it and cut out. Decorative details are added with a hammer and different kinds of awls.

Basketweaving is another widespread craft, and it makes use of a variety of plant fibers, especially the leaves of the coconut palm and the banana tree. There is a certain tendency to weave pieces in modern shapes, but traditional forms are still found at the popular markets and in the inland villages. Almost all the inhabitants of Cazeau, a small village near Port-au-Prince, weave coconut palm leaves into baskets that are sold at roadside.

Haiti is one of the centers of primitive painting. In almost every town—especially in the ones most visited by tourists—there are shops offering vivid paintings by local artists. The major dealers go to considerable lengths to discover new artists and to obtain exclusive rights to their work.

301

302

303

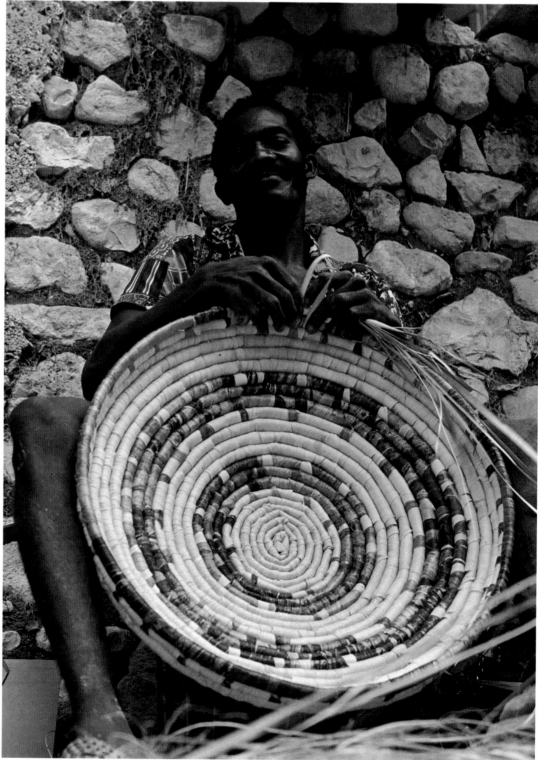

301　Women carry large packages, baskets, or any sort of object on their heads with great ease. Kenscoff, Haiti

302　The basketweavers of Cazeau customarily shape the base of the basket in a radial form to start. Later, they place shoots perpendicular to the base and weave them so as to form the sides. Haiti

303　Making baskets with banana leaves is fast work. Narrow strips of leaves are twisted together with another one forming a kind of rope, which, while it is being shaped, pulls the basket into shape. Port-au-Prince, Haiti

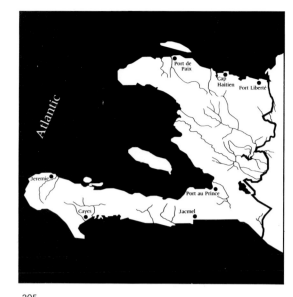

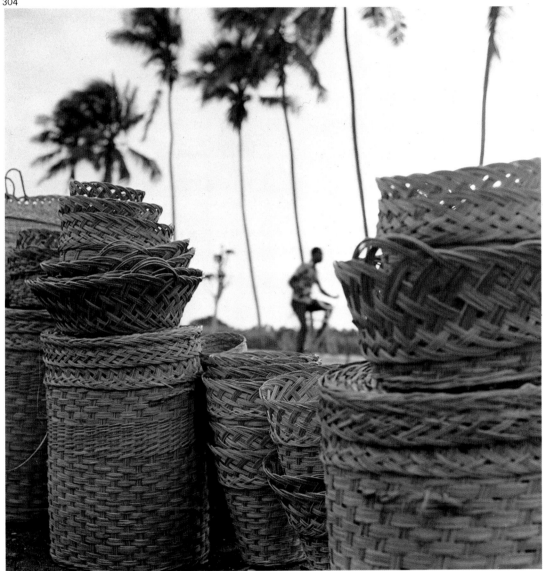

304 Everywhere baskets made from coconut palms can be seen. Cazeau, Haiti

305 Straw mats are also a common product. Port-au-Prince, Haiti

306 Primitive painting, oil on canvas. Jacmel, Haiti

The Dominican Republic

The production of handicrafts here is less varied than in neighboring Haiti. In an attempt to maintain and promote handicraft centers, the Dominican Foundation of Development has created workshops and opened an exhibition center for products from all over the country. At the foundation, leather is one of the most commonly seen materials, being worked into frames for mirrors, briefcases, coasters. The leather is dyed with aniline and the decoration is executed with nickel-plated iron stamps. There is a tradition for leatherwork in the country, but at present the most widely produced articles are those connected with the commercial uses of amber.

307

308

310

309

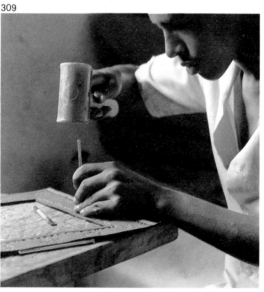

311

307 Stamped leather holster. Santo Domingo, Dominican Republic

308 Mirror frame. Santo Domingo, Dominican Republic

309 Leather stamping with metal tool. Santo Domingo, Dominican Republic

310 Detail of the most common designs for stamping leather. Santo Domingo, Dominican Republic

311 Painted wood carvings are a modern Dominican handicraft. San Cristóbal, Dominican Republic

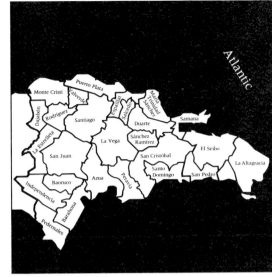

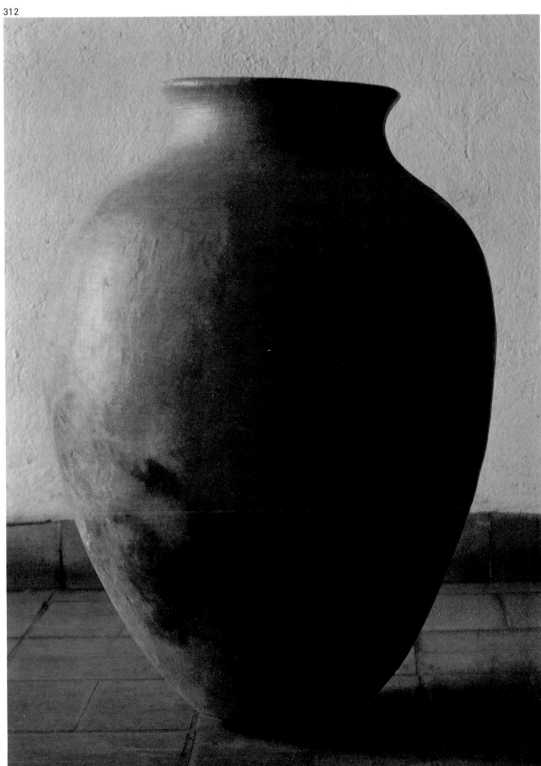

312

313

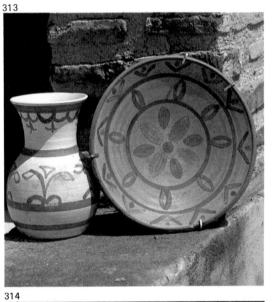

314

312 Striking, large terra-cotta jar, approximately three feet tall. Moca, Dominican Republic

313 Moca is one of the few potters' centers in the Dominican Republic. Its workshops produce practical utensils as well as these more decorative, handpainted ones

314 Although little developed, basketweaving is another handicraft. Here are saddlebags of *guano*, a name used in Latin America to designate any kind of palm leaf. Iguanito, Dominican Republic

Puerto Rico

Handicraft activity is limited in Puerto Rico. Wood is the material used most often. There are a number of people who carve small religious statues on the island, but all these workers are quite old and do not pass on their craft to apprentices. Nevertheless, the people make great use of these statues, or santos. The only wood that is still carved is from the native cedar tree. Other kinds of wood are becoming scarce, and their price makes them unavailable for this purpose. Traditionally, statues were painted in oil but because of their great demand artisans instead coat the images with many layers of varnish.

Perhaps one of the most original handicrafts of Puerto Rico is the fashioning of musical instruments from leather, specifically the *bordonúa*, the *cuatro* (four), and the *tres* (three), of which the first two are still used in all traditional festivals, while it is already difficult to find anyone who manufactures the *tres*.

The *bordonúa* is made from white or red guaraguao wood and, occasionally, from cedar, palm, or oak. Formerly, the instrument had only six strings and was valued by the natives for its deep tone. Larger than the Spanish guitar, the *bordonúa* is believed to be descended from the old type of guitar known as the *vihuela*.

The contemporary *cuatro* has ten strings, grouped in twos; the front and back are flat, like those of the guitar, but on the sides there are several half-filled-in, arc-shaped incisions. The *cuatro* is a popular instrument whose players learn by ear and teach each other the melodies they know. A method of transcription is now being tested that will permit professional instruction on the instrument.

315

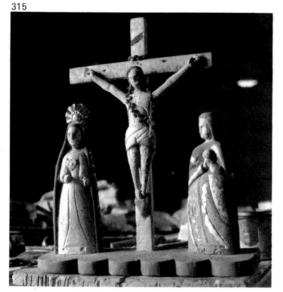

316

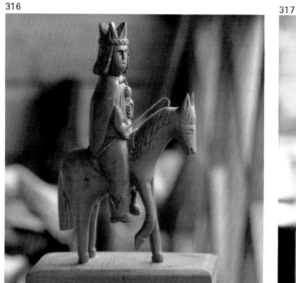

317

318

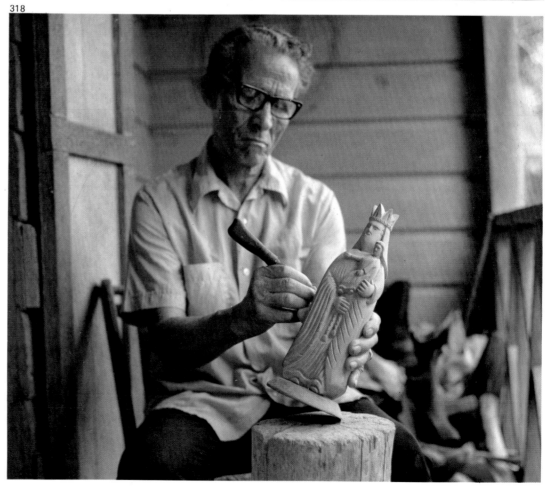

315 *Passion and Death*. Oil on wood. Ciales, Puerto Rico

316 Wise Man on horseback. Artisans always represent the Magi on horseback as a sign of respect. Ciales, Puerto Rico

317 Two figures representing the Virgin of Carmen. Notice the subtle differences between the two, caused, variously, by a knot in the wood or a slip of the gouge. Ciales, Puerto Rico

318 Artisan with his gouge, giving last touches to his wooden Virgin of Carmen. Ciales, Puerto Rico

The *tres* is less well known. Its name apparently derives from the number of strings. Specialists do not believe, however, that any of these stringed instruments antedates the colonial period.

319

320

321

322

319 Old-style *bordonúas*. Utuado, Puerto Rico

320 This artisan makes a fan of templates for all models. Notice the incorporation of unorthodox shapes, such as the fish. Utuado, Puerto Rico

321 Various shapes of instruments can be seen here; mandolins, violins, *bordonúas*, etc. Utuado, Puerto Rico

322 The instrument on the right is the *cuatro*, with incisions on its sides and the cords grouped in twos. Utuado, Puerto Rico

101

GUATEMALA

323 Detail of the embroidery on a huipil, a woman's blouse
that is woven on a backstrap loom

Introduction

All the arts were shown to Hunbatz and Hunchouén, the sons of Hunahpu. They were flute players, singers, blowers of blow guns, painters, sculptors, jewelers, and silversmiths: these were Hunbatz and Hunchouén.

Popul Vah. The sacred book of the Mayas

The important characteristics of the Mayan culture are described in the introduction to the chapter on Mexico. Nevertheless, given that the Maya established themselves in the uplands of Guatemala, whence it seems they expanded to occupy Mexican territory, specifically Yucatán, Honduras, and San Salvador, this is an opportunity for a more in-depth discussion about the life of this group, who for good reasons have been turned into one of the most representative of the continent. In fact, some historians are distinguishing two major groups among the Mayan linguistic family, the first being those who occupied the Yucatán Peninsula and alternated power with the Toltec until the forming of the Mayapán League, and the second being the Quiché, who expanded into part of Guatemala starting from west of Lake Atitlán.

The social organization of the Maya, unlike other great cultures of the Americas such as the Inca and the Aztec, did not depend on a central government; instead they were organized around many large centers of

324

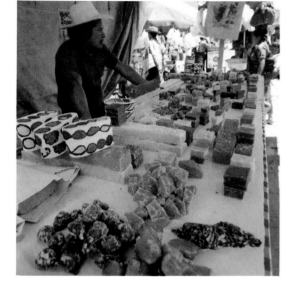

325

324 It is common to find brightly colored candy being sold in the markets. Sololá

325 This woman wears a traditional hat for the pilgrimage to the Sanctuary of Our Lord of Esquipulas. Note the many small objects that adorn the hat. Esquipulas, Chiquimula

civic-religious buildings. The most important people in each center were those of the priesthood, not only for their role as intermediaries with the gods, but also for their knowledge of astronomy and agriculture. Thus the different Mayan laws could be interpreted only by the ruling class. Nevertheless, a certain equality existed internally; the land was cultivated cooperatively, and after the part to be handed over to the state as tribute had been separated out, the harvest was divided in proportion to the number of members in each family. The flourishing agriculture, the base of the Mayan economy, gave impetus to the culture and helped its expansion; the Maya were continuously clearing new land for cultivation, which was only productive for two years. The conversion of jungle to fields for cultivation disrupted the equilibrium of the land and impoverished it so that it had to be left uncultivated for three years.

Another important feature of the Mayan culture was architecture; the cities were constructed around a temple whose central point was usually a pyramid; temples were rectangular, with one main facade and various doors that were reached by large flights of steps. The houses of the lowly were clay huts with a roof, covered with palm leaves, of two slopes; the wealthy families or nobles lived in stone buildings. In the mountainous regions the Maya built walled cities. Although the government of each city was independent, a network of roads was built to keep them in contact and facilitate the exchange of products.

The deciphering of the Mayan calendar has contributed important new information. The Mayan calendar,

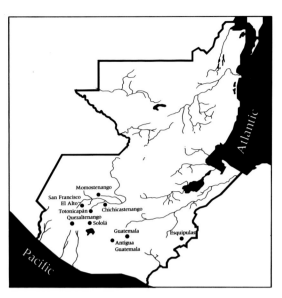

326

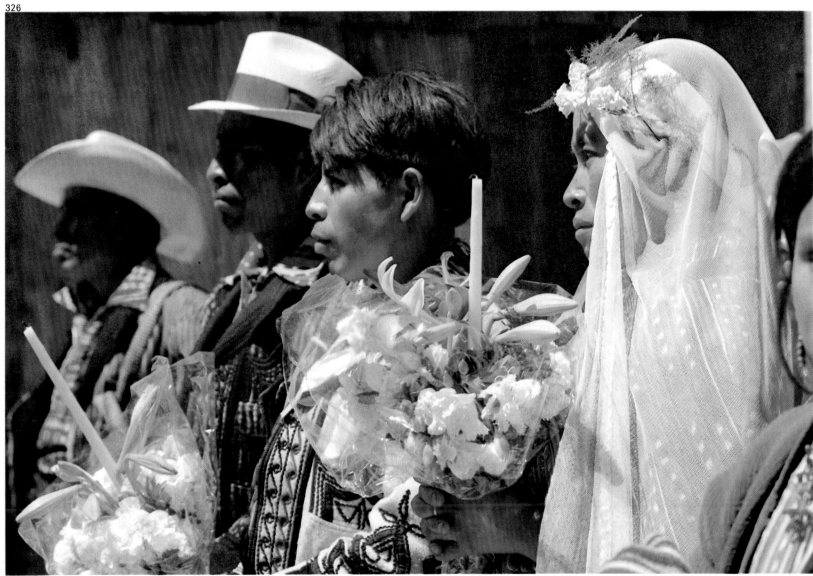

326 Weddings are turned into communal occasions; in the village square, next to the market, bride and groom await the start of the ceremony. Both man and woman are attired in their best clothes and carry identical bunches of flowers. Sololá

or *Haab*, which proves their extensive knowledge of astronomy, was divided into 18 months of 20 days each, and 5 further days were considered *nayeb*, or unlucky. *Tun*, the year, was therefore 365 days, 20 years (that is to say, 7,300 days) made up a *katun*, a period commemorated by the erection of stone stelae. Each 50-year cycle was considered an era and the start of each one was celebrated with great festivities.

Another example of the cultural level achieved by the Maya is the use of zero in their numerical system. Because of their constant use of numbers and the fact that the Maya dated all the pieces they made and the monuments they built, it has been possible to establish a chronology of the most important events relating to this culture. Finally, it must be pointed out that the Maya occupy an outstanding position in the cultivation of the arts—architecture, painting, lapidary, pottery, woodcarving, and weaving.

One of the principal orographic characteristics of Guatemala is the volcano-covered surface, although nowadays only three are still active. The Pacific coast is bordered by a strip of lowland no more than 30 miles (50 km) wide; from this strip the land rises rapidly and steeply, reaching an altitude of 8,000 to 9,000 feet (2,500 to 3,000 m). In the southern part of this mountain formation, at an altitude of some 1,300 feet (400 m), the three active volcanoes are found: Pacaya, Fuego, and Santa María-Santiaguito. The more or less continuous eruptions of these three keep the southern highlands covered with a layer of lava and ash.

The Guatemalan extension of the Andes has three mountainous spurs that form small, fertile valleys at

327

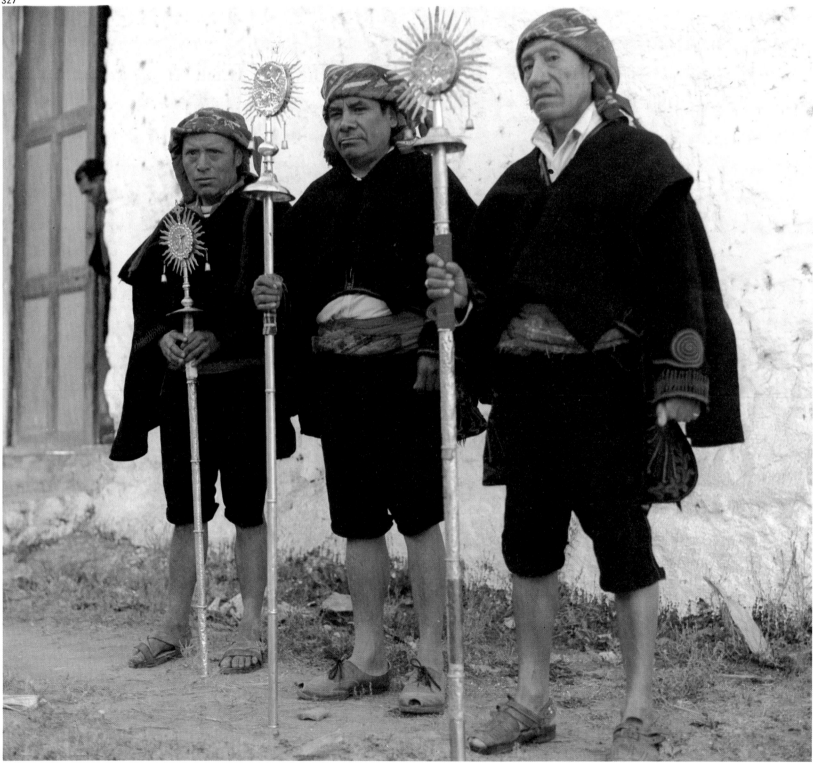

altitudes from 4,900 to 7,800 feet (1,500 to 2,400 m). The majority of the population lives in this volcanic region and the capital of the country is located there. To the west of the volcanic region is a narrow, exitless valley, encircled by volcanoes, where Lake Atitlán is found. The highlands descend gently to the coast, and in this area coffee is grown in valleys.

In spite of the harshness of the climate in some areas, the devastation of the forests in others, and the heavy rain, Guatemala is essentially an agricultural country. For several years it has been trying to make fertile the regions of the chaparral, which is covered with shrubs and spiny trees, through the use of artificial irrigation.

Guatemala, with its 42,000 square miles (109,000 sq. km) and 6,620,000 inhabitants, is a densely populated country in relation to its neighbors in Central America. Its population is more than 50 percent Amerindian, a fact that influences the popular arts of the country. The Indian population is less affected by outside influences and has a great interest in persisting as much in their traditions as with the crafts that are derived from them.

328

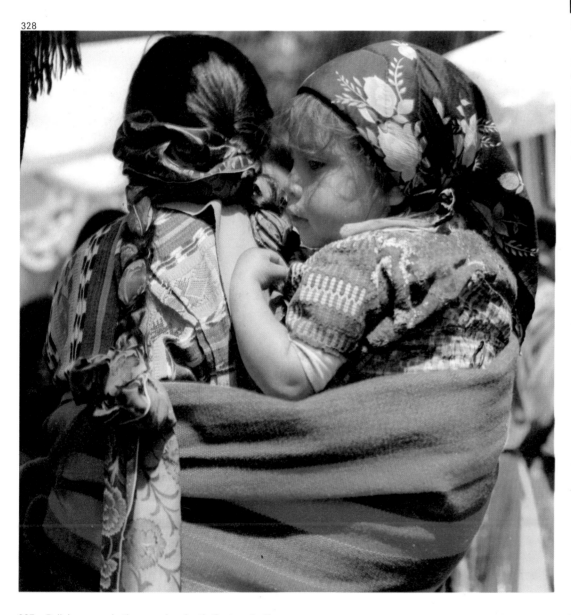

329

327 Religious organizations are abundant in Guatemala. The brotherhood of the organization, or *aupatanes,* are dressed in their costumes and carry staffs of identification. Chichicastenango, Quiché

328 Little girls, from when they are small, wear the same type of costume as their mothers; the women braid their hair with a long silk handkerchief that is not only a decoration, but also imparts information, according to the color, about their social position. San Francisco El Alto, Totonicapán

329 Leatherwork is also found in Guatemala; made in this material are stirrups with embossed decoration. Sololá

Pottery

Guatemalan pottery comes from two forceful and contrasting sources: traditions of the indigenous pre-Columbian people and European influence, the latter brought with the Spanish at the beginning of the sixteenth century. Evidence of the former has been handed down through generations of the indigenous peoples, and it still survives with slight variations, depending on techniques and characteristics of the Amerindians. Examples of such autochthonous features are the making of freehand pottery, since the potter's wheel was unknown to them; firing in one bake in the open air, flush with the floor and at much lower temperatures; the use of a special finish based on polish and engobe or clay slip.

The European tradition of pottery relies on a different technology, involving the use of a mechanical wheel or a potter's wheel; baking in a kiln; glazing or waterproofing with a process based on lead, antimony, or tin; and baking or firing a second time. Another significant difference between the two traditions concerns the gender of the person who makes the pottery. In the pre-Columbian tradition the potters are almost exclusively women; in the Spanish tradition they are predominantly men.

Important centers for traditional Indian pottery are found scattered across the country. Among those considered outstanding for their production, proven skill, and the variety of their artistic creations are the craft communities of Santa Cruz Chinautla and San Raimundo, both in the department of Guatemala, which are known for flat dishes used for cooking tortillas, called comales; San Luis Jilotepeque in Jalapa, Santa Apolonia in Chimaltenango, Santa María Ixhuatán in Santa Rosa, a village which was Indian in origin but is now composed of ladinos (people of mixed blood who speak Spanish, follow Spanish customs, and wear European clothes) and mestizos; and Rabinal in Baja Verapaz. The centers of Santa Cruz Chinautla, in the central region, and San Luis Jilotepeque, in the eastern region, are both Pokomán in origin; Santa Apolonia, in the central highlands, is a Cakchiquel town.

The articles produced in these three centers show obvious similarities, but there are also notable differences. The color of the clay used in Chinautla is reddish or white, while in San Luis Jilotepeque it is a coffee-gray color. The initial procedures also differ in the way the base of the piece is prepared, since in Chinautla and San Luis the bottom of a broken or upturned piece of earthenware is used, while in Santa Apolonia the base is made of a thick circle of clay. The ways the walls are made also differ. In Chinautla they are raised by modeling; in San Luis the clay of the base is stretched upward, and in Santa Apolonia thick rolls of clay are added, which are later thinned out.

In Chinautla the piece is polished with green stone shaped like an ax or chisel, sometimes of pre-Columbian origin; in San Luis the piece is polished with the seed of a tree known as the "eye of the deer," and in Santa Apolonia a piece of brass or leather is used. In Chinautla and San Luis, the craftswoman rotates the piece skillfully by hand, while in Santa Apolonia she molds the object while moving around it.

The final finish of the pieces is also different: in San Luis a bright red color is applied to the object after it is dry; in Chinautla a rosy white color is used; in Santa Apolonia, orange. These three pottery centers differ also in the number of handles or holders that are added to the pieces. In Santa Apolonia and Santa Cruz Chinautla an object is given three handles while in San Luis Jilotepeque it has two.

330
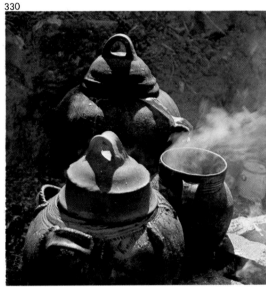

331
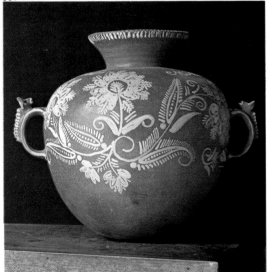

332
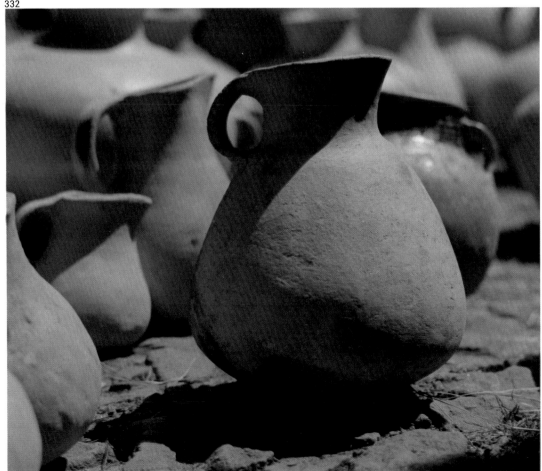

330 In the markets beautiful examples of this popular art are found; these pots, blackened by use, have high-standing tops. Totonicapán

331 Polished earthenware jar, painted with phytomorphic designs. Chinautla, Guatemala

332 Baked clay vessels for everyday use; the forms are simple and the finish fairly coarse. San Francisco El Alto, Totonicapán

Other pottery centers of no less importance are San Antonio las Trojes near San Juan Santepéquez, Rincón in Jutiapa, Casilla in Santa Rosa, San Pedro Jocopilas, and other villages in Quiché where *pichachas*, or colanders, are made. In addition, there are centers located in various small villages in the mountains surrounding San Pedro Carchá and San Juan Chamelco in Alta Verapaz, in some villages and hamlets of Huehuetenango and San Marcos, in Barreal and Maraxco in Chiquimula, in San Luis in Petén, and several other places. Another truly exceptional example of this craft, with great meaning and folkloric character, is the colored pottery of the Indians of Rabinal in Baja Verapaz. In some towns of Guatemala the painted pieces are decorated with geometric patterns and phytomorphic, zoomorphic, or human figures, even though the former decoration is by itself almost sufficient complement to the pieces. The Holy Child, images of Saint Joseph and the Virgin Mary, the ox and the ass, the Magi, and cherubim and angels are also made.

The pottery-making tradition that was imported by the Spanish introduced new techniques and a different process of manufacture. It should be noted that despite the length of time that has elapsed since the first contact between the indigenous people and the Spanish, the two currents still survive and interweave on a daily basis, resulting in cultural interchanges in the methods of manufacture.

It must be remembered that several Indian populations use European craft methods, particularly those related to the use of a lead-based varnish to produce glazed earthenware. Apart from this, the hybridization re-

333

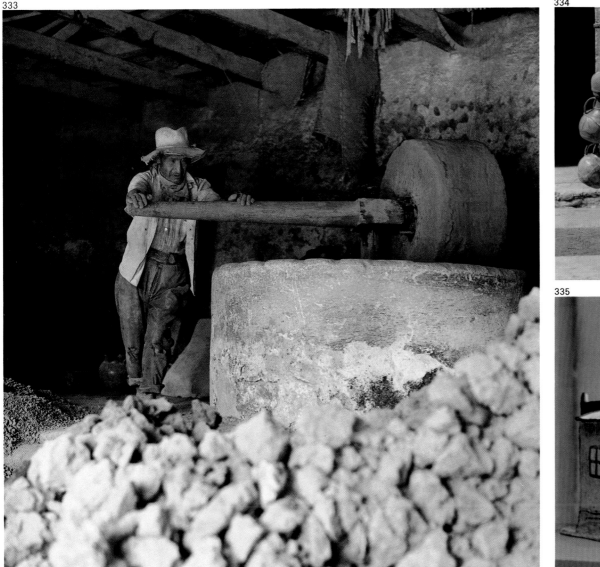

334

335

333 Mill for grinding clay in the pottery center of Montiel. Antigua Guatemala, Sacatepéquez

334 *Cacaste* or pack frame for the transport of the earthenware of Totonicapán. Chichicastenango, Quiché

335 Baked and painted clay church. Rabinal, Baja Verapaz

109

sulting from exchanges of styles from both traditions must be mentioned. Traditional Indian potters have adopted the *porrón* (a water jar, often with two handles) and other obviously Hispanic forms; the Hispanic tradition also accepts styles that are clearly indigenous in origin.

Pottery of Hispanic origin is produced primarily in the city of Antigua Guatemala: majolica (pottery typical of Majorca) and the antique glazed earthenware produced here have made it one of the most important centers of production in Hispano-America. It has been thought of as such since the early sixteenth century, reaching its peak in the seventeenth and eighteenth centuries.

The glazed earthenware that is famous throughout the country is produced and distributed in the suburbs and surrounding districts of the twin towns of San Cristóbal Totonicapán and San Miguel Totonicapán. The green and dark brown glazed whistles made in the shapes of fish and birds originate here, as do the the knick-knacks that fill the markets and fairs, and the celebrations of the Feast of Corpus Christi throughout Guatemala. In this area dwell highly skilled flower painters who specialize in decoration using an appliqué technique called *pastillaje*. Their most frequently used decorative motif is the pine cone, but a flower with varied petals appears predominantly on the many shapes of candlesticks, including those in the shape of a small horse. Other pieces made here are jugs, mugs, teapots, cups, censers, tureens, pots and pans, and a variety of bowls, including sugar bowls, all of which are frequently green or dark brown; when lighter, softer colors are used, the pieces are

336

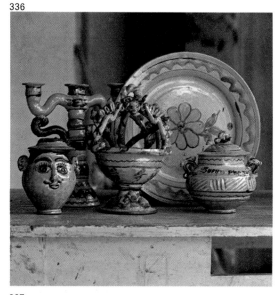

337

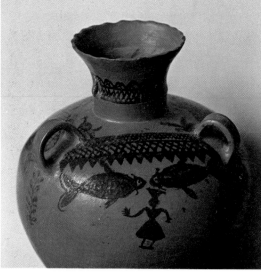

338

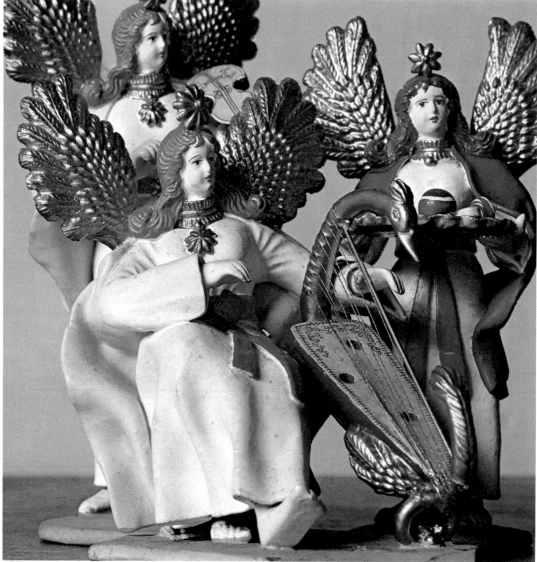

336 Glazed pottery from the pottery center of Montiel. Antigua Guatemala, Sacatepéquez

337 Polished and painted clay jar. San Luis Jilotepeque, Jalapa

338 Painted pottery angels with musical instruments. Antigua Guatemala, Sacatepéquez

decorated with phytomorphic designs. The highly distinctive method of decoration called *chorreado* (dripping and spattering) can also be seen on these pieces.

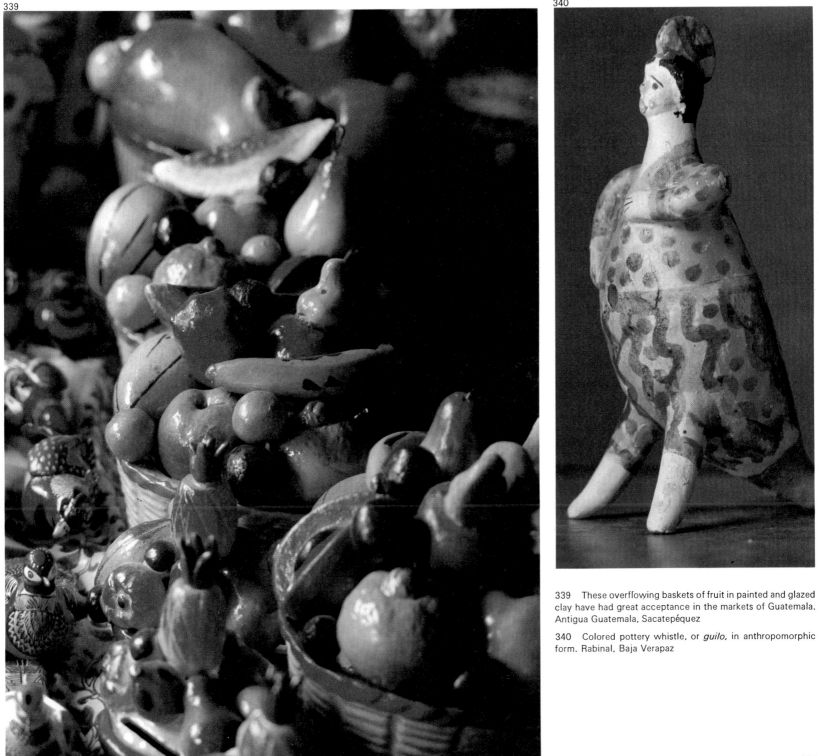

339 These overflowing baskets of fruit in painted and glazed clay have had great acceptance in the markets of Guatemala. Antigua Guatemala, Sacatepéquez

340 Colored pottery whistle, or *guilo,* in anthropomorphic form. Rabinal, Baja Verapaz

Masks

In nearly all ages and cultures, masks have been designed to fulfill a supernatural function, be it ritual, religious, or magical. In ceremonies, initiation rites, or the curing of the sick the function is magical; in the hunt it is mimetic; for the sacrifice, mourning at funerals, or the burial of the dead it is ritual. It is important to understand that in some Guatemalan towns the sacred ceremony of keeping vigil over the masks and costumes before a dance begins is still practiced. There is no doubt that the most ancient cultures of Guatemala used them, with all their symbolism, to encompass these functions.

Masks can be classified in ways other than by their uses and functions. For example, they can be categorized by the materials used in their construction, such as skins or skeletons of animals, horse's mane, or wood, the most common material. Various types of wood are used: simple tree bark; fine woods such as cedar and mahogany; softer, paler, and lighter woods such as pine or fir; and the magic wood of the coral tree, or *txite*.

Another classification of the masks can be made in regard to their shapes, further grouping them by the persons they represent, be they anthropomorphic or zoomorphic. Among the human and humanized forms there are conquistadors, Indians, old people, women, Malinche (the Indian woman who became Cortes' interpreter and mistress), devils, skulls, or corpses. The zoomorphic masks, which are used for animal dances, represent deer, monkeys, tigers, tapirs, dogs, etc.

The procedure used to make masks is very similar to that used in making images of saints and religious

341

342

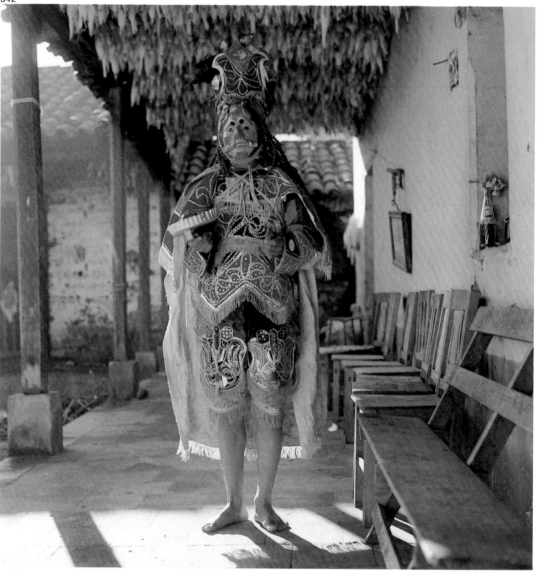

341 Mask made of wood and plaster

342 Costume of the Quiché king, dance of the conquest. Chichicastenango, Quiché

343 Group of masks showing the imagination of the artists in the representation of the different faces. Antigua Guatemala, Sacatepéquez

figures in polychrome wood, a craft that earned Guatemala one of the highest places of honor during the centuries of Spanish rule. The similarity is due mostly to the finish, which uses the technique of creating a flesh color following the methods of the Hispanic and Guatemalan image makers; despite the care given to the refinement of the carving in the delicate facial features of the figure, every year they are retouched for the next celebration so that they become covered with thick layers of paint. These religious images are destined for worship or for procession inside the church and for domestic use in altars at home; however, the masks are nearly always used for worship outdoors at the great communal festivals.

The masks that personify grotesque figures seem to have a different origin. The dramatic and fearsome devils of Alta Verapaz may be derived from Spanish Corpus Christi, or from the Indian underworld called Xibalbá, or they may represent guardian gods of the Kekchi or the old devil gods called Tzultacae. These masks usually have two or three horns and are adorned with ornaments depicting snakes and toads, the animal supplicants for rain (for sowing and harvesting), unpleasant reminders of the ancient worship and agrarian rites. Craft establishments still exist where masks that duplicate those from ancient times are made. Here masks are also loaned out for the principal festivals dedicated to patron saints.

Among the most interesting masks of Guatemala are those that personify the devils Tzultacae with long horns, and those of macaws or turkeys and chuntos from Alta and Baja Verapaz; those for the dance of the deer,

343

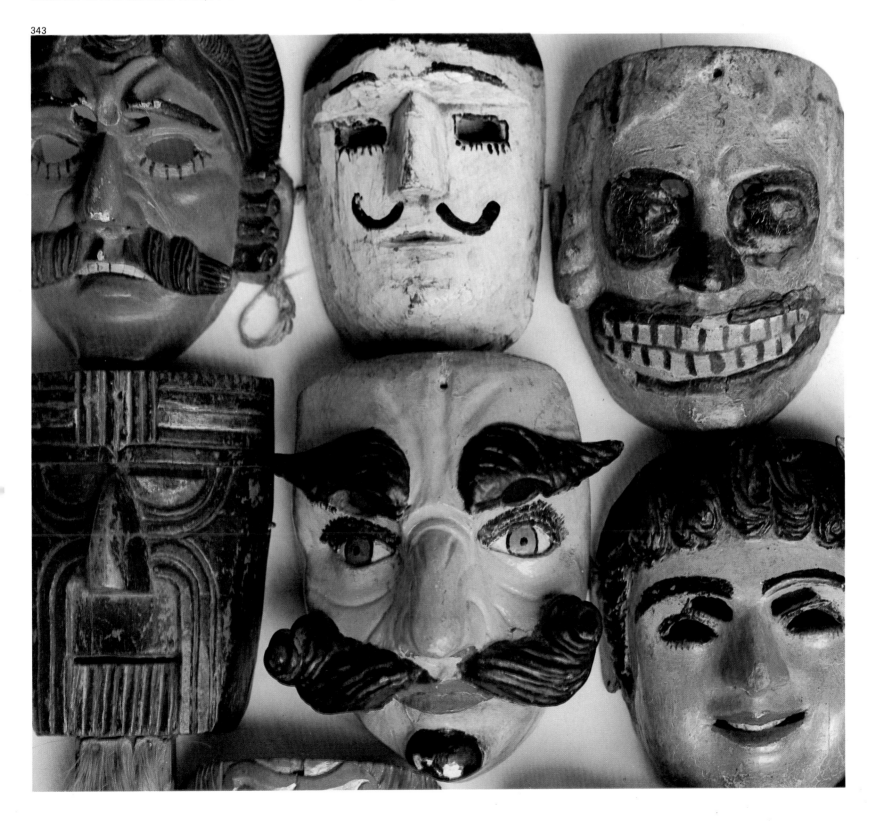

adorned with animal horns and mirrors, from San Juan Comalapa and San Pedro Laguna; those of Nahualá, which were formerly magnificently decorated with bushy mustaches and thick eyebrows and kept in public and private collections, but which today are carved and blackened by another very different technique; those of the giants of Jocotenango and other towns in the department of Sacatepéquez; those of the micos, or long-tailed monkeys, made of myrobalan wood in San Tomás Chichicastenango, Cubulco, and Joyabaj. Some masks have very different ethnic origins, such as those representing the conquistadors with their white or rosy skin, gilded corkscrew beards, and blond curls, like the mask of Tonatiuh, the god of the sun. (The figure on which the conquistador mask is based is Alvarado, conqueror of Guatemala in 1524. The implication is that he is the son of the sun.) This type of mask contrasts strongly with those representing the indigenous population, with brown skin, hooked nose, and straight black hair surmounted by quetzals. A good example of this type is the mask representing Tecun Uman, the Quiché king and national hero at the time of the conquest; it is used in the dances of the conquest in Quiché, Totonicapán, and San Juan Comalapa. It should be noted that when Tecun Uman dies in the drama, the mask is changed to a death mask.

Also worthy of mention are the masks of the dance drama, *Rabinal Achi*, those of the decorated sticks of the dance of Patzca, also those masks of the dance of St. George and the Dragon, the dances of the Negroes and the mute child, all of Rabinal; also those of the little bulls of Todos los Santos Cuchumatán.

344

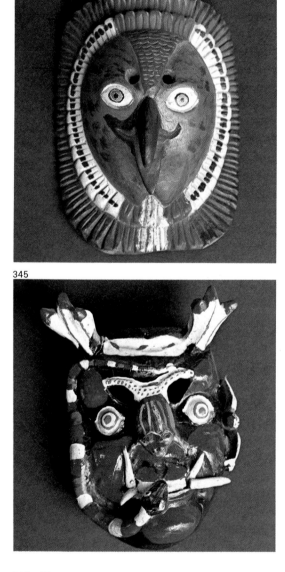

345

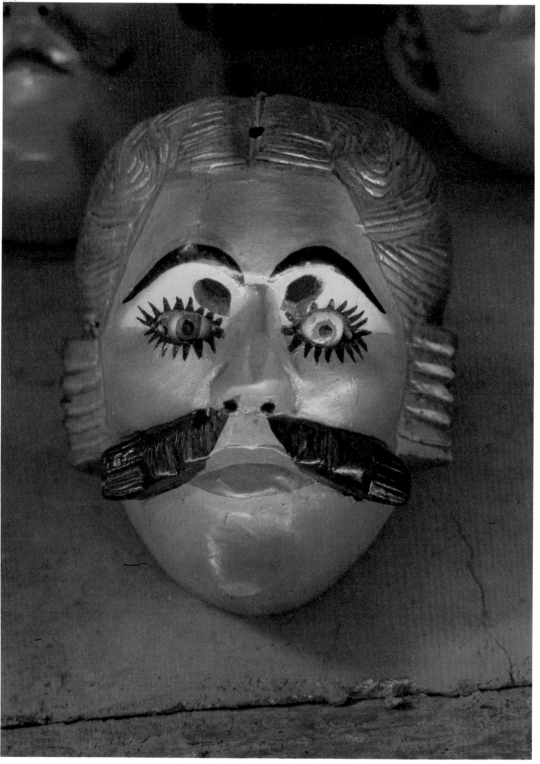

346

344 Bird mask

345 Mask of a devil; carved and painted wood. Antigua Guatemala, Sacatepéquez

346 Mask of a conquistador. Chichicastenango, Quiché

Basketry

Reeds, new growth of trees, vegetable fibers and roots, rushes, grasses, and various palms are essential materials in Guatemalan crafts. But it can take a technical specialist to tell the differences among the many materials used in these crafts. For instance, in basketmaking the stems of semirigid grasses are the principal materials employed, with bamboo and several varieties of ditch reed being used as much as palm and wicker; in the production of both sleeping mats and ordinary mats, two types of rushes, *sibaque* and tule, are preferred; wicker, palm, coarse straw, and yet another type of rush, junco, are all used for making hats.

Canastos (flat baskets without handles) are used for carrying produce to the market on one's head; these products may be tortillas, fruit, green vegetables, corn or bean seeds, atole (a drink made from cornmeal), or other drinks; when the merchandise is transported by vehicle, it is protected by net bags made of agave fiber. The *canastos* serve to hold, store, and exhibit the produce in the market. There are distinct types: in Amatitlán, for example, they are almost flat in order to hold sweets, in the style of reed trays, and have a cover; some serve as measures; others are more like balance pans for weighing, etc.

In the most important basketry centers in the central region, San Juan Comalapa and San José Poaquil in the department of Chimaltenango, they make *canastos*, *canastas* (baskets with handles), *petacas* (rectangular baskets with covers), *petaquillas* made of uvo grass (*petaquillas* are baskets with square base that have circular openings), and miniature baskets of all types.

347

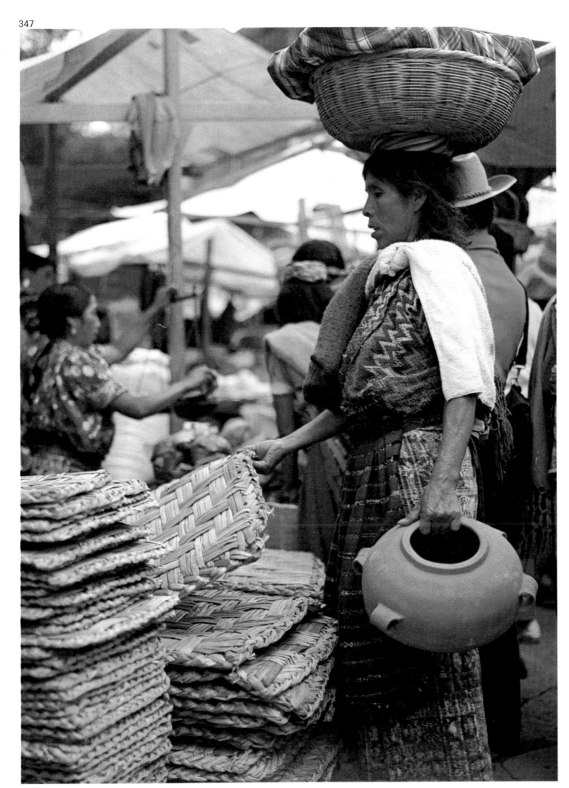

348

347 A woman is inspecting petates or *esteras,* which are woven in various sizes according to their use (as carpets, shields against the wind, etc.). Totonicapán

348 *Canastos* of vegetable material; they are very widely used and woven in several departments. San Francisco El Alto, Totonicapán

115

In several villages in Alta and Baja Verapaz different types of *canastos* are made to be sold mainly in the markets of Cobán and San Pedro Carchá, and also in Salamá, Cubulco, and Rabinal. The *canastos* made from small reeds in the Ixil towns of Chajul, Cotzal, and Nebaj in Quiché deserve special mention for the material used in their construction.

Sometimes a wooden foundation is used for articles made from wicker, whereas the use of rushes or other semirigid materials allows the warp and the weft to be of the same material. When palm is used to make such items as wastepaper baskets, the warp requires a more rigid framework. This is true of bread baskets that are woven on a weft made up of bunches of palm, using a spiral technique.

The differences in size, finish, and style of the *canastos* are also surprising, from the large ones used for carrying and exhibiting bread at the fairs to the tiny children's toys that can be seen in the busy markets of Esquipulas. The multicolor, dyed baskets made by the Chorti Indians in Olopa, Camotán, and Jocotán are also seen here. At the Feast of Corpus Christi one can buy *canastillas* (small *canastas*) in the markets of Guatemala City, as well as *petaquillas* and *canastillas* made from ditch reed in San José Poaquil.

Another specialty is the making of petates—sleeping mats from interwoven vegetable fibers. The petates (named after the rush from which they are made), or *esteras* as they are also called, are pieces of rush matting that, since they were first produced, have been the Guatemalan Indian's lifelong companion, even serving

349

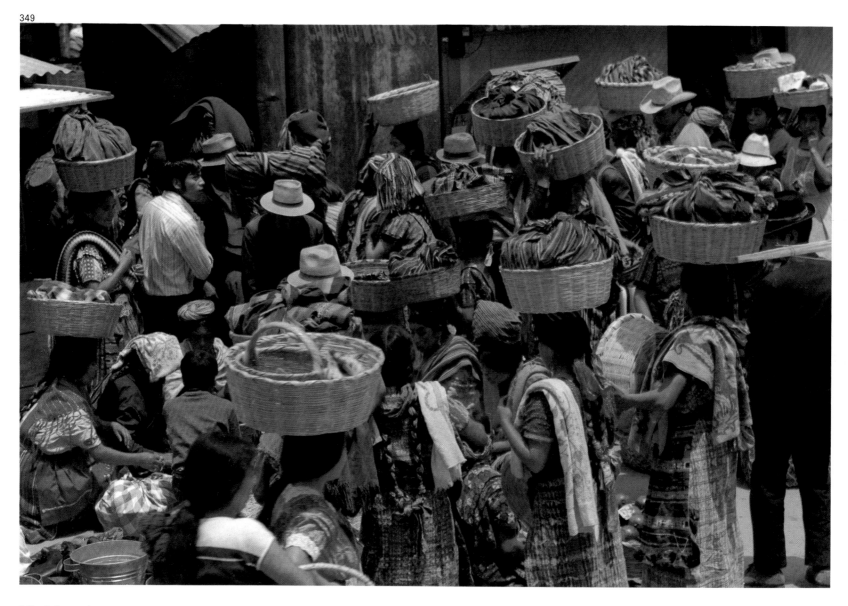

349 It is mostly women who attend the markets, as both sellers and buyers. Purchases are beginning to fill the baskets, which are carried on the head with admirable balance

as his cradle as well as his shroud. The neighboring villages of San Antonio Aguas Calientes and Santiago Zamora, near the outskirts of Antigua Guatemala, are the Cakchiquel centers of this traditional craft in the department of Sacatepéquez.

The most commonly used raw materials are tule and petate (another species of water rush), which the people of the two villages mentioned above gather from a nearby lake. The techniques of making sleeping mats from these materials have remained almost unchanged over the centuries and are very similar to each other. Virtually the only differences are that mats made of tule are plumper and woven with fibers bunched in fours, while those made with petate are woven with fibers bunched in twos.

Mention must also be made of the soplades, or fire fans, made from sibaque, as well as the raincoat-umbrella made of palm leaves sewn together called a suyate or suyacal (from the Nahuatl words soyatl—a palm, and calli—a house). They were traditionally used during the rainy seasons, but they are gradually being replaced by gaudily colored modern plastics.

350

351

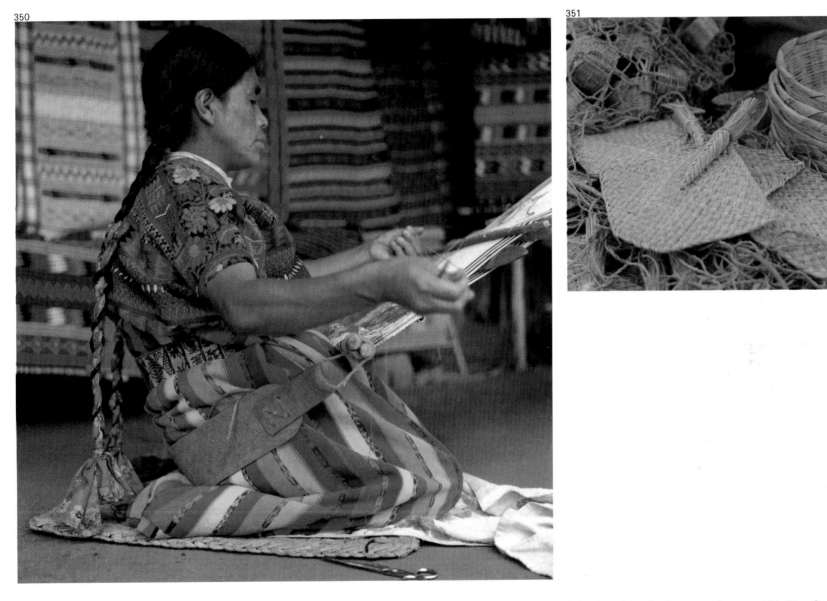

350 Note the mat on which the woman is sitting. One of the traditional elements of the daily life of the Guatemalans is the use of the petate or estera. San Antonio Aguas Calientes, Sacatepéquez

351 Soplade, or fire fan, woven from vegetable fiber. San Francisco El Alto, Totonicapán

117

Carving

Guatemala is a country rich in forests of fine and common woods. Mahogany, cedar, whitewood, conacaste, Samoan rain tree, jaracanda, lignum vitae, guachiplin, chichipate, the ant tree, oak, cypress, coral tree, fir, white pine, yellow or common pine, as well as other species of trees, are all found here in abundance. Among other Guatemalan wooden arts and crafts, those which deserve special mention include the making of furniture, saints' images, musical instruments, small boxes, toys, and kitchen utensils.

Antigua Guatemala, a city of crafts par excellence, makes furniture in fine woods such as mahogany, cedar, conacaste, and whitewood. The design is principally colonial, following models and patterns from the Hispanic period and keeping some of the traditional techniques, such as turning, and in particular carving, with wood being used in relief and for other decoration. Frequently seen are small chairs with woven-rush seats, lyre-shaped decorations or other motifs, and turned or carved legs. These chairs are called *petatillos* because their seats resemble the rush sleeping mats called petates.

Several other items are made with techniques based on turning (forming by using a lathe), among them candlesticks, corkscrew-shaped columns for Solomonic lamps, cups, trays, plates, and wide bowls. Some toys are made in this way, such as spinning tops made of pine, chichipate, and guachiplin. Also made are kitchen utensils such as chocolate whisks, wooden spoons, pounders, rolling pins, spoons, ladles, knives, etc.

In Totonicapán small guitars are made from whitewood and *cajeta* wood. They are then brightly co-

352

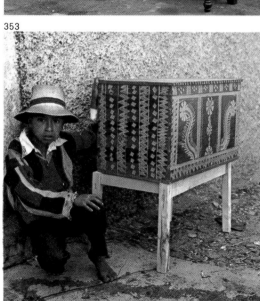

354

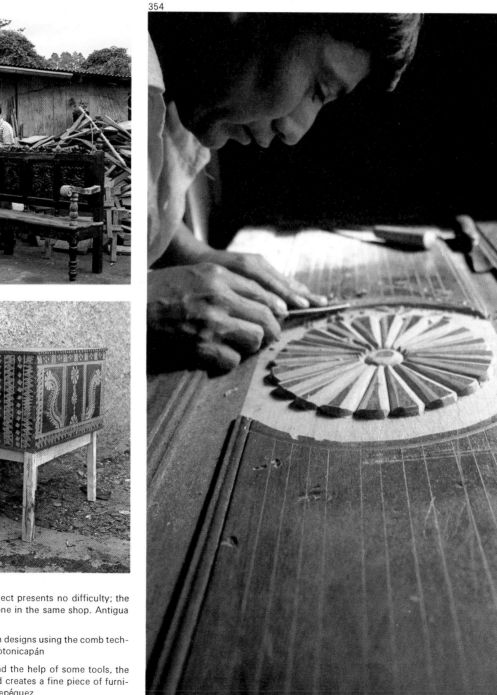

353

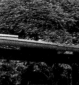

352 The size of a carved object presents no difficulty; the work, from start to finish, is done in the same shop. Antigua Guatemala, Sacatepéquez

353 Painted wood chest, with designs using the comb technique. San Francisco El Alto, Totonicapán

354 With infinite patience and the help of some tools, the craftsman carves the wood and creates a fine piece of furniture. Antigua Guatemala, Sacatepéquez

lored with dyes, varnished, and strung with wire. They tend to be sold as toys at nearly all the fairs of the country. The name *cajeta* wood comes from its use in making oval polychrome boxes (a *cajeta* is a small box) in which sweets are kept, particularly those made in Amatitlán.

The principal center for wooden arts and crafts is in the department of Totonicapán, particularly among the Indian population of Chimente, who specialize in making furniture of white pine or fir. The toymakers of Chimente have an extensive and varied repertoire, but especially interesting are their small wooden horses, carts and trucks, clowns in a ring, acrobats on a spring, jointed fish, and carved and decorated dolls, all vividly painted with aniline dyes.

Even more famous are their distinctive trunks or chests, many painted by using an unusual and ingenious technique: a comb with widely spaced teeth is drawn over the paint while it is still wet, leaving circular, undulating, or straight patterns, depending on the way the comb is moved. Whether the chests are carved, painted, or both, the designs on them incorporate geometric motifs, which are usually diamond shaped. Some of these trunks are painted with floral decorations, with birds and quetzals, or with village landscapes and folk scenes, distinguished by the same traditional designs.

355

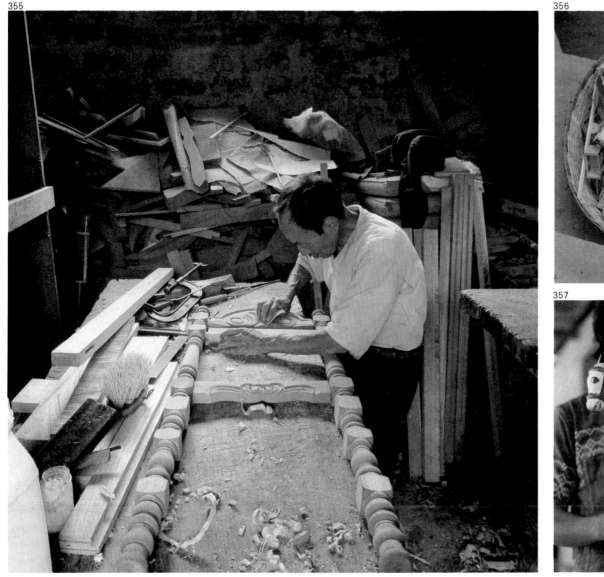

356

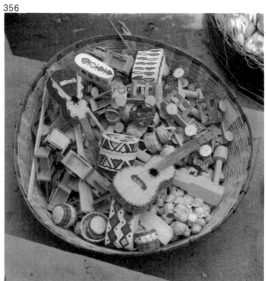

357

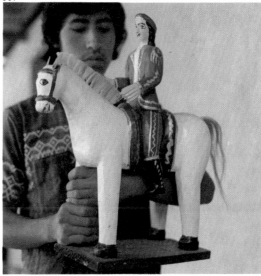

355 Once the carving of the piece is finished, the roughness is smoothed with sandpaper. Antigua Guatemala, Sacatepéquez

356 In all the markets small toys made of whitewood are sold. Totonicapán

357 Horse of carved and painted wood. Chichicastenango, Quiché

Costumes and Weaving

The rich variety of Guatemalan weaving can be seen in the finish and texture of the clothing that is made and worn by the inhabitants throughout the country. The technique is complex and expert; the forms, varied. The decorative motifs are unique and of a high quality of design, combining realistic emblems that may be phytomorphic, zoomorphic, anthropomorphic, or geometric representations. The color combinations are harmonious and balanced, and numerous raw materials are used.

Nowadays, natural coloring material such as indigo blue from the anil plant, purple extracted from the purpura mollusc, or bright red from the cochineal insect found in the Indian fig tree are rarely used except in industry; in other fields modern yarns and fibers such as silkaline, mercerized thread, lustrine, rayon, and perlon have been substituted for vegetable fibers.

On the other hand, though modern fibers are common, the primitive backstrap, or waist, loom *(mecpal)* is still widely used throughout the country—primarily for making a type of woman's blouse called huipil. The treadle, or foot, loom introduces a western and Spanish influence, mainly on the *corte* (skirt of standard length) and *refajo* (wraparound skirt). These skirts worn by the Indian women are made almost exclusively by the men.

In addition to the workmanship, other indigenous elements include the traditional backstrap loom mentioned above; the *malacate* (spindle for cotton) or primitive *hueso* (bone used as a spindle); some of the raw materials, such as white or creole cotton, or the undyed tawny brown cotton called *ixcaco;* various dyes and coloring matters; possibly the combination of colors and the composition of styles in the weaving; some of the traditional techniques, decorative motifs, and distinctive patterns; the realistic or stylized animal and plant figures.

Western elements that have been incorporated into the Amerindian culture include equipment and tools such as the treadle loom; the distaff; scissors for cutting the pieces; some techniques of embroidery and stitching; the use of sheep's wool; the wide variety of clothing styles, particularly for men, such as trousers, shirts, loose jackets, and attachments such as buttons; different dyes; decorative motifs such as bulls, horses, roses, lions, and inscriptions using the letters of the alphabet.

Women's clothing is also varied; for daily wear the huipil is the most characteristic and highly prized article of the Indian woman's costume. The huipil is a type of blouse that has many styles and purposes: for daily use, for work in the kitchen, for ceremonies, and for religious sisterhoods (in which the most beautifully finished ones are found). The huipils or overhuipils comprise one or more pieces (usually two or three) that are made separately on a backstrap loom and sewn together later; some huipils are short, like the waist-length ones of Palín; others are extremely long and reach down below the knees, like those of San Mateo Ixtatán.

The huipils in the Ixil area of San Juan Cotza, Nebaj, and Chajul are famous, as are those of Chichicastenango and all places in the department of Quiché; they are also famous in Alta and Baja Verapaz, principally in Cobán, San Pedro Carchá, Tactic, and Tamahú in the Indian areas of the Kekchi or Poconchí; also those of the Cakchiquel, principally in the departments of Sololá, Chimaltenango, Sacatepéquez, and Guatemala; those of Quezaltenango, San Cristóbal, and San Miguel Totonicapán, in the west; those of the Mam communities and other indigenous groups in the department of Huehuetenango, principally those of San Mateo Ixtatán, Soloma,

358

359

358 Detail of a huipil. San José Nacahuil, Guatemala

359 Detail of a embroidered huipil. San Cristóbal Totonicapán, Totonicapán

360 Woman embroidering a huipil in a street in the Riscos district of Momostenango. Totonicapán

360

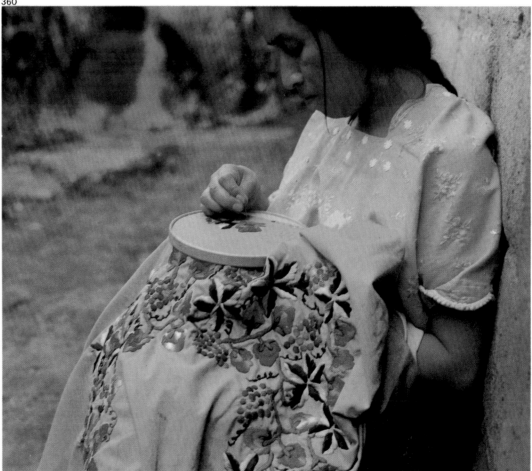

Comitancillo, Todos los Santos Cuchumatán; and those of Palín in the southern region of Guatemala, in the department of Escuintla. A special technique of weaving in which the brocade for the huipil is done on the same backstrap loom extends over many regions: among them are the villages of San Antonio Aguas Calientes, San Pedro Ayumpuj, San José Nacahuil, Rabinal, San Martín Jilotepeque, and Santa María de Jesús.

There are various techniques for making *cortes*, which also come in different styles, one being in plain colors, usually blue (an imitation of indigo) or red (that mimics cochineal). The *jaspeado*, or the tie-dyed style of *corte*, is starting to be found in only a few villages in the main center of the country's uplands. The yellow silk *corte* of San Pedro Sacatepéquez (San Marcos) and the tie-dyed ones of Salcajá (Quezaltenango) are noteworthy.

Jaspeado, also known as ikat (the process of dyeing the warp or weft before weaving to create patterns), was commonly found in several towns, and now, as in the past, it is a tradition over a wide area of Totonicapán and Salcajá; from these places the products are distributed throughout nearly all Guatemala. These items are known for their colorful decorations that can be composed of rows of anthropomorphic figures; plant, flower, and animal motifs; or complicated sayings or inscriptions that sometimes identify the owner of the item or its town of origin. *Jaspeado* is mainly used to make fabrics for the belted *cortes* or *refajos*, or for the underskirts and full skirts of the women's dress in Quexaltenango and Totonicapán; today such fabrics can also be seen in

361

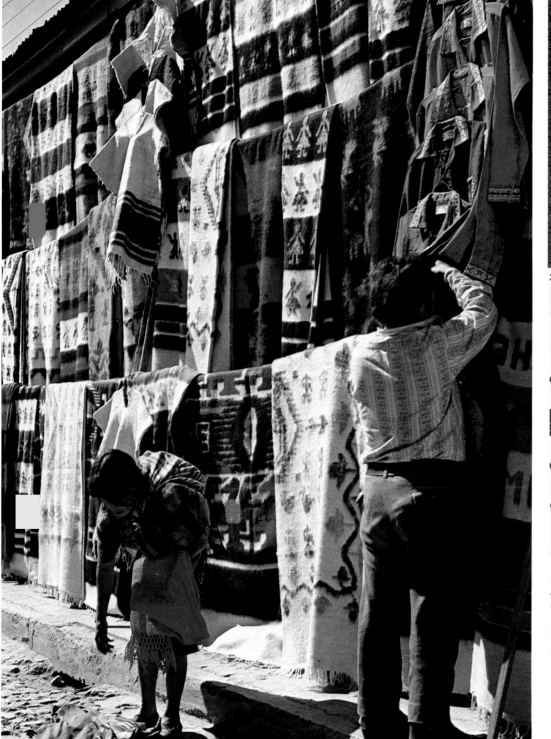

362

363

361 Woolen products are used especially in the colder regions of Guatemala, such as the departments of Quezaltenango, Totonicapán, and Huehuetenango

362 Detail of a huipil woven on a backstrap loom. Comalapa, Chimaltenango

363 Outstretched huipil woven on a backstrap loom. San Pedro de Sacatepéquez, Guatemala

121

other, far-distant villages. *Jaspeado* is also used to make a wool or cotton shawl called a *kaperraj*, an article of dress extremely widespread among Indian women. The *kaperraj* is similar to the rebozo (a lightweight shawl), which is made in many areas. Although both are often worn as a simple headdress, they are commonly used on the shoulders for carrying children.

The *tzut* or *tzute* (kerchief) is also a common article of dress, sometimes being a simple rectangular or square piece of fabric woven on a backstrap loom. It can be made in one or two pieces and in the latter case, as with the huipil or *cortes,* they are sewn together or joined with backstitch or a handwoven or embroidered band. *Tzutes* are often used as headdresses, shoulder decorations, napkins, or for many other practical purposes. The native Maxeño of Chichicastenango use them as headdresses.

Another essential article of clothing for women is the belt. Sometimes it is made of interwoven fabrics that are twisted or doubled when placed around the waist; at other times it may be four fingers or more wide and have special designs that alternate different patterns. Such belts are frequently used in the western regions and are now also becoming common in other areas. Some sashes are also made in the central part of Guatemala, where thick, wide bands of cotton or maguey fibers are embroidered with colored threads, as is seen in the sashes of Chuarrancho and San José Nacahuil; the decorations on women's sashes in Sololá, Chichicastenango, and Quiché are also embroidered in silks and silkalines. The embroidered sashes of Santiago Sacate-

364

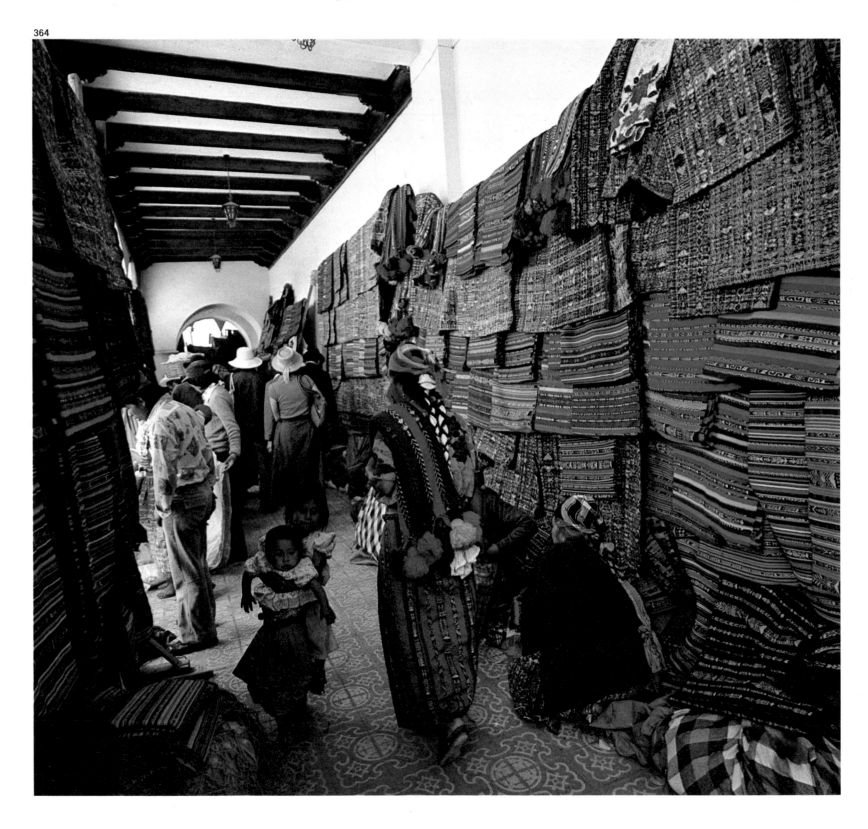

péquez are narrower and are finished off with long, colored threads that end in small woolen tassels.

Western tradition has clearly had a greater influence on men's costume, and the process of change and substitution has greatly affected their dress so that now very little variety exists in men's clothes. The most current, widely used articles of men's clothing in many towns on the central, intermediate, and western highlands are a loose coat or jacket made by local tailors in blue or black wool or drill, a white shirt in plain cloth, a *rodillera* or ruglike woolen blanket, plain white trousers of various lengths, a colored woven sash, and a straw or felt hat.

One of the more attractive and majestic costumes is worn by the men of Chichicastenango. It is made of cut and sewn wool and is embroidered with symbolic decorations, although little by little these are being replaced by new floral decorations.

Along the same lines are the large woolen capes or *capixayes* (from the Spanish *capa y saya*, cape and skirt). It is possible that their origin lies in priests' habits, but now they are worn by the Indians of San Juan Atitlán, Todos los Santos Cuchumatán, San Martín Sacatepéquez (Chile Verde), and San Antonio Papoló. In the villages of the department of Sacatepéquez, near Antigua Guatemala, *capixayes* were once made of blue-dyed wool, but nowadays almost no one uses them.

Sashes, belts, or bands are also an important part of men's dress. Some of them are beautiful works of

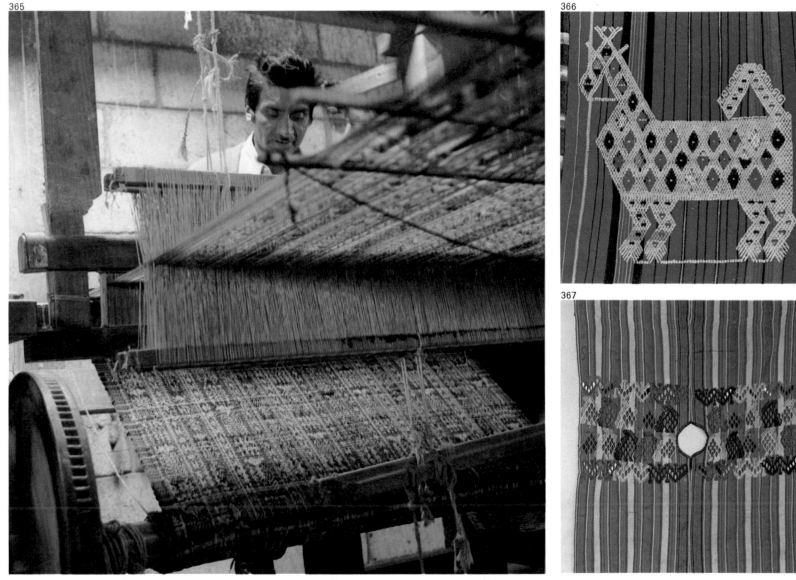

364 Stall with *refajos* in the ikat style. San Francisco El Alto, Totonicapán

365 Industrial workshop that employs only men. San Cristóbal Totonicapán, Totonicapán

366 Figure of a horse on fabric woven on a backstrap loom. Chichicastenango, Quiché

367 Outstretched huipil woven on a backstrap loom. San Juan Sacatepéquez, Guatemala

123

art, like those woven in Chichicastenango, where silks dyed with purpura were once used; or those of San Martín Sacatapéquez (Chile Verde) with their green and purple diamond-shaped geometric designs; or those of Nahualá with their figures of a two-headed eagle, a motif that has finally taken root and is frequently seen in Guatemalan weaving. In addition to these accessories, mention must be made of the specialized craft of making ponchos and other woolen items on a foot loom. The sheep shearing and the carding, cleaning, and washing of the wool are usually all done in the same village.

The manufacturing center of Momostenango uses a lot of wool, as do Nahualá, Santa Catarina Ixtahuacán, San Francisco El Alto, Chichicastenango, Comitancillo, Chinautla, Santa Bárbara, and Aguacatán. On market day the large plaza of Momostenango and all the surrounding streets are filled with a wide variety of woolen goods, principally ponchos or multicolored *chamarras* (wool blankets worn as a wrap during the day and used as a bedcover at night). These are made in widely varying techniques and decorated with unusual designs.

Wool dyeing is another specialty of Momostenango, particularly white, black, and dark brown wool. Some coloring materials used are logwood, or *palo de Campeche*, for black and dark blue; the indigo plant for light blue; cochineal and red sage, *cinco negritos* or *chinche negrita*, for red; fustic wood, or *palo amarillo*, for yellow; Campeche wood, or *palo de Brasil*, for purple; a mixture of logwood and indigo for green; elder bark for brown.

368

369

368 Knitted bag with a traditional decorative design incorporating a date of particular importance to the user. Sololá

369 Traditional man's and woman's costume in the area of Lake Atitlán.

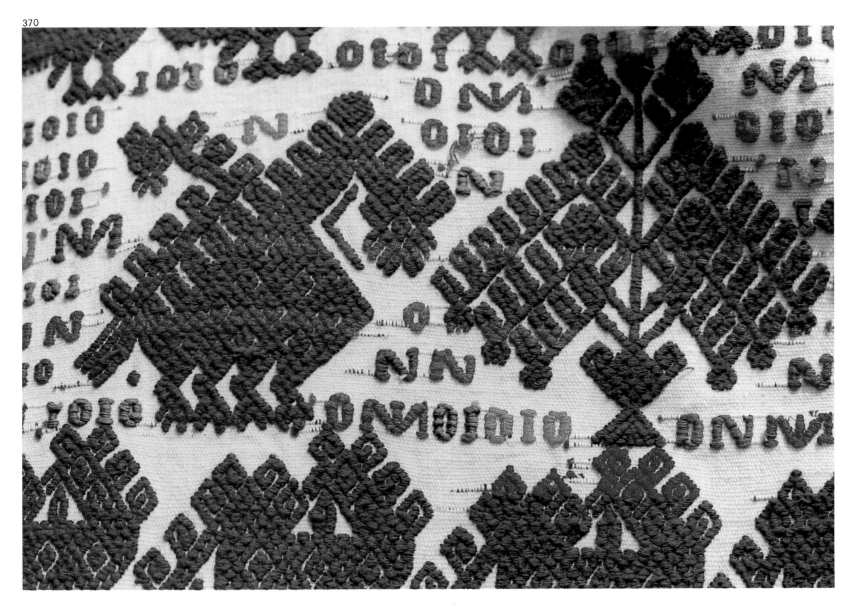

370 Detail of a huipil. San Pedro Sacatepéquez, Guatemala

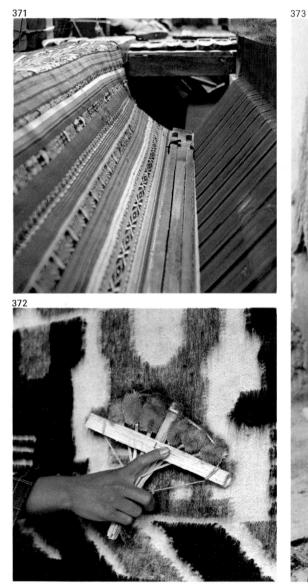

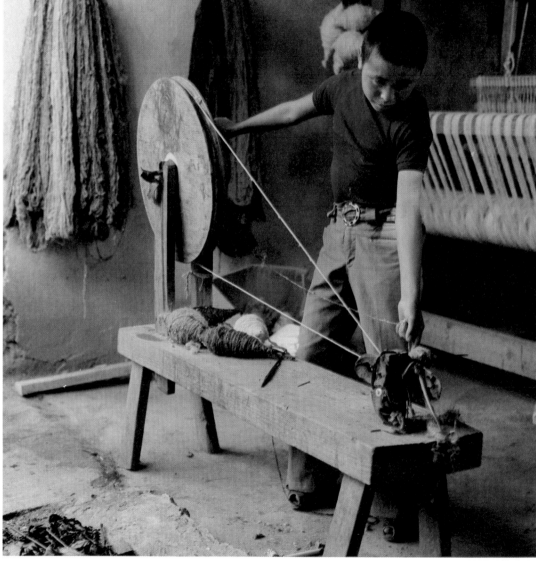

371 Detail of a loom showing the warp and woven fabric from which women's skirts are made. San Cristóbal Totonicapán, Totonicapán

372 Napping a finished blanket for added warmth and softness with a handmade brush. Momostenango, Totonicapán

373 Spinning wool. Momostenango, Totonicapán

374

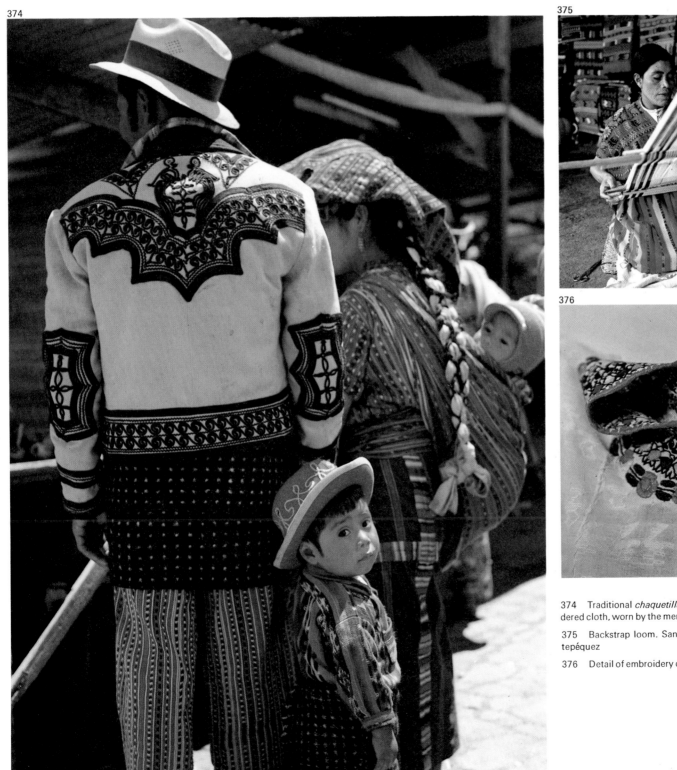

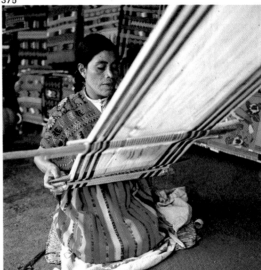

375

376

374 Traditional *chaquetilla* (short jacket), made of embroidered cloth, worn by the men of Guatemala's highlands. Sololá

375 Backstrap loom. San Antonio Aguas Calientes, Sacatepéquez

376 Detail of embroidery on a woman's blouse

Catalogue

377–381 Glazed pottery plates. Antigua Guatemala, Sacatepéquez

382 Polished and painted pottery pitcher. San Luis Jilotepeque, Jalapa

383 Large and small pitchers of polished pottery. San Luis Jilotepeque, Jalapa

384 Polished and painted pottery vessel in the shape of a duck. San Luis Jilotepeque, Jalapa

385 Large earthenware jug of polished pottery. Chinautla, Guatemala

386 Zoomorphic vessel; polished and painted pottery with overlaid decoration. Chinautla, Guatemala

387 Polished and painted pottery canteen. Chinautla, Guatemala

388 Incense burners of polished and painted pottery. Chinautla, Guatemala

389 Clay incense burner and tureen. Antigua Guatemala, Sacatepéquez

390 Glazed pottery tureen. Antigua Guatemala, Sacatepéquez

391 Glazed pottery candlestick in the shape of a he-goat. Totonicapán

392 Utilitarian earthenware. San Francisco El Alto, Totonicapán

377

378

379
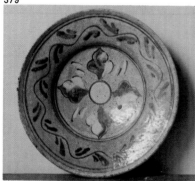

380
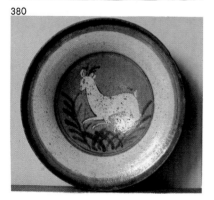

381
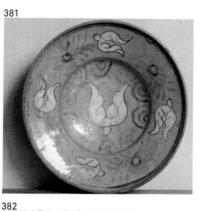

382
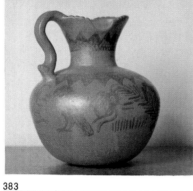

383
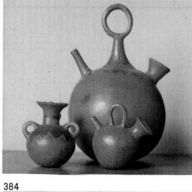

384
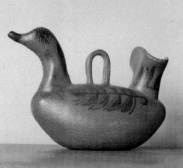

385
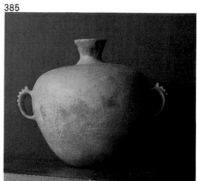

386

387

388

389

390
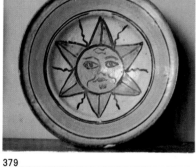

391

392

393 Utilitarian earthenware. San Francisco El Alto, Totonicapán

394 Utilitarian pottery. Chichicastenango, Quiché

395 Painted pottery whistle. Antigua Guatemala, Sacatepéquez

396 Painted pottery musicians. Rabinal, Baja Verapaz

397 Pottery shepherds, painted with oils. Antigua Guatemala, Sacatepéquez

398 The Infant Jesus, Mary, Joseph, and the Magi. Pottery painted with oils. Antigua Guatemala, Sacatepéquez

399 Painted sculpture of Saint James (Santiago). Chichicastenango, Quiché

400 The Three Kings, painted pottery. Rabinal, Baja Verapaz

401 Figure from the dance of the conquest, painted pottery. Rabinal, Baja Verapaz

402 Nativity of painted pottery. Rabinal, Baja Verapaz

403 Painted pottery figures. Rabinal, Baja Verapaz

404 Polished and painted pottery candlestick, with overlaid decoration. Chinautla, Guatemala

405 Processional image, painted pottery decorated with feathers. Rabinal, Baja Verapaz

406 Processional altar of painted pottery, dedicated to Saint Peter. Rabinal, Baja Verapaz

407 Painted pottery piggy bank in the shape of a toad. Antigua Guatemala, Sacatepéquez

408 Mask of wood and plaster

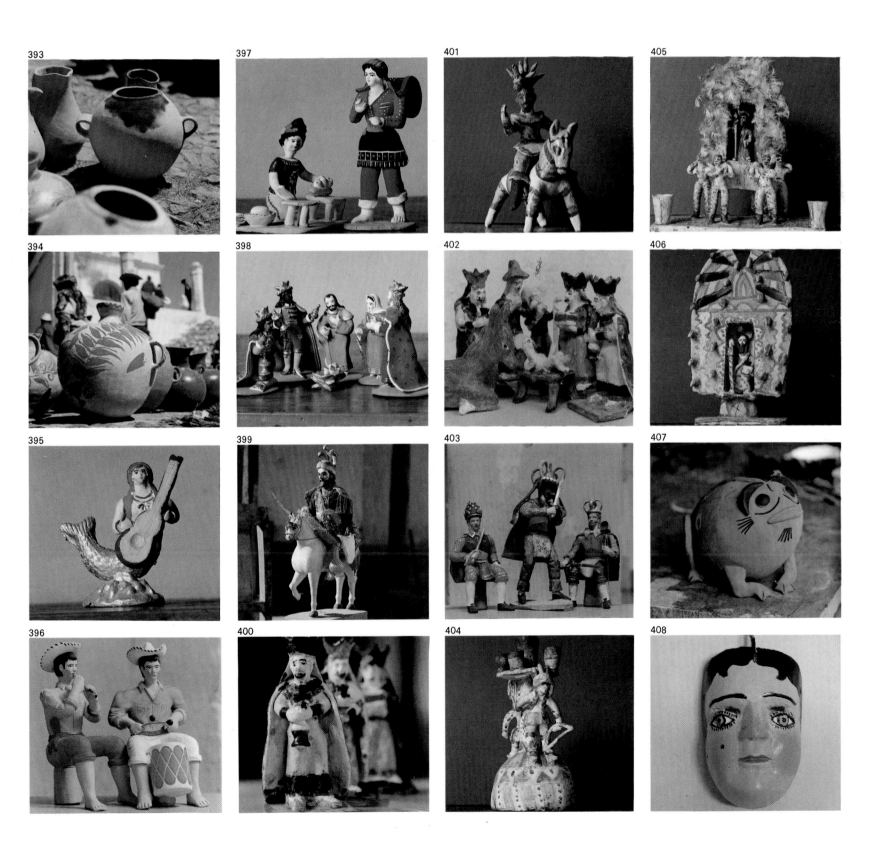

HONDURAS

409 When one of the handmade hats of Honduras is held against the light one can appreciate the fine weaving of the crown. Gualjoco, Santa Bárbara

Honduras is better known for its striking pre-Hispanic cities and monuments than for its folk art; its diverse archeological ruins constitute a cultural treasure thousands of years old. The most famous of these monuments is the sacred city of Copán, where the art of sculpture or stone carving reached its zenith as the Mayan world was achieving its highest level of culture.

Outstanding among the crafts of the colonial period was the production of multicolored pottery; also notable are the alabaster vessels of the valley of Ulúa, widely known throughout Mesoamerica. During the colonial period, the ancient and seignorial city of Valladolid de Comayagua was the most important pottery center for the production of majolica and glazed pottery. Today, however, all that remains of the work in this area are a few examples of bricks and tiles once used in floors, walls, and cupolas of temples, and isolated pieces scattered among various museums and private collections.

In several parts of the country there still exist other towns that have a long tradition of pottery making but in a more popular vein. Traditional pieces include pitchers with figures of animals, such as the deer or roosters of Ojojona, decorated with raised, red engobe, now covered with oil paint, from Apacilagua and Orocuina in Choluteca, Langue in the department of Valle; the pots, jars, and griddles of La Campa, in the former territory of Gracias, now called Lempira; and the comales or griddles of Peñasco in Ocotepeque and other towns. All these articles give testimony to the continuity of the ancient indigenous tradition of ceramics.

410

411

410 Shaping the crown of the hat with the aid of a wooden form. The damp cloth keeps the part not being worked from drying out. Gualjoco, Santa Bárbara

411 Animal pitcher with a deer head. Ceramic painted in oil paint. Ojojona, Morazán

For some time now woodcarvers have been using to good advantage such fine woods as mahogany and cedar, which are available in the forests of Honduras, for re-creating designs taken from the Mayan tradition.

It is evident that in Honduras there has been a deliberate effort to develop a native crafts industry that would reflect in character and spirit the transcendent influence of the art of the ancient pre-Columbian civilizations.

The area near Lake Yojoa or Taulabé, the largest body of fresh water in Honduras, is the former territory of the Lenca and Ulúa Indians. This area is renowned for the craft settlements of Santa Bárbara, which produce articles made of soft palm fibers and reeds. What has made these craftsworkers especially famous is the Ilama hat, comparable in quality to those made in Panama, Colombia, or Ecuador, though not as well known.

In Ilama, Gualala, San Francisco, and La Ceibita both palm leaf and palm fiber hats are made; in Gualjoco, Santa Bárbara, San Vicente Centenario, Los Anices, La Ceibita, Zona, Ceguaca, San Francisco, and La Arada fine quality hats are woven of reeds. Raw material for the palm hats is obtained from carefully cultivated trees in various parts of the region but primarily from Ilama, which supplies not only its own workers but also those of Gualala and other villages. The material is kept covered and moist until ready for use. The women use it to weave baskets, bags, cradles, jug-shaped baskets, cigarette cases, change purses, wallets, table mats, etc.

For hatmaking craftsmen obtain bundles of palm when the material is dry. When they are ready to work

412

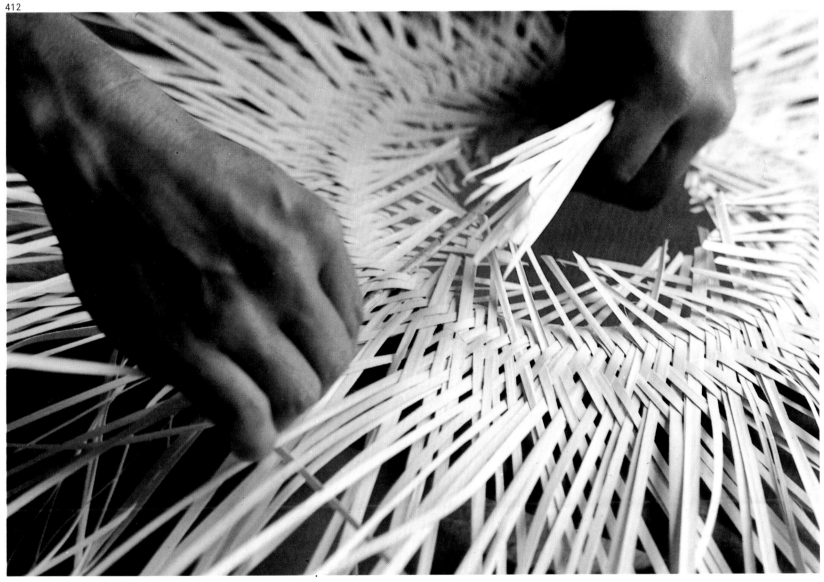

412 *Hijiaduras*, the additional palm strips that form the brim of the hat. Gualjoco, Santa Bárbara

the palm is soaked so that it becomes flexible enough to be worked without danger of breaking. Initial bleaching is done first with sunlight; then bundles of the material are set in a container and treated with sulfur smoke. After three days the material is spread out in the sun to dry completely. When colored fibers are desired, bundles of palm are treated with aniline dyes dissolved in boiling water; the only instrument employed is the bone used to smooth out the fibers.

Fine reed hats are made in a similar fashion; the same bone is used for smoothing and is used to split the reed and to scrape out the pith. Reeds may be dyed with pine nut shells, *yuquilla,* with salt and alum added to fix the aniline. Work begins with the star or square; the weaver generally takes four small bundles of twelve strands each and keeps adding, as needed, more palm fibers or reeds called *hijiadura,* since these are the *hijos* (children) or continuation of the former. To shape the crown of the hat, the work is placed on a cylindrical wooden form that is then set on a rectangular table or bench with a round hole in the center to hold the form; the flat surface serves as a base for shaping the brim, which is finished off with an edging. Throughout the long and painstaking process of weaving the material is kept moist with a wet cloth or blanket so that it will be flexible enough to work with. It must be kept covered and moist even during the periods between weaving sessions.

Decoration is done in various ways and the type of adornment on the hat takes its name from the partic-

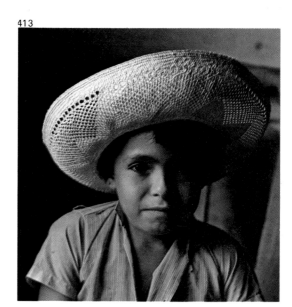

413

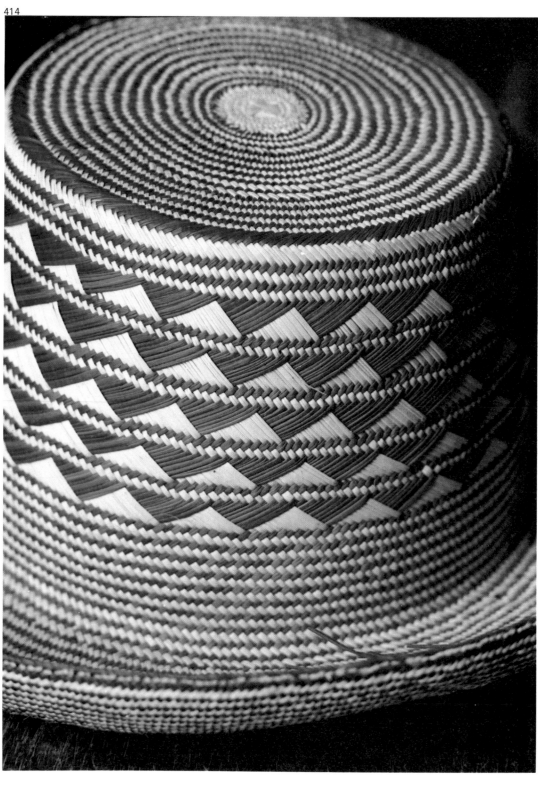

414

413 Reed hat made in the *calado* technique. Gualjoco, Santa Bárbara

414 Reed hat woven in the *banderita* style. Santa Bárbara

134

ular weaving technique used: *trenza, banderita, calado,* or *cordón.* Hats and certain other objects are also decorated with designs and slogans that are embroidered in bright-colored wool.

Although all the various stages in this lengthy process are still being repeated in the craft centers mentioned here, nowadays there is a tendency in Santa Bárbara to partially reduce the handwork of the individual hatmaker by making use of ready-woven strips of palm or reed that are made by several communities of artisans in this region.

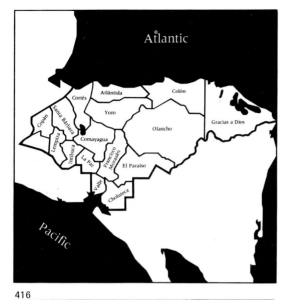

415

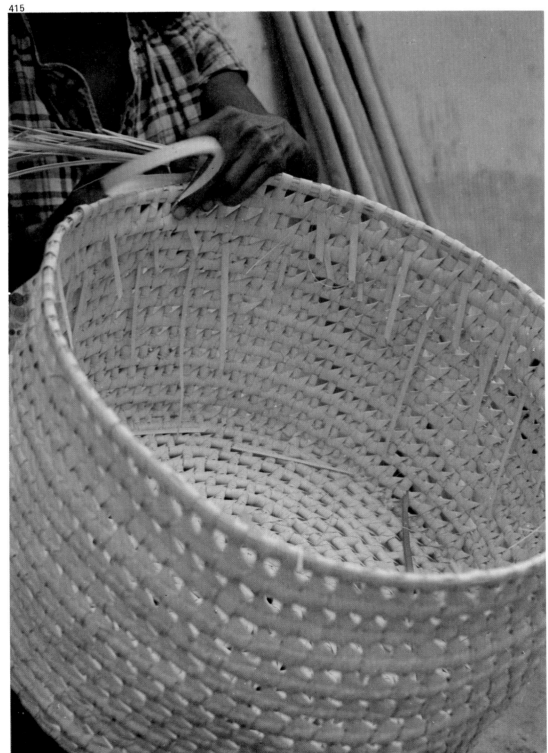

416

415 Large basket made out of palm strips for storing clothing. Ilama, Santa Bárbara

416 Baskets are made in different sizes. The basket lid in the foreground shows the spiral pattern of the weave. Ilama, Santa Bárbara

EL SALVADOR

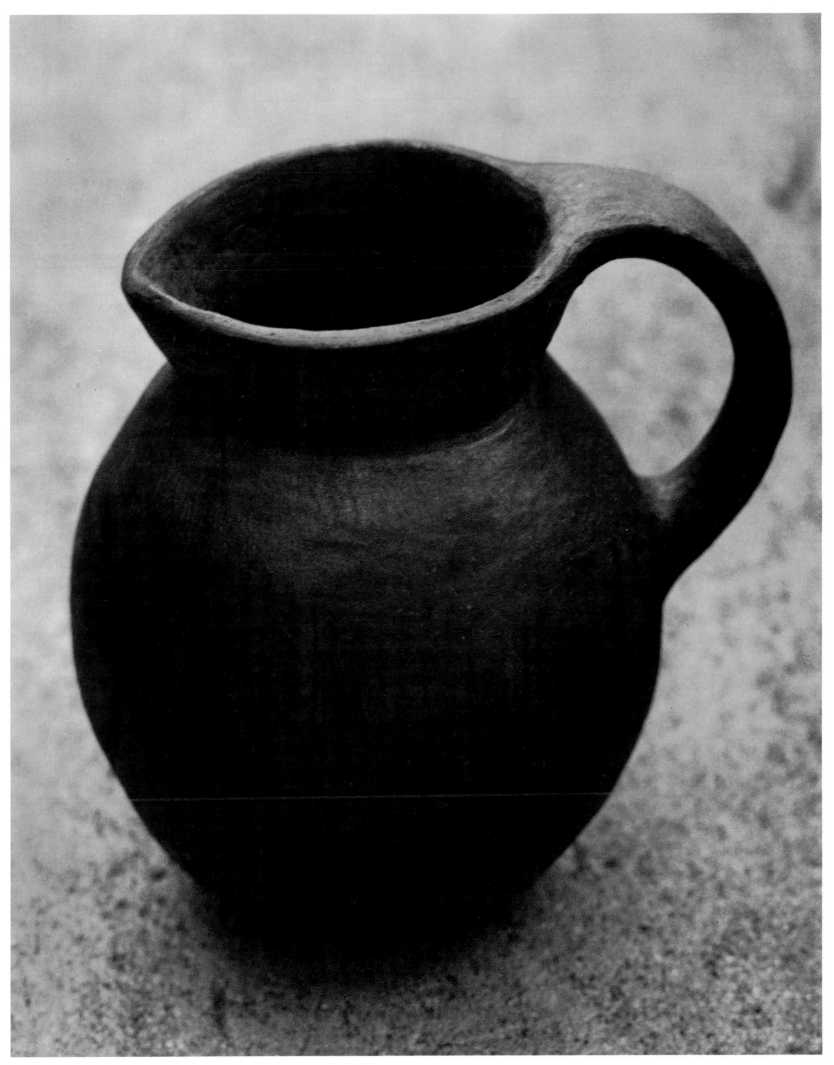

417 Water jug of polished black pottery. Guatajiagua, Mora-
zán

El Salvador is one of the more densely populated countries of Central America. Its agricultural economy has always been based on a variety of products: cocoa was one of the most important in the pre-Columbian era; indigo, *jiquilite* or *sacatinta* (*Indigofera suffructicosa*) was a product in the same period up into the nineteenth century; and balsam still continues to be taken from some seacoast villages. These old agricultural activities have been expanded principally to include the cultivation of coffee and cotton.

El Salvador received its Mayan influence, and even more than that of the Mexicanas, from its ancient inhabitants through the Nahuatl language, the origin of the Pipil language; today this language is preserved almost solely in the proper names of several peoples who have inherited the indigenous pre-Columbian cultures that built, at various times, the ancient monuments of Tazumal, Cihuatán, Quelepa, San Andrés, and Tehuacán.

Other groups, such as the Chorti, live in Tejutla, Metapán, Citalá, and other villages in the northeast of the country near the frontier with Guatemala and Honduras; while in the southwest, the Pocomames of Chalchuapa, Atiquizaya, and Ahuchapán are to be found; toward the eastern border are the Lenca Indians in Usulután, Sesori, Chilanga, Chaparrestique, Gotera, and other villages near the frontier with Honduras.

The Pipil language is only spoken nowadays by some one thousand people throughout the country, and those languages of the other groups have disappeared. Nevertheless, remnants of the cultures mentioned can still be found in the crafts that have been preserved.

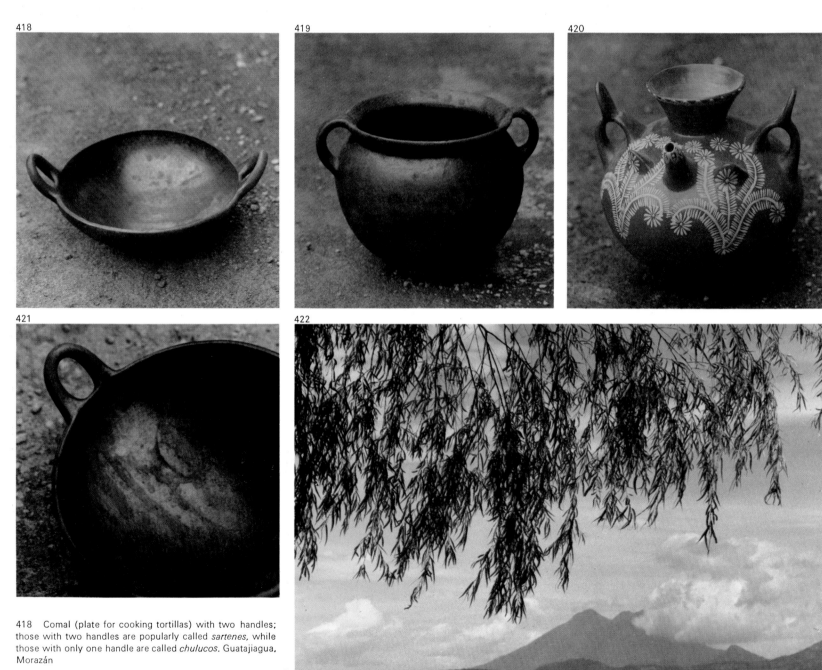

418 Comal (plate for cooking tortillas) with two handles; those with two handles are popularly called *sartenes,* while those with only one handle are called *chulucos.* Guatajiagua, Morazán

419 Traditionally shaped pot that has widespread use. Polished black pottery. Guatajiagua, Morazán

420 Typical pitcher with an unusual style of handles and a relief design on the spout. The decoration is traditional to the area. Guatajiagua, Morazán

421 The unique polished quality of this black pottery is evident here. Guatajiagua, Morazán

422 El Salvador is a mountainous land with many volcanic formations. The Andes range crosses the country from east to west. View of Lake Ilopango with San Vicente volcano in the background. San Salvador

Folk arts and crafts fill the stalls of the markets, and at festivals and fairs many examples can be seen in a variety of forms, designs, and multicolored decorations. The craft centers are scattered all over the country; for example: Guatajiagua in Morazán, Las Minas in Chalatenango, Quezaltepeque in La Libertad, Ilobasco in Cabañas, Santo Domingo in Sonsonate.

The village of Guatajiagua, in the east of the country, is probably of Lenca origin and is one of the more important centers for traditional pottery, as much for its acknowledged styles as for its special finish. The colored pitchers and earthenware jugs of Guatajiagua are famous, with their legs or supports, tapering handles, beak-shaped spouts, round mouths with lids, bright red engobe, and decoration of white flowers. These and other pieces are made daily by the women, who follow a traditional pre-Columbian technique. While they are working they move, half crouching, around the piece they are making.

The clay comes from the region of the same town, principally El Barrial. The measures used for its sale as well as its transportation are baskets. Generally two types of clay are used, one gray and another brownish, to which is added sand or volcanic tufa, which is rich in silica. The clay requires a patient and careful process of mixing, beating, filtering or sifting, drying, and dampening; afterward it is placed on the packed earth —it is at this moment that it can be considered ready to be made into objects.

Comales are made in the bottom of a shallow hole in the ground; for other pieces blocks of clay are used

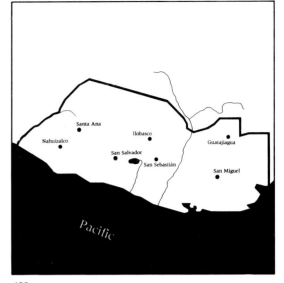

423

424

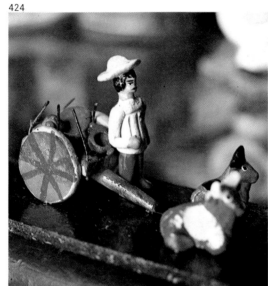

425

426

427

428

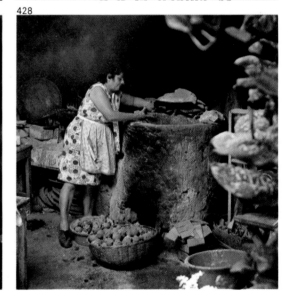

423 Representation in painted pottery of children playing a game with the piñata, in which a clay pot has to be broken with a stick by the blindfolded participant. Ilobasco, San Salvador

426 In this instance, the "surprise" in the chicken is a woman selling fruit, but the subjects are varied. Ilobasco, San Salvador

424 Oxcart. Such pottery miniatures were once made only at Christmastime but are now made year round. Ilobasco, San Salvador

427 This "surprise" chicken contains an erotico-religious scene. Ilobasco, San Salvador

425 "Surprise" chicken. Painted pottery miniature. Ilobasco, San Salvador

428 Potter as she charges the kiln; this job must be performed daily. Ilobasco, San Salvador

from which the excess is removed. The piece is then tapered with the aid of a corncob. The drying is done in the open air. All the pieces are fired in a domed kiln and coated in a solution of dissolved clay that produces a pleasing and characteristic reddish color after it is baked. To finish the object, it is painted with white phytomorphic decoration.

Other domestic utensils, such as two-handled comales, skillets, pots, and pitchers, have a black ceramic finish, whose basic technique follows a fairly original procedure. The special technique, called *rusiada*, consists of the application of a coat of *nacascol* water (from the fruit of the *Nacascolo* tree, *Caesalpinia corioria*) and splinters of quebracho bark, which not only make the pieces waterproof but also give them their distintive dark, almost black, color. *Nacascol* is also used to dye *jícaras* and *morros* (gourds and gourdlike fruits used as bowls) black, principally in Izalco and Nahuizalco.

Another important pottery center is Ilobasco, where the technique of glazing is used as much as painting. The pieces are made on a wheel or in a mold and fired in a kiln at high temperatures. Their designs are predominantly indigenous pre-Columbian; the pieces are decorated with zoomorphic and anthropomorphic figures in high relief and polychromed with modern commercial colors.

The pottery is made into ashtrays, plates, flower vases, paperweights, book ends, and other objects of more decorative character and function. The skilled craftswomen of Ilobasco are beginning to modify the themes,

429

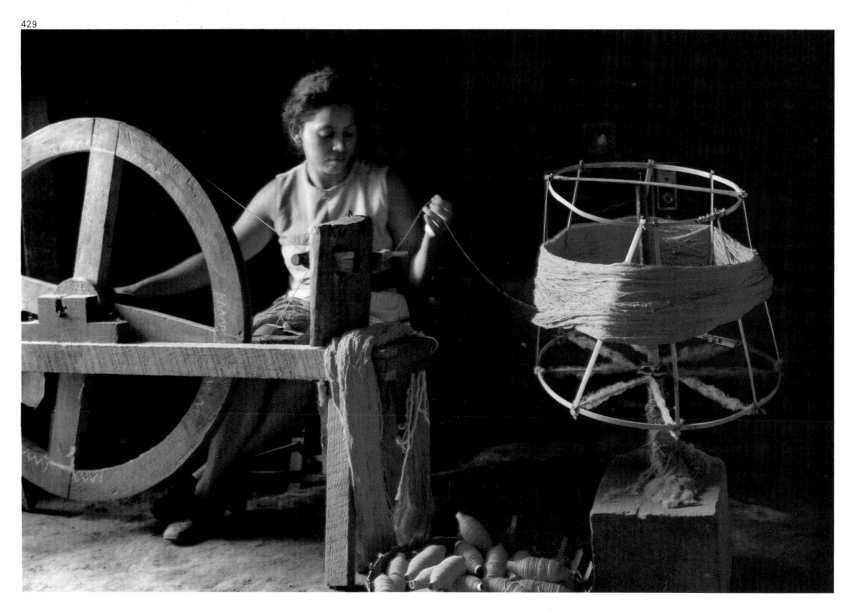

429 The *canillera* winds the yarn onto bobbins. San Sebastián, San Salvador

430 Front view of the warp showing the "cross," divided by two sticks, which keeps the threads in order. San Sebastián, San Salvador

motifs, shapes, designs, and traditional techniques to which they adhered until a short time ago. This is a result of the demand from the growing markets for their goods, which in turn require new means of production and commercialization.

In addition to these new subjects, the making of dolls and miniatures in clay still continues; still sold in the picturesque back streets of Ilobasco are small hollow chickens, eggs, or fruit that, when opened, contain minute figures of *misterios* or Nativities. There are also figures or busts that copy the costume and physical characteristics of the almost extinct original Salvadorans. Erotico-religious subjects are also very common.

This craft production in Ilobasco once was seasonal, only done for Christmas Eve, but it has now become a year-round activity involving most of the town's inhabitants. The clay dolls and miniatures are handmade, sometimes with the aid of a mold, and are then given several coats of a solution of powdered paint, water, and glue, which acts as a fixative; other clay figures are painted with oils.

The weavers of El Salvador must also be mentioned in this brief survey of its crafts. There are still native women in Izalco, Nahuizalco, Panchimalco, and the Costa del Bálsamo who use a backstrap loom to weave multicolored fabrics; in Izalco and in Juayúa (La Unión) backstrap looms are used to weave the sashes or belts that form a distinctive part of these women's costume. In various villages in the departments of San Vincente, Sonsonate, and Ahuachapán fabrics are made on treadle looms.

430
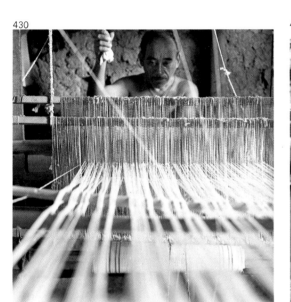

431

432
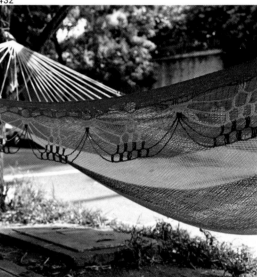

433
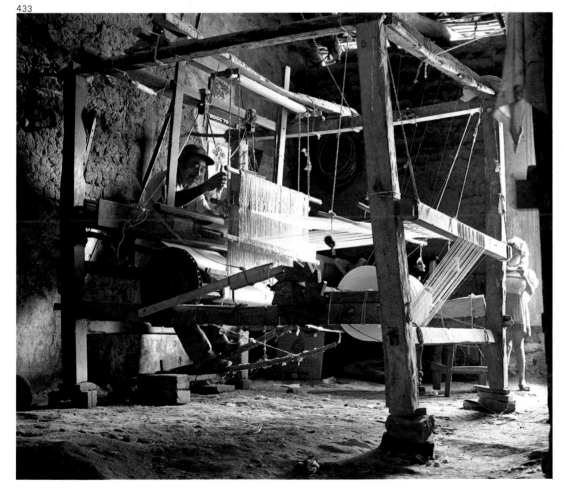

431 Pedals of a loom that raise or lower the harnesses. San Sebastián, San Salvador

432 Hammocks are made in white or striped cotton, the latter usually being orange, blue, and red. The side decorations vary according to the judgment of the weaver. San Sebastián, San Salvador

433 View of the entire structure of the loom. Notice the back beam onto which the warp is wound, and the cloth beam onto which the finished fabric is wound. San Sebastián, San Salvador

The use of treadle looms is common in various villages, principally in Nahuizalco, where *refajos* are made from *naguilla* fabric for the skirts of the native women's costume; and in Tonacatepeque, San Salvador, where bedspreads and *naguilla* are produced. The woven fabrics are used primarily for bedspreads, hammocks, *cortes*, and curtains, with an extensive market throughout the country and its neighbors. Dyeing with indigo has almost disappeared, except in Chalatenango, and commercial colorants have been substituted.

The weaving of vegetable fibers such as tule (rushes that grow abundantly throughout the country), palms, wicker, and ditch reeds is fairly widespread. Of the many varieties of rushes, the most common is the water rush, which is gathered on the seacoasts; from it wastepaper baskets, fruit baskets, glass racks, and many other items are made in Nahuizalco. The wastepaper baskets are made in many different sizes. The first step in making them is to dry the tule in the sun, thus obtaining its characteristic coffee color. Then the fibers must be soaked to give them flexibility so that they can be woven. The wastepaper baskets have a wooden base which is covered with a grillage that fits around it. The basket may be decorated, varnished, or simply painted white.

Other vegetable fibers are used—mainly to make mats—that are also of the rush family. The core of the tule cane is used to make fire fans, *yaguales* (pads for carrying bundles on the head), bags, carpets, and other objects. The bark of the tule is used to make petates and *acapetates* (mats that serve a variety of purposes). Tule is used to make braided rugs of various sizes and with special designs.

434

435

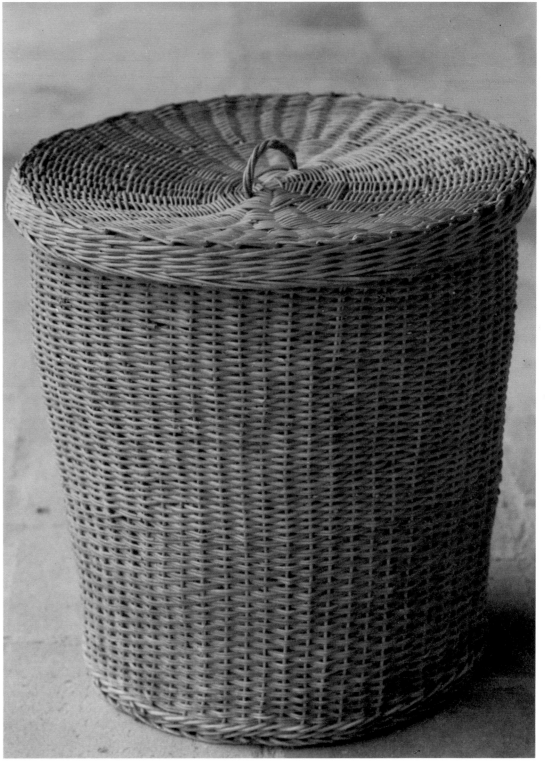

434 Detail of a large basket made with tule. San Salvador

435 Wicker wastepaper basket. It is common to darken the vegetable fibers in the sun. Nahuizalco, Sonsonate

142

Fine and ordinary hats are made from palms, principally in the village of Tenancingo in the department of Cuzcatlán. More recently handbags, baskets in modern designs, and multicolored hats have also been made. In Nahuizalco wicker is also used in workshops to make furniture, lampshades, folding screens, baskets, trays, hats, cradles, clothes, baskets, bread baskets, and other items. This fiber is also important in the neighboring country of Guatemala.

Some of the most useful baskets, called *tumbillas*, are made by the men of various villages, principally in Nahuizalco. *Tumbillas* are rectangular baskets, with or without covers, that often serve as wardrobes for the country people, and are sometimes made in *caña de castilla*.

Other crafts more recently introduced into the markets of El Salvador are the decorations made from the seeds or fruit of vegetables: Saint Peter's tears are red beans from the *palo de pito* (*Erythrina americana*); deer eyes are from the tamarind or oak, or are coffee beans, all of which have been threaded on nylon or metal thread. These are sometimes alternated to make necklaces, brooches, or other adornments, such as earrings, figures, or keyrings, which are sometimes varnished or painted.

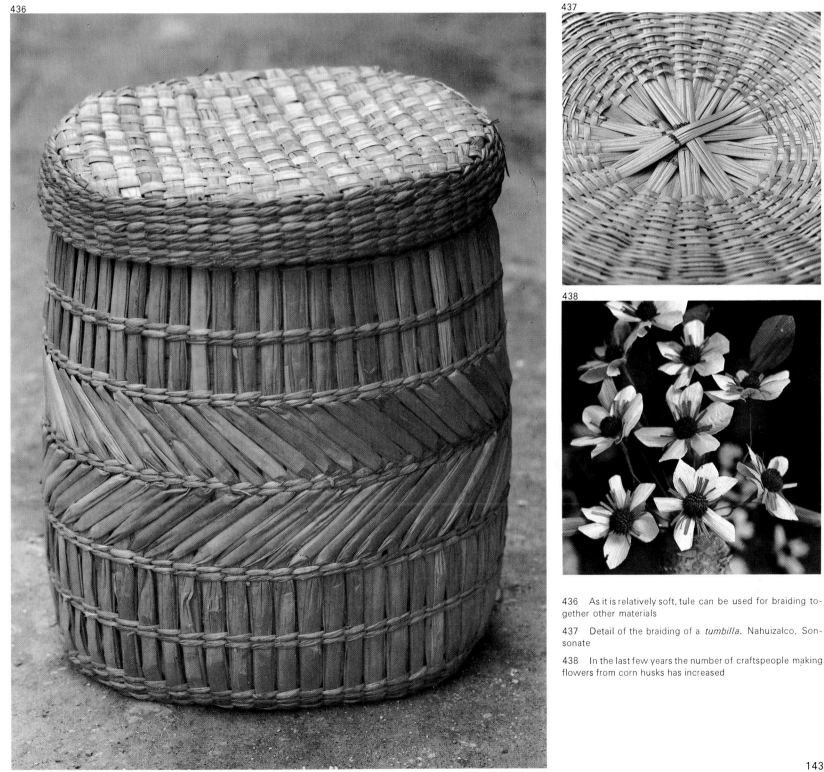

436

437

438

436 As it is relatively soft, tule can be used for braiding together other materials

437 Detail of the braiding of a *tumbilla*. Nahuizalco, Sonsonate

438 In the last few years the number of craftspeople making flowers from corn husks has increased

143

NICARAGUA

439 In the streets of some towns these carriages, fulfilling
the functions of taxis, can still be seen. Masaya

Nicaragua is a country of singularly contrasting geography. Such an environment provided a wide scenic framework within which an Amerindian culture developed that connected the high civilizations of Mesoamerica —Toltec, Nahua, Circuncarib, even the Chibcha of Colombia— with those more distant South American and Andean influences, the Chavín and Tiahuanaco. This culture of the isthmus, with its select aesthetic taste and its advanced manual technology, conceived the ancient Nicaraguan rock carvings; the stone monuments of the islands of Zapatera, Ometepe, and Solentiname; the pottery of its Namdaime, Zapatera, Luna, and Managua phases. The ancient inhabitants of this land were the Nicaraos, Chorotega, and Chontal.

Much later the mestizo culture, with its complex ethnic range, was overlaid onto this same structure of indigenous people in Nicaragua. After the Spanish Conquest the Indians learned new cráfts and new trading methods and systems of competitions, cultivated and used new raw materials, and trained themselves in the use of new tools and equipment, new practices, and different styles and designs. At the same time they continued to practice their old crafts, in their original or modified forms, almost solely for their own consumption.

Today in many villages several of the essentially Indian cultural characteristics, including language or local custom, are either starting to disappear or have already died out completely. However, some of the ancient, more outstanding and traditional crafts still survive.

A variety of items seen in Nicaragua are genuine examples of folk art: particularly impressive among these

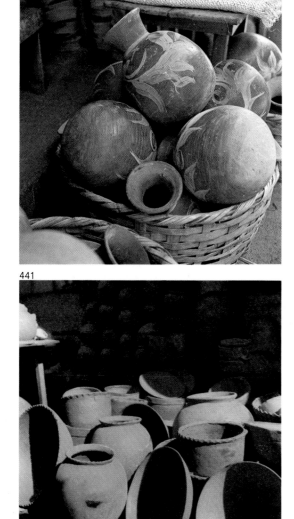

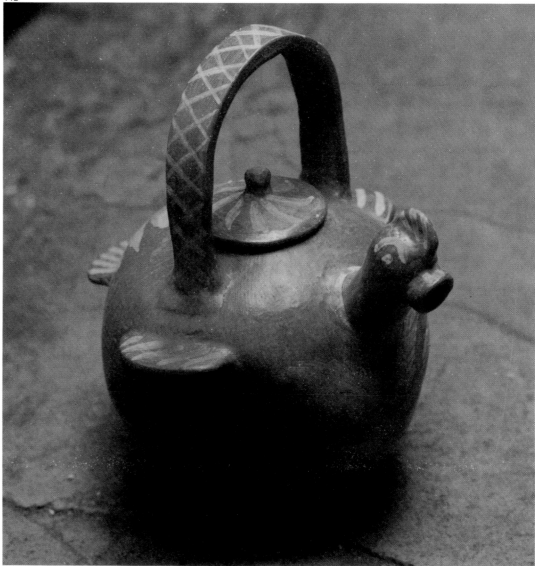

440 Polished and painted pottery. Masaya

441 Pottery for everyday use. Masaya market

442 Pitcher of polished and painted pottery; zoomorphic figure of traditional design. Masaya

are the objects made from the fiber of the giant lily, called cabuya, which are mainly hammocks and saddlebags as well as other items derived from rigging and ropemaking. Other craft items include hats made from *palma real* or *palma de Castilla;* narrow-mouthed baskets from bamboo cane; rush matting, brooms, and baskets from *zoyate* (fiber of agave or yucca plants); furniture from wood and fibrous material; toys and musical instruments from olive wood; and delicious sweets, such as those from Chichigalpa, which are frosted.

Special attention must be given to the black, polished pottery that is now found only rarely in the South American continent. The origin of this type of pottery is a point of controversy. On one hand its similarity to certain pottery sherd would indicate a pre-Hispanic origin. On the other hand, it is a fact that since the conquest Spanish-style kilns have been used to fire fine black pottery made with strips of clay. At times the pieces are incised with white decorations of flowers, ornamental borders, or bunches of flowers; the incising is done with a sharp bone after the first firing.

The most important center for pottery is Jinotega, a village situated in the north of Nicaragua, where modeling is done freehand with clay taken from the neighborhood of the small village of Anapás. More traditional styles and decorations are used for everyday objects such as cooking utensils, jugs, and large earthenware jars for daily use, and for miniature toys. Nowadays preference is given to a variety of nontraditional decorative products of a more "manufactured" nature, which is opening the market to tourism.

443

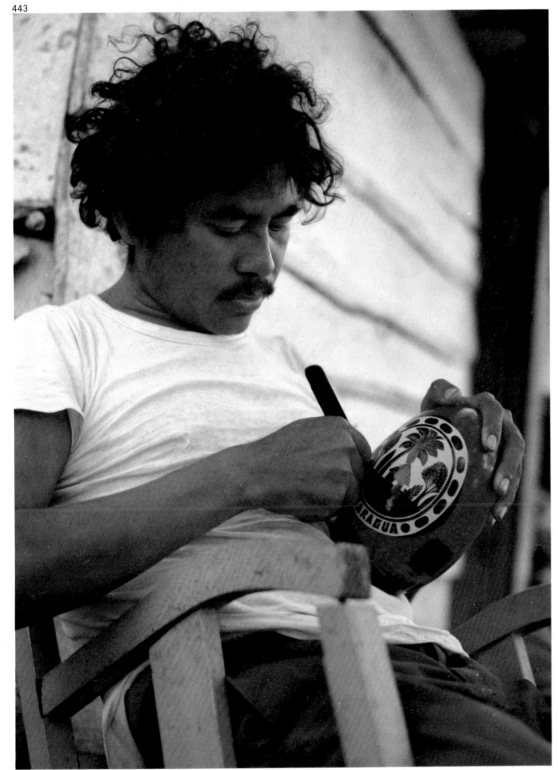

444

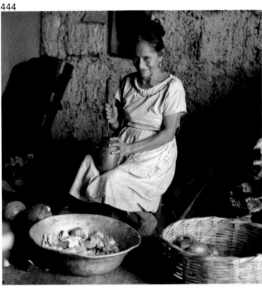

445

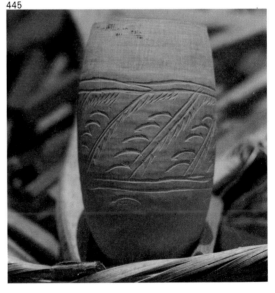

443 Craftsman making a *jícara* with the lacquer technique. Monimbó, Masaya

444 Before the dyeing and engraving, the *jícaras* must be cleaned out. Monimbó, Masaya

445 Carved *jícara*. Monimbo, Masaya

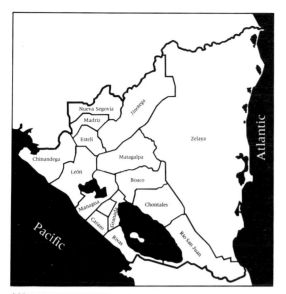

Some centers for pottery in the mestizo tradition still exist: Masaya, San Juan de los Platos in Masaya, Los Cocos in Matagalpa. Another line of pottery is made in La Paz Central, León, where small money boxes, whistles, figures for the Nativity, and other items painted in oils are made.

The decoration of *jícaras*, which are small bowls or cups made from gourds for drinking chocolate, is one of the more original, more ancient, and more widespread crafts in Nicaragua. Its pre-Columbian origin is known for certain from archeological discoveries, and its use is thought to predate the very earliest appearance of pottery. In considering the importance of such a popular craft, one must remember that since the pre-Hispanic era it has been associated with the consumption of cocoa, and that this, along with indigo, were two of the more flourishing crops grown for export from Nicaragua in the colonial era.

There are two principal methods of making *jícaras* still carried on today in the district of Monimbó in Masaya. The first is for those called "white," and the second for those called "colored." The raw material used for both of them is mainly the fruit of the *árbol de jícara* or calabash tree, although the *jícara sabanera*, or savannah calabash, is also used to a lesser extent. The first step in the preparation of both is to boil the gourd with lime so it will soften and can be peeled more easily. After this it is carved with a knife to leave the natural color, which with time and use will start to take on a pleasant, light yellowish patina.

After the initial boiling of the colored *jícaras* a lacquer technique called *maque* is applied as waterproof-

446

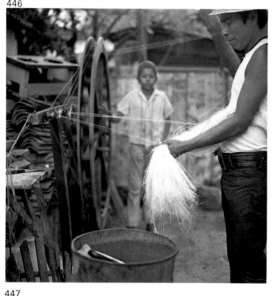

447

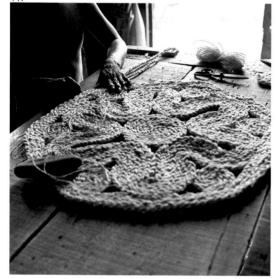

446 Braiding the fiber called cabuya. Masaya

447 Rugmaking is widespread; sometimes anilines of purple, green, or blue are used to dye the fiber. Masaya

448 Detail of the weaving of a basket. Masaya

448

ing. This consists of mixing together lacquer gum and *perrubia,* or rock gum, and then dispersing the mixture in alcohol. Aniline dyes are added and mixed into the lacquer; purple, yellow, green, or blue are mainly used. It is customary to give the surface of the piece several layers of color before it is worked on.

The styles and designs of these *jícaras* are quite varied, but the most common is that used on the one made as a container for the traditional drink of the country, a mixture of ground roasted corn, sugar, water, and ice called *pinol.* The *jícara* is made in three parts: the bottom, or *banco;* the *jícara* itself; and the lid or cover.

The influence of the old colonial cattle ranches has lasted to the present day and helps explain the great variety of leathercrafts that are produced in Nicaragua and are associated with life in the country, such as the saddlery of Chontales, Chinandega, and León.

The area of Nicaragua's great lakes—El Mar Dulce (The Freshwater Sea) as the conquistador Gil González de Ávila called it—has also been, since the earliest days, an important source of raw materials, and the use of rushes and other vegetable fibers developed from here.

In this brief survey of the crafts of Nicaragua one must also take note of the basketry of Monimbó and Masatepe; the items made from the cabuya fiber, such as the hammocks and saddlebags of Masaya and Chontales; ordinary baskets called *cestos,* narrow-mouthed baskets called *canastos,* and brooms made from *zoyate;* rush mats and hats made from *palma real.* Today rugs are also made either from cabuya or rope.

449

450

451

449 Sheath of embossed leather for a machete. Masaya

450 Leatherwork; embossing the back of a chair. Masaya

451 Fire fans are braided with both natural and dyed palm. Masaya market

149

Toys should also be mentioned. In addition to the clay toys of Jinotega, La Paz Central, and San Juan de los Platos, rag dolls are also made, as well as items made of turned wood, including wooden clowns, little timber horses, and dancing dolls; small carts, wheelbarrows, and brooms; several varieties of small *jícaras;* and chocolate whisks. These are mainly produced in the San Jerónimo district of Masaya.

Of the musical instruments made in Nicaragua, there are marimbas, reed whistles (*chirimillas*), drums (*tuncunes,* an onomatopoeic name that recalls the Maya *tunkul*), cane bows (*quijongos,* similar to the *zambumbia,* which is a rustic instrument in the shape of a drum and is played by rubbing a rod attached to the parchment), the fife (*chau-chau*), the common bongo drum (*tacatín*), and the whistle (*tatil*).

In the colorful local markets and popular meeting places, which are the descendants of the old Indian marketplaces called *tianguis,* it is possible to observe not only the spontaneity of the people, but also the enormous variety and wealth of creativity in the folk arts and crafts.

In addition to the markets, several religious holidays are turned into genuine, lively folkloric festivals, in particular the famous *griterías* dedicated to the Virgin of the Conception. This festival occurs during the first days of December, in Granada as well as El Viejo in Chinandega, in León as well as Mayasa. In these places it is customary to build improvised altars decorated with paper. A wide range of local products is exhibited, such as sweets, whistles, rugs, and artificial flowers. There are also the famous dances, such as that of the *gigantona* (huge card-

452

453

452 Small wooden horse with a long shaft that ends in a wheel, one of the most popular toys in the markets. Masaya market

453 Religious figures, carved in wood and painted in vivid colors, are sometimes found in the markets. This figure represents Saint Jerome

454 Lakes have been very important in Nicaragua. On their edges an important production of vegetable fibers has developed. Lake Masaya

board figures used in a carnival parade) of León, where beautiful masks, of such wood as fine cedar can be seen, especially those of the Bull Deer or *Toro Venado.* Other dances include the farce of *Gueguense* or *Macho Ratón* (the Male Rat) and that of the *Mantudos,* of which the poet Rubén Darío spoke. The dances are nearly always accompanied by whistle or drum music.

454

COSTA RICA

455 Recently repainted wheel of an old cart. Carts like this
are presently being replaced by other means of transportation.
Sarchi, Alajuela

Before the Spanish Conquest the territory that is now called Costa Rica was inhabited by small numbers of Chorotega, Carib, Nahua, and certain other natives. According to the estimates of Spanish explorers, there were probably no more than twenty thousand Indians living in this region at the time of the conquest.

As occurs elsewhere in Central America, the groups mentioned here do not constitute isolated units but are part of a much broader culture. Central America has received influences both from the north and from the south. For the most part the inhabitants—the Nahua, for example—were small groups split off from some larger tribal configuration.

Costa Rica was discovered by Christopher Columbus during his fourth voyage. The conquistadors were received by men and women wearing a profusion of gold ornaments, which led the Spaniards to the false conclusion that they had reached a prosperous land—this explains the name "Costa Rica."

Over the centuries Costa Rica's social organization has had some unique characteristics. The Spanish settlers mixed with the small autochthonous population. This happened elsewhere, of course, but not to the degree that it occurred in Costa Rica. Conquistadors and natives had to join forces to help the country survive. There were no divisions of rich and poor—everyone was poor. Today the population is almost entirely white, with few mestizos; 10 percent are black; and only 0.05 percent can be considered Amerindian. It might also be added that Costa Rica is one of the least densely populated countries, with thirty-nine inhabitants per square kilometer. Furthermore,

456

457

456 The wood, sometimes cut into planks, is left outside to weather so that it will not warp when used. Sarchi, Alajuela

457 From these sectioned red wood and other tree trunks comes the wood needed to build the carts. Sarchi, Alajuela

very hard. This does not prevent the occasional use of inferior types in order to lower the price. Artists consider the good carts to be those with a good sound because the wood "sings," and wealthier farmers are willing to pay well for carts that sound better, since this is a sign of prestige.

The artists must be well versed in various skills in order to be able to construct the entire cart. In their workshops there are always small forges to be used in working the iron. Everything must be perfectly fitted, and thus many parts are handmade to ensure the performance of the finished product. Some ready-made hardware, as well as certain types of machinery, however, are used to make the job easier.

One of the characteristics of the cart is its solid wheel, constructed of sixteen equal sections. To assemble the wheel, the pieces, triangular in shape, are fitted one by one into a mold; pressure is applied toward the center of the circle, with large clamps, and the final piece is added. No glue is used. Afterward the wheel is trimmed and the rim is protected by a strip of metal. The wagon itself is a parallelogram almost perfectly constructed in two sections: the floor of the cart and the lateral walls that are attached along the perimeter. The front wall forms a small angle, the base of which serves as a seat; the walls can be detached for loading.

The most complicated step, though not the most difficult technically, is the finishing and painting of the cart. The artists paint baroque shapes, mainly inspired by flowers and leaves. There is no fixed pattern; colors are chosen freely at the painter's discretion. The finished product is brightly colored and of great beauty.

460

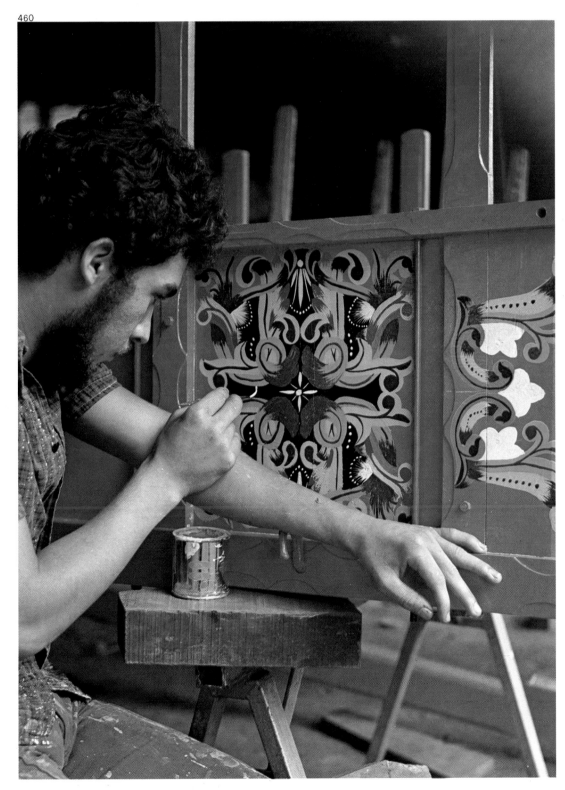

461

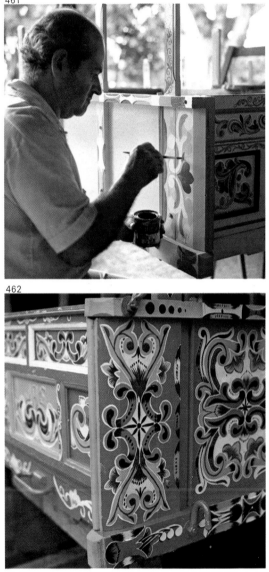

462

460 No patterns are used —nor are the outlines sketched in; the artist skillfully paints, freehand, leaves and flowers in intricate design. Sarchi, Alajuela

461 The basic designs are being filled in with fine lines to enrich the decoration. Sarchi, Alajuela

462 Detail of one side of a freshly painted cart. Sarchi, Alajuela

PANAMA

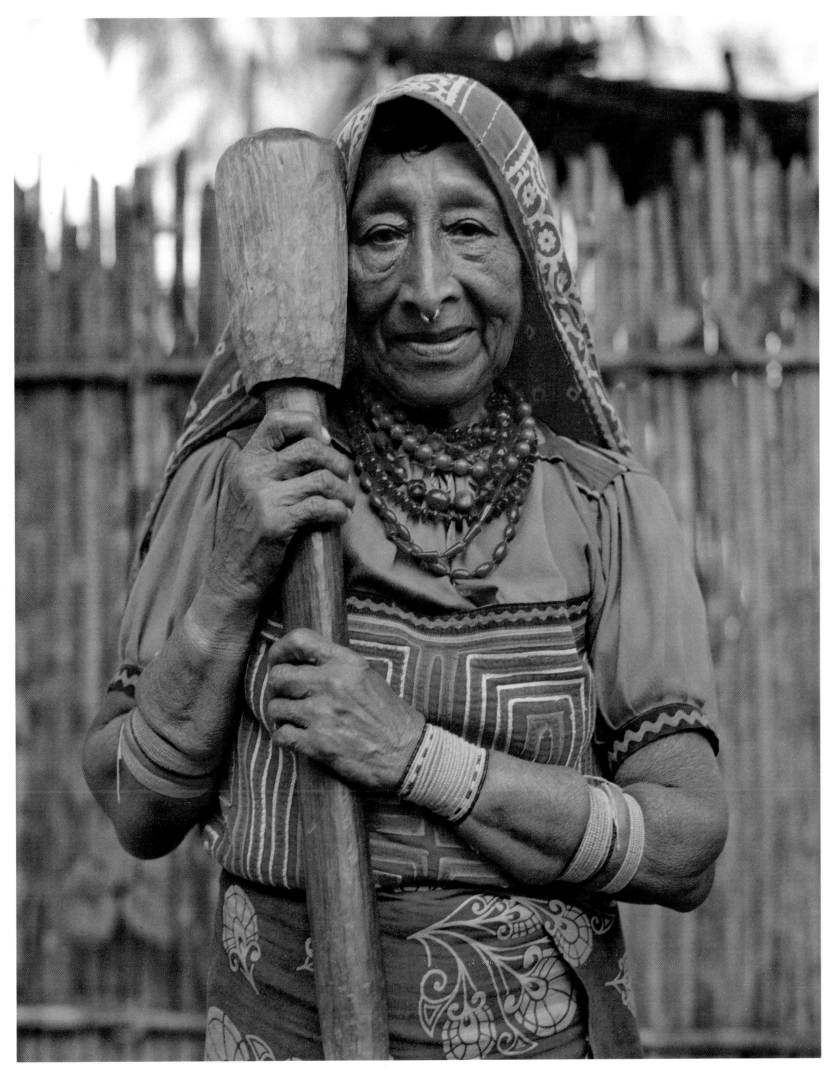

463 Cuna woman wearing a nose ring, a traditional ornament. Her arm ornaments are repeated on her legs and are decorated with glass beads

The entire history of modern Panama has been conditioned by its geographic contours. Ever since its discovery, the isthmus of Panama has been the crossroads of the Atlantic and the Pacific.

The Spaniards who first reached its Caribbean coast encountered fierce resistance from the natives and were able to construct only a small fort. Alonso de Ojeda set sail to look for reinforcements and never returned to Panama; his boat ran aground on the Cuban coast. The man who colonized and explored this territory and who discovered the Pacific shore was Núñez de Balboa. From that time on Castilla de Oro, or Panama as it came to be known, grew into the headquarters for expeditions, which were as frequently directed northward, to Nicaragua, as southward, to Ecuador, Peru, and Chile.

As soon as the short distance between the Pacific and Atlantic was verified, an attempt was made to establish a direct passageway between the two oceans. During the time of the conquistadors more or less open pathways were discovered and the first roadways between one shore and the other were built. Cities were also established at both ends of the passageway in order to control access. In this way Panama became a nerve center that the Spaniards defended as much from attacks by Indians, who fought hard against the invader in this territory, as from piracy, which developed in the Caribbean. Among the pirates, Henry Morgan is famous in Panama for setting fire to the capital city, which had to be rebuilt on its present site, some four miles (6 km) inland. During the war against England, Spain lost control of the area in 1739 and had to use the old sea route around Cape Horn.

464

465

464 Cage made from willow switches. Notice the delicate osiers used for the walls and roof. El Valle, Panama

465 Soapstone carving. Generally the figures represented are animals. El Valle, Panama

466 Ruins of the old Panama City, destroyed in a fire set by Henry Morgan; today it is a park

466

Panama was governed by Colombia, which signed a treaty with the United States for the construction of the canal. When the Colombian Senate decided to break the treaty, the United States prompted and helped the Panamanians set up an independent country. The canal once again turned into the focal point of Panama's history and the United States succeeded in gaining control of the Canal Zone in exchange for financial and medical aid. Panama was not to regain complete sovereignty over the canal for a century after signing the treaty with the United States.

The least-populated country in Central America, Panama has a surface area of more than 29,000 square miles (76,000 sq km), while its territorial width is as little as 31 miles (50 km) and reaches 118 miles (190 km) at its widest point. It is a very mountainous country, with level strips of land along the coast that are easily flooded. With the exception of the volcanic peaks, the median altitude of Panama's mountainous area is about 2,950 feet (900 m). Short-coursed, swollen rivers flow from the mountains, creating fertile valleys, where the bulk of the country's agricultural produce is raised. The famous canal runs between the Talamanca and San Blas mountain ranges.

In the province of Darién, which borders on Colombia and has the highest measured rainfall in the world, the perpetual rains and the dense, almost impenetrable vegetation have prevented, up to the present, the construction of that stretch of the Panamerican Highway intended to link the northern portion with the southern.

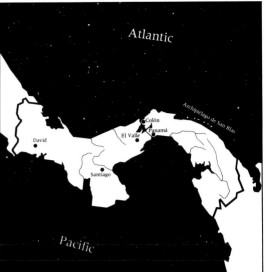

467

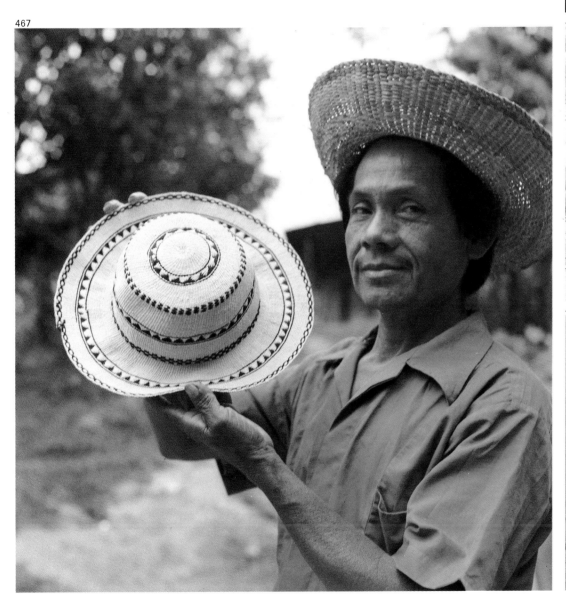

468

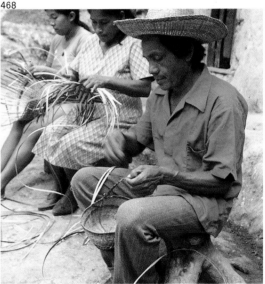

469

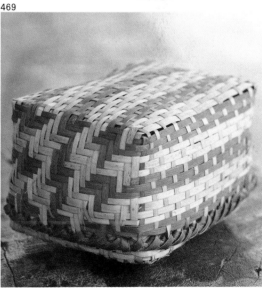

467 A handsome sombrero woven from the bellota plant. The dark color is achieved by boiling the vegetable fiber with aniline dyes. This method protects the color from fading in the sun. El Valle, Panama

468 The entire family is skillful at weaving baskets, bread baskets, sombreros, etc., in order to help make a living. El Valle, Panama

469 Woven from bellota fiber, this chest is made up of two similar parts, one of which fits inside the other. El Valle, Panama

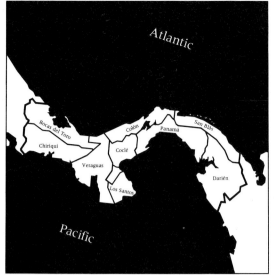

The Chocó Indians inhabit this jungle area, and despite their small numbers they maintain social independence. Another indigenous group, the Guayami, live in the extreme west of Panama. Along with the Cuna, who shall be discussed later, these two groups comprise 10 percent of the country's total population. Another important minority, comprising 15 percent of the total population, are the blacks, descended from the slaves who fled from the Spanish and formed small communities in Darién's jungle region. Subsequently, the blacks were reintegrated with the other inhabitants for the purposes of building the canal and gathering pearls on the islands off the coast.

In order to devote the greatest possible attention to the Cuna, of the crafts of continental Panama only the baskets made from the leaves of the bellota and the small figures carved in saponite, commonly called soapstone because it eventually dissolves when submerged in water, will be mentioned.

Numbering some twenty-five thousand people, the Cuna group inhabits the more than three thousand coral islands of the San Blas archipelago and the fringes of the Atlantic coastline stretching from Colombia to the Gulf of San Blas. The chieftains of each Cuna community maintain relations with the Department of Indian Affairs or with Panama's Ministry of Government and Justice, but the chieftains have established their own internal norms of operating and tolerate no interference on the part of the Panamanian authorities. The communities are organized into clans governed by elders. Marriage among the young is arranged by relatives and divorce is

470

471

472
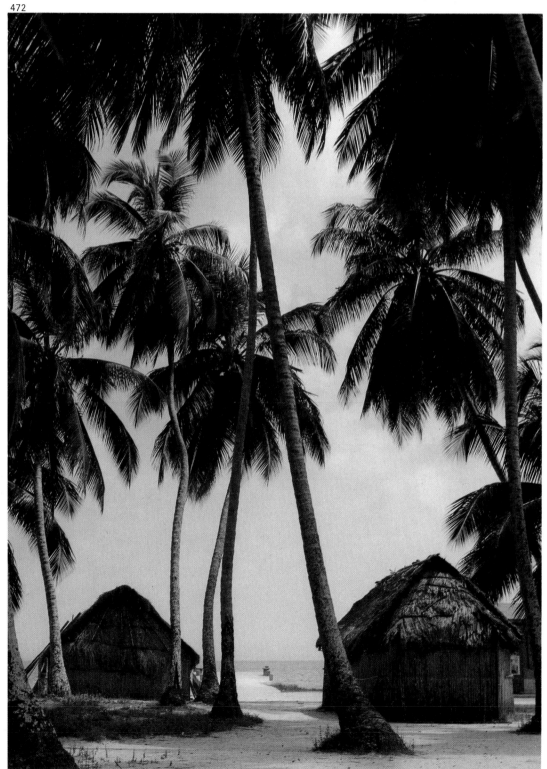

470 Made from palm fronds, the roofs of the huts are repaired by inserting new sheaves. Isla Nalunega, San Blas

471 Cuna woman deftly guides her canoe with a single paddle. Isla Corbisqui, San Blas

472 The sandy soil of the San Blas Islands is held in place by the roots of palm trees. The walls of the dwellings are made from cane. Isla Nalunega, San Blas

recognized. The clans usually live in a communal dwelling and sometimes the youngest sisters of the oldest women will be found living in the same house. The sons-in-law work for the father-in-law, following his orders and accepting his division of labor among clan members.

The Cuna have tried to maintain their traditions and consequently have shunned visits from outsiders and for the past seven years have prohibited strangers from spending the night on the islands. Among the Cuna, land is common property, but coconut palms and all other trees are privately owned. Most of the women stay on the islands, but the men roam along the coast, where they cultivate the land. Communication between the islands and the mainland is easily managed by *cayucos,* canoes fashioned from hollowed-out tree trunks to which outboard motors have been attached.

Among the most notable characteristics of life among the Cuna is the fact that they are the creators of some of the most spectacular handicrafts in all the Western Hemisphere. For the bodice of their blouses, Cuna women manufacture *molas* in reverse appliqué from various colored fabrics that are laid one on top of the other and then cut and sewn to form lovely geometric designs, zoomorphic figures, and tribal symbols.

Cuna women customarily decorated their undergarments with characteristic paintings, but the difficulty of obtaining aniline dyes on one hand and the easy availability of various colored fabrics on the other led to the making of *molas,* beginning around the turn of the century. Originally, *molas* were made in two colors, one fabric

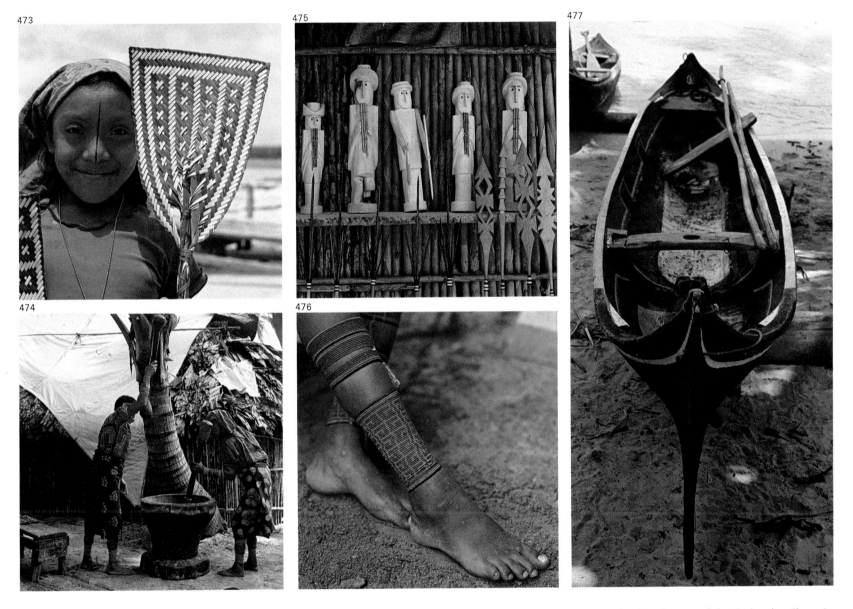

473 Vegetable-fiber fans woven by the Cuna, who rarely engage in this craft. Isla Nalunega, San Blas

474 Enormous mortar in which the women, relieving each other in the arduous labor, grind grain with the aid of two large pestles carved from wood. Isla Nalunega, San Blas

475 Figures in balsa wood and cut-out wooden arrows. Isla Corbisqui, San Blas

476 Detail of leg ornaments, similar to ones for the arm. Isla Nalunega, San Blas

477 Interior view of a canoe. Painted oriental motifs can be seen in some of them. Isla Nalunega, San Blas

being superimposed on the other and the upper one cut through and sewn down. The procedure was later complicated by increasing the number of fabrics and colors.

The Cuna also carve balsa wood into small idols or magic-religious figures used in praying for the recovery of sick people. Some of their weapons are also worked in wood but the Cuna's masterwork in this material is to be found in their canoes, which customarily are made from hollow mahogany trunks. Now that this tree is growing scarce, however, light canoes called *piraguas* or machine-made boats are often seen. The Cuna venture as far as ninety miles (150 km) out to sea in their canoes.

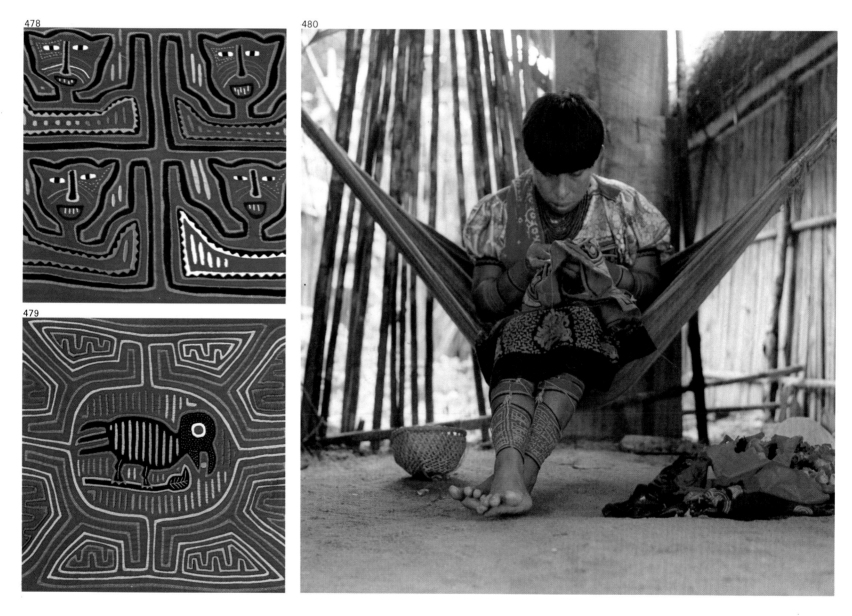

478 *Mola* on bodice of woman's blouse. The design is completely geometric in many of them. Isla Corbisqui, San Blas

479 The craftsworkers like to represent stylized flora and fauna. Isla Corbisqui, San Blas

480 Making the *mola*—daily work among most of the Cuna women. Isla Nalunega, San Blas

481

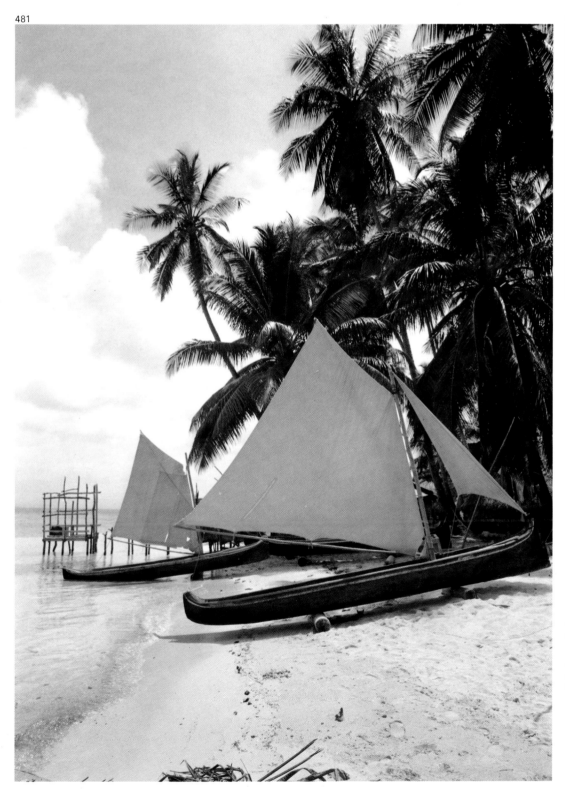

482

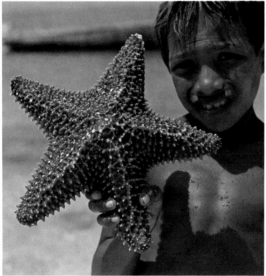

481 Sometimes the canoes are equipped to bear sails. Mahagony or cedar tree trunks are used for making canoes. Isla Nalunega, San Blas

482 Cuna children learn to swim almost at the same time that they learn to walk. They know the ocean floor well and deal in their discoveries. Isla Nalunega, San Blas

COLOMBIA

483 Palmetto straw hats, the so-called Panama hats, drying
in the open air; the artisan's imagination is revealed in the dif-
ferent designs of the decorations. Sandoná, Nariño

Introduction

In the territory now called Colombia a number of cultures arose over the centuries that had affinities with both Central American and Andean civilizations. Nevertheless, even eminently expansionist groups like the Maya and the Inca found it nearly impossible to overcome Colombia's formidable geographic obstacles. Native groups within Colombia itself encountered the same difficulty and, as a result, most were content to occupy a zone marked off by insurmountable natural frontiers, retaining an independent status with respect to groups in the surrounding areas.

For this reason, despite the fact that at first glance Colombia might appear to be a kind of crossroads open to influences from all sides —Mesoamerica, the Antilles, the Amazon, the altiplano —it has been extremely difficult to specify with any accuracy exactly which external influences have played a part in the development of Colombian folk art. There are exceptions; for example, Andean influence is evident in the culture of San Agustín near the source of the Magdalena River, where the characteristic megalithic sculptures of the Andes are found everywhere. Or, to cite another example, the tiered temples of the Tairona culture along the banks of the Magdalena bear witness to a Mesoamerican influence.

The Quimbaya Indian culture developed in the Cauca Valley. Its members were expert goldsmiths and potters and their social structure was made up of three classes —the elite, goldsmiths, and merchants —reflecting their need to engage in trade with the products they produced. The quality of Quimbaya goldwork is superior to that of the rest of the continent; moreover, Quimbaya goldsmiths made important technical discoveries such as lost wax casting.

The Muisca culture, or Chibcha as it is sometimes called, developed on the plateau of Bogotá and Boyacá. Some historians believe that the ethnic origin of the Muisca, an Amazonian people, may be the same as that of the Arawak; the latter, who were very numerous, lived along the Atlantic coast and throughout a large part of the Amazon jungle.

The San Agustín culture had already disappeared by the time the Spaniards arrived. In addition to the aforementioned groups, the conquistadors encountered a large number of communities that varied from societies of nomads, hunters, and gatherers to sedentary cultures that not only had a higher level of social organization but also had highly developed techniques in pottery, goldwork, and textile production, to name a few. The natives offered firm resistance to the conquest, and the Spaniards responded with arrogance and brutality. They exterminated entire populations and plundered great quantities of precious metals. Once the country was conquered, the conquistadors mixed with the Indians, as did the black slaves, who had been imported soon after the conquest.

For this reason, Colombian folk art includes not only the peculiarities of its own autochthonous tradition but obvious European and African influences as well. The mixing of these social and religious components generally manifests itself quite clearly in the exercise of the various crafts; a study of this process may yield observations that are useful in understanding the history of a country.

Colombia is the only South American country that has coasts on two oceans: about 1,000 miles (1,600 km) of Atlantic coast and 800 miles (1,306 km) of Pacific coast. Three branches of the Andean mountain system

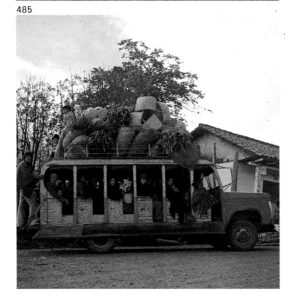

484

485

486

484 Lake Cocha is the largest in southern Colombia. Nariño

485 All means of transportation are used to the utmost. This bus, commonly known as *la escalera* (the stairway), runs between Popayán and Pasto

486 Wool brushing and carding is done with a tool called a *cruceta*, which is made of thistles and is shaped like a fan. Iza, Boyacá

and their spurs extend along the western coast following the perimeter of the country. In the Cordillera Central there are several peaks of altitudes in the vicinity of 1,650 feet (500 m) with perpetual snow; the highest of these, the volcano Huila, has an altitude of 18,865 feet (5,750 m). The Cauca and Magdalena rivers drain the valleys formed by the cordillera. The Magdalena, navigable for almost its entire length, is an important means of communication. In earlier times it was the only mean of access to the interior of the country.

The triangular zone limited by the Atlantic, the Pacific, and the Cordillera Oriental, which comprises 45 percent of the country's territory, is inhabited by 95 percent of the population. This mountainous zone that descends toward the coast, in bleak plateaus of about 1,000 feet (300 m) in altitude, followed by a wide strip of fertile valleys, has practically nothing in common with either the eastern plains nor with the Amazon jungle. On the plains, where immense meadowlands are drained by numerous river systems, cattle raising is an important activity. The jungle, a region of about 13,500 square miles (350,000 sq km), is the least densely populated area of the country; it has 0.2 inhabitants per square mile (0.5 sq km).

Colombia has about 24 million inhabitants and only 2.2 percent of them can be considered descendants of the ancient tribal groups. Of the Chibcha linguistic group there remain the Cuna, the Paez, and the Panzáleo groups. Of the Carib group, the Chocó and the Motilone remain. Some other smaller groups remain as well, such as the Barbacoa, the Tairona, the Quimbaya, the Chimilo, the Pijao, etc. Of the rest of the population, 47.8 percent are mestizos, 24 percent are mulattoes, 20 percent are white and 6 percent black.

Even though there are relatively few descendants of the original pre-Columbian inhabitants of the country, there still exist within Colombia, despite the economic and technologic development, tribal communities that remain faithful to their own traditions and that are all but indifferent to modern industrial development. The relative isolation of these groups resulting from the country's unusual topography has been an important factor in the preservation of such tribal traditions.

Colombian folk art makes use of a wide range of materials and techniques: metal, wood, fur, clay, reed, and fiber have all lent themselves in numerous ways to the creativity of the Colombian craftsworker.

The examples of folk art from specific craft centers that are reproduced and described here have been selected on the sole basis of quality of workmanship. This criterion is a departure from the plan of the book as a whole; nevertheless it has seemed to be the best way of demonstrating the skill of the Colombian artisan. Keep in mind, however, that this is not a definitive sampling of the wide variety of Colombian craftwork.

A few centers where authentic folk art is produced are as follows: for pottery—Chamba, Popayán, Pitalito, and Carmen de Viboral; for weaving—San Jacinto, Cerrito, Iza, La Jagua, Guajira, and Sibunday; for basket-weaving—Tenza, Vaupés, Emberés de Saija, Hoya de San Juan, and the Pacific coast; for woodcarving—Pasto and Popayán; for goldwork—Mompós and Barbacoas; and for leatherwork, Belén, Envigado, and Chocontá.

488

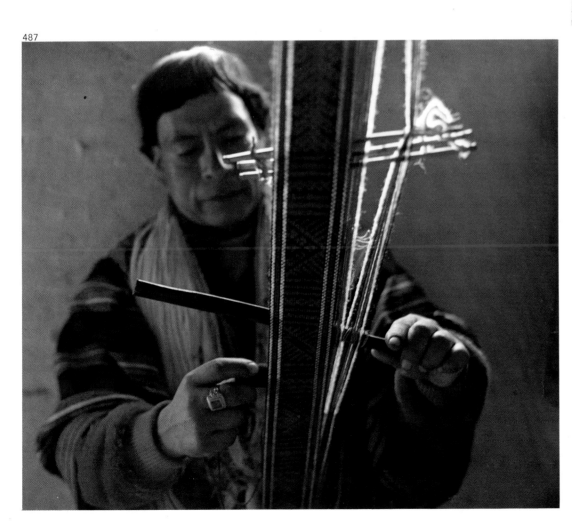

487

487 Kamsa Indian weaving a sash, or *chumpi*, on a back-strap loom. Sibunday, Putumayo

488 Magnificent bullfight scene made of fired and glazed clay. Chiquinquirá, Boyacá

169

Pottery

The region of Ráquira, to the west of Tunja in the Cordillera Oriental of the Andes, has been known as an important pottery center since ancient times. One of the early chroniclers noted in this regard: "Potters' towns, the conquistadors called them; in all the towns and villages around Tinjacá there were outstanding artisans who were so absorbed in their work with clay that the arrival of the Spaniards scarcely distracted them from their occupation. . . ."

Pre-Columbian archeological remains suggest that Ráquira and the surrounding territory shared techniques and styles with other Chibcha groups who were also potters, and that a wide variety of vessels, bowls, pitchers, plates, and cups was manufactured for household use or for trade. The remains also indicate that these potters took special pains in the elaboration of ceremonial vessels. They used engobes, vegetable and mineral pigments, incising, relief work, and modeling to achieve intricate decoration in geometric designs or human and animal shapes, giving evidence of a high level of technical advancement in this craft.

The arrival of Europeans distorted the process of native cultural development and imposed substantial changes in the practice of the potter's art. The objects traditionally made by the natives were stripped of their essential elements—their symbolic designs and special meaning—and persisted in the early days of the colonial period as naked, strictly utilitarian objects that became an effective means of helping to pay the heavy tribute demanded by the new landholders and *encomenderos*.

Slowly, as the process of intermingling continued, the craft began to adapt to new concepts and new demands. In time pottery became a folk art that reflected the special cultural and ethnic background of this community; both technique and design give clear evidence of the dual origin of these potters.

Of the techniques the Spaniards brought with them, native potters adapted the Mediterranean-type kiln, lead glazing (a process that today is increasingly rare), and the use of certain forms and utensils. They chose to ignore the potter's wheel. The use of iron-rich earth and river sand for decoration is reminiscent of the earlier native production, as is the rounded and austere shape of the vessels.

The Ráquira potter has at hand all the materials necessary for the practice of his art. The soil of the region is rich in clays of alluvial origin, including fine kaolins; river sand provides a rough texture to the clay mixture; and everywhere there are abundant supplies of the dark iron-rich soils and the white chalky deposits that Ráquira potters use sparingly in decorating their wares. To get wood and charcoal to stoke their adobe kilns they have only to go to the nearby woods, which have been subjected for countless years to a continuous and systematic process of deforestation.

There are no hard and fast procedures for the preparation of clays or for the addition of sand, grog, or other such agents. Each artisan works out mixtures and proportions according to the materials he has at hand and the qualities and characteristics he wants to give the objects he is making. He begins by grinding up lumps of clay with a long wooden pestle, removing the most obvious impurities. He stores the result in large vessels in a cool place, half-buried in the earth. Sufficient water is added to convert the mixture within a few hours into a moist, homogeneous mass. He kneads this carefully, adds an appropriate quantity of sand, and lets it stand, this time in the form of conical or rectangular blocks, each of which contains the approximate amount needed to make the piece.

489

490

491

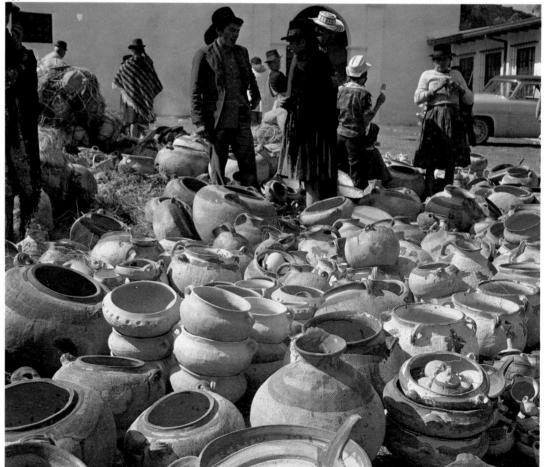

489 Traditional pieces from the rural areas near Ráquira. Boyacá

490 Little horse of Ráquira of baked clay. Boyacá

491 Pottery market in Villa de Leyva. Boyacá

When the material is of the desired consistency, the potter takes a chunk in his hands and gives it a sharp blow with his fist, forming a hollow. He places the clay on an old plate, piece of wood, or on the bottom of a broken pot and begins to turn it by means of the slow circular motion of the hand while using the other hand to impart the shape. He rapidly produces the first version of the piece and lets it stand until it dries slightly and acquires a harder consistency. Then he takes it up again, this time using a smooth stone to press outward from the inside, thinning and extending the wall that he supports from the outside with the other hand.

If he is making a large vessel, such as the great jars used for storing liquids, the potter may use the coil method, adding successive rolls of clay coiled round and round, the coil resting on the base portion. When the clay is sufficiently firm, the potter scrapes the outside surface with a piece of gourd, thin wood, or tin that he calls a *ruca*. With this he corrects the shape and removes impurities and excess sand. To finish the inside, he uses a smooth stone that he moistens constantly, rubbing the inside surface and smoothing it with small circular movements. When the polishing is finished, the potter allows the vessel to dry in the open air, protecting it from the hot sun. The pieces continue to pile up in a shed or in the halls of his home until he has enough finished to justify firing the kiln.

The day of the firing, while the family hurries to get wood and place it in the hearth of the kiln, the potter prepares a thin mixture of red ground clay and water and applies it rapidly to all the pieces, sometimes with a

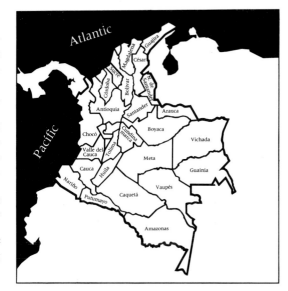

492

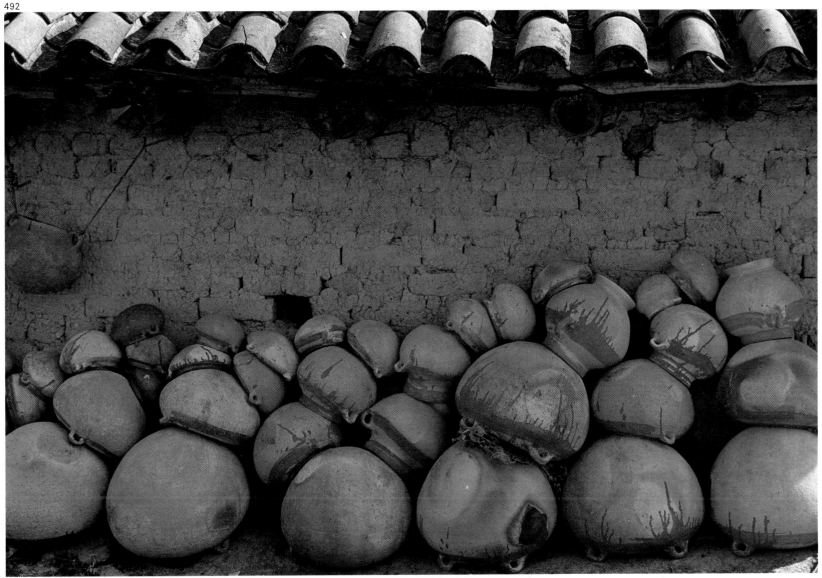

492 Once finished, the pieces are stored in a lightly protected area under the eaves. Ráquira, Boyacá

small brush but more often with a chicken feather, adding little irregular touches and fanciful lines, or perhaps a few parallel stripes, which constitute the only decoration these pieces will have.

The kiln used by the Ráquira artisan to fire his work is of the Mediterranean type, usually arched and sometimes conical. It uses a direct flame and is built of adobe and stones with bits of broken pots stuck in here and there. It consists basically of a firing chamber with a chimney located above and separated by a grating. It has a large, arched opening which sometimes has pots fastened on the edges; this facilitates sealing the kiln during the firing process.

The kiln must be carefully loaded. This is a task that must be done by a skilled, experienced potter who thoroughly understands the conditions and requirements of each piece and who knows how to stack them so that they receive the appropriate temperature. The potter secures and shores up his carefully studied structure with bits of broken earthenware stuck in here and there. Then the mouth of the kiln is sealed with stones, bricks, and moist earth, which is also used to seal up cracks.

The firing begins with a long period of slow heating after which large logs are added to make a hot fire that may last for six or more hours. The kiln is cooled down slowly and a rest period is allowed before the final stage of removing objects from the oven.

Most of the pottery produced is utilitarian and traditional in character, rustic in appearance, and austere

493

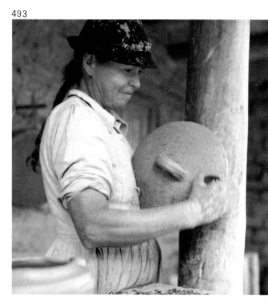

494

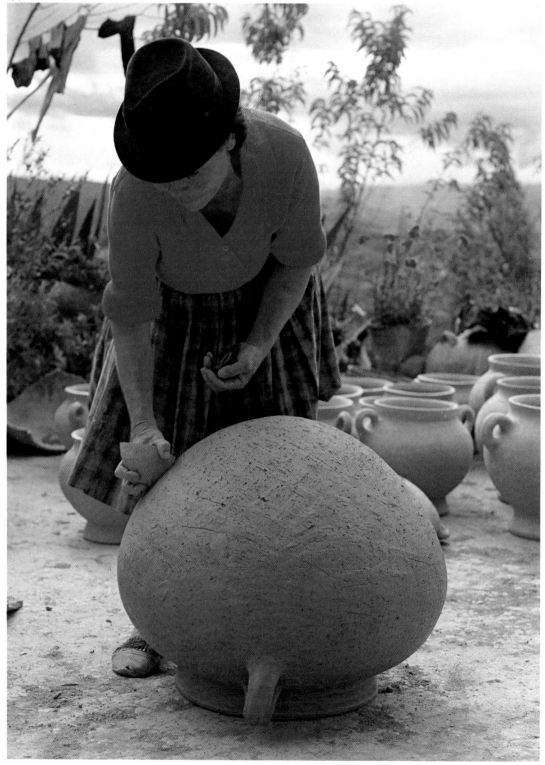

493 Potter polishing the top of a pot. Ráquira, Boyacá

494 Piece is being polished while the clay is still wet. Ráquira, Boyacá

in style, without ornamentation. It is pottery designed and adapted for the domestic tasks of country folk: cups, pitchers, pots, *areperos* (dishes for *arepas* or griddlecakes), bowls, and *chorotes* or chocolate pots, vessels in which the country people cook or preserve their food or store or transport such liquids as water, *chicha*, or *guarapo*.

Alongside this basic production, but still within the tradition of this craft, is the whole area of toymaking: tiny horses, hens, sheep, whistles and ocarinas, banks, and charming miniature replicas of pottery vessels, called "corn kernels."

Although to a limited extent, dinnerware and certain modern utensils the country people have adapted are also produced: pitchers, saltcellars, coffeepots, casseroles, trays, ashtrays, cups, and candelabra. Like the traditional objects of rural origin, these have a simple, almost elemental design and little or no ornamentation.

In great straw bundles the artisan transports his wares on muleback, and sometimes on his own back. He takes them to nearby plazas or to the town's weekly market where he sells them to local merchants or to wholesalers, who then send them by car or truck to various distribution centers. Although this is the solution he generally prefers, since it allows him to count on a stable buyer to whom he can sell all his merchandise, the potter sometimes sets up his own pottery stall in order to sell his wares directly, item by item, which may give him an increase over the meager price he gets from wholesalers or middlemen.

495

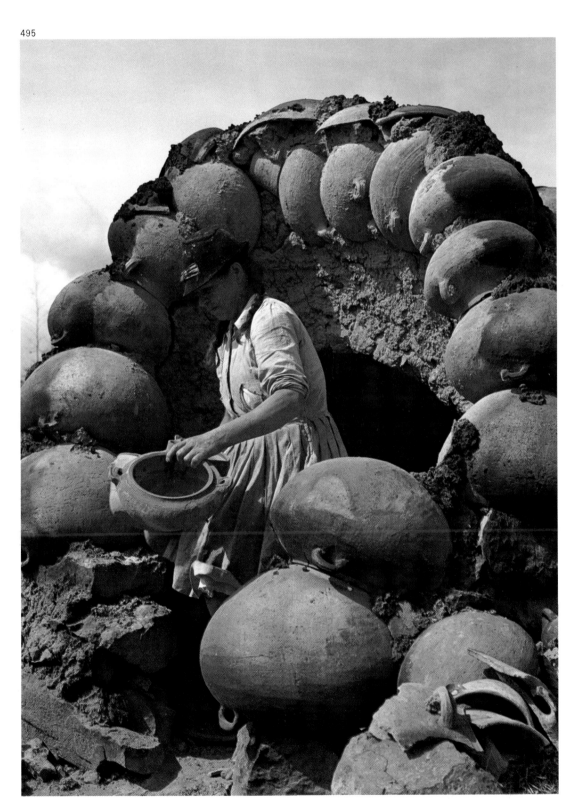

496

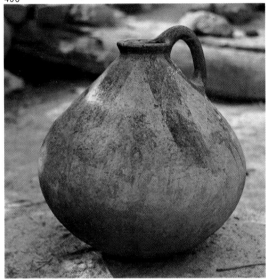

495 Traditional arched kiln in the Ráquira area, with the front part rimmed with pots to facilitate sealing during firing

496 Fired clay pitcher. Ráquira, Boyacá

497 Folk scene in painted clay. Musicians with their instruments in the doorway of a home. Chiquinquirá, Boyacá

498 Packing method using rope, straw, and ferns for transporting finished articles. Villa de Leyva, Boyacá

Artisans from all parts of Colombia work together in manufacturing centers to produce —sometimes on a large scale —the traditional palmetto straw hat commonly known as "Jipi" or "Panama." This venerable native technique originated in Jipijapa, a small coastal town of Ecuador. At the beginning of the nineteenth century this craft moved toward the neighboring regions of Nariño, in the south of Colombia, where it became part of a long tradition of textile production; from there it extended to the departments of northern Colombia. Production centers were created in Sandoná, Aguadas, Sauza, Utiza, Bucaramanga, Usicuarí, and San Pablo, among others. As time passed these places developed their own styles and techniques.

The raw material used to make the hats is the tender sprout of the iraca palm tree *Carludovica palmata* — a plant that is variously known as *toquilla, palmiche naouma, murrapo, alagua,* or *rabiahorcado,* according to the region. Many other items of domestic use are made from it, including baskets, table mats, brooms, and toys.

The preparation of the plant for use constitutes a separate specialized occupation that includes the careful selection of the stalks; the separation of the fronds into narrow, even strips; heating; the repeated washing and drying of the fibers; and the essential task of bleaching, which in some localities culminates in "baking." In this step the straw is submitted to the action of sulfur smoke in rudimentary ovens that have walls made of sticks interwoven with reeds and reenforced with mud.

The white iraca palm is the one most frequently used for hatmaking. In earlier times a wide range of

Straw Work

499

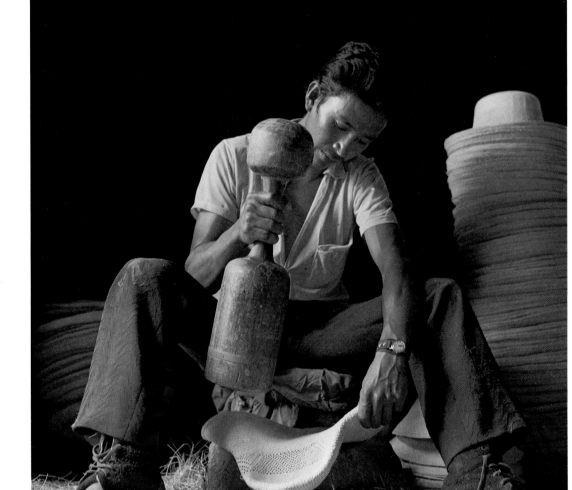

500

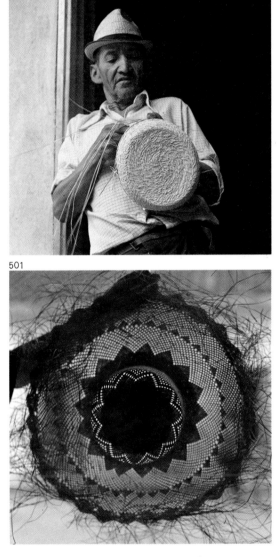

501

499 Pounding a palmetto straw hat. Sandoná, Nariño

500 Basket woven of natural palmetto straw, decorated with fine lines of dyed straw. Sandoná, Nariño

501 Palmetto straw mat to adorn a table or chest. Sandoná, Nariño

beautiful brown shades was achieved by using dyes made of walnut leaves and bark, but this technique is no longer used.

Not long ago commercial aniline dyes came into use; weavers themselves can prepare the materials and achieve strong colors by boiling the material for a few minutes and adding a household substance such as lemon or salt as a mordant.

The actual making of the hat consists of two well-defined stages: weaving, which is invariably done by peasant women who alternate the weaving with household chores and farm work; and finishing, a detailed process usually executed in urban workshops by skilled workers, who are nearly always male. The weavers use only a few basic pieces of equipment for their work: a rough wooden support that holds the form on which the weaving is done, a medium-sized stone to hold the work in place, a piece of cloth to keep the fibers from getting dirty, and a small container of water so the weaver can periodically moisten her fingers.

Seated on the floor or on a small wooden bench, the weaver begins to interweave the fibers, extending the weaving radially and adding "increases" as the work advances. She makes the center and works downward to form the crown; then she weaves the brim, finishing it off with a little braid.

The work has taken countless hours of painstaking effort. The production of an article of average quality requires a week's work, and the manufacture of a good, thick, even piece of weaving may require fifteen,

502

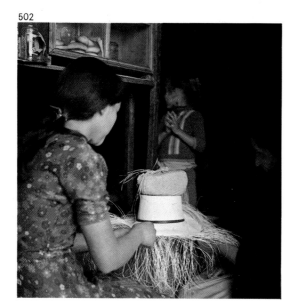

503

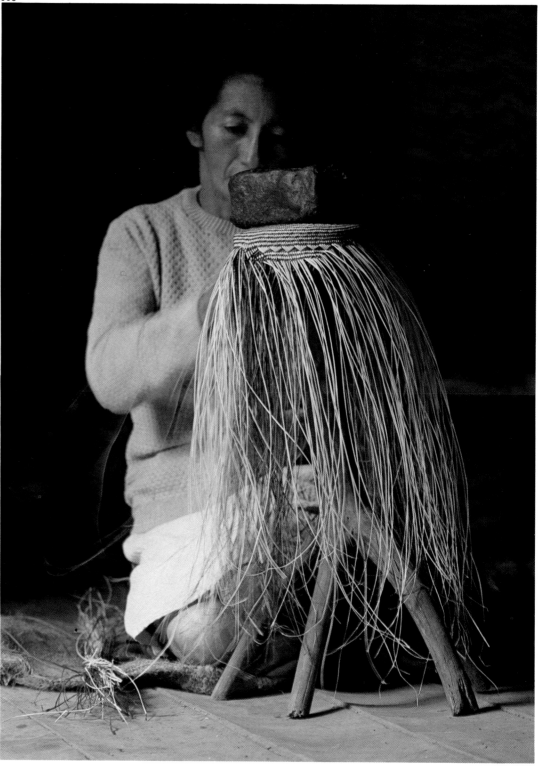

502 Weaving the brim of a hat. Often a whole family works together in the production of an article. Sandoná, Nariño

503 The crown and brim of the hat are woven on a special frame; the work is held in place with a weight. Sandoná, Nariño

176

twenty, or thirty days. The quality of the weaving differs according to the material selected and to the weaver's idiosyncrasies, which can make subtle changes in the texture. For example, some weavers work only in the early morning or in late afternoon when the air contains the exact amount of moisture necessary to keep the fibers from becoming stiff and to maintain them in the pliable condition needed for optimum results.

The weaver's contribution is limited to this initial stage. She takes her wares, still "in the rough," to regional markets and sells them to middlemen or to shop owners who handle the finishing and sales of the hats. Finishing involves several steps: the weave must be tightened and loose ends must be clipped; this is followed by scrubbing with a brush and soapsuds, sulfurizing, rewashing, evening the texture by beating the surface with a heavy, rounded mallet, and finally blocking the hat on a wooden mold to give it final shape and to establish its size.

Although the material, the technique, and the fineness of the weave are characteristics common to all palmetto straw hats, the design, which was originally patterned on autochthonous models, has developed along different lines according to the customs, styles, and needs of various regions of Colombia and, to a great extent, the country to which the hats are exported. Even today hats are manufactured with tall, medium, or low crowns; with wide or narrow brims; of plain, elaborate, or dense weave. Hats are given different names according to their characteristics, quality, or place of origin: Suaza, Jipa, Borsalino, Ranchero, Alón, Redondo, Palmeado, Jalisco, to name a few.

504

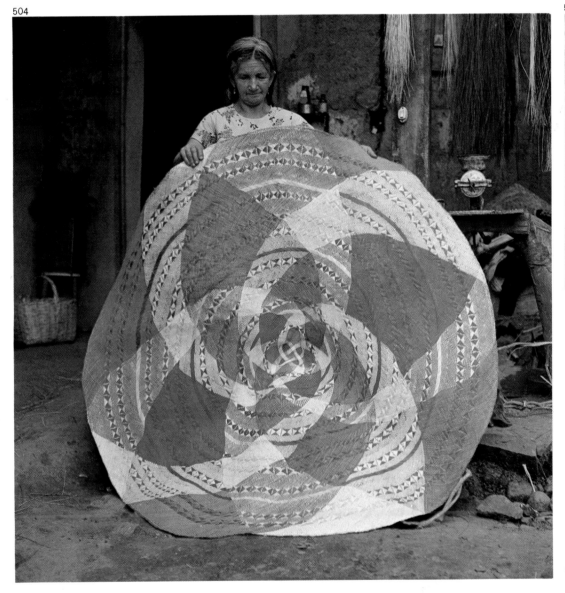

505

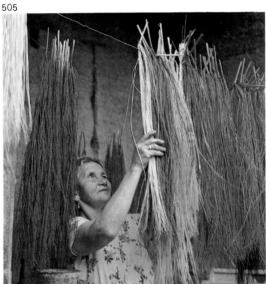

504 Rug or mat of palmetto straw. Sandoná, Nariño

505 Palmetto straw is sometimes hung out to brighten the colors of the designs in the finished rugs or hat

Varnished Wood

The technique of using Pasto varnish, which is really neither a varnish nor a lacquer, to decorate many different types of wooden objects, such as furniture, plates, trays, boxes, vases, and other vessels, is one of the few techniques of pre-Hispanic origin still in use today. The process used by today's craftsworker is almost identical to that used by the original native artisans; the only changes are from adaptations to a natural evolution in design.

The long tradition of this craft as well as the unusual qualities of the vegetable resin that is used as its raw material are well documented in the accounts and notes of the early chroniclers and of colonial scholars. The craft is practiced exclusively in the city of Pasto. Although at the beginning of the seventeenth century some accounts refer to the existence of this industry "in Quito and in other parts of Peru," everything seems to indicate that even in that period the varnish was a craft specialty of this area, where it is still practiced today.

The "varnish" is made from the resin secreted by the mopa-mopa bush, a wild shrub of the humid jungle regions of Putumayo and Caquetá in the southeast of Colombia. Twice a year the plant produces new buds, and little balls of resin —soft, springy, and olive green in color— are formed as the new leaves develop. The Sibunday Indians, who live nearby, gather this material and make it into loaves that they deliver periodically to Pasto and sell by the kilo to local artisans, who immediately begin the process of preparing it.

After pounding and breaking up the block of varnish, they carefully cleanse the material, macerating and softening it by bathing it repeatedly in boiling water while removing bark, leaves, and other impurities that may

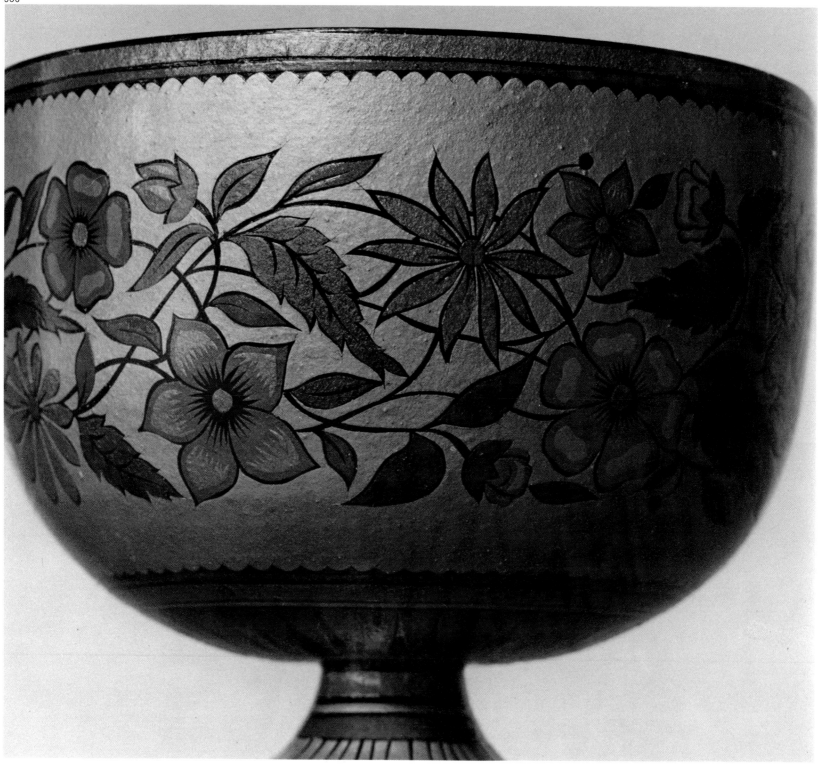

have adhered to the sticky material. When the mass of material is completely free of foreign matter it is put through a common kitchen grinder —a short while ago it was chewed by the artisan—until it is reduced to a fine dough. The artisan then proceeds to tint it, first dividing it into portions according to the amount he needs of each color, then adding the appropriate amount of powdered aniline, which he mixes in carefully to obtain a perfectly even tone throughout. Each one of these portions is stretched until it is made into a thin, transparent sheet, the resin being handled by two people who use both hands and their teeth in order to obtain a regular surface without wrinkles.

In order to carry out the "varnishing" process, the artisan uses only simple equipment: a sharp knife, a small electric hot plate used to fix the resin and make it stick, some brushes, a ruler, a compass, and an ordinary pot into which he will occasionally dip the material to heat and soften it.

In applying the varnish the first step is to properly prepare the surface of the piece of furniture or wooden item that is to be the base. Formerly, when all items had to be waterproof because they were used as kitchen utensils, etc., and were brought into constant contact with moisture, they were entirely covered with an initial coat of resin to which were added figures and designs as successive coats were applied. Today most items have a decorative rather than utilitarian function, and the varnish is applied to a wood base that has been adequately treated with a coat of mastic and oil-base paint that appears in its characteristic colors —red, green, and black.

Two kinds of varnish are made in Pasto. In the type called "pure varnish," which is most widely used today,

507

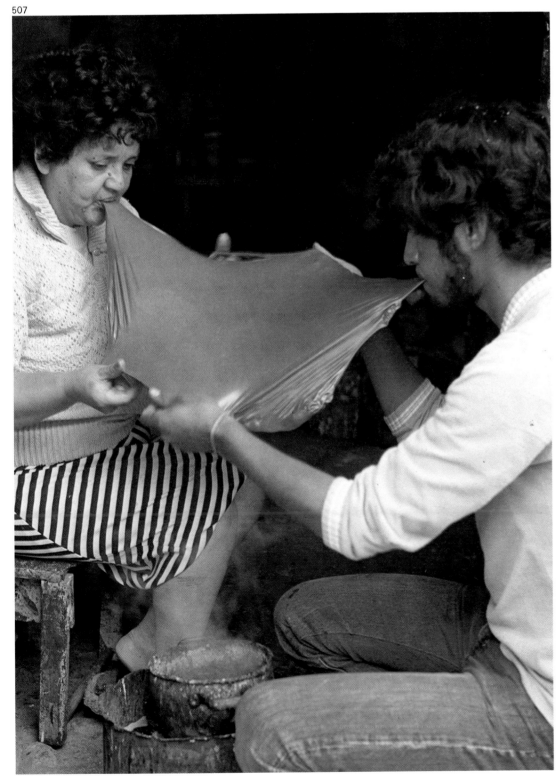

508

506 Bowl decorated with Pasto varnish. Pasto, Nariño

507 In order to stretch the sheet of resin two persons must work together. Stretching is done over a small fire and great care must be taken not to tear the sheet. Pasto, Nariño

508 Detail of a wooden bowl decorated with Pasto varnish. Pasto, Nariño

179

the artisan places the sheet smoothly over the object before beginning to draw and cut out the figures with the point of a knife, lifting up and removing the cutout portions. He uses as many layers as necessary for the design he is making, superimposing and pressing them down with the palm of his hand as he heats the object slightly on the hot plate, which causes the varnish to harden. The result is a smooth, hard surface in brilliant colors that reminds one of lacquerware to which craftsworkers have added an unnecessary coat of commercial varnish.

Throughout the long history of this craft only the traditional technique known as "shiny varnish" was used. This technique has declined in recent years and has now all but disappeared; it is practiced at the moment by only a handful of artisans. This technique differs from the one just described in that gold and silver leaf is used in the decorative motifs underlying the transparent layers.

During the last thirty years the shiny paper used in commercial packing has gradually replaced the metallic leaf once used. The technique requires special skill as well as a sustained and meticulous effort, since the varnish must hold the metallic layer fast between two layers of resin before one can proceed to cut out the figures; the first layer holds it fast to the surface of the object, while the second, which is especially thin, covers and protects it, allowing the shiny surface to gleam through, producing the characteristic effect of this type of work. Because this technique demands great patience and skill, it has unfortunately been displaced by others that are better suited for a rapid, voluminous, commercial production.

509

510

509 The stage at which one of the layers of resin is being cut out. Pasto, Nariño

510 Detail of a bargueño worked in Pasto varnish. Pasto, Nariño (Convento de la Candelaria, Ráquira, Boyacá)

511 Wooden ladles with carved handles. Obonuco, Nariño (Museo de Artes y Tradiciones, Bogotá)

One of the most important craft centers to develop in the Americas was Quito, Ecuador. Its influence extended from Tunja, Colombia, in the north to ancient Charcas in the south and included the southern part of Colombia, which concerns us here. Its schools and craftsworkers were thus part of the domain of the Inca, who were renowned for the high quality of their artisanry. Here, by accident of history, there came together a wide variety of cultural influences: Flemish, Mudejar, Italian, and Spanish. Throughout this zone of influence a solid artistic tradition began; a number of crafts —woodcarving in particular —enjoyed a development that has continued up to the present.

The religious zeal of the Spaniards began to manifest itself with the arrival of the conquistadors; woodcarving and cabinetmaking thus had their initial development in the production of altars, coffers, retablos, religious images, and church and monastery furniture. Once the era ended that had given rise to these great works, woodcrafts little by little began to approach the concept of carpentry and handwork that is appreciated today throughout the country. It is in southern Colombia, however —perhaps because of the native ability of the inhabitants and their constant contact with the cultures of the south —where carving has remained a constant expression of the values of the past, when it reached a high level of formal virtuosity.

Wood appropriate for carving, sometimes of exceptionally fine quality, has remained abundant, despite the implacable process of lumbering, especially in Patía and in the large neighboring zones of Putumayo and Caquetá, or in the immense forests that stretch from the base of the Andes to the Pacific coast. This abundance,

Carving

511

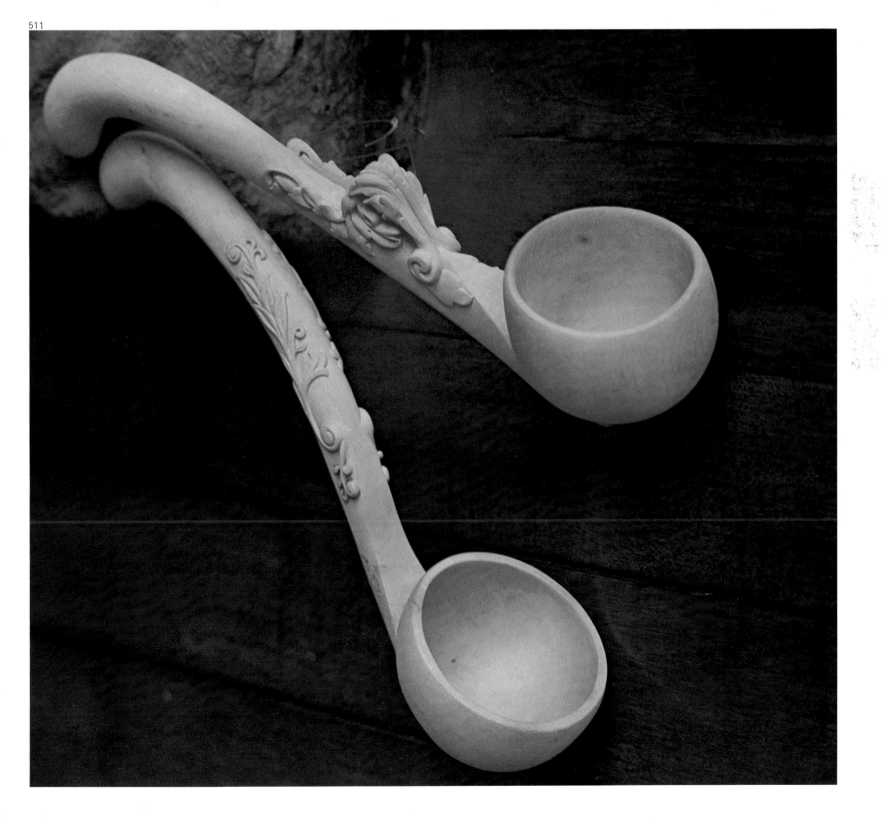

however, is not exactly at the disposition of the artisans of the south. The oaks, cedars, mahogany trees, *chachajos*, tamarinds, *matilones*, pines, and the lignum vitae that grow there were at one time an important factor in the development of the craft, but are now the object of massive and well-organized export operations. The regional woodcarver, with great difficulty and at considerable sacrifice, can obtain only a certain few varieties to which he must now limit his labors: cedar, orange, *romerillo* pine, and, on rare occasions, lignum vitae and tamarind.

Sometimes, if a project requires it, the woodcarver must go into the wilderness or the highlands of Mapachico and Yacuanquer and obtain from the natives of the area the right to select and cut a few branches or trunks of *majua* or *café*. Since dry wood is high in price, craftsworkers usually buy it green; they plane it and then store it in great piles outdoors in the shade until the weight and color of the wood indicate that it is ready for use.

In addition to the usual tools of the trade (handsaws, gouges, files, chisels, planes, etc.) the woodcarver makes use of the ubiquitous native machete and numerous instruments for carving and ornamentation that he fashions himself out of old knife blades, nails, or needles. Since he finds tools of national manufacture to be of poor quality and imported tools unaffordable, he usually makes use of such items as old automobile springs or discarded tools to make his own gouges and chisels. A tree trunk to support his work, sometimes replaced by an old seat, a simple vise and some molds or supports that he also devises himself complete his equipment.

With a machete or handsaw the carver cuts pieces of wood upon which he traces a pattern —with card-

512

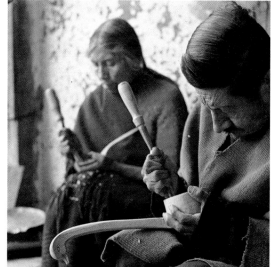

513

514

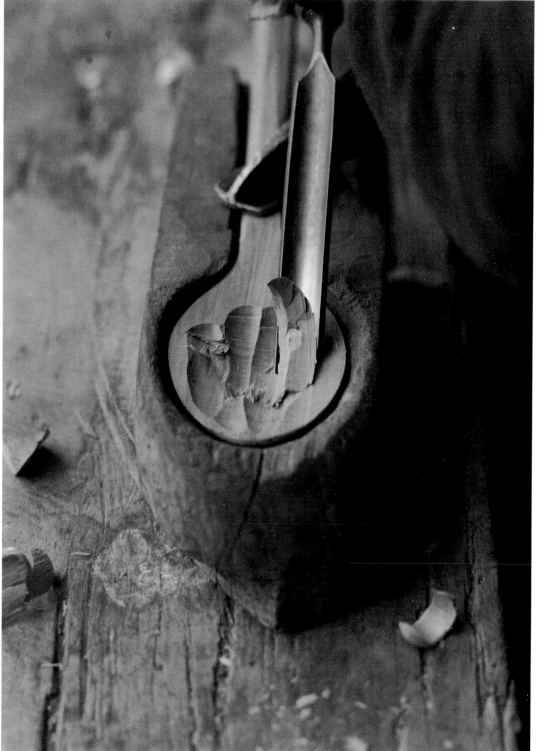

512 Finishing the bowls of the ladles. Obonuco, Nariño

513 Cutting wood to make a spoon base. Obonuco, Nariño

514 The spoon is usually placed in a wooden mold to hold it steady while it is being carved. Obonuco, Nariño

board or rubber —before smoothing the wood with a mallet and chisel. He uses gouges and knives to create the shape, and on occasion he uses a tool called the *muñequín*, a short-bladed plane that adapts to curves. To secure the pieces, he sets them in a mold or simply holds them firmly on his lap while working on them with gouges.

The woodcarver then turns to the most demanding and painstaking work: the modeling and carving, for which he employs a number of homemade tools. He chisels out the desired shape, following a carefully studied design that he preserves on small patterns made of thin cardboard. He then polishes the object thoroughly, using files and sandpaper to achieve a fine finish that reveals the quality of the wood.

Some of the objects made are tablespoons, ladles, smooth trays in a variety of shapes, and sets of decorated dinnerware in different sizes, sometimes in the form of marvelous miniatures. On rare occasions, and only when commissioned, carvers make special boxes and other types of receptacles. These objects are carefully designed and are decorated with contrasting smooth and carved areas. Motifs include flowers, foliage, garlands, lozenges, and latticework, as well as birds, butterflies, frogs monkeys, and squirrels. The ornamentation reflects in a simple, direct way, without elaborate commentary, the everyday environment.

An article that has become identified with the craft is an enormous ladle with a carved handle; this has become a kind of symbol in that its elaborate decoration combines traditional influences and reveals the level of virtuosity achieved by these carvers.

515

516

517

515 Carved wooden stool. Obonuco, Nariño

516 Stool carved from a single piece of wood. Vaupés community (Museo de Artes y Tradiciones, Bogotá)

517 Artisan carving a leaf design on the handle of a wooden spoon. Obonuco, Nariño

Catalogue

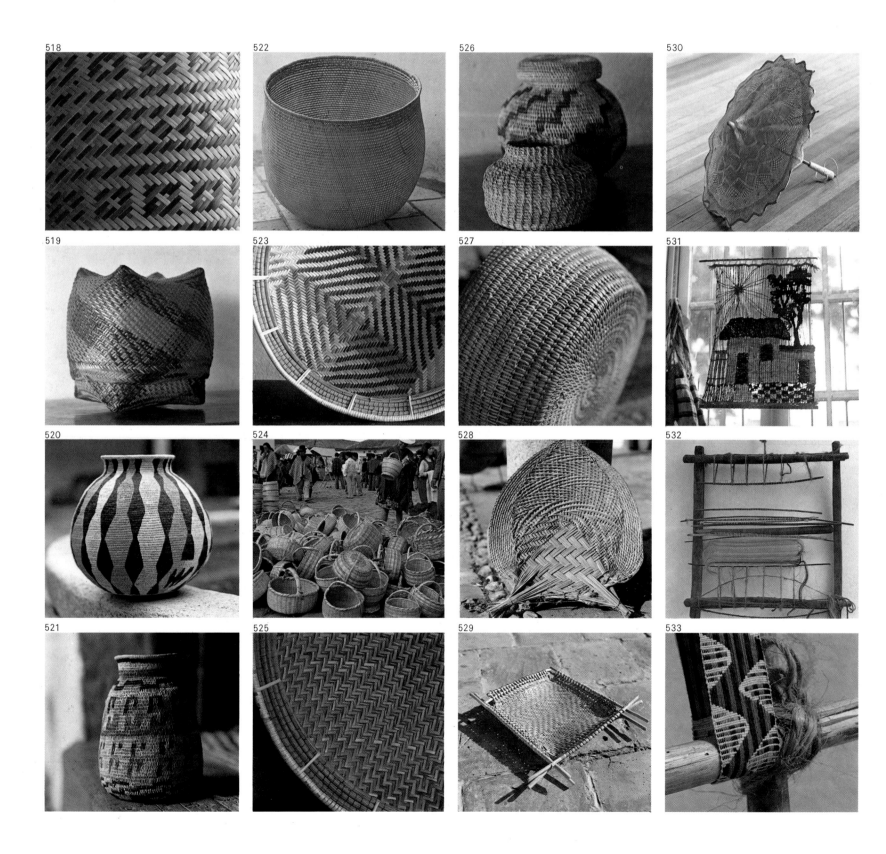

518 519 520 521 522 523 524 525 526 527 528 529 530 531 532 533

534 Natural wool blanket woven on a treadle loom. Iza, Boyacá

535 Handwoven wool fabric to be used for making a bag. Sutamarchán, Boyacá

536 Natural wool blanket woven on a treadle loom. Iza, Boyacá

537 Tapestry with appliqué designs. Santa Rosa section of Bogotá

538 Tapestry with appliqué designs. Santa Rosa section of Bogotá

539–542 *Molas*, textiles made of many layers of cloth. Cuna group, Antioquía

543 Ceremonial vessel. Vaupés group

544 Rural pottery shop. Tuaté, Boyacá

545 Ceremonial vessel with tribal designs. Vaupés group

546, 547 Fired, glazed clay. Chinquirquirá, Boyacá

548 Chest made of animal horn

549 Credenza with inlaid work in wood and bone. Bogotá

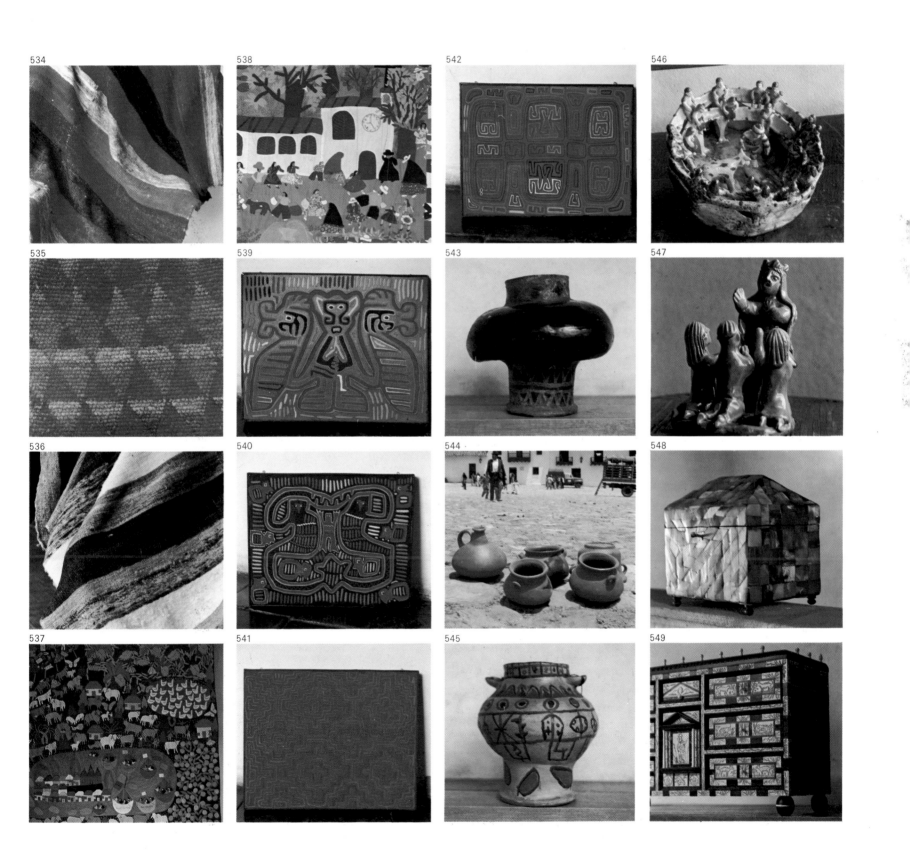

534

538

542

546

535

539

543

547

536

540

544

548

537

541

545

549

VENEZUELA

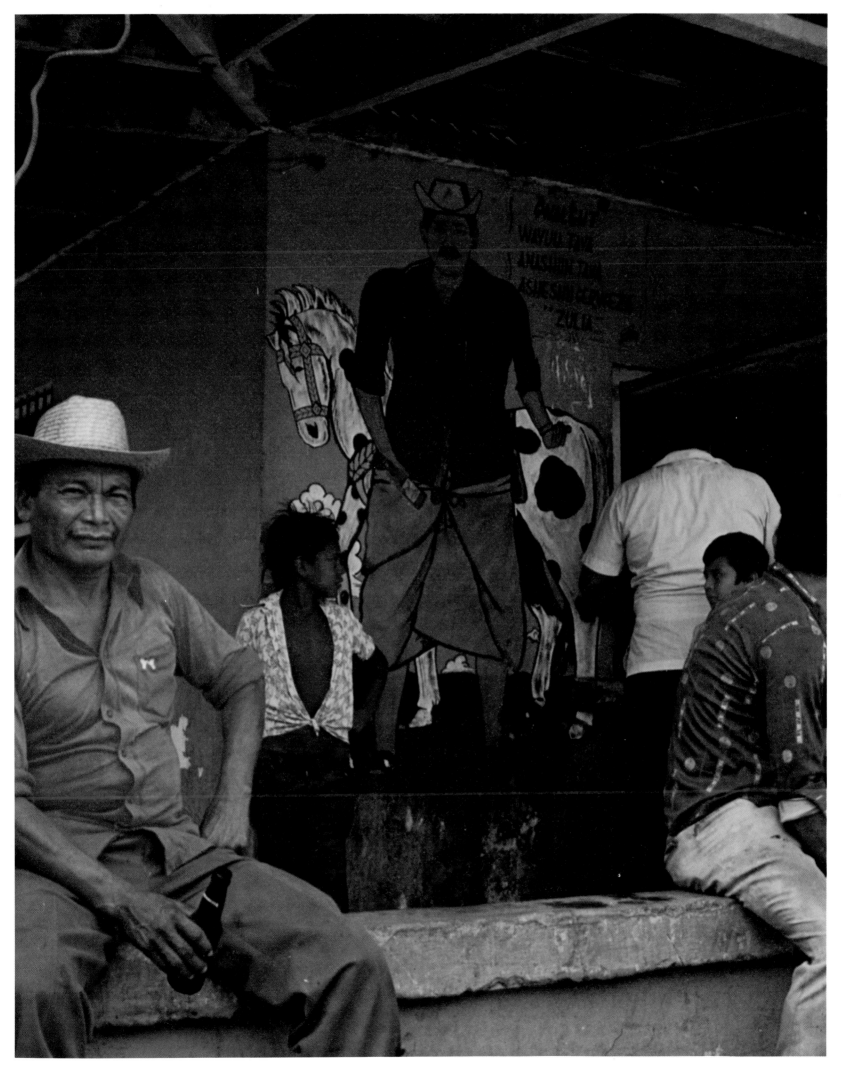

550 Oil has meant visible economic improvement in the entire Lake Maracaibo region. Vestiges of popular art can still be seen, as in the drawing illustrating the advertisement for beer on the wall of small bar. Los Filuos, Zulia

Introduction

In ancient times, present-day Venezuela was inhabited by tribes belonging to linguistic branches of the Carib, Arawak, and Chibcha. (See the chapters covering the Antilles, Brazil, and Colombia.) Columbus reached the Venezuelan coast on his third voyage (1498–1500) and was so struck by the landscape that in his diary and in his letters to the crown he described it as the "Earthly Paradise." What most impressed the navigator —and, later on, Alonso de Ojeda and Americo Vespucci —was the Orinoco Delta. The force of the river emptying into the sea and forming a gigantic wave when it met the salt water made Columbus think, with good reason, that this time he had not landed on an island but on terra firma and he gave that name, Tierrafirme, to the Colombian-Venezuelan coast.

The length of the Venezuelan and Colombian coast was explored rather slowly in comparison to the exploration of the rest of the continent; the settling of the land by the conquistadors was neither easy nor immediate. For years the natives defended their lands with guerrilla tactics that thwarted, one after the other, every attempt at colonizing their territory. On the other hand, rumors of fabulous treasures of gold and jewels caused the Europeans to send expeditions in search of the wealth. After many failures and much looting, it was realized that the Indians' gold, largely in the form of personal adornments, had been accumulated over the centuries and was from mines that were nearly exhausted.

The first settlements in Tierrafirme were not established until after 1525. Mexico had already been con-

551

552

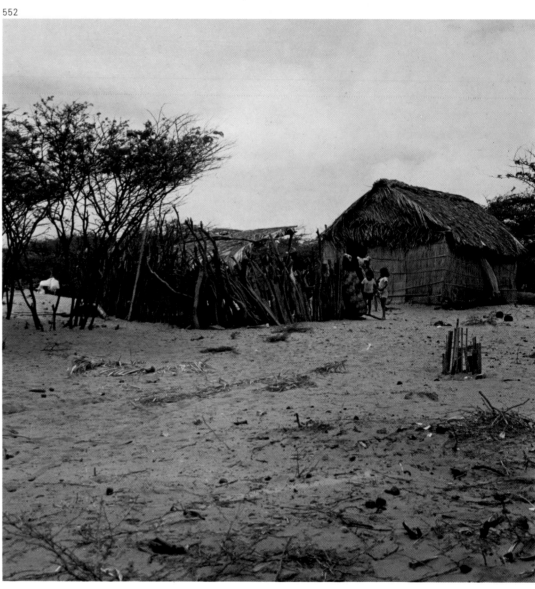

551　In Venezuela there are many monuments to the liberator Simón Bolívar, the man responsible for the victory over the Spanish and for independence. Mérida

552　Desolate landscape of the Guajira; sandy soil, scant vegetation, and cane houses. Los Filuos, Zulia

quered, the conquest of Peru was foreseeable, and the skirmishes began between the Spanish and the Germans, to whom Charles V had ceded the right to exploit Venezuela. Nicholas Federmann is one of the German explorers best known for his numerous forays as well as for his valor and bravery.

Many expeditions set out from Venezuela, following the course of the Orinoco River and heading inland. Like the expeditions that departed from Santa Marta and Cartagena in Colombia, one after another left in search of El Dorado, the legendary land of gold and riches that, according to common belief, existed at the headwaters of one of the rivers in that region. This mythical land was sought after for hundreds of years.

The orography of Venezuela is varied. In the west, the almost desertlike Guajira Peninsula (shared by Colombia)—with three thousand hours of sun per year and an almost constant temperature of 82° F (28° C)—is an extremely dry region almost devoid of vegetation. The so-called Venezuelan Andes, with peaks reaching 16,400 feet (5,000 m) in the Sierra Nevada de Mérida, are an extension of the western range of the Colombian Andes. Above the high plateaus on the eastern edge of the Andes, rise two almost parallel mountain ranges: one follows the coast of the Caribbean and the other extends a little way inland. The greater part of the country is irrigated by the Orinoco River, whose course is almost 1,500 miles (2,500 km) long. The river's basin is known as the Plains, which is divided into the High and the Low, despite there being little difference in altitude between the two. It is a marshy area, with long periods of rain and frequent floods. Finally, the area known as the Venezuelan Guayana

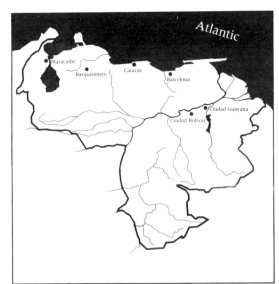

553

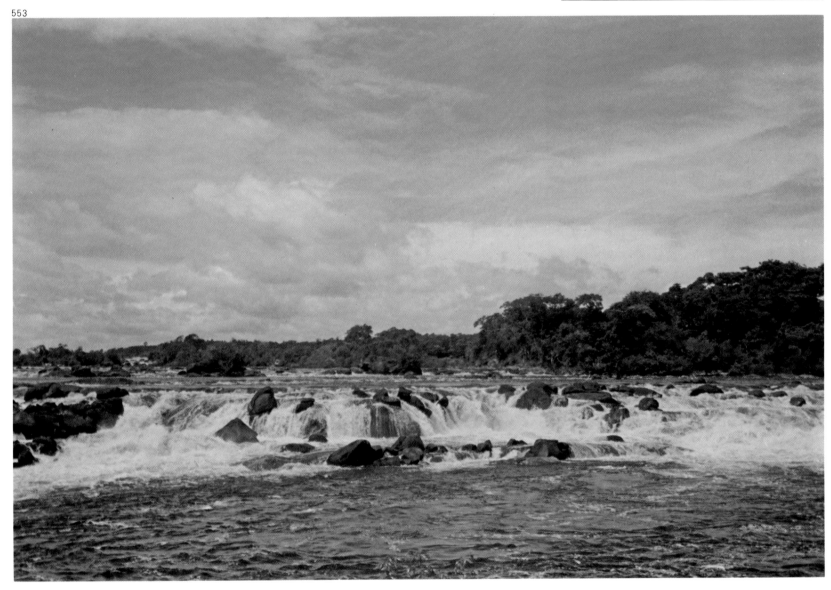

553 The long course of the Orinoco is uneven in some places. These waterfalls and banks form a magnificent sight.

189

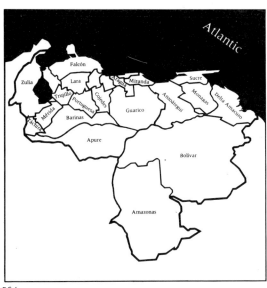

should be mentioned. It is a large expanse of land, some 15,500 square miles (400,000 sq km), 45 percent of the total surface area, with dense vegetation where the only native groups maintaining their ethnic characteristics still live.

Since 1927 the presence of oil has been the determining factor in the economic and even in the political life of Venezuela. The discovery of great deposits of this economic resource —Venezuela ranks third in world production—has stimulated an accelerated rate of growth in the country. The physical appearance of certain regions has been altered by oil wells that now dot the landscape. Petroleum has converted Venezuela into the richest country of Latin America, giving it the highest standard of living and the highest per capita income. The large cities have been rebuilt; huge buildings have been erected and the communications systems have been improved. The difficulty with and the cost to society of this development are the oil cities, which are located in desolate, arid regions where everything is built on a temporary basis. When the oil runs out at one of these sites, a ghost town is all that remains.

In some areas outside the range of the petroleum industry, certain handicraft activities are carried on, among which pottery and weaving stand out. Native groups also maintain a handicraft tradition whose products are illustrated in the catalogue of this chapter.

554

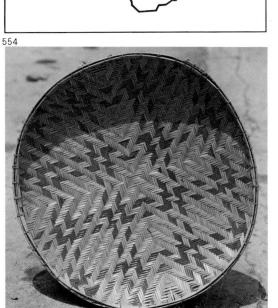

555

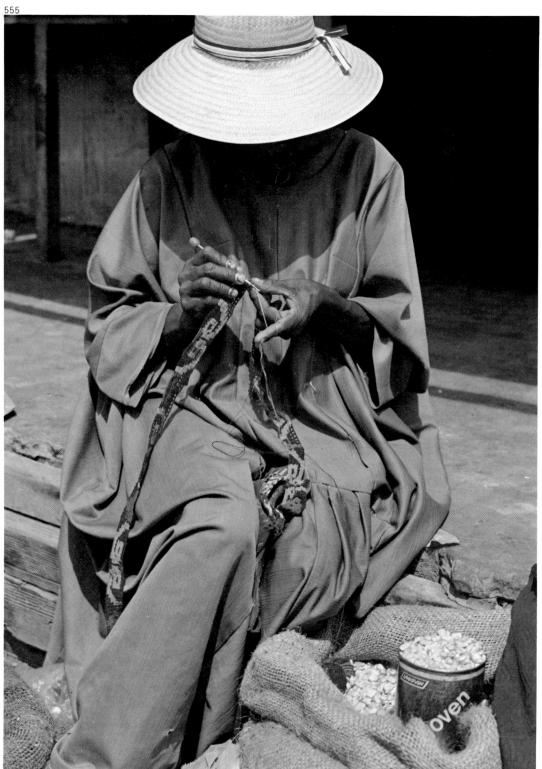

554 Tribal groups of theVenezuelan Guayana make baskets and other objects similar to those made by the Indians of the Amazon region. Caicara del Orinoco, Bolívar

555 Guajira women wear long, full dresses in solid colors or prints. Los Filuos, Zulia

Most Venezuelan pottery is utilitarian and is destined for domestic use. Designs and other decorative elements occur less frequently in ceramic pieces than in the more elaborate pottery.

Mérida is a lovely city that preserves some examples of colonial architecture. Situated more than five thousand feet (1,500 m) above sea level, Mérida provides a view of impressive Mt. Bolívar, Venezuela's highest mountain. Nearby is the small urban nucleus of Ejido, where, up until a few years ago, a rich tradition of pottery making survived. An attempt was made to convert Ejido into a tourist attraction and, as a result, the craft was completely wiped out. Contributing to this demise was the problem of transporting the clay on foot from the distant deposits. As a consequence a town of potters has been reduced to a few artisans.

The clay is worked by hand and the pieces are smoothed with a gourd or smooth stone. Without using a kiln, the pottery is fired on the ground in large bonfires that are kept burning all night until the process is complete. Obtaining firewood is becoming more expensive every day, which is another factor contributing to the failing interest in pottery making.

The products are varied: large jars, pitchers, platters, dishes, candelabra, etc. On the arid Guajira Peninsula, water is stored in large earthern jars curiously decorated with simple geometric designs in rudimentary red lines, which distinguish the ware from the rest of the country's pottery.

Other pottery-making centers are Tarija, San Cristóbal, Valera, Quibor, and José de Colorico. In general,

Pottery

556

557

558

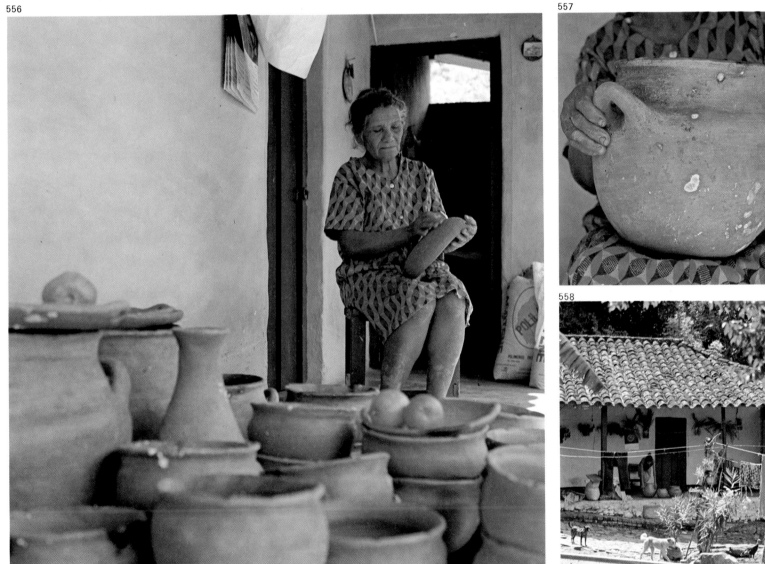

556 When the piece is dry, the rough spots are smoothed with a round stone or with a piece of calabash gourd. Ejido, Mérida

557 Artisan with her own terra-cotta pot. Ejido, Mérida

558 The women alternate housework with pottery making. Ejido, Mérida

the pottery is simple in shape, with the only exceptions occurring when the artisan imitates ancient pieces found in archeological ruins.

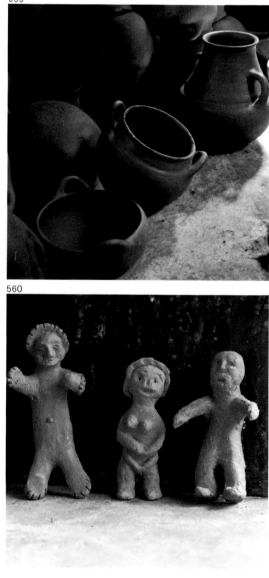

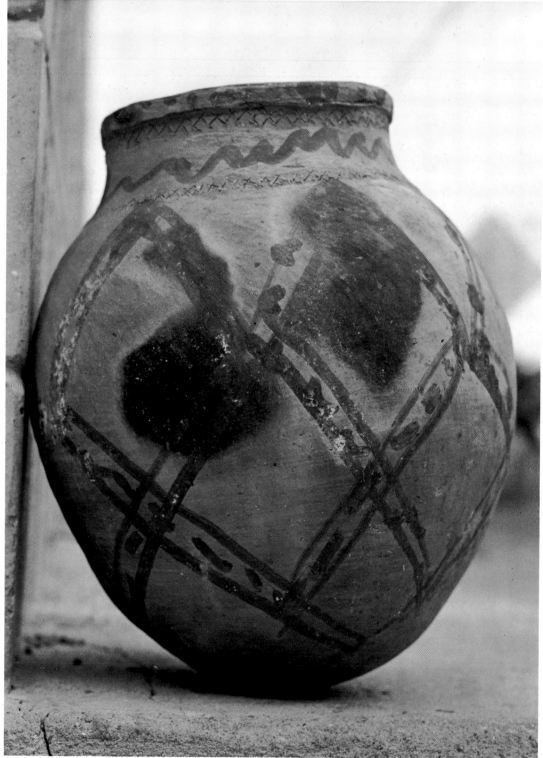

559 Pieces stored away for future sale. Ejido, Mérida

560 The children imitate their elders; a certain ingenuousness can be seen in their work. Ejido, Mérida

561 Jar for storing water. Terra-cotta with geometric designs in traditional Guajiro painting. Paraguaipoa, Zulia

On the border between Colombia and Venezuela, the Guajira Peninsula, which belongs almost totally to Colombia, is a desert area inhabited by the Guajiro Indians. Americo Vespucci speaks of them in his writings and describes how they survive, combating the barrenness of the region. The Guajiro lived both on dry land and in houses built on piles in Lake Maracaibo. Fish constituted the main staple of their diet. They made use of large leaves brought in from other areas to protect themselves from the sun as well as to compensate for the scarcity of water by collecting dew. To lessen their thirst, the Guajiro commonly chewed coca leaves mixed with lime from snail shells. They dedicated themselves to trade, bartering salt, which was plentiful, for gold. One of their principal occupations was harvesting cotton, which helps explain the weaving of shawls and hammocks (the latter called *chinchorros*) among their crafts.

The Guajiro families in Los Filuos live in small houses, generally made of cane, scattered throughout the outskirts of the present center of the village, where there is a marketplace and a few brick buildings. From their huts, the Guajiro go to the village to make purchases and sell their products. The Guajiro women who weave work at large vertical looms in their homes, which are often no more than a simple inclined roof protecting its inhabitants from the sun.

Today the basic material preferred by the Guajiro for weaving is mercerized cotton. The color combinations they use include yellow, red, and blue or green. Two types of weaves are used in making *chinchorros*: the chain

562

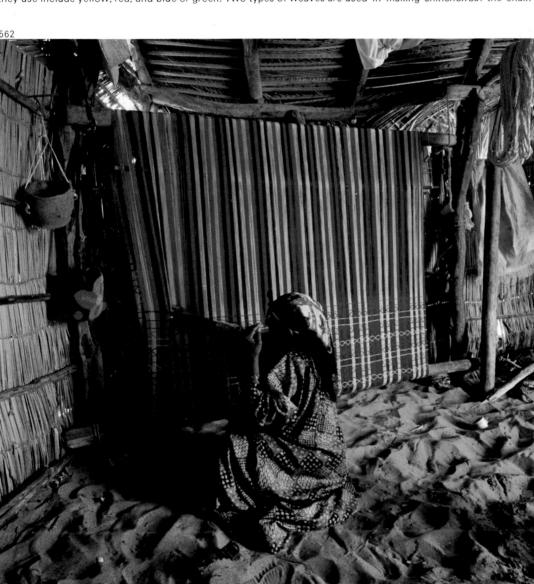

563

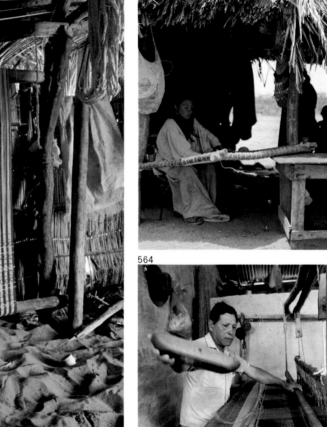

564

562 In this photograph one can appreciate both the size of the loom, made from four long poles, and the characteristics of the Guajiro home. Los Filuos, Zulia

563 The Guajiro women are very fond of embroidery. While being worked, the cloth is held taut in a rectangular frame. Los Filuos, Zulia

564 Weaving a shawl with dyed lamb's wool. The warp is almost always red and black with an occasional use of white, while the weft is yellow and green or white and red. El Tintorero Ranch, Quíbor, Lara

weave and the *tripa*, from which many patterns can be obtained. In one, the design consists of parallel lines with a small ornamental fringe; in the other, the lines are diagonal and the fringes of the warp are interwoven, which increases the range of the colors. The Guajiros are also experts with the crochet needle. They weave innumerable kinds of bags. Whenever they are able to get wool and cotton in a variety of colors, they put aside the plant fibers or other such material with which they have been working.

The high plateau of Barquisimeto stretches between the valleys of Turbio and Tocuyo. This area averages sixteen hundred feet (500 m) above sea level; vegetation is scarce, except in the Tocuyo Valley. Scattered in the vicinity of the town centers are ranches which comprise various structures, from the main house to stores and workshops, and which characteristically are fenced in by hedges or walls. Within these enclosures, shawls and rugs in a great variety of shapes are manufactured. The traditional examples are striped, in various colors; in them the warp is scarcely noticeable, although sometimes it stands out. Even though weaving was once strictly a family business, commercial success has allowed the weavers to hire assistants.

565

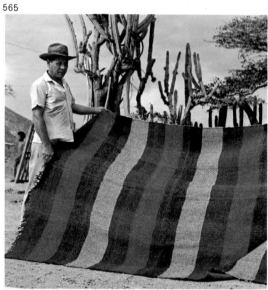

566

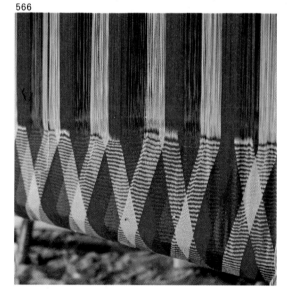

567

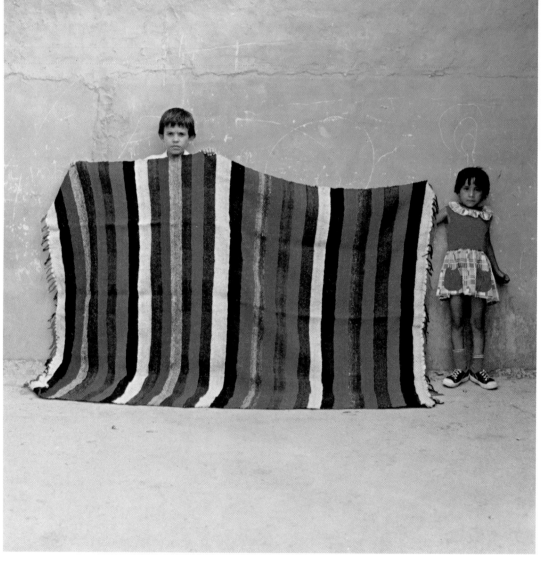

565 Blanket woven in traditional colors. Typical vegetation of the region can be seen in the background. Quíbor, Lara

566 Detail of the weave in a *chinchorro*, or hammock, worked in a *tripa* weave. Los Filuos, Zulia

567 Weft-striped blanket. Quíbor, Lara

194

568, 569 Figures of a bird; carved tree roots. Boconó, Trujillo

570 Gourd receptacle for storing water. Santa Elena de Guairén, Bolívar

571 Gourd bowls with painted decorative motifs. Alto Caura, Bolívar

572 Engraved and painted spoon and bowl made from gourd shell. Maracaibo, Zulia

573 *Guuwi*, a dagger of carved mahogany; handle protected with plant-fiber cloth. Alto Caura, Bolívar

574 Detail of a *manari* strainer. Caicara del Orinoco, Bolívar

575 Basket or tray made from plant fiber. Caicara del Orinoco, Bolívar

576 Basket made from plant fiber. Indigenous group of San Francisco of Yuruari. Bolívar

577 Basket woven from bitter cane. Coro, Falcón

578 At times, plant fibers must be imported for basketweaving. Leaf of a Jamaican banana tree. Coro, Falcón

579 Detail of a weaving made with *mecatillo* fiber. Mérida

580 Earthenware pot with plate cover. Coro, Falcón

581 Double-handled earthenware pot. Coro, Falcón

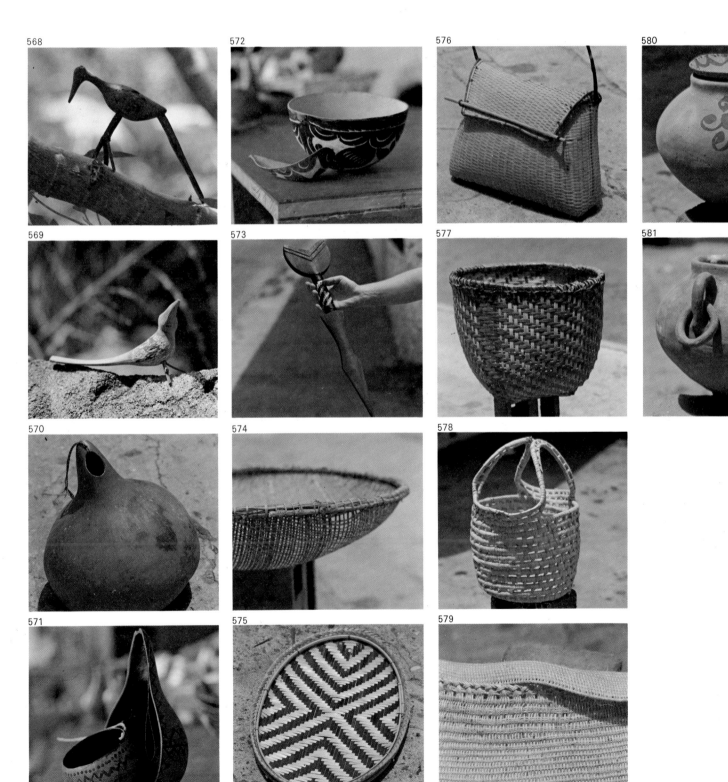

568

569

570

571

572

573

574

575

576

577

578

579

580

581

BRAZIL

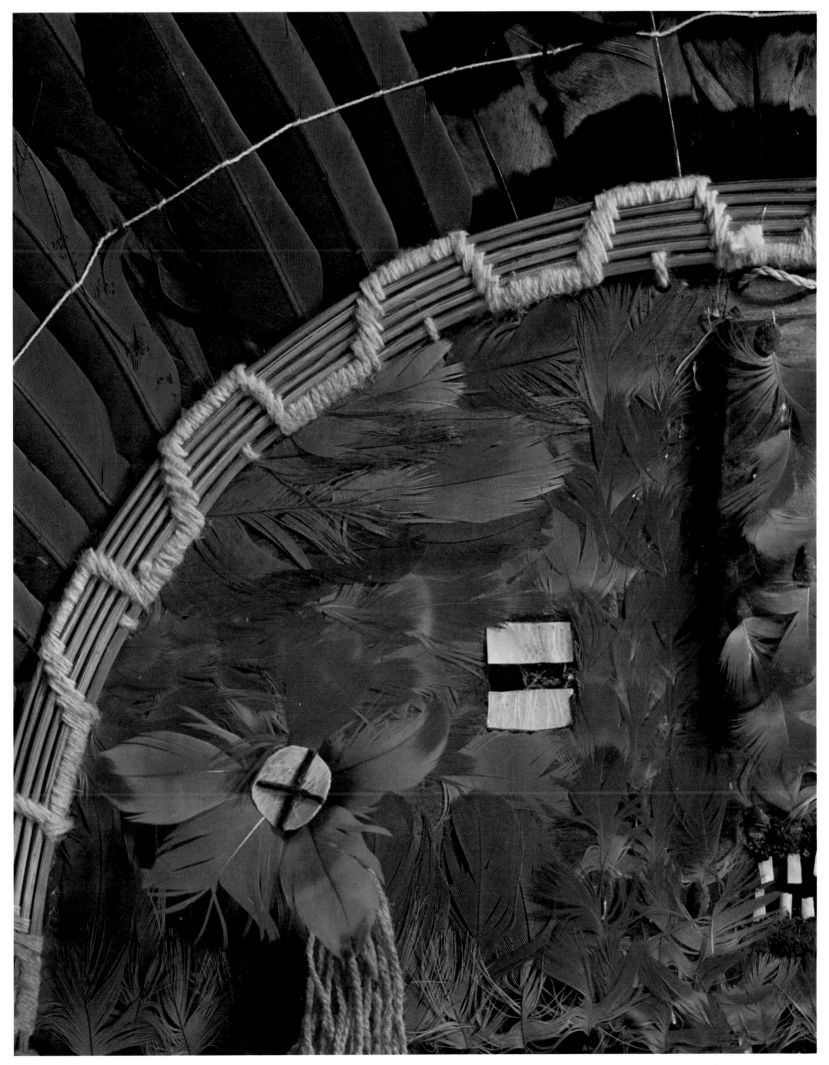

582　Detail of a mask of macaw feathers mounted on wood.
Tapirapé group

Introduction

Although evidence would seem to indicate that no culture of comparable importance to the Maya or Inca developed in the land that is now Brazil, remains of ancient man have definitely been identified in Lagoa Santa in the state of Minas Gerais. In addition, all along the Atlantic coast, tumuli have been found that belonged to a social group named after the *sambaqui*, or piles of mollusc shells that were the basic diet of these people. Among the shells archeological traces of this culture have been found. These discoveries prove the existence of human life in the far distant, Paleolithic-Neolithic past in what is now Brazil. There is no doubt that as the vast uninhabited areas of the Amazon jungle are explored there will be new discoveries, revealing secrets that, in due course, might mean an important change in contemporary understanding of the archeology and anthropology of the continent.

The Portuguese navigator Pedro Alvarez Cabral landed on the southern part of the Brazilian coast in 1500 believing that he had discovered a large island, which he called Veracruz. From here the conquest of one of the wildest and most inaccessible parts of the continent started. In about 1536 Francisco de Orellana, one of Pizarro's force in Peru, set sail along the Andean tributaries of the Amazon and followed the course of the river looking for a passage to the Atlantic. He finally reached the mouth of the Amazon in 1541.

The most important ethno-linguistic groups in Brazil at the time of its discovery were the following: the very numerous Tupí-Guaraní, who occupied the valleys of the Paraná, Paraguay, and Amazon; the Ge, who lived in the central and eastern plateau regions; the Arawak and Carib, who inhabited the area called Brazilian

583

584

583 Copacabana Beach is one of the tourist symbols of Rio de Janeiro. Here business is also carried on as well as festivals and religious ceremonies

584 In the cattle country a range of leathercrafted products for everyday use is made. Caruaru, Pernambuco

Guayana, on the north Brazilian coast. It is believed that these last-named people came to the continent after fleeing from the Antilles, where they had already become acquainted with the ways of the conquistadors. They did not succumb to the offers and promises of the Portuguese, but put up a stubborn resistance; for example, the Carib used poisoned arrow tips, a rare occurrence among indigenous groups in other areas. Nearly all these groups were divided up into communities of some two thousand people; they relied on a certain freedom of movement from one place to another, according to their need for food or desire for new lands to conquer. The presence of foreign forces also obliged them to flee from their villages at times.

In a short description of the geography of a country as enormous as Brazil, it is only possible to use very general terms. As a result, one must distinguish among only four major areas. First is the Amazon Basin, the greatest river system in the world. Rivers such as the Negro, Purus, and Tocantins run into the Amazon, which has a course over 4,000 miles (6,500 km) long and an estimated five hundred or more tributaries. The Amazon Basin, extending over some 2,500,000 square miles (6,500,000 sq km), is flat and suffers periodic flooding, and the long periods of persistent rain make it very humid. The Amazon rain forests have dense, leafy trees with almost impenetrable vegetation. The second major area is the basin of the Paraná River, which forms a natural boundary with Paraguay in the far south of the country. The terrain in this area is more varied than that of the Amazon and its climate milder. Third, in northeastern Brazil lies the tableland, the famous Brazilian sertão, a dry interior zone that

585

585 The making of rag dolls is common all over Brazil, as well as other simple toys for children. João Pessoa, Paraíba

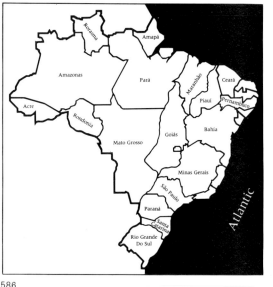

has been the birthplace of a multitude of legends and popular myths embodied in the figure of the *cangaceiro* (the noble bandit, defender of the oppressed). In the north of the state of Bahia, a small area of this huge tableland has been turned over to agriculture. The tableland falls away steeply to the coast, where, because of the difficulty of penetrating the interior, there is a concentration of people; a certain fringe area of the tableland is also populated. Finally there is the coastal zone, where about 45 percent of Brazil's population lives in 17 percent of its surface area. The southeastern area is called the wealthy triangle; such cities as Rio de Janeiro, Belo Horizonte, and São Paulo confirm this name.

Brazil has a population of about 120 million, of whom only approximately .1 percent are indigenous, descendants of the groups named above; they live mostly in officially protected territories. The Cayapo, Xinguano, Bororo, Carajá, Tucano, among others, maintain almost intact their way of life, language, and customs, such as body painting, feathered costumes, religious rites, and crafts. There are numerically very few people in these tribes, but their characteristic art contributes greatly to the folk art of the country, which is also influenced by the important contribution of the African races. The black population of Brazil was imported as slaves, as manual labor to exploit the Brazil tree (which gave the country its present name). Then the sugarcane cycle was started, with the infamous sugar plantations, called *engenhos*, which were in the same mold as those devoted to gold, diamonds, and coffee. Brazil is now the foremost economic power in South America.

586

587

586 The same as children all over the world, a Brazilian child looks with delight at even the most rudimentary toys. The most frequent racial mix in South America is between whites and the indigenous people, the child of which is called mestizo, but in Brazil there are many mulattoes, like this child, who are the offspring of black and white. Caruaru, Pernambuco

587 Statuary made in a mold and hand painted; intended for followers of the Umbanda, a religious cult that combines elements of spiritualism and African religions; it is most commonly found among urban dwellers. Fortaleza, Ceará

According to the creation myth of the Desana, each Indian group was ordered to specialize in a specific craft or activity by the god of creation. This concept of a tribe's special art or craft being derived from mythology is found in such cultural areas as the Alto Xingu. The groups respect these divisions and, although they may be quite capable of working in all materials, limit themselves to bartering their own products with those of their neighbors.

The objects, in their turn, have sexually related meanings. Because of its shape, the bow is a masculine symbol and the basket, feminine. The *cesto*, a large basket, is associated with the womb because of its full-bellied shape, its capacity as a container, and the fact that it is continuously being filled and emptied. This identification of baskets with females is carried to its ultimate conclusion among the Guayakí, who burn a woman's *cestos* when she dies. Clay is also associated with women; in addition, colors are given meanings according to the type of object or person.

Most Indian groups place a great deal of importance on the adornment of the objects; often, the piece is not considered to be finished if it is not decorated. Elaborate geometric compositions are used to represent tribal symbols such as the supernatural being called the *taangap* of the Cayabí; legendary serpents, generally the anaconda; the macaw's bill, emblem of the Xinguanos; the *pacú*, a large river fish, and its offspring.

Indian basketry in Brazil has two distinctly different styles: one is from the jungle, the other is from the grassland. People of the linguistically related Tupí, Carib, Arawak, and Tucano-datxea, who live in the jungle,

588

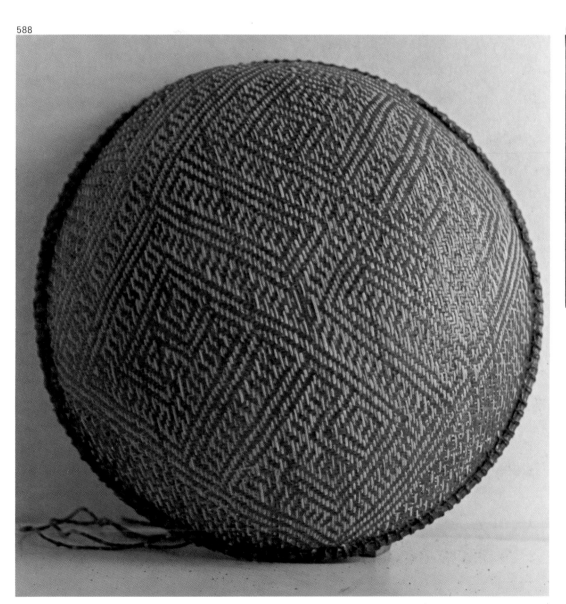

588 Painted basket of the Cayabí Indians. The design represents the *taangap*, a supernatural being with four limbs and two pairs of eyes. Xingu National Park

589 Part of a large *canasta*-shaped carrying basket; these are common among all the tribes of the Río Negro area. Maku group. Río Negro

generally make their baskets from fine petioles of the talipot palm or fine sheets of tirite stem. In most cases these materials are painted and then woven to achieve special designs that are specific to each tribal group or cultural region. Beautiful effects are obtained, with as much regard to the shapes of the baskets, which are truly sculptures in braid, as to their decorative patterns. The enormous variety of designs is obtained through the technique of interlaced braiding done on the diagonal, which is similar to that done with rigid materials.

Instead of weaving on looms or making pottery the people of the grassland have long specialized in another craft—braiding. For them braiding has important cultural significance and widespread use: beds or sleeping mats, net containers for carrying children, baskets for carrying produce from the fields, masks for dances, body ornaments, and various containers are all braided. Such groups as the Ge (Cayapo, Timbira, and Shavanté) prefer to work with dried stems rather than rush. They also use the prefoliation growth of the talipot palm, which splits into very fine strips. (The jungle tribes use more rigid materials for their baskets, and paint them afterward.) The lack of pottery in their culture has forced them into developing a manufactured basketry based on the technique of stitched braiding, whose products are so compact that they can be used as containers for liquids without being waterproofed. Characteristic of this style is the basket that the Shavanté call *baikite*. They are made in various sizes and are used as cradles, containers, baskets for carrying provisions, and for other uses.

The preparation of manioc (cassava) necessitated the development of different types of fine sieves and a

590

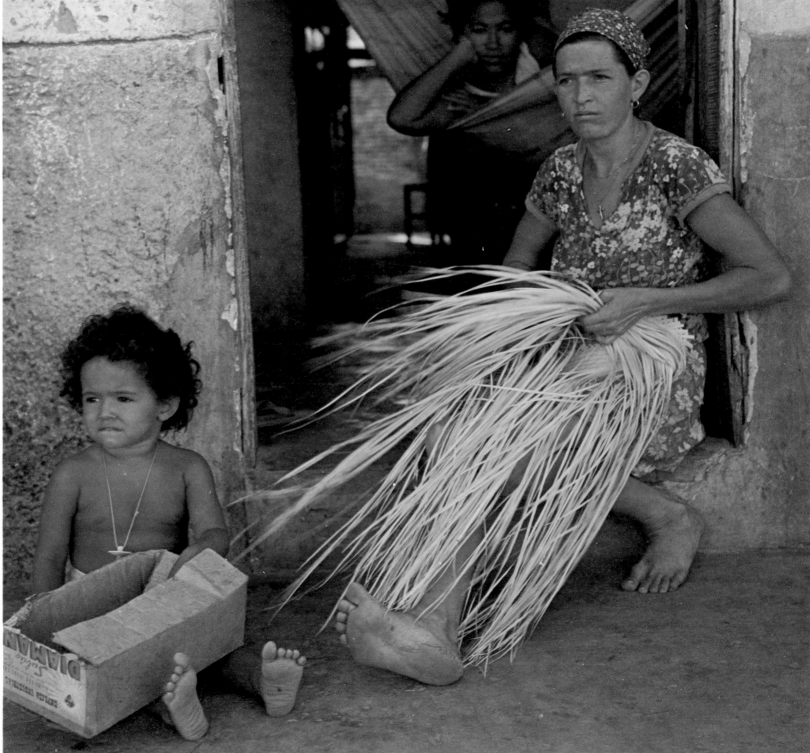

basket, the *tipiti,* used to filter out by distension the poison in the bitter manioc paste.

Apart from the braiding done by the indigenous peoples, other types of bread baskets, large baskets, bags, etc., in whose styles a European influence can clearly be seen, are also woven by the Brazilians.

591

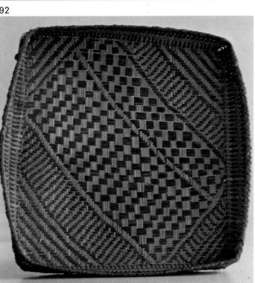

593

592

594

590 Basketmaker braiding the leaves of the *carnauba,* a Brazilian palm from whose dried leaves a type of fat for making candles is obtained. Aracati, Ceará

591 Basket in the shape of a bag with a cover, braided from from two *buri* leaves and their petioles. Shavanté group, Rio das Mortes

592 Flat basket with two-color decoration. Tirío group, Rio Paru de Este

593 In the markets it is easy to find baskets with distinct European influence; they are expertly made by the local crafts-workers of Caruaru. Pernambuco

594 In popular craftwork one finds varied and excellent examples of basketry. This photograph shows several types baskets used by fishermen. João Pessoa, Paraíba

Sandcraft

This craft is limited to a very small area. Nevertheless, the unusual nature of the craft and the meticulous quality of the work deserve some attention. Majorlandia is a fishing village, where houses are made of logs and mud, on the north coast of Brazil, surrounded by immense expanses of sand that form gentle dunes. There, completely at home in her environment, lives a woman who could be called "the artist of the sands."

Her first step is to dye the sand different colors, and then with it she makes complicated designs in large or small used bottles. She uses long spatulas with spoon-shaped ends to put the sand into the containers, and very fine burins to make sure that each grain is placed exactly right. With incredible skill this woman invents and reproduces scenes ranging from pastoral landscapes to photographs of entire families. Once the bottle has been completely filled, with the decoration continuing all around the perimeter, it is tightly plugged to prevent the contents from slipping.

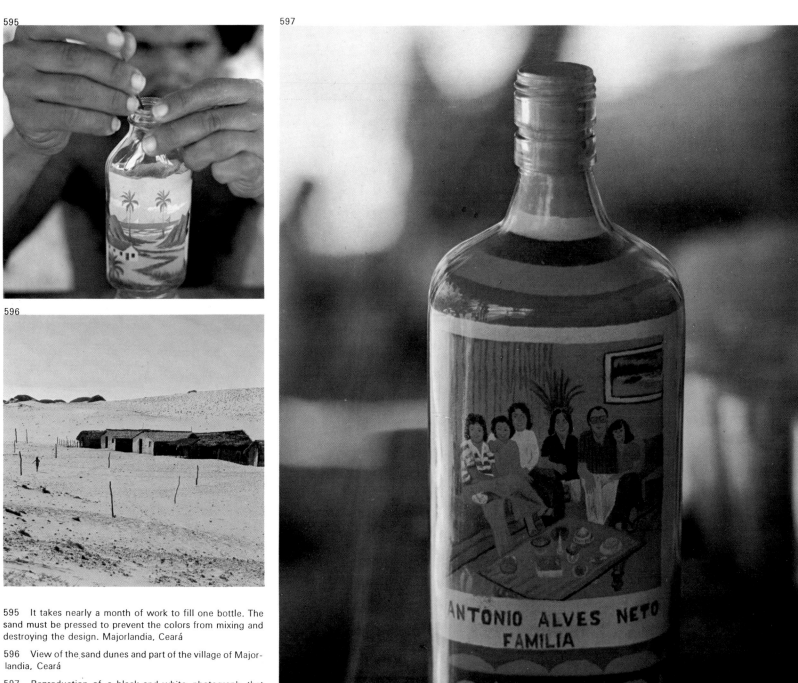

595 It takes nearly a month of work to fill one bottle. The sand must be pressed to prevent the colors from mixing and destroying the design. Majorlandia, Ceará

596 View of the sand dunes and part of the village of Majorlandia, Ceará

597 Reproduction of a black-and-white photograph that the craftswoman has improved by adding decorative details and color. Majorlandia, Ceará

Pottery

Social change in Brazil, brought about by industrialization and tourism, has generated a gradual demand for crafts, which has increased the production of pottery. Now it is not solely the women who model clay to make household utensils; the specific demands of the new type of customer have altered both the potter and the products.

Caruaru, in the state of Pernambuco, was the first place to produce this new type of pottery. Made here are small clay figures and scenes from everyday life, including birth, marriage, and death, as well as scenes showing soccer championships and astronauts and space capsules. A popular pottery figure is the mythical figure from the sertão, the *cangaceiro* (an outlaw who is the champion of divine law and reestablishment of social order).

Another important pottery center in the state of Pernambuco is Tracunhaém, where the majority of the inhabitants are potters specializing in making religious figures.

In the state of São Paulo (southeastern Brazil), in the Paraíba river valley, there are several small villages that constitute one of the largest centers for the production of clay Nativity scenes during the Christmas season; of these villages, Taubaté and Pindamonhangaba are outstanding. The tableaux contained in these scenes are fascinating. In addition to the figures that belong at the Nativity, there are soldiers from the war with Paraguay, Adam and Eve, slaves, hunters, musicians, soccer players, etc. Nowadays the demand for these figures is so great that professional and amateur potters work year round to fill it.

There are also tribal communities in Brazil that have a long tradition of pottery making. The Pano group of

598

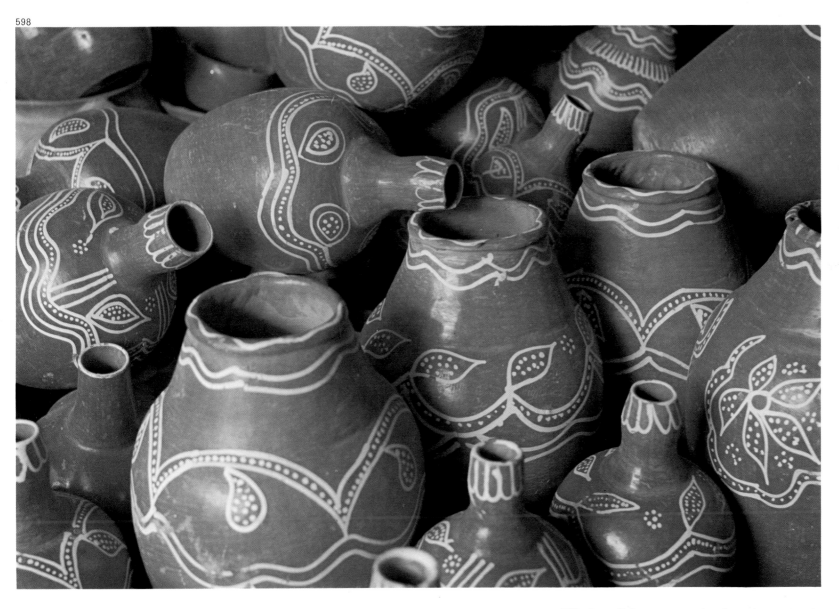

598 From tribal groups, potters have learned to use the color obtained from *tabatinga*, a soft and oily sand which, when finely ground, passed through a fine sieve, and baked, produces the color used in the decoration of everyday earthenware. Moita Redonda, Ceará

the Jurúa Purus basins make a very refined pottery with a technique similar to that used for making glazed porcelain. They use white, various shades of red, chestnut brown, and black to create decorative designs.

The Waurá Indians make pottery for all the Xinguano groups. Their pottery is distinguished by the enormous size of the pots and the small- and medium-sized earthenware bowls called *cuencas*, whose sides are finished in the shape of an animal. No less than eleven types of mammals and seventeen types of birds have been identified. The Waurá women are so highly prized for their ability to make pottery that such groups as the Txikão and Suyá try to kidnap them and make them part of their own villages.

One of the best-known types of pottery in Brazil is the *litxokó*, a small figure made by the potters of the Carajá group. Originally *litxokós* were represented with all the Carajá tribal characteristics: circular tattoos under the eyes, pendants, feather cockades, lip decorations for men, and *tangas* (small rectangles of beadwork with black, red, and blue designs) for women. A few years ago the Carajá started to produce and sell figures representing scenes from their daily life. According to studies, the Carajá also represent members of other tribes such as the Javahé, a subgroup of the Carajá, the Cayapo, and the Dobai of the Rio das Mortes. These figures are made without faces, which are replaced by a plane of sloping clay in the case of the Cayapo, and a tall cylinder in the case of the Dobai. The absence of tribal characteristics of the other groups is an example of the ethnocentricity of the Carajá.

599

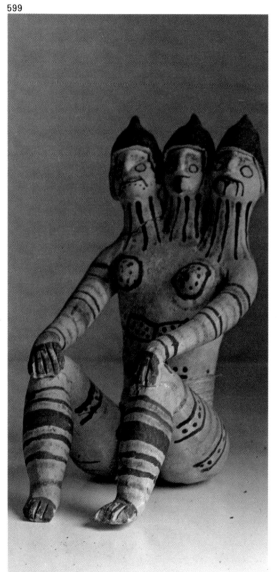

600

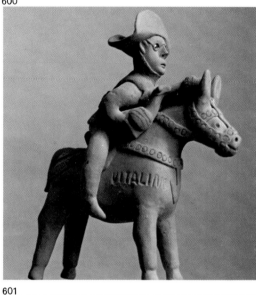

602

601

603

599 *Litxokó*, a three-headed female figure: the circular tattoos of the tribal emblem can be seen under the eyes. Carajá group. Araguari River

600 *Cangaceiro*, the bandit of the sertão, whom the common people see as their champion. Caruaru, Pernambuco

601 Virgin with Child. This piece of religious pottery contrasts with the more realistic style of the Caruaru. Tracunhaém, Pernambuco

602 Zoomorphic vessel in the form of a deer; the inside is painted black, as is customary in the pottery of the Waurá. Xingu National Park

603 Only the top half of this ceremonial drinking vessel is used; the bottom half, which is hollow, has small stones inside that produce a sound like a maraca. Waurá group. Xingu National Park

Body decoration is common among the indigenous peoples of Brazil, and although this section is concerned specifically with *plumaria,* the art of embroidering or decorating with feathers, it is a convenient place to discuss the importance of the symbolism contained in the form and color of the adornments of the tribal communities. The adornment of the body with removable ornaments, body painting, or coiffures contains not only a purely decorative element, but it also constitutes a visual language that, on one hand, acts as tribal identification and, on the other, imparts information about the sex, age, and social status of an individual within the community.

Most of the indigenous groups of Brazil have examples of this. The Xinguanos shave their heads, on which they paint designs that are repeated on their bodies. The Mehinacú paint their hair with various red and white designs, some of which are exclusively for *chamanes,* shamans, and the Mehinacú expression *metalute* means "to be without feathers," naked, incomplete—a state that their religion allows only at certain times and never in public. The face and body painting of the Kadiwéu of the Matto Grosso is considered to be the most elaborate on the continent (painting the face confers human dignity on the individual and each style indicates to which particular caste he belongs).

Colors have their own symbolism: the earth, according to the Desana, is red and feminine; the sun, creator of life and fertilizer of the earth, is masculine, although it also has a female part, and its yellow color is represented in *plumaria* decorations; blue is an ambivalent color as it represents the middle area between the earth and the

604

605

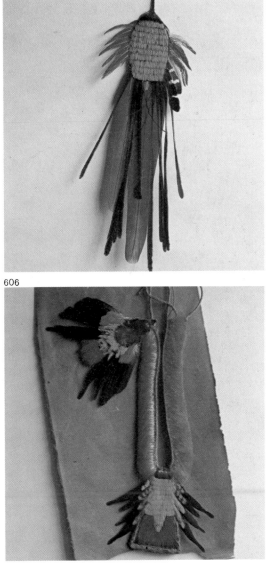

606

604 On holidays the Kaa women drape their children in mesh woven from cotton and adorned with feathers

605 Man's lip ornament mounted over two large macaw feathers. Urubú-kaapor group

606 Woman's necklace; note the technique of joining the feathers to the medallion and dorsal pendant. Urubú-kaapor group

atmosphere. In general terms, one can say that colors are associated with the fundamentals of psychology, biology, and physiology. Blue, the color of communication, can be either good or bad and is connected with thought and meditation. Goodness, fertility, the east, energy from the sun are identified with the color yellow and are represented in the ventral area of the body. Red is for sexuality, blood, and health, and is the trunk of the human body; it is considered positive, as opposed to black, which is negative. White, the color of semen, also symbolizes fertility.

Plumaria can be summarized as having two major styles corresponding to the two types of cultures. The first, as represented by the Tupí, has developed in the tropical jungle and extends into the countries of the Amazon that border Brazil; the second belongs to the culture on the edge of the jungle and is consequently rustic in nature, as represented by the Macro-ge, who are found only within Brazil.

The art of the Tupinamba featherworker is characterized by the use of both small feathers and fabrics. Outstanding among these featherworkers are the Tupinamba on the coast, the Mundurucú of the tributaries of the Tapajós and the Madeira, and, nowadays, the Urubú-Kaapor of the Gurupi River. The Kaa craftsmen fasten the tiny feather quills together with interwoven cords, thus obtaining decorative articles with a texture similar to the smooth body of a bird and with a movement as delicate as if they had wings. The Indians use feathers from nearly forty species of birds —in particular cotingas, honeycreepers, toucans, curassows, and macaws. These offer a wide variety of texture, color, and luster, and beautiful decorative effects are created.

607

Macro-ge groups such as the Carajá, Bororo, and Cayapo use the long tail feathers of the macaw and water birds such as the great egret, the spoonbill, and the jabiru, whose thick quills are hidden by rows of smaller feathers. These are assembled on a rigid frame that when worn transforms the human figure into something unreal and fantastic.

To conclude, the Tupí and the Macro-ge are two groups outstanding in *plumaria*, and although they work in different styles (miniaturist, and showy and grandiose, respectively), they can be considered the greatest crafts-workers of the art in the continent today.

Another aspect that should be mentioned is that the art of *plumaria* is done by the men who wear it. This establishes their preeminence in the ceremonies and shows their elevated status in the family structure. The previous comment about the symbolism of color also applies to the *plumaria* ornaments, which contain references to the tribe, to social class within the tribe, and also show the skill of the craftsman as a hunter of birds, a much-admired ability.

608

609

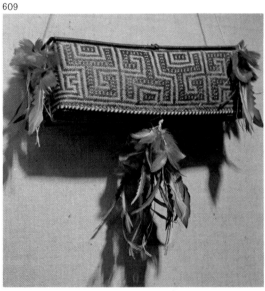

610

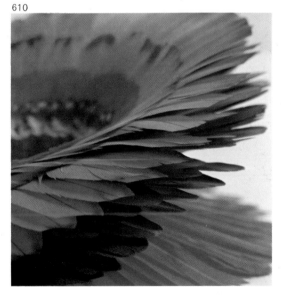

607 Man's bracelet made from bunches of feathers mounted on cords of talipot palm leaves. Group from the cultural area of the Xingu

608 Ceremonial necklace made from macaw feathers, seeds, and bamboo quills. Apalai group

609 Basket in the form of a parallelepiped, woven from vegetable fibers and decorated with parrot feathers. Hixkaryana group

610 Detail of an *acangatar*, a crown, the main ceremonial decoration of the Kaapor. Yellow feathers, symbols of the sun, from a type of thrush called the *yapu*, are fastened and laid over a fabric base

Hammocks

Brazilian weaving is essentially represented by the making of hammocks. The hammock was unknown in Europe before the conquest and it astonished the Portuguese conquistadors, who described it in their writings. Pedro Vaz de Caminha said, "They [the dwellings] are all of a piece, there are no partitions; inside they have many pillars and, from one to the other, a net is attached at both ends, high off the ground, in which they sleep." Without doubt hammocks were introduced into Europe by the English and central Europeans, who were troubled by the fierce heat of Brazil much more than were the Spanish or Portuguese. Hammocks were later substituted for straw mattresses on ships. Although it is an object with obvious Indian origins, its use had spread throughout Brazil by the nineteenth century.

Hammocks are woven with cotton thread or are braided with other vegetable fibers. To a great extent the choice of the material depends on the climate and vegetation of the area; those made from vegetable fibers are more common in the north and northeast areas. The predominant colors for hammocks are yellow and orange, but sometimes blue or dark green is used, and some are plain white. Once the cotton is spun and made into skeins, it is dyed with anilines, dried, and the color is fixed by the sun.

The hammock is woven on a treadle loom with a shuttle and various-sized reeds, and the finish is done according to the judgment of the craftsman. Varying decorative stitches are put laterally along the hammock, which has handles at both ends by which to suspend it.

611

612

613

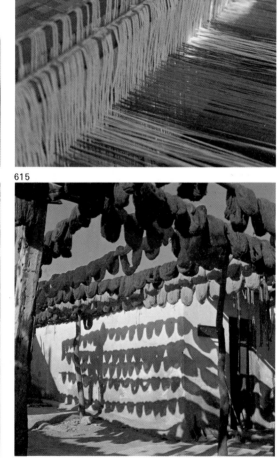

614

615

611 Craftsworker fastening the *varanda*, lateral decoration that will enrich the fabric of this white cotton hammock. Boqueírão, Paraíba

612 Many hammocks are made in Boqueírão. A frequent sight in the streets is the finished product being carried to the central warehouse. Paraíba

613 At one time the hammock was a part of everyday life, used domestically and made in the home. Now its production has been industrialized and an attempt is being made to increase sales by offering it as a luxury or leisure item. João Pessoa, Paraíba

614 Detail of a treadle loom showing the heddles, which separate the unwoven warp threads from the woven warp. Boqueírão, Paraíba

615 Skeins of dyed cotton drying in the sun on the patio of a family workshop. The long exposure outside prevents loss of color later. Boqueírão, Paraíba

The craft of working in thread is almost on the verge of extinction in Brazil, but still worthy of mention are bobbin or pincushion lace and needle embroidery. Lace edgings of different widths and finishes are made with bobbins, which were introduced by the Europeans. With the help of fine wooden needles to mark the crossing points of the threads, following a sketched pattern, the same designs are made time and again. The lace edging is sometimes several yards long, with a width of up to six inches or more.

Drawn-thread work stands out among needle embroidery produced in Brazil. This type of openwork embroidery originated in Europe in the twelfth century and reached its peak in Scandinavia. The method basically consists of drawing out threads from the ground fabric and bunching those that are left, without crossing them, to form different designs with the use of embroidery stitches. Drawn-thread work can be used all over the fabric or made into borders. The laborious nature of the work and its scant economic return have meant a reduction in the number of craftswomen who are involved in this work in the Aracatí area.

Another type of needle embroidery done in Aracatí is cross-stitch over a special canvas that has a network of holes. It is placed over the ground fabric, and the cross-stitch is done following its guidelines and is later removed.

Embroidery and Lace

616

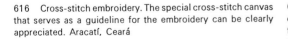

617

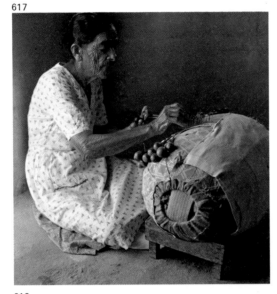

619

618

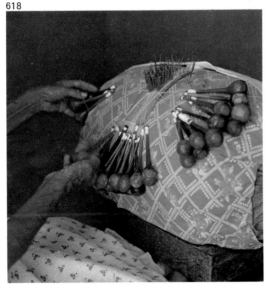

616 Cross-stitch embroidery. The special cross-stitch canvas that serves as a guideline for the embroidery can be clearly appreciated. Aracatí, Ceará

617 Lacemaking is done by the women to help the family economically. With enviable patience and the ability to take full advantage of the sunlight, this woman is starting to braid the threads for lace edging. Majorlandia, Ceará

618 Detail of the needles, pincushion, and bobbins for making lace edging. Majorlandia. Ceará

619 In order to make pulled-thread work the fabric is fastened in a round wooden frame clamped by two concentric rims to make the fabric taut. Aracatí, Ceará

Catalogue

620 Detail of a design on a basket representing the *pacú* fish. Yawalapiti group. Alto Xingu

621 Detail of a design that represents the track of a serpent. Yawalapiti group. Alto Xingu

622 Fire fan braided from dried *tuco* stems. Tucano group

623 Fire fan braided from dried *tuco* stems. Cayabí group

624 Birdcage. Txikao group

625 Tray for serving food. Tiriyó group

626 Tubular basket with hanging feather tassels. Tiriyó group

627 Models of votive offerings cut out or cast in metal. Juàzeiro do Norte, Ceará

628 Wooden votive offering. Campina Grande, Paraíba

629 Votive figure in carved wood. Canindé, Ceará

630 Wooden votive offering. Pernambuco

631 Wooden votive offering. Canindé, Ceará

632 Wooden sculpture representing the Divine Holy Spirit. Belo Horizonte, Minas Gerais

633 Wooden scoop for stirring manioc. Xinguano group

634 Mask of wood and bark paste. Tukuna group

635 Tucano wood carving of a bird. Brasília, Goiás

620
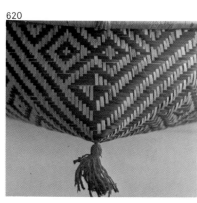

624

628

632
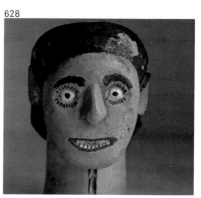

621
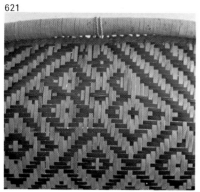

625
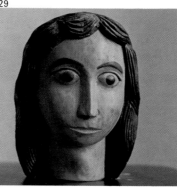

629

633
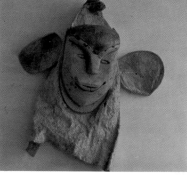

622
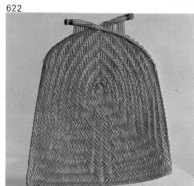

626

630
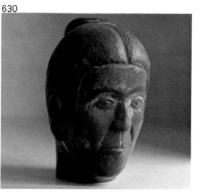

634

623

627
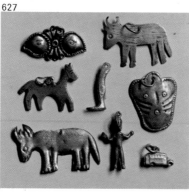

631
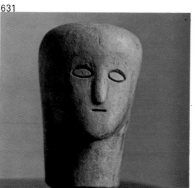

635

636 Oil paint on fabric. Rio de Janeiro

637 "Protector tree"; picture worked in wool. Bahia

638 Singer's cart; oil paint on fabric. São Paulo

639 Bead sash decorated with feathers. For ceremonial use by a woman. Urubú-kaapor group

640 Comb with wooden teeth decorated with feathers, for ceremonial use. Urubú-kaapor group

641 Clay objects; the bird is also a whistle. Tiradentes, Minas Gerais

642 Figure of a man, made in clay and painted. Sergipe

643 Clay figure representing Saint Luke. Tracunhaém, Pernambuco

644 Painted clay figure of women in a circle. Jequitinhonha, Minas Gerais

645 Earthenware bowl with one side shaped like a tapir. Waurá group

646 Clay bowl. Waurá group

647 Clay vessel with rim. Waurá group

648 Clay doll with tribal characteristics. Carajá group

649 Galinho do Céu, or Bird of Paradise; painted clay. Taubaté, São Paulo

650 Clay turtle. Goiânia, Goiás

651 Iron mobile. Recife, Pernambuco

ECUADOR

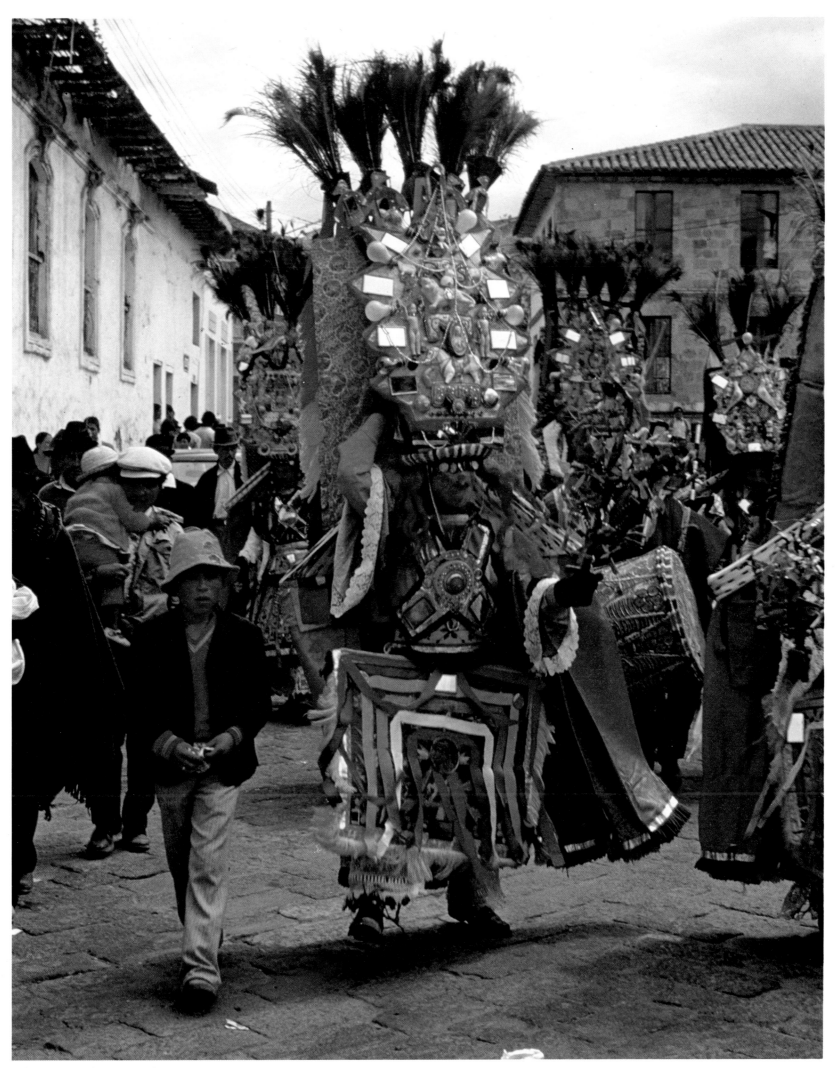

652 Dancer wearing a costume for the Corpus Christi dances.
Pujilí, Cotopaxi

Introduction

Like the other Andean countries Ecuador experienced two successive conquests: first, in the second half of the fifteenth century the coast and central portion of the country became incorporated into the Incan Empire, the Indian state that had spread from southern Peru and now dominated all of Andean South America; then, in 1534 the Spaniards, led by Sebastián Benalcázar, invaded Quito. At the time of the Inca expansion, the mountainous area was inhabited by sedentary tribes who practiced agriculture, built stone and adobe houses, and made pottery as well as textiles of cotton and other vegetable fibers; some tribes in the south were even working with metal. Early chronicles and archeological discoveries indicate that the Cañari, who lived in the territory of the present-day provinces of Cañar, Azuay, and Loja had developed sophisticated techniques for making objects of gold, gilded copper, and clay. The Puruhá Indians of Chimborazo and Bolívar were skillful weavers who used both cotton and cabuya fibers. There is little doubt that ceramic work and weaving were done throughout the mountainous area.

The Incan civilization did not destroy these cultures but it did modify them by changing their social structure and by requiring local production to adapt to the needs of the empire. The Spanish Conquest subjugated the native population and made of it a work force that was utilized to some extent in the production of various kinds of artwork but whose main purpose was to serve the economic interest of the metropolis.

During the colonial period textiles were produced in workshops where, in inhuman conditions, Indians produced cotton, wool, and cabuya fabrics as well as hats, wicks, and sandals, or alpargatas. The shop at Otavalo, for example, had as many as five hundred workers. Ceramic work was also important during the colonial period; judging from documents of the period, Cañar, Cuenca, Pujilí, and Saquisilí were centers well known for quality and volume of production. Metallurgy was limited during the colonial period to extracting gold from the mines in the south, which were exploited through the forced labor of the Cañari Indians. The religious art of the period — church buildings, religious statues, and the like — reflects the high degree of perfection achieved by native sculptors working in stone and wood; only a few of these artisans are known by name.

When we consider folk art in its historical perspective we should not neglect the continuous but unrecorded production of artwork that continued during the period of the republic, which began in 1820 and continues up to the present and which reflects the modest needs of the population.

Ecuador, which has a total surface area of about 106,000 square miles (275,000 sq km), has three geographic zones that are clearly defined as to climate, topography, and natural resources: the Costa, the western coastal zone — the strip of land between the mountains and the sea; the Sierra, the mountain or central area that includes the Interandean Lane; and the Oriente, the jungle or eastern zone lying beyond the mountains. Ecuadorian territory also includes the Galápagos archipelago located a thousand miles off the coast on the Equator. The mountain provinces are, from north to south: Carchi, Imbabura, Pichincha, Cotopaxi, Tungurahua, Bolívar, Chimborazo, Cañar, Azuay, and Loja. The Interandean Lane that Humboldt called the Avenue of the Volcanoes varies in width from 25 to 40 miles (40–65 km) and presents a series of habitable areas at altitudes between 6,000 and 10,500 feet (1,800 and 3,200 m), above which, from altitudes of 10,500 to 15,500 feet (3,200 to 4,700 m), there are strips of barren territory. And above this lie the perpetual snows of the Andes, with peaks up to 20,000 feet (6,000 m).

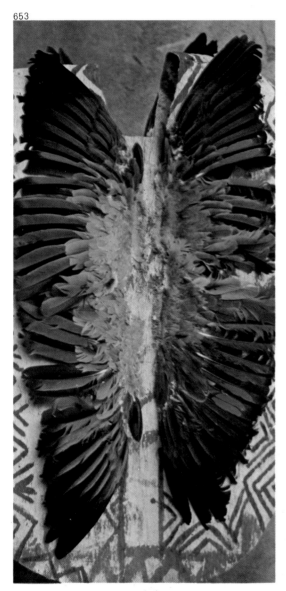

653

654

653 Ceremonial pectoral with balsa wood base decorated with feathers. Canelo group. Sasaima, Cundinamarca

654 The zone to the east of the Andes has tropical vegetation. This typical wooden dwelling is raised above ground level for protection against moisture during the rainy season

655 In Ecuador the social and commercial center is the crowded, noisy marketplace

Our brief survey of Ecuadorian folk art will provide a sampling of styles and production techniques characteristic of the mountainous or Interandean region of the country. Some examples of the artisanry of two jungle groups will be given as well: that of the Cayapa of Esmeraldas province and that of the Canelo of Pastaza province. As each of the crafts included in the survey is discussed an attempt will be made to provide appropriate background information.

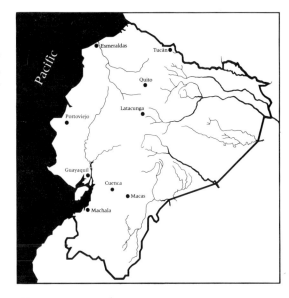

655

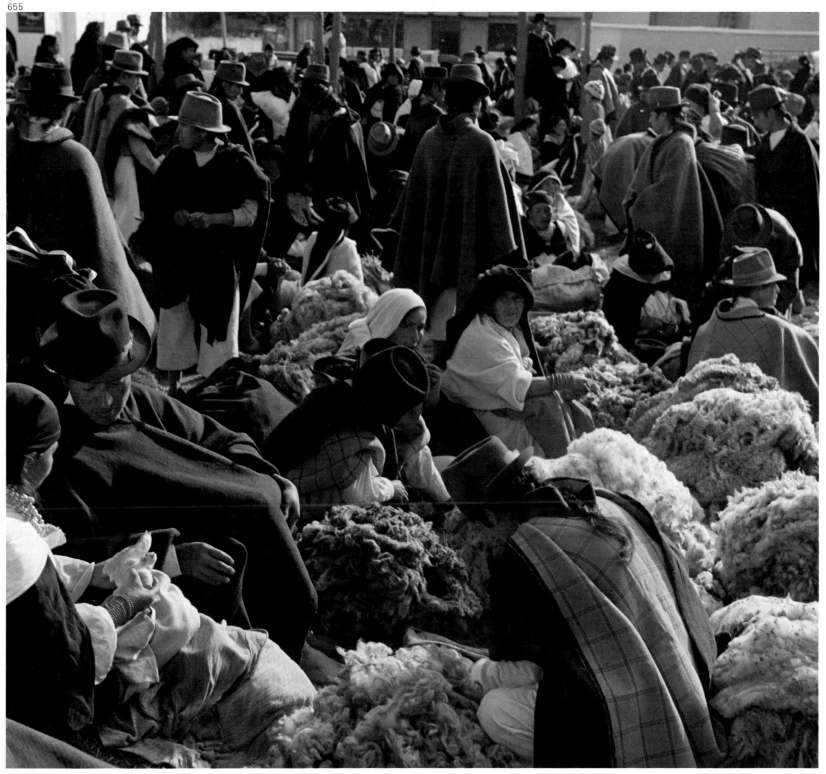

Plant-fiber Weaving

In the mountain area and in the eastern part of Ecuador a variety of vegetable fibers are woven. (In the section on textiles the weaving of cotton will be discussed.) One of these fibers, palmetto (*Cardulovica palmata*), is used for weaving the famous hats of Jipijapa, erroneously called "Panama hats." Palmetto is native to the province of Manabí, on the coast; during the second half of the past century it was introduced in the province of Azuay, where hats woven of it became so important that they are now the chief export item. This hat also became part of the characteristic dress of the native women of Cuenca. Part of the folklore surrounding this craft stipulates that the palmetto hat should be so delicate and flexible that when rolled up into a tube it can pass through a man's wedding ring. At present the chief production center for palmetto hats in Ecuador is Azuay. New styles of hats are being made with openwork weaving and dyed fibers. Since the palmetto fiber is by nature extraordinarily long and flexible and can easily be dyed, its uses are diversified: it is used in making purses, boxes, dolls, crèche figures, place mats, and even skirts and dresses.

The American agave or century plant yields a long, resistant fiber of varying thickness that absorbs dye well. Since precolonial times it has been used in weaving many different kinds of objects: bags, sandals, rope, and, nowadays, rugs and table covers. Among the various kinds of bags of woven cabuya, the *shigra*—a Quechua word meaning "bag"—is especially interesting. It is a cylindrical bag woven with a needle in a buttonhole stitch by women. *Shigras* are woven in many different sizes, from the minute—two to four inches (5–10 cm)

656

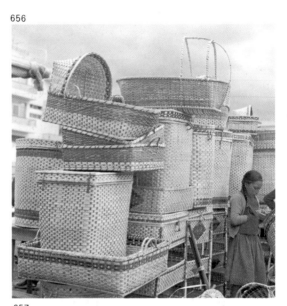

657

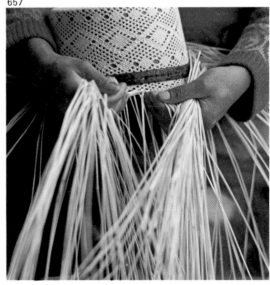

658

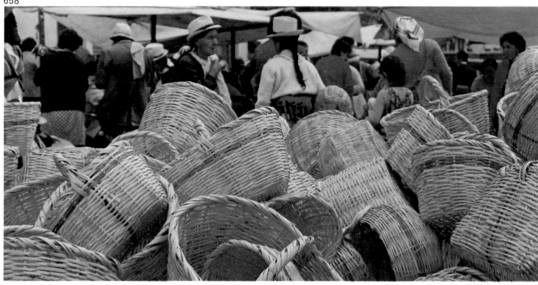

659

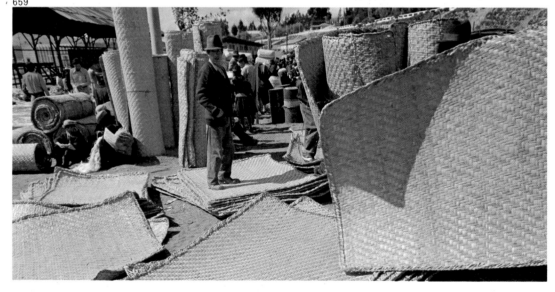

656 Basketry from San Joaquín at the market in Cuenca. Azuay

657 Artisan weaving a palmetto hat. Sigsig, Azuay

658 Carrizo baskets at Cuenca market. Azuay

659 Totora mats from San Pablo Umbabura at the market in Ambato. Tungurahua

in diameter—to the enormous that measure a foot (30 cm) across. The craftswoman begins to weave from the center of what will become the circular base and keeps weaving successive spirals, changing the color of the fibers according to her judgment of what will make an attractive design. Two cords of woven cabuya are sewn to the finished bag so that it can be carried; it is usually carried so that it hangs down the back. What is unusual about the *shigras* are the bands of different geometric figures that appear in the weaving in red, black, brown, gold, purple, and blue. The result is a positive/negative design formed by the contrast between the colored shapes and what remains in the natural-color fiber.

The Cayapa of Esmeraldas weave mats and baskets from palm-leaf stalk bark cut into strips about one-eighth of an inch (3 mm) wide. The weave is diagonal, with strips alternating, usually three above and three below. The bark is dark on one side and light on the other. By weaving half the elements with the dark surface up and the other half with this same surface down, it is possible to obtain many different shapes; animal designs such as frogs and monkeys as well as bands of geometric designs are used in this kind of weaving.

In the mountain region weaving is done with totora or cattail fiber as well as with fibers of *suro* and of carrizo or ditch reed. Totora fiber is used in making mats and fire fans. *Suro* and carrizo are used for making various types of baskets and boxes. In San Joaquín, near Cuenca, large and small baskets and trays are woven of a vegetable fiber known in the region as *duda*.

660

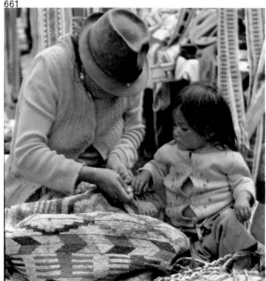

661

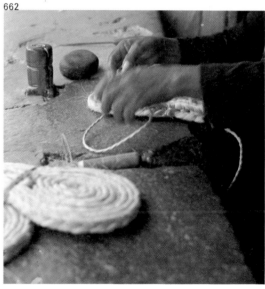

662

660 Palm-stalk fiber mat with designs of people and animals. Cayapas, Esmeraldas

661 *Shigra* weaver at the market in Salcedo. Cotopaxi

662 Artisan making soles for alpargatas (sandals) out of century-plant fiber. Pomasqui, Pichincha

Weaving

Weaving is probably the second most important folk art in the Americas, with pottery coming first. The climate has not permitted the preservation of precolonial Ecuadorian textiles, but there are at least two indications of their importance. The first is the reference made by Cieza de León in his *Chronicle of Peru* to the fine quality of the garments worn by the natives of Ecuador. The other is the importance during the colonial period of the textiles from the Quito area, a clear demonstration that the colonial production was based on a native tradition of textile making.

The poncho and the sash (*chumpi*) in Quechua are the two best examples of the continuity of the native tradition both in technology and in design. The poncho, worn and woven almost exclusively by men, is nearly always made on a backstrap loom; colors are produced by the use of commercial aniline dyes. Traveling from north to south one can observe changes in style in the Ecuadorian poncho; only a few of these styles can be described here. The poncho of Carchi is heavy and solid navy blue in color, similar to the ponchos of the central mountain region. Two types of ponchos are used in Imbabura: the Natabuela style and that of Otavalo. The Natabuela poncho, woven of very thick wool, can be recognized by the predominance of the color pink and by two or three bands of light colors —white, green, yellow, or ochre —in ikat (when a warp or weft is dyed before weaving to create a pattern). The Otavalo poncho is heavy, reversible, and has one side navy blue and the other gray; the cloth is produced on mechanical looms. It has a small collar and a blue cotton binding around the edges. In Sala-

663

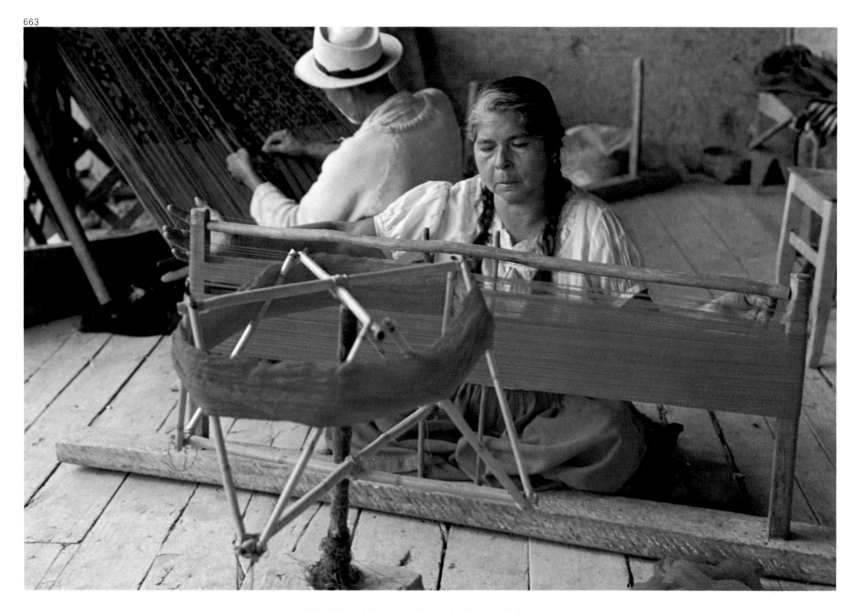

663 Artisan (in foreground) preparing the warp before weaving a woolen *macana*. Pulcay, Azuay

664 Woolen poncho woven on a backstrap loom. Natabuela, Imbabura

saca, in Tungurahua province, two lightweight ponchos of wool are used one on top of the other. Both are long and narrow, reaching to the elbow and to mid-calf. One of them is white, and on top of it another, black in color, is used; both are plain with a simple embroidered border along the side bindings. In the province of Chimborazo men wear a heavy dark red or navy blue wool poncho that has a small collar. In Cacha, a town in the same province, a lighter poncho is woven that has a red or blue background and colored bands that sometimes include ikat weaving. In Cañar two lightweight ponchos are also used, one on top of the other. These are wool and solid black in color. The first covers the shoulders and reaches down to the knees; over it is worn an almost square poncho that covers half the forearm and hangs down to the thigh. The Cañarejo poncho usually has a binding of black or navy blue velvet with a simple machine-embroidered border. In the province of Azuay the ponchos of Sigsig, a very old town in the south of Gualaceo, deserve special mention. These heavy ponchos have blue or red backgrounds and bands of ikat weaving in contrasting colors.

Sashes, whose styles also vary from region to region, are also usually woven on backstrap looms. In Otavalo and Salcedo sashes have a woolen warp and a cotton weft; in Chimborazo they have a woolen warp and weft or woolen warp and cabuya weft; in Salasaca and Cañar the warp and weft are cotton. Little by little synthetic fibers are replacing wool in sash making. The Otavalo sashes are narrow, perhaps two inches (5 cm) in width, with a simple geometric design in dark colors repeated for the entire length. Salcedo sashes are wider and generally have a

664

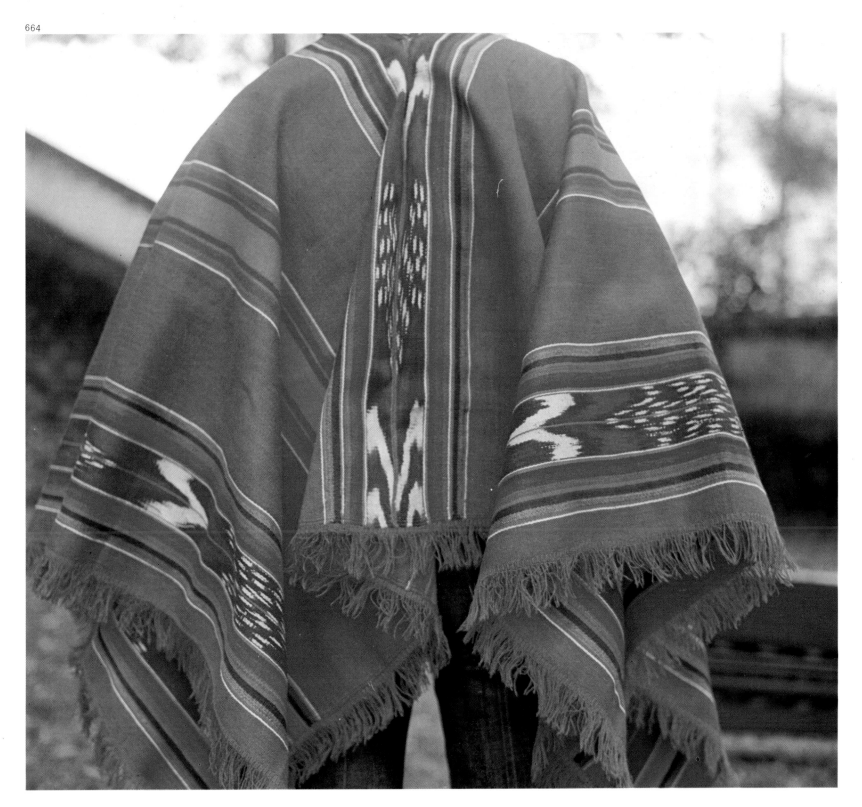

design consisting of a series of geometric shapes alternating with isolated figures of animals. The inhabitants of Salasaca weave sashes exclusively for their own use that are noted for their fine quality. Narrow, with one color generally predominating —blue, wine, or violet —the sashes have a complex design consisting of a series in which different geometric figures alternate with designs of people and animals. In Chimborazo there are two characteristic sashes: one with a woolen warp and weft, about three inches (8 cm) wide, in which red, yellow, blue, and black yarns are combined in geometric designs, squares, or rectangles; and another sash having a cabuya weft and a bright-red woolen warp in which the cabuya is visible only at the edges. Finally there is the Cañar sash, which is woven nowadays of mercerized cotton in a wide range of colors, with only contrasting colors being used in a given sash. The design consists of a series of squares or rectangles in each one of which there appears a different motif: human figures, animals, geometric forms, flowers, and even radios, television sets, and trucks.

Embroidered blouses are another interesting folk art of the mountain area; these blouses are part of the female costume in the various regions. In the province of Imbabura the blouses of Angochura, Zuleta, Natabuela, Otavalo, and Cotacachi are notable. These blouses are of white cotton, with full sleeves and embroidery in one or several colors at the edges of the sleeves and on the bodice. In Chimborazo we find a less sophisticated type of embroidery that is no less attractive. This is a rather ingenuous embroidery used around the edge of the neck, on the sleeves, and around the bottom edge of a garment called *camisa de mujer*, which functions as a kind of slip. In Cuenca, Azuay, multicolored flowers and leaves are machine embroidered on the girls' skirts. In Cuenca little woolen mats are also embroidered with simple figures of animals, flowers, and with decorative borders.

The *macana* of Cuenca is an item of feminine apparel of Spanish origin. This is a rebozo or stole of fine wool or cotton that is made on a backstrap loom with ikat weaving. It terminates at either end with wide bands of openwork weaving and fringes; the bands may be decorated with embroidered flowers or sequins. The weaving is generally of two contrasting colors: light blue and navy blue; red and black; gold and black; gold and red; green and black. In Pulcay, a small town about three miles (5 km) northeast of Gualaceo, extremely fine examples of these garments are produced.

665

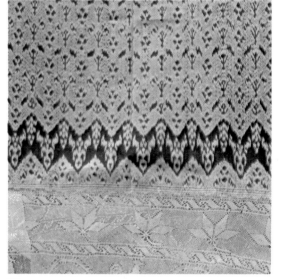

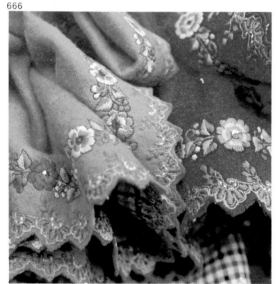

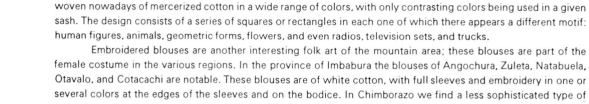

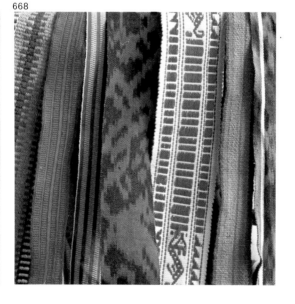

666

667

668

665 Woolen *macana* woven on a backstrap loom. Pulcay, Azuay

666 Woolen skirts with machine embroidery. Cuenca, Azuay

667 Hand-embroidered woolen mats. Cuenca, Azuay

668 Sashes of wool, cotton, and synthetic fibers

Ceramics

Although the Spanish colonization brought with it new techniques, new styles, and a system of production adapted to the socioeconomic regime imposed by the mother country, there was already existing a long tradition of native artisanry upon which these changes were superimposed. The introduction of the potter's wheel and glazing techniques had important consequences for the production of ceramics. Nevertheless, as occurred elsewhere in the colonies, native techniques, designs, and forms persisted and were preserved. Later in the colonial period still more changes were introduced, but the demand of the local population for ceramic objects continued unaltered; for this reason, the ceramics of the mountain area are made primarily for local consumption. Plastic and aluminum articles and enamelware are much in evidence in local markets, and although these have to some extent replaced ceramic objects, the everyday utensils of the local population still include the *barros,* the generic name given to the clay plates, pots, mugs, bowls, and platters produced throughout the mountain area. The slight variation in shape, size, and color of these items permits identification of their place of origin.

We shall limit this discussion to the ceramics produced in the provinces of Cotopaxi and Azuay in the mountain regions and to the province of Pastaza in the eastern zone. There are three important production centers in Cotopaxi: El Tejar, La Victoria, and Pujilí, located to the west of Latacunga, capital of the province. El Tejar (tile works) is a village whose name derives from its tile industry. The piece that displays the exceptional skills of the potters of El Tejar and La Victoria, a nearby village, is a pitcher known by the Quechua term *pondo.* Raw materi-

669

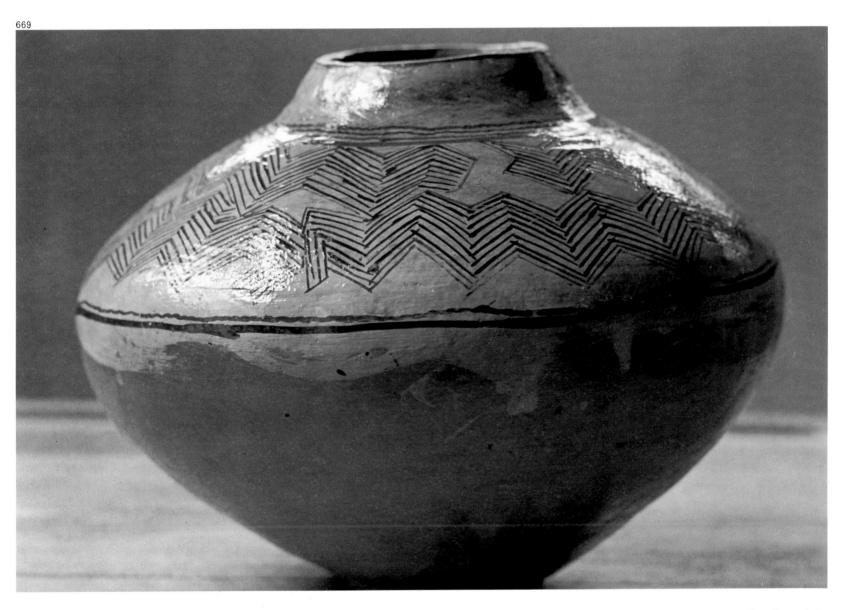

669 Coil-built bowl with slip and decoration of natural pigments, with a copal glaze. Canelo group. Pastaza

als are obtained from local deposits of clay. The piece is formed by means of the coil technique. Starting from a mold, in which the base is formed, cylindrical strips are added that vary in length according to the size of the diameter that is desired. As these strips are added, the artisan, with one hand inside the piece and the other outside, keeps smoothing both surfaces, giving the walls the desired thickness. For this he uses a smooth piece of ceramic with curved edges. The neck is shaped with the same technique. To achieve an even smoother finish a piece of damp leather is used.

Some of these pitchers are decorated with a band of repeated geometric designs incised around the mouth or upper portion of the body of the piece. Another type of decoration consists of a red engobe around the neck. On some pitchers a face is modeled at the neck, reminiscent of precolonial ceramic designs. As the piece is being formed, the artisan, using his foot, turns it round and round to shape it. These pitchers are produced in sizes varying from six inches to three feet in height. The firing, or *quema* as the natives call it, is done in an open fire for large pieces and in a circular oven for small- and medium-sized ones.

These pieces, which are rarely glazed, are perfectly adapted in shape for water and grain storage and can be carried on the back with the aid of cords. In El Tejar a type of roof cross is made of glazed ceramic and is similar to those that will be discussed in the section on religious festival art.

Pujilí, previously mentioned for its importance as a center of ceramic production during the colonial period, produces unglazed, molded pitchers, mugs, bowls, and pots, which are baked in an open fire. Among these articles the shallow bowl called *tostadora* or *callana* (the Quechua word for bowl) is of special interest. This is an unglazed flat plate, fifteen to twenty-five inches (38–64 cm) in diameter, produced in a mold, and sometimes finished with a red engobe. The *tostadora* is used to toast barley or corn; it is a basic piece of domestic equipment in the mountain region. Besides this utilitarian item Pujilí produces a considerable variety of decorative pottery, and the region has become famous for these articles. They include ceramic fruits, animals, bullfighters, Nativity figures, and such familiar mountain folk as musicians, farmers, and soldiers. All these shapes are produced in molds and are generally baked in an open fire. Some figures are painted in vivid colors with a type of enamel; others are left unpainted, sometimes used as the roof figures mentioned above. Some of the figures of animals and fruits are used as banks. One particularly interesting Pujilí figure is that of the dancer attired in the bright-colored costume of the Feast of Corpus Christi in Pujilí. The same figures on a smaller scale are used as toys.

Of the ceramic centers in the province of Azuay only San Miguel de Porotos, Chordeleg, and Cuenca, capital of the province, will be discussed. The present-day province of Azuay was part of the territory inhabited by the Cañari tribe, which achieved a high level of skill in ceramic production and in metalworking. The province continues to be the most important area of the country in the production of all types of crafts; besides ceramics it produces textiles, embroidery, palmetto hats, filigree, painted furniture, onyx work, wood carving, tinwork, and roof crosses. There are excellent clay deposits near Azuay that provide the raw material for ceramics. The pottery of Azuay is distinguished by the variety of shapes and types of decoration. That of Cuenca and Chordeleg is notable for the use of glaze. A wide range of qualities and prices is produced; we found the most reasonable prices of all at the weekly markets held throughout the mountain area. In the city of Cuenca the Corazón de Jesús zone is noted for

670

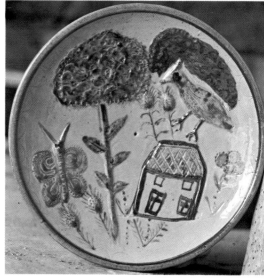

671

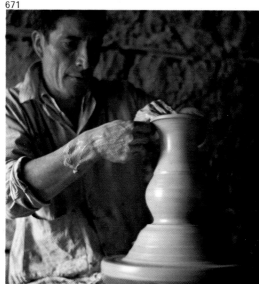

672

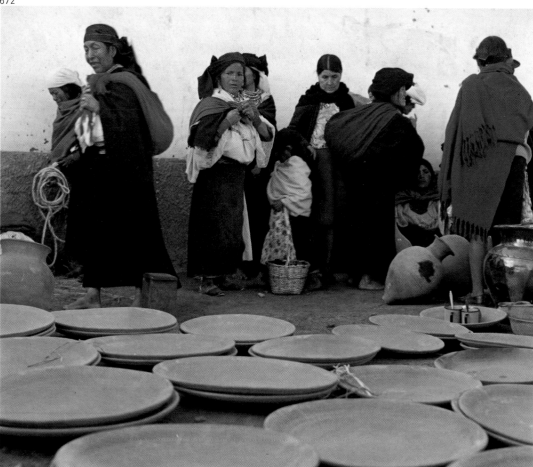

670 Turned ceramic plate with relief decoration painted with mineral pigments and glazed. Chordeleg, Azuay

671 Artisan turning a pitcher for a set of dishes. Chordeleg, Azuay

672 Unglazed, molded *tostadoras* at Otavalo market. Imbabura

673 Coil-built ceramic pots from San Miguel de Porotos. Azuay

its pottery. Here household articles are produced such as pitchers, pots, candleholders, mugs, animal banks—all in imaginative shapes. This work is glazed and decorated with leaves, flowers, and borders with the color green predominating. A type of large mug, known in Quechua as *Cuenca latu*, used for eating throughout the mountain region is also made here.

Chordeleg, about forty miles (65 km) east of Cuenca, is the most important pottery center of all Ecuador. The potters of Chordeleg, all of whom are men, make cooking pots and casseroles, vessels for storing *ají* (peppers), coffeepots, basins, flowerpots, vases, platters, tureens, and complete dinner sets. These items are made on a wheel and glazed; decorating techniques include incising, relief work, the addition of hand-modeled figures, and the use of painted designs of fruits, flowers, leaves, and borders in blue, green, yellow, purple, and black. Glazing is done with lead, tin, fine sand, copper, and cobalt oxide. Firing is done in a circular kiln made of adobe with wood as fuel. Women participate by helping to move the pieces and charging the kiln; in some isolated cases a woman may actually decorate a piece. The hand-modeled figures—roosters, birds, fish, snakes, lizards, frogs, calves, goats, and leopards—are placed as handles on tureens, pitchers, sugar bowls, and serving dishes.

In the extreme north of the valley of Cuenca within an area of about one mile around the town of Jatunpamba, near San Miguel de Porotos, there is a village of potters whose household wares are much appreciated in the markets of Cuenca and Azogues. Right in the town square of Jatunpamba an excellent quality clay is obtained

673

for making pottery. Jatunpamba specialties include pots, large pitchers, casseroles, and *tostadoras* with handles. Unglazed and bright red in color, these articles stand out in the pottery stalls of marketplaces because of their polished surface and regular shape. It is the women of this village who make this pottery; men help by carrying raw materials and baking the pieces in an open fire. These pieces are formed by use of the coil technique, somewhat modified by the introduction of a precolonial tool, the clay beater. Two beaters are used, one concave and one convex; these are used to tap the outside and the inside of the article in order to obtain the desired thickness and to pack down the clay. A very popular item that is made in San Miguel consists of three spherical bowls about four inches (10 cm) in diameter that have covers and curved handles that meet in the center, above the bowls. These are used for condiments and are known by the amusing name *conquienvinísteis* (whomdidyoucomewith).

In eastern Ecuador, in the province of Pastaza, near Puyo, pottery is produced by the Canelo. The Canelo make five different kinds of ceramic vessels: *chicha* jugs and mugs, cooking pots, soup bowls, and human and animal figures that are used in ceremonies and festivals. All pieces are made using the coil technique and are baked in an open fire. Engobes and paints are made by using various minerals, and clays are obtained from rivers and streams in the area. Two types of resins, a dark one resembling copal and a white one that comes from a rubber tree, are used to form a film over the pieces that performs the same function as a glaze. The copal-type resin is applied immediately after firing, while the article is still hot. The white resin is used on the parts not touched by the copal and is applied after the article has cooled. The pieces are painted in geometric designs in red and black with a brush made from the potter's own hair. Canelo pottery is made exclusively by women, and all aspects of the art—its technology, shapes, designs, and colors—are articulated with the group's system of beliefs and reflect its repertoire of symbols. The symbolic aspects of this pottery have been analyzed in detail by Norman E. Whitten in his study of the Canelo.

674

675

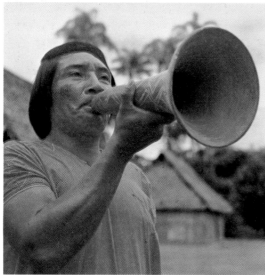

676

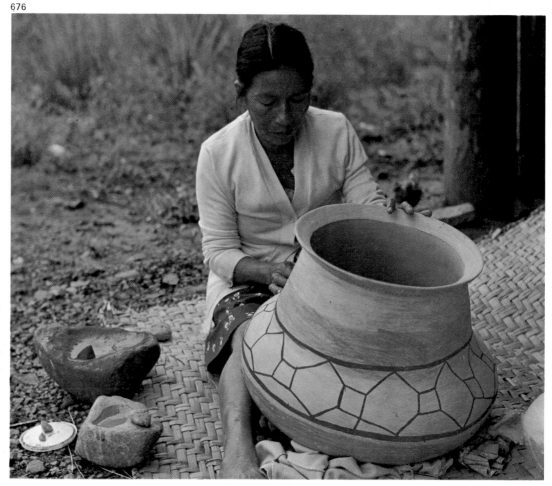

674 *Soto të'qui* in the Secoia language means "big plate"; it is used for cooking tortillas made of yucca. Secoia, Cundinamarca

675 Ceramic trumpet (*duruhuë*), used to inform members of the tribe that a meeting is about to begin. Cundinamarca

676 Artisan decorating a coil-built *chicha* jar with natural pigments. Canelo group. Pastaza

677 Coil-built ceramic mug with slip and mineral pigment decoration and a copal glaze. Canelo group. Pastaza

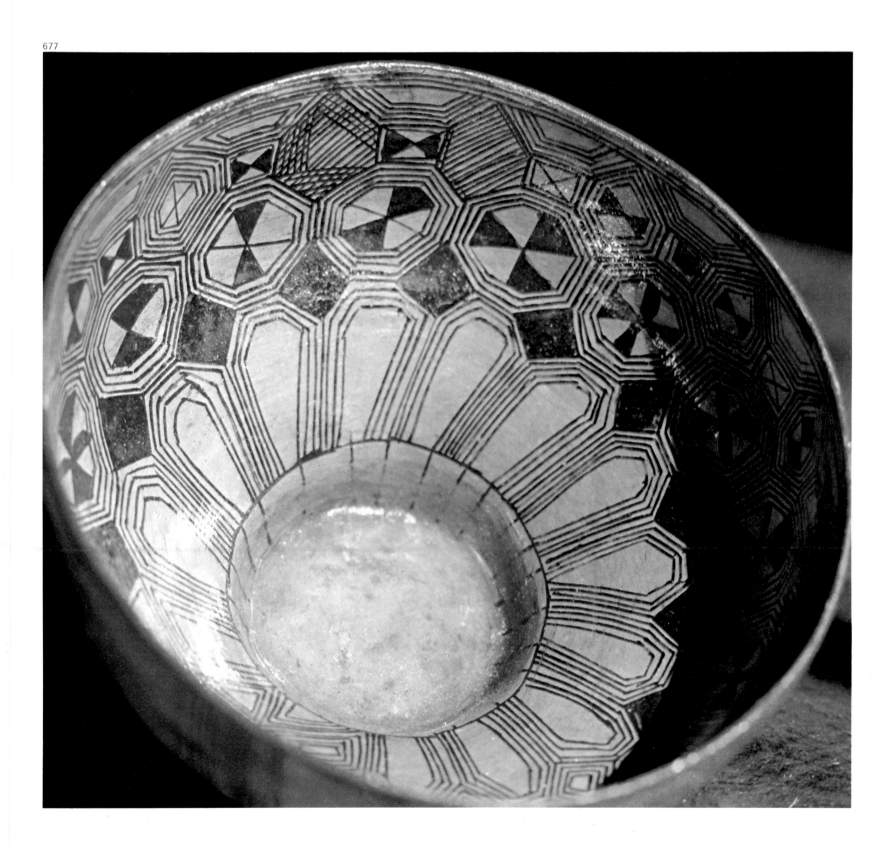

Catalogue

684 Clay bowl with symbolic tribal designs. Riochico, Napo-Pastaza

685 Coil-built ceramic pot. Canelo group. Pastaza

686 Vessel for drinking *chicha* at festivals. Ceramic painted in natural pigments. Canelo group. Pastaza

687 Turtle-shaped ceramic vessel for drinking *chicha*. Canelo group. Pastaza

688 *Cua'coro*, clay pot for cooking *chicha*. Secoia, Cundinamarca

689 Coil-built household pot whose inside walls are protected by a coating of nettle juice. Canelo group. Pastaza

690 Wooden images of Saint Mark and Saint Isidore. Gualeceo, Azuay

691 Molded, painted figure of a Corpus Christi dancer. Pujilí, Cotopaxi

692 Train of the costume of a Corpus Christi dancer. Pujilí, Cotopaxi

693 Edging of a mask, crocheted in wool and embroidered. Azuay

694 Hand-embroidered wool fabric. Cuenca, Azuay

695 Handwoven woolen poncho. Sigsig, Azuay

696 Detail of a woolen saddle blanket woven on a backstrap loom. Azuay

697 Bark painting. Canelo group. Pastaza

698 Adornment given as a gift when a new home is inaugurated, at a housewarming. Imbabura

699 Iron roof cross. Cuenca, Azuay

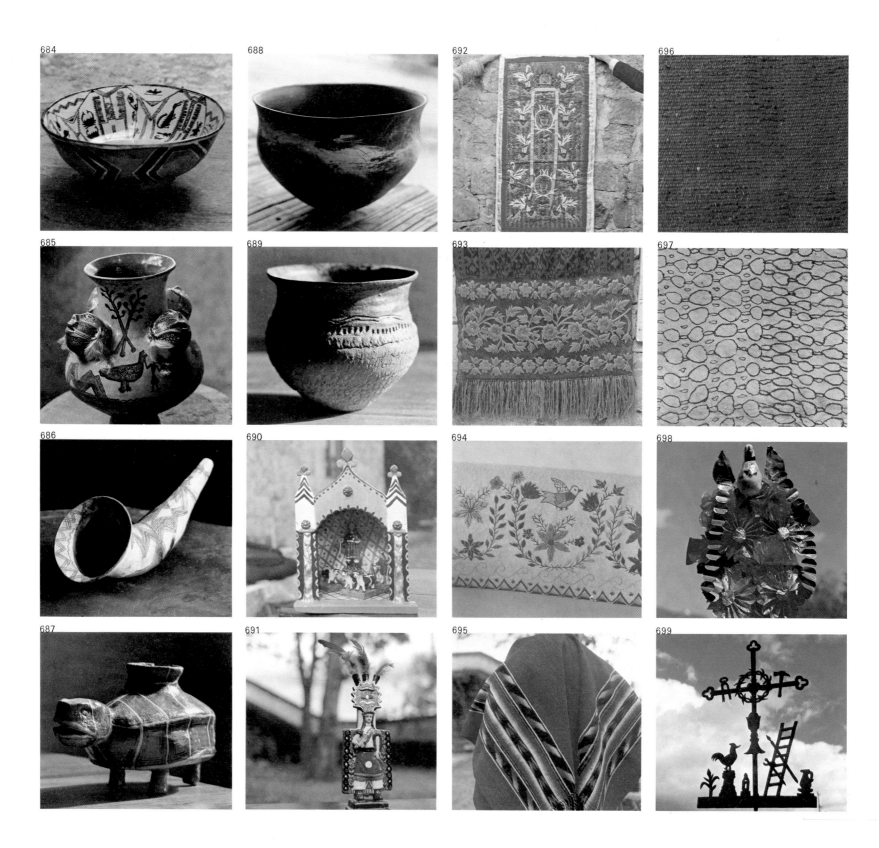

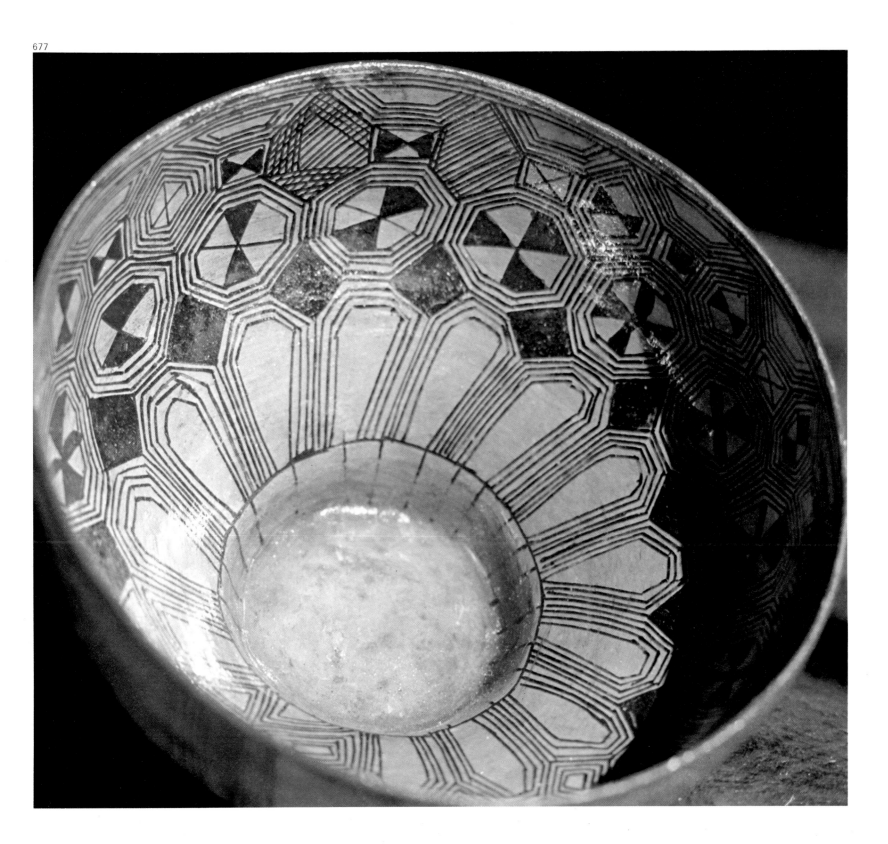

Religious Festival Art

The Feast of Corpus Christi includes performances by dancers in showy costumes who dance in the streets and plazas of towns to the sound of drums, the *pinguyo* (reed flute), and the *rondador* (panpipes). Mountain areas famous for their Corpus Christi dancers are Pujilí in Cotopaxi, and San Andrés de Pilaro and Pelileo in Tungarahua. Two parts of the dancer's costume are of particular interest: the tiara and the *cola*. The tiara, or *huma*—the Quechua word for head—resembles a miter and is worn over the front part of the brim of a hat. The face of the tiara is covered with beads and stones, necklaces, earrings, bits of mother-of-pearl, figures of lambs, and reliquaries.

The other article mentioned, the *cola*, is a stiff, rectangular piece of cloth that covers the back part of the tiara and hangs down the dancer's back. The *cola* is made of satin or other shiny material embroidered in colored and silver threads; it is made of vivid colors with flowers, crosses, equestrian figures, the Ecuadorian coat-of-arms, and the dove of the Holy Spirit. It also has tiny mirrors fastened to it and long colored ribbons.

The people in the town of Pomasqui in Pichincha province worship the Christ of the Tree, to whom many miracles are attributed. The votive offerings that are displayed on the side walls of the sanctuary in the town square attest to this; these are oil paintings on cloth, in wooden frames, measuring about five feet (1 1/2 m), that depict when the protection of the Christ of the Tree was invoked or the various stages of healing that led to a cure.

San Antonio de Ibarra is well known for the quality of its hand-carved religious images; it produces Nativity scenes, saints, and virgins as well as decorative figures. Gualaceo in Azuay province also produces hand-carved

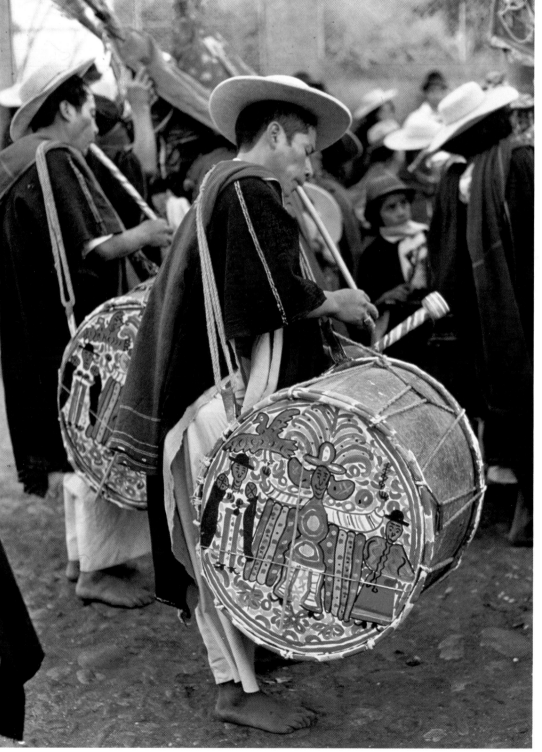

678 Decorating a "bread baby." Calderón, Pichincha

679 In addition to the motifs deriving from the Christ of the Tree, decorations include a great diversity of other motifs, such as this representation in oils of the Christ of the Highway

680 Musician from Salasaca in the Corpus Christi festival in Pelileo. Tungurahua

images of painted wood, but these are for a strictly local clientele and are not sold to tourists.

The protection of the home, family, and animals is assured by means of the roof crosses and figures that are placed on the ridgepole at a roof-raising —an occasion for which the owner of the house gives a party.

The most elaborate roof crosses are those of Azuay province, where they are made of stone, ceramic, and metal. The city of Cuenca is famous for its street of ironmongers, where metal crosses are made that have symbols of the Passion, silhouettes of angels and animals, and even bullfighters, painted black or in bright colors.

For the Day of the Dead in the beginning of November the entire mountain region people make *guaguas de pan*, or bread babies (*guagua* is the Quechua word for baby). These are offerings that are taken to the cemetery and presented to relatives who have died. They are very simple figures of persons and animals made of bread dough and decorated with tiny pieces of the black, red, and blue dough that have been tinted with anilines.

In Cuenca these figures are also made for the festival of the Procession of the Christ Child at Christmas and for Godparents' Thursday before carnival. This craft has given rise within recent years to a more elaborate version, consisting of bread-dough figures of dolls, clowns, animals, Nativity figures, and flowers —all decorated with gold filigree and finished with a coat of clear varnish. These have become some of the typical souvenirs of Ecuador and they are produced by artisans from the area of Calderón, just north of Quito in Pichincha.

681

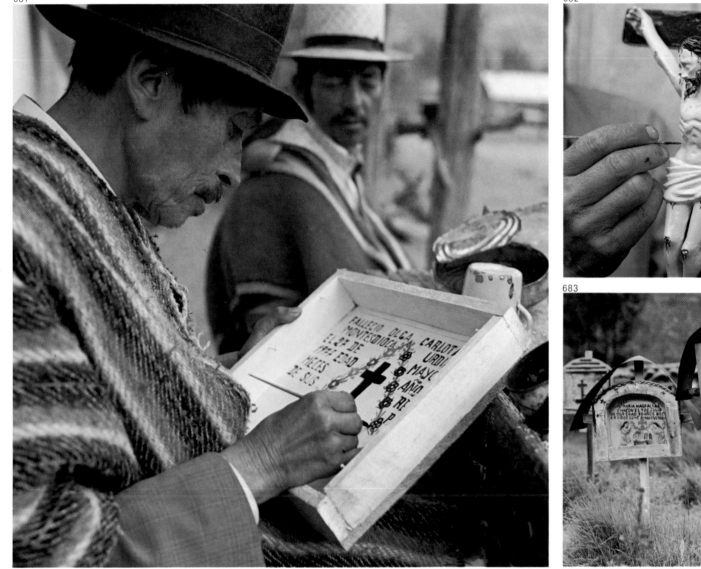

682

683

681 Artisan painting a memorial plaque for a cemetery cross. Chordeleg, Azuay

682 Christ made of painted wood. Gualaceo, Azuay

683 Cemetery with hand-painted memorials to the dead. Azuay

Catalogue

684 Clay bowl with symbolic tribal designs. Riochico, Napo-Pastaza

685 Coil-built ceramic pot. Canelo group. Pastaza

686 Vessel for drinking *chicha* at festivals. Ceramic painted in natural pigments. Canelo group. Pastaza

687 Turtle-shaped ceramic vessel for drinking *chicha*. Canelo group. Pastaza

688 *Cua'coro*, clay pot for cooking *chicha*. Secoia, Cundinamarca

689 Coil-built household pot whose inside walls are protected by a coating of nettle juice. Canelo group. Pastaza

690 Wooden images of Saint Mark and Saint Isidore. Gualeceo, Azuay

691 Molded, painted figure of a Corpus Christi dancer. Pujilí, Cotopaxi

692 Train of the costume of a Corpus Christi dancer. Pujilí, Cotopaxi

693 Edging of a mask, crocheted in wool and embroidered. Azuay

694 Hand-embroidered wool fabric. Cuenca, Azuay

695 Handwoven woolen poncho. Sigsig, Azuay

696 Detail of a woolen saddle blanket woven on a backstrap loom. Azuay

697 Bark painting. Canelo group. Pastaza

698 Adornment given as a gift when a new home is inaugurated, at a housewarming. Imbabura

699 Iron roof cross. Cuenca, Azuay

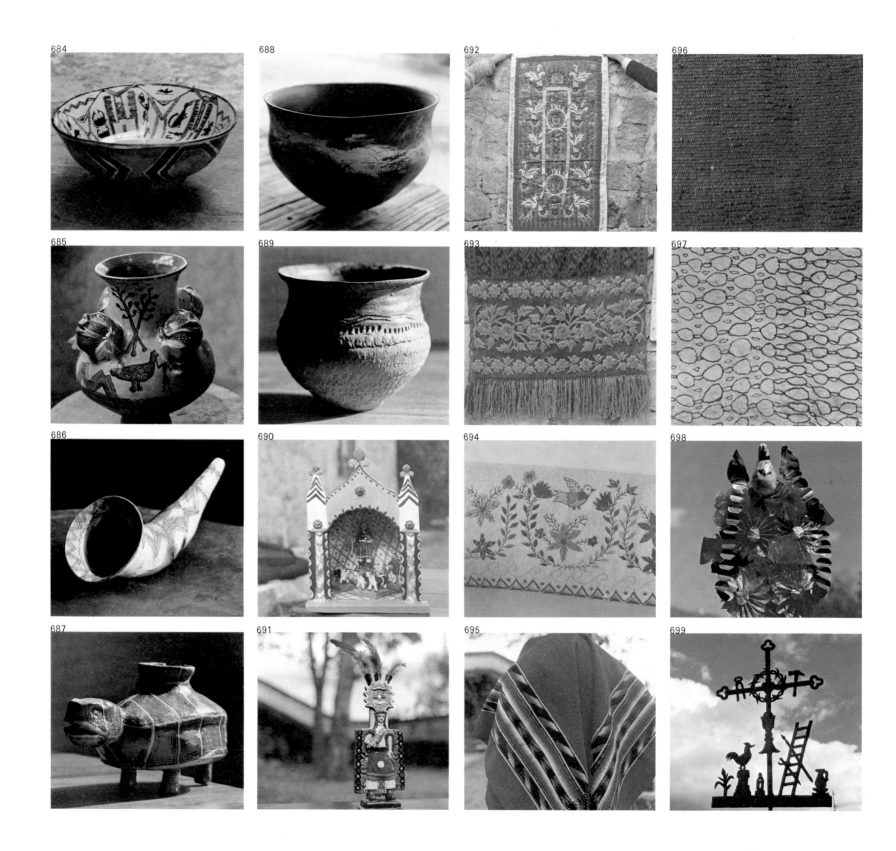

700 Painted wooden washtub. Cuenca, Azuay

701 Feather crown. Canelo group. Sasaima, Cundinamarca

702 Baskets woven of totora. Chimborazo

703 Palm-leaf stalk basket with a cotton strap. Canelo group. Pastaza

704 Palmetto straw hat. Sigsig, Azuay

705 Fabric mask. Imbabura

706 Necklaces of glass beads, tiny bells, seeds, and bones. Canelo group. Pastaza

707 Glass bead necklaces. Canelo group. Pastaza

708 Comb made of thorns held together with cotton thread. Canelos group. Pastaza

709 *Tupu* or metal jewel. Cotacachi, Imbabura

710 Wooden dolls. Capayas, Esmeraldas

711 Balsa wood bird with burned designs. Shore of the Tena River

712 Sculpture of painted balsa wood. Shore of the Tena River

713 Carved wooden figure of a jaguar. Canelo group. Pastaza

714 Shaman's stools of carved wood. Canelo group. Pastaza

715 Mortar for grinding grain. Pichincha

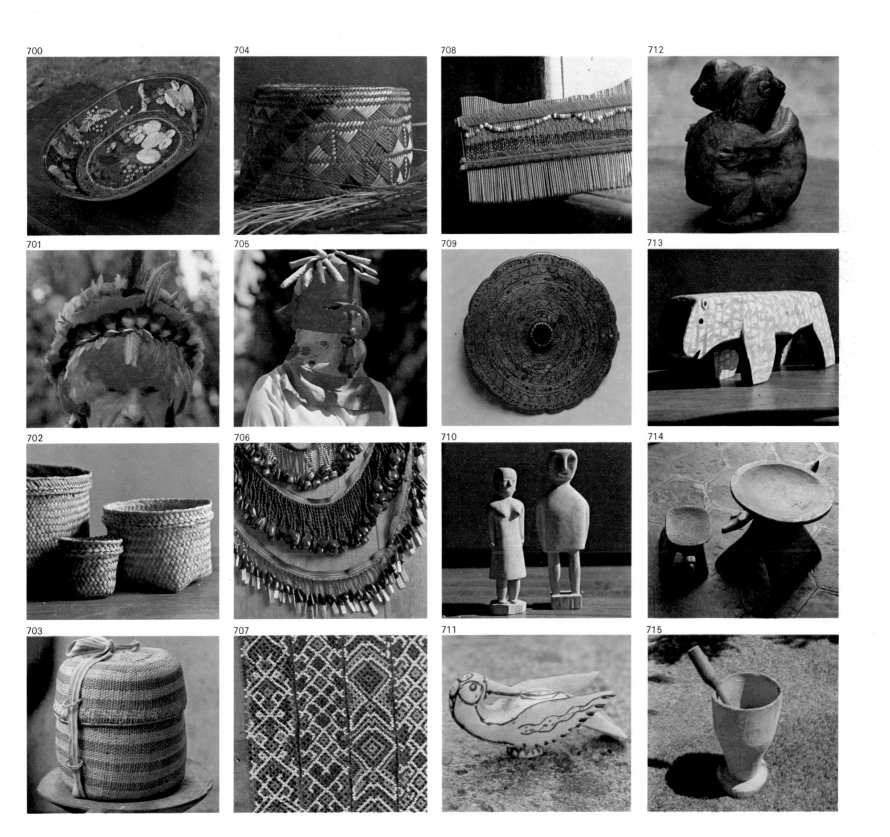

PERU

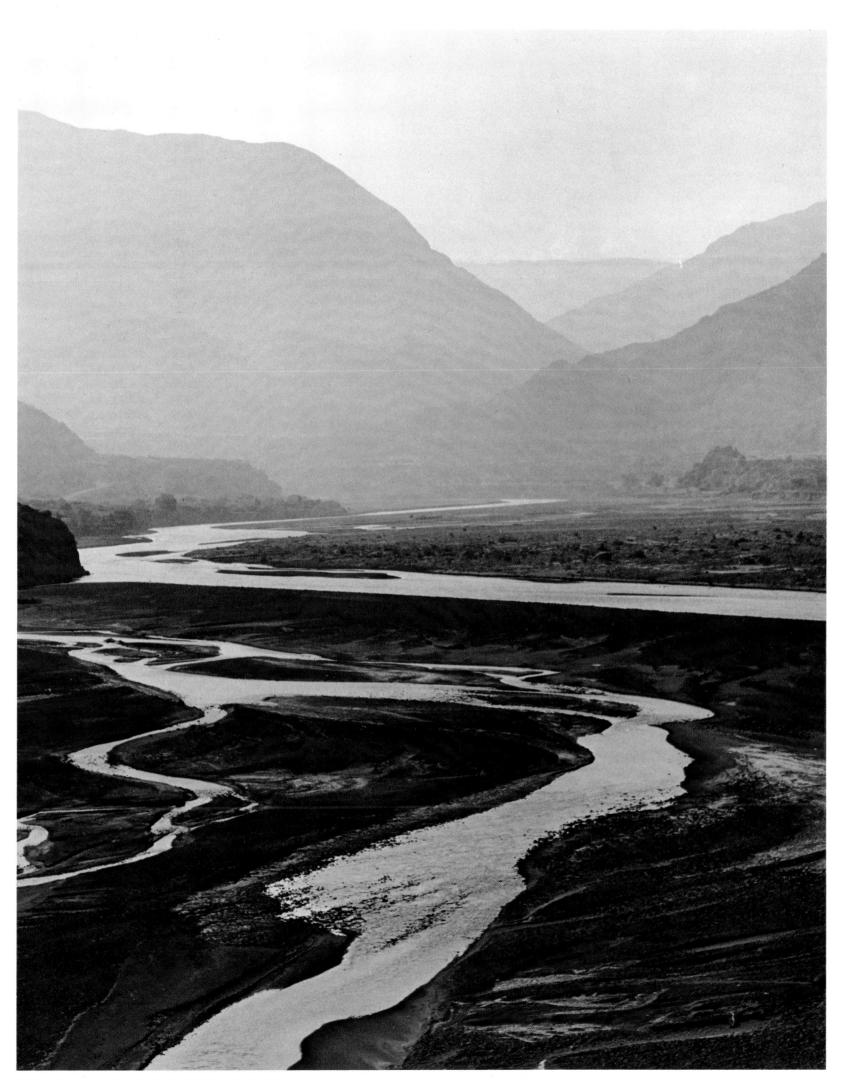

716 Altiplano, seen from 7,900 feet (2,600 m), showing
the characteristic mountain configuration of the area. Ayacucho

Introduction

And from that time onward, oh traveler, if you want to find the place where the captive woman was sacrificed, the place the inhabitants of Huancayo call Palla-huarcuna, examine the chain of hills and between Izcuchaca and Huaynanpuquio you will see a rock shaped like an Indian woman wearing a necklace around her neck and a headdress of feathers. The rock appears to have been carved by an artist, and the natives of the country . . . consider it the evil spirit of their land, believing that no one dare spend the night at Palla-huarcuna without being devoured by the stone phantom.

Ricardo Palma, *Traditions of Peru*, "Palla-huarcuna," Volume I. 1860

Peru as it exists today is an amalgam of episodes that have left their mark on the historical, social, and cultural development of the country. Difficulties still remain in establishing a precise chronology of the pre-Columbian cultures. On one hand, dating techniques change and every advance in this field means that all the data previously obtained must be reevaluated; on the other hand, the research is based on limited or incomplete material, with every new discovery confirming or amending previously formulated theories.

Dates for the beginning and ending of the various civilizations are vague; their distinctive characteristics are equally imprecise and there was often a symbiotic relationship between one civilization and the other. These relationships can be detected —or sometimes merely suspected —in the archeological ruins. It is also possible to identify the presence of two major ethnic groups: one whose ideology urged them to the conquest of new territories, another who stayed within a small area, dedicated to a religion or the creation of magnificent works of art. For example, the Chavín culture (c. 700–c. 200 B.C.) extended along the entire coastal area of Peru to a point about two hundred miles (320 km) south of Lima. In the course of their expansion they influenced the Paraca, but not only did the Chavín allow this people to retain their individuality, they also enriched their development through new ideas, some of which are still reflected in the magnificent textiles of the Paracan tradition.

At any rate, the expansionist civilizations, such as the Chavín, dedicated themselves not only to the conquest of new territories, but also to the cultivation of different plastic art forms. For example, they can be considered master goldsmiths. In other groups such as the Nazca, Chimu, Mochica, and Chancay archeologists have found artistic work in textiles, ceramic, and gold of the technical perfection reached by those civilizations that developed within the land which is now Peru and which gave rise to the Incan Empire.

The empire began as a small group of Quechua Indians who lived on the altiplano (high plateau) of Peru; its first center was Cuzco. A state with an internal democratic organization was developed that, despite their roles as conquerors, respected the individuality of their subject peoples. The Empire of the Sun eventually stretched from Peru and Bolivia along the coastal strip of Ecuador north to the Colombian border; in the south it penetrated deep into Chile, where it was forced by the Araucanian Indians back to the southern shores of the Maule River. It is important to note that in the area of the Empire of the Sun (modern Peru) the majority of the pre-Inca cultures,

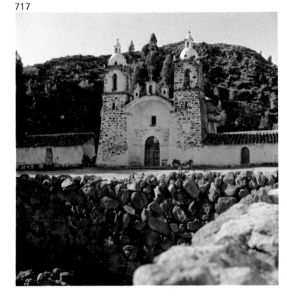

717

718

717 Complex works of colonial-style architecture are found in the large urban centers but the measure of Spanish determination to dominate Peru can be seen in the traces left by the conquistadors found in small villages. San Pedro de Lloc, Lambayeque

718 Impressive retaining wall in a Cuzco street. In spite the fact that Cuzco is one of the country's principal tourist attractions, its inhabitants retain their traditional dress and customs

719 Machu Picchu, a city built by the Inca Empire that is the largest example of their architecture

including the Aymará (Tiahuanaco) and the Quechua (Inca), left their marks in large archeological centers where, once again, we can gauge the inventiveness of their leaders and the skill of their artisans. Chavín de Huantar, Chan Chan, Pachacamac, Cuzco, and Machu Picchu, in their various stages of preservation, are all examples of the continuous and enviable process of acculturation to which this area was subjected.

When the Spanish Conquest started, the Inca Empire found itself in a difficult domestic situation. The elite in Cuzco had lost its fighting spirit and the Quechua were embroiled in a civil war, which doubtless made them easier to subdue. Thanks to the records of the time—for which the unions between the conquistadors and the daughters of leading local dignitaries were a valuable source of information (the historian Garcilaso de la Vega, called The Inca, was the child of such a marriage)—we know to some depth and thoroughness the Incan way of life. The Spaniards forced a new culture on them that did not respect the old one and, in a short time, the Inca Empire disappeared. The conquistadors used the existing politico-cultural organization only as a base on which to impose their own.

On the positive side, however, the fruits of the new culture brought by the Spanish resulted in the creation of magnificent works of colonial architecture and introduced new craft techniques, among them the potter's wheel, earthenware glazing, and the treadle loom. Folk art was thus modified by outside influences, by the way of life and behavior of a few adventurers and soldiers whose greatest desire was to re-create in the conquered land what they

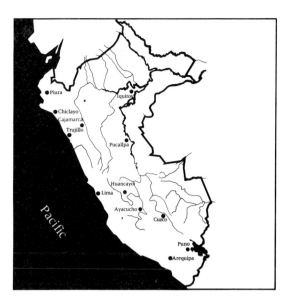

719

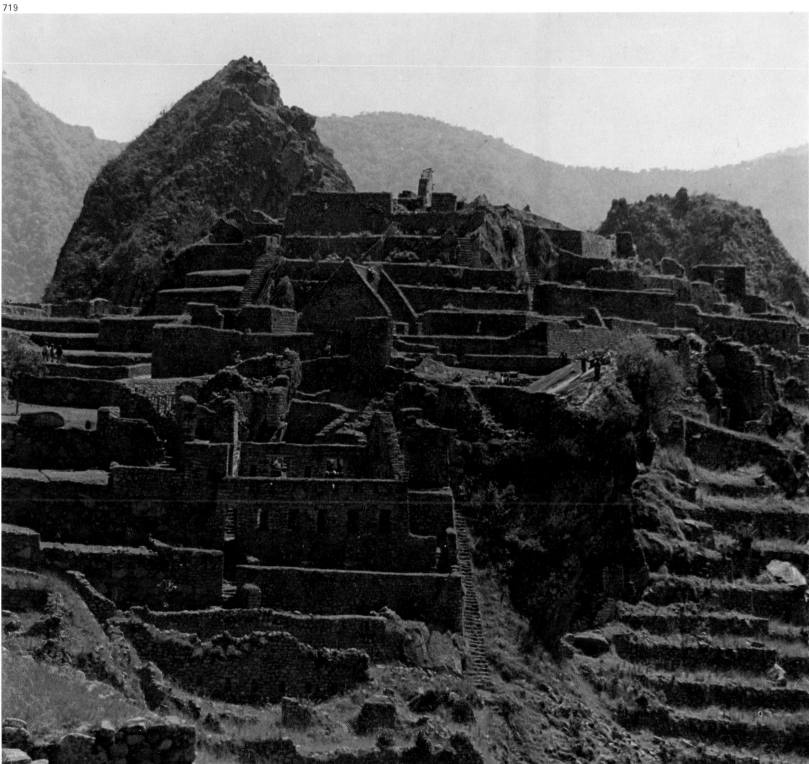

had abandoned in their own. Native artisanry in particular began to reflect a Christian influence that mingled with the religious art of the ancient civilizations.

In modern Peru it is possible to distinguish three quite distinct ways of life, each shaped by one of the three clearly defined and diverse geographic zones: the coast, the mountains, and the jungle. The Andes mountain range crosses the country from north to south; to the west the coast is arid and the abundance of water that flows through the valleys seldom reaches the sea since it is used to irrigate the fields. The Humboldt current, with temperatures below that of the Atlantic waters off the coast of Brazil at the same latitude, sends cool water along the coast of Peru, encouraging the presence of plankton and, consequently, marine life. The coast of Peru is devoted to fishing and the production of fish meal, both important components of the country's economy.

Contrary to what might be supposed, the Andes in this area are not crowned with rugged peaks, except in the north, where such peaks as Huascarán (22,205 feet; 6,768 m) have perpetual glaciers, but rather form a chain of rolling mesetas at altitudes of 10,500 to 16,250 feet (3,500–5,000 m), where conditions of life are arduous. Valleys at 8,200 feet (2,500 m) are truly oases in these endlessly bleak and desolate plateaus.

The Amazon jungle is hot and wet with the typical tropical climate of a rain forest and vegetation so lush that it is virtually impenetrable. However, to transform this into cultivated land is enormously difficult because of the scarcity of organic elements in the soil. The thin layer of humus is quickly and easily eroded as soon as any

720

720 View of the Aguaytia, a tributary of the Ucayali River which, with the Marañón, forms the Amazon. Throughout the jungle rivers are the primary means of communication. Signs of life can be found along the banks

721 Market day is held weekly at certain points between urban centers. Here Peruvians go to buy, to sell, and to meet one another. It is possible to buy anything at these markets, including livestock, furniture, clothing, jewelry, etc.

attempt is made to cultivate the land, since the felling of the trees exposes the soil to the elements and destroys the delicate equilibrium of the rain forest.

In the jungle live many tribes whose cultures and distinctive languages and customs are quite diverse. Urban centers, such as Iquitos and Pucallpa, located on the banks of the Amazon, the Ucayali, and other rivers, are inhabited mainly by mestizos.

Peruvian folk art is an amalgam of varied expressions; it is a living art, springing from human and geographic differences. It is evolving in all parts of the country, from the most secluded areas to sections of urban centers, and it encompasses all forms of artistic expression. Modern Peruvian artisans are skilled in ceramics, leather, wood, and wax, and through them the ancient cultures that existed before the arrival of the Spaniards live on. The distinctive characteristics and ways of those who dwell in the virgin jungle, the arid zones, or at a height of 6,300 feet (4,000 m) all leave their imprint equally on many works of folk art.

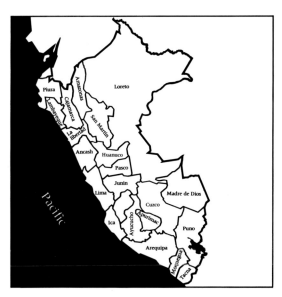

721

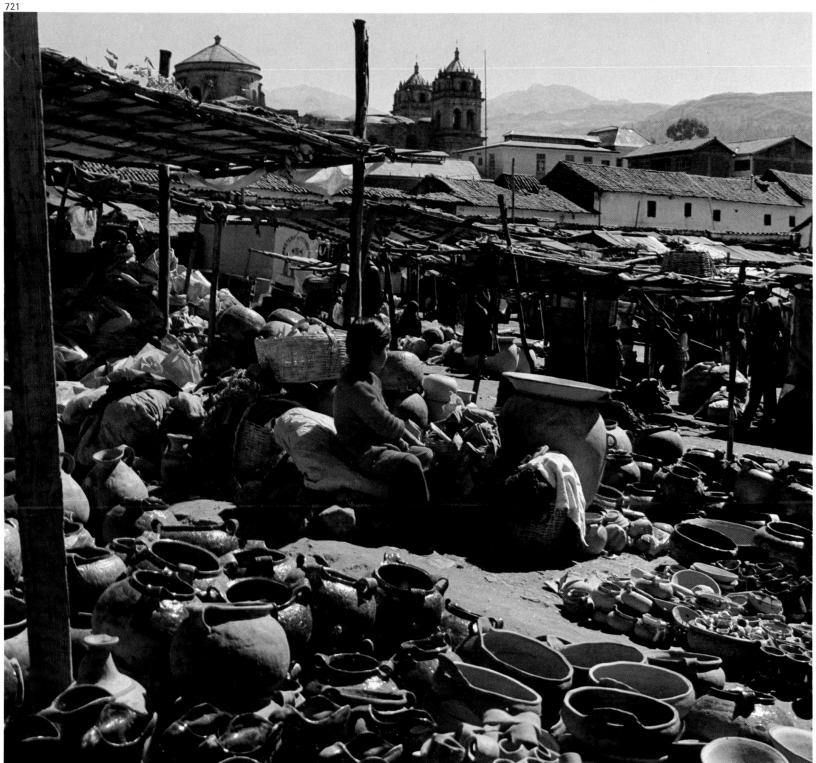

Pottery

The pottery produced in Peru is varied, rich, and complex; in each department we can find pieces unique in their form, color, and finish. Different types of pottery are found in the departments of Piura, Lambayeque, Ica, Cajamarca, Ancash, Junín, Huánuco, Huancavélica, Ayacucho, Apurímac, Cuzco, Puno, Loreto, Amazonas, and Madre de Dios. Although there are certainly objects of other materials, such as plastic, to be found in the town markets, baked clay is still used for making domestic utensils in the rural areas. Each potter has his own particular clay beds, the locations of which he is reluctant to reveal. When the land is not his, he has to strike a deal with its owner. Generally the potter mixes different soils and sometimes adds sand, grog, and ashes of tree bark; these give the mixture greater ductility and plasticity and help prevent cracking during firing.

Once the basic mixture is obtained, it is sifted and ground to produce a very fine clay that then is mixed with water and left to stand for a day. The final kneading is done with the hands or feet. The whole procedure has been explained in general terms as it is almost impossible to discover the precise technique of each potter, who keeps it a secret that is revealed only to his apprentices. The basic color of the object comes from the composition of the clay, but each potter has his own tricks. Sometimes pieces are dipped in a special clay dissolved in water, giving a distinctive color when baked; at other times the color depends on the method of baking or heating; in some cases the pieces are painted and glazed after firing.

The system of firing varies from one department to another. The kilns are quite simple. In some places such

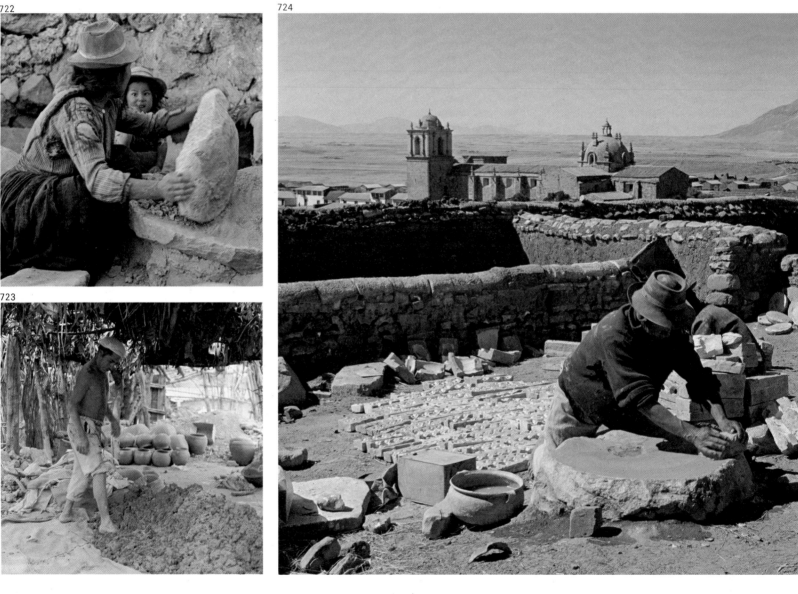

722

723

724

722 On the altiplano both men and women are potters. The preparation of the clay requires patience and skill; with the help of a large stone the clay will be ground and separated from the bits of stone. From an early age the children watch the work of their elders. San Pedro

723 After the clay has been ground and dampened, it must be kneaded to produce a dense consistency. The potter treads the clay, without rest, until it is ready. Simbilá, Piura

724 When a mold is used the clay must have exactly the right degree of dampness. The whitish color of the clay is characteristic of this area. Pucará, Puno

as Pucará and Checcapupuja the circular walls of the kiln are made with adobe bricks; a tunnel is made just outside the kiln and excavated to the center in order to hold a fire underneath. Holes are then made in the floor of the kiln so the heat from the fire can pass through to the pieces placed above.

An alternative method of firing is the use of a framework of wood or metal called a grillage in which the pieces to be baked are interlaced with fuel and then placed on the framework. The fuel—wood, the remains of former "bakes," horse or cow dung, etc.—are placed all around to cover the structure completely. In Pirua the floor is dug up and the pieces to be baked are placed in the hole and mixed with fuel; the walls are those of the same pit.

The principal drawback of these methods is that the potter can work only when the weather is good. During rainy days work is interrupted and the potter concerns himself with other tasks. It is a real spectacle to arrive at a small village on the undulating high plateau at the time of a "bake"; from behind fences and stockades and from out of courtyards a column of people emerges that leads one unerringly to where the potters live.

In the Amazon jungle another method of baking pottery is used: generally a fire is lit, the pieces are placed directly on top, opening down, and firewood is placed all around. The pottery of the jungle is different from that made in the rest of the country. The style of baking means that the walls of the pieces are less thick; it is surprising to find that the *tinajas*, or large earthenware jars, have thin walls. The forms and designs used by the potters,

725

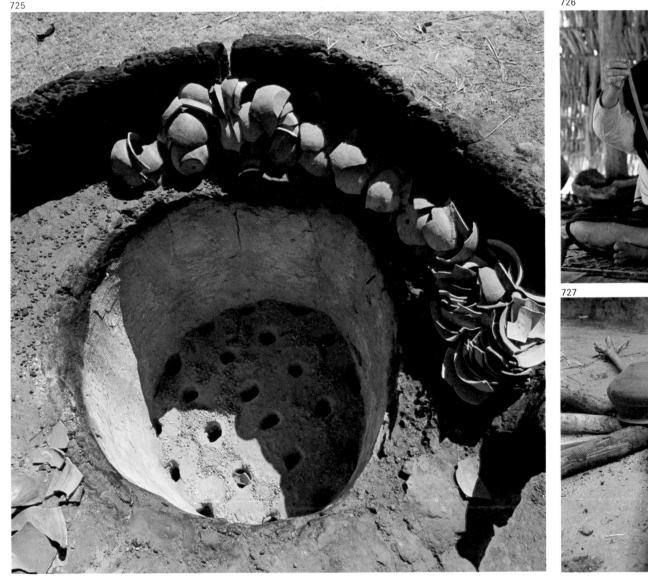

726

727

725 Oven constructed so that the heat from the fire below gets through the holes and bakes the pieces piled on top. Checcapupuja, Puno

726 In the Amazon these potters use strips of clay, which has been kneaded once, to make earthenware jars from spirals. The outsides of the pieces are smoothed with their fingers. Yarinacocha, Loreto

727 Primitive system for baking pieces: a simple fire of slow-burning wood with the pieces placed mouth down as is customary in this area. Yarinacocha, Loreto

predominantly women, distinguish them clearly from those of potters in other districts and indicate that they belong to a distinct ethnic group.

Ayacucho is a well-known pottery center in the Santa Ana district where there are various craftsworkers who make grotesque figures hinting at the depressed conditions of the peasants. Another characteristic piece is a whistle representing five musicians, called *la corte celestial* (court of heaven), who are seated holding their instruments as if they were playing in a concert. But perhaps the more important pottery centers in this district are Quinua and Moya, where the most distinctive pottery style on the high plateau is made: the ceremonial zoomorphic vessels that are decorated with original designs intended to represent the mottled skin of the animal after which it is modeled.

Pottery is produced in abundance in the department of Ayacucho; pottery for everyday use, toys, and wedding plates are just a few of examples. Model churches are also an important part of Ayacucho's output. They are made in all sizes, with either one or two towers, but always with a clock that is a copy of the one on the main church in Ayacucho. One of the traditional practices still carried on in its entirety is the feast of the *zafacasa*, a ceremony intended to protect the house itself and the people who live in it. This involves placing a spired Ayacuchan model church on the roof of a house, often accompanied by other figures related to the occupation of the owner of the dwelling (farmer, herdsman, etc.); all the village helps at the feast, to which the owner invites all his friends.

728

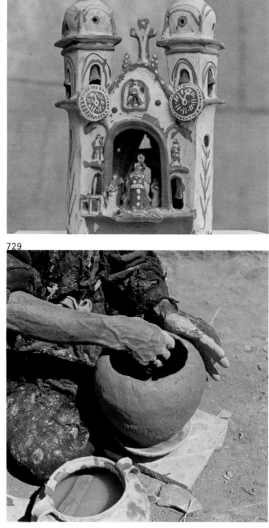

729

730

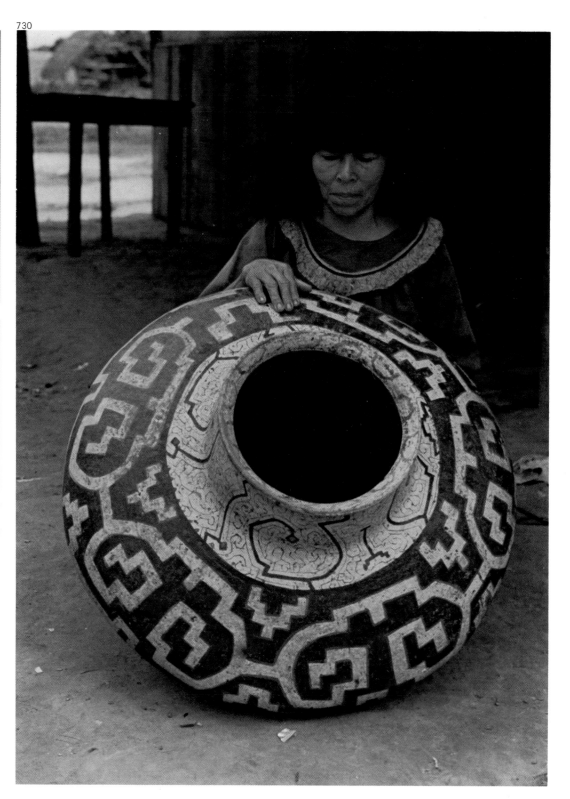

728 This piece is a copy of the Ayacuchan churches. In the capital of the department there are more than twenty-seven churches. The clocks are inspired by the one on the cathedral in Ayacucho. Quinua

729 Always with water at hand and using a primitive wheel without a spindle the potter is adding clay to make a vessel. His fingers, the water, and a fragment of pottery are his only aids. Santiago de Pupuja, Puno

730 Earthenware jar with traditional Shipibo design. The last phase of the finish is to give the piece a coating of hot vegetable resin that protects the painting. Earthenware jars of this size are made in two or three parts and the joints are smoothed with a piece of dry gourd. Yarinacocha, Loreto

In Piura and Lambayeque pottery is made in an individual style, with incised patterns of several designs. Small pottery stamps are used to print the required design. The objects made in this area are generally used for transporting and storing water, an indispensable item in an arid area. They are also used for fermenting *chicha*.

Generally the pottery of the high plateau is decorated with forms suggested to the artist by his environment. In the forest it is different; the designs come from ancient beliefs and represent myths, incorporating stars, lakes, and serpents. Each group has its own preferences and forms of representation.

It is not possible to enlarge on this, or even name all the pottery-making centers (among them the bulls of Santiago de Pupuja; the *limitatas*, or jugs, from Puno; the three-fire hearths of Pallalla) as the list would be pages long. We can only add that to see one of these authentic artists working with such rudimentary equipment as a wheel consisting of a simple piece of wood on a flat surface, a piece of rind from a gourd or nothing more than their dexterous fingers, inspires in the spectator a profound respect for traditional art as well as a sincere prayer for its continuance.

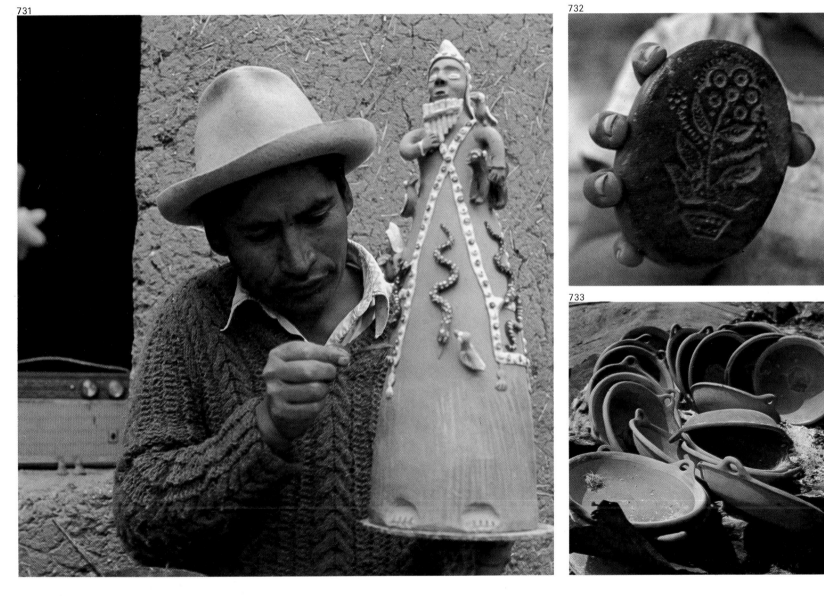

731 From the imagination of the craftsworkers of the altiplano comes this fanciful pottery figure. The people of the Andes also believe that wizards live in the jungle. Quinua, Ayacucho

732 In Simbalá a piece is decorated while it is still soft by pressing it with a *labradora*, a clay stamp with motif in relief. There are many different designs on such stamps. Piura

733 Pottery is placed with firewood to bake on a metal plate flush with the floor. In other places such as Simbalá the level of the floor is lowered slightly. Piura

Weaving

Peru produces weaving of many different types. A surprising variety of tools and fibers, both animal and vegetable, is used for weaving. In the rural areas of the altiplano the peasants use two types of looms seemingly without preference: the backstrap loom and the horizontal ground loom. These, although quite rudimentary, are the easiest to transport, enabling the women to work on them while tending the livestock in the fields. The first type needs only a tree to which to fasten one end of the loom; the second requires no more than a small patch of flat ground in which to drive the stakes. Mention must be made of the skillful weavers of *warakas* who, using only their hands, braid woolen cords into complex designs.

The treadle loom, introduced by the conquistadors, is generally, though not exclusively, used by families of weavers who make pieces to sell in the markets as well as for their own use. There is also a vertical loom, consisting of a frame of four pieces of wood. Other weaving devices —crochet hooks, bobbins, needles —are used to make lace edging and other elements that are not a traditional part of Peruvian dress but are clearly of European origin. Only the making of fishing nets has not suffered European influence since it is an art practiced long before the colonial period.

Besides special tools and instruments, there are characteristic methods of working that serve to distinguish the products from certain regions: whether the warp is double or single; the direction in which the thread is twisted (in San Pedro de Lloc, for example, it is twisted to the left instead of to the right, as is generally

734

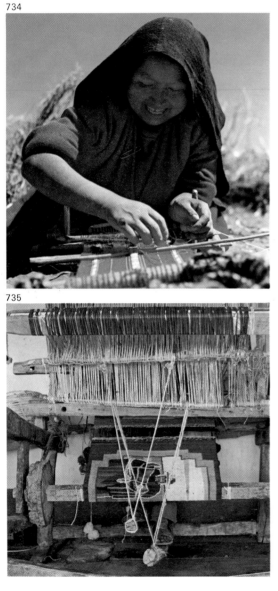

735

736

734 The weaver can drive the four stakes, with which the base of the loom is constructed, into a small patch of ground. Weaving for *chuspas* or pouches is started at both ends and finished off in the center with a needle. Taquile Island, Lake Titicaca, Puno

735 The treadle loom was introduced by the Spaniards. Usually this loom is used for wholesale production for trade in the local markets and even in the capital. Ayacucho

736 The backstrap loom must be fastened to a fixed point, generally a tree; the body creates the tension of the warp, with the feet wedged against a rock. It can be seen that this device has not been modified since ancient times except for the use of acrylic fibers in the weaving. Ayacucho

done); and lastly the use of certain stitches such as the palm or palm opposed. The twist of the yarn is important, since the quality of the product depends not only on the material but also on the twist: the more tightly the thread is twisted the greater the consistency of the weave and durability of the product.

The decorative motifs and colors used also indicate where the textiles come from: geometric designs are characteristic of the saddlebags made in Chavín de Huantar; Lambayequen ponchos bear sayings referring to their owners; in Piura, clothing tends to be black; the ponchos of Cajamarca are distinguished by having a different color when reversed; in Tacabamba shawls are blue and white with phytomorphic designs; the best blankets, which are woven in Pallén, are outstanding for their thickness and their combinations of colors, with designs often representing the fauna and flora of the area.

Ayacucho deserves special mention. A family of weavers living there has investigated the process of dyeing wool with natural products; the result has been a much wider range of color tones which, along with the creation of new forms and designs, permits the creation of highly original tapestries, which are perhaps closer to fine art than to folk art.

In the department of Cuzco, and in general throughout the Andean region, traditional dress is still worn. The women wear a double shawl, the small one, the *lliclla*, protects her from the cold and is often fastened with a pin called a *tupu*, an ornament which in ancient times was made of silver. The larger shawl, the *inkuña*, is used

737

738

739

737 Typical mountain scene; women utilizing every minute to spin. Here a country woman, with her child on her back, is working wool while waiting for transportation

738 Fishing nets are made and mended with crochet hooks. Yarinacocha Lagoon, Loreto

739 Women of the altiplano wear four to seven skirts, all of which are decorated and have a wide ruffle. On the ground a magnificent Cuzqueño fabric in double-warp weaving can be seen. Urubamba, Cuzco

for carrying objects. The designs of the *llicllas* radiates from a symmetrical axis that separates two bands of complicated motifs, usually in red and white, although green or violet are sometimes used. The background is dark, in most cases black. These double-warp weavings demonstrate the indisputable excellence of the Cuzco weaver. Both men and women carry small striped scarves in which they keep money, coca, and even amulets. In other parts of the Andes money is carried in pouches with small flaps into which amulets can be tucked to prevent them from being stolen.

All the men of the high plateau wear the *chullo* (a knitted cap with earflaps). The designs of these caps indicate their wearer's place of origin. The *chuspa* is a pouch or bag that is a necessary item of the Andes dweller, since in the traditional costume there are no pockets.

The designs of the Andean textiles contain meanings, and sometimes the meanings coincide with pre-Columbian symbols. On Taquile Island in Lake Titicaca fabrics are made with a high twist to the yarn and great complexity in the design. Tradition demands absolute secrecy with respect to the significance of the designs, and according to belief it would be preferable for all traces of the Indian culture to disappear than for the white man or mestizo to know the meaning of the symbolism. Nevertheless, some of the meaning has been revealed and hence it has been possible to establish certain criteria of identification.

The sashes and ornamental borders of the *llicllas* and *inkuñas* relate true incidents of marriages, deaths,

740

741

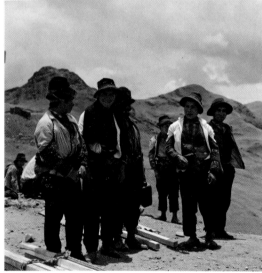

742

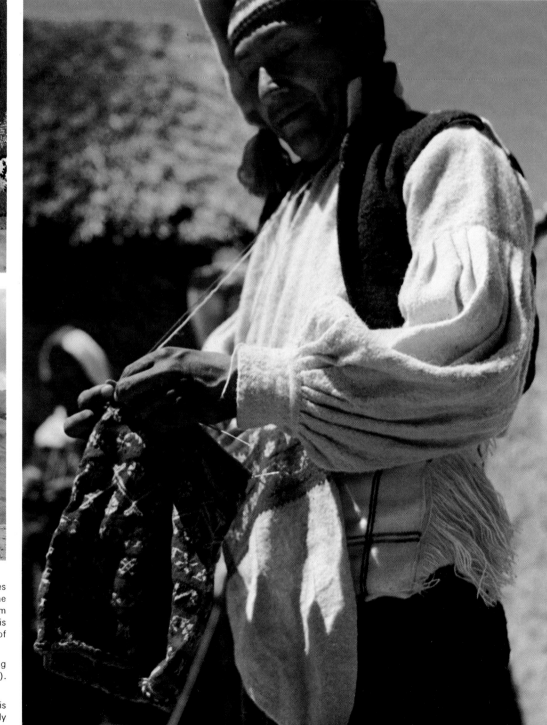

740 In this detail from a tapestry, the variety of techniques used in weaving can be seen. The range of colors that the creator has obtained is amazing, considering they come from completely natural products. The artisan spends nearly all his or her life dedicated to the perpetuation and rediscovery of old techniques. Ayacucho

741 In remote areas it is still possible to see people wearing *mokitos* (knitted woolen sleeves of a complicated pattern). Huancavélica

742 This man in traditional dress, from Taquile Island, is skillfully knitting a *chullo*, the typical cap of the area. Nearly all the men of the island are experts in this art, which is now being commercialized easily because of the excellent quality of workmanship. Although the products sold to tourists do not remain strictly faithful to traditional colors and designs, complex textile works are nevertheless being created

epidemics, droughts, etc. The color of the sash determines to whom it belongs: blue is the color of the shaman, green is for a child, and a belt of indeterminate color is for an adult. These ceremonal items, which belong to people of importance in the community, must never fall into the hands of strangers and can be discarded only by being burned or buried.

The inhabitants of the jungle use lightweight linen and cotton for making their fabrics. Textiles have painted motifs, although sometimes they may be embroidered or appliquéd. Textile decoration, like that on their pottery, is linear and may seem to the casual observer to be mere geometric designs; in reality here also worship of the gods is depicted on objects of everyday use.

743

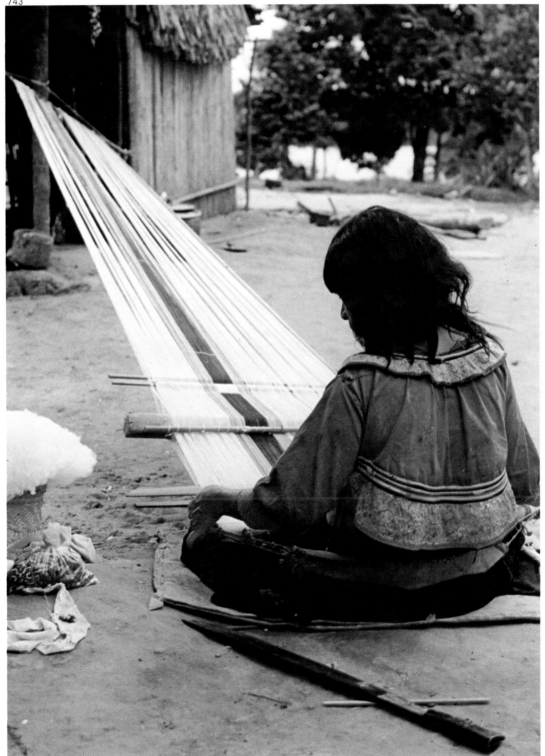

744

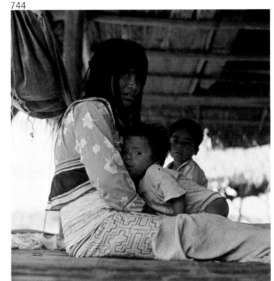

743 Shipibo woman weaving fabric from cotton that she has spun herself. The backstrap loom is traditional for weaving this type of fabric, and has a warp of considerable length. Once finished, the material will be painted or embroidered with traditional designs. San Francisco Javier, Loreto

744 In the jungle a woman uses a piece of cloth wrapped around her body as a skirt; the most highly valued designs are hand painted. The blouse, of unusual cut, is made from printed fabric; at the neck and shoulders a small ruffle of another material is added. The bead belt, which is always white, shows that she has a small child, whom she carries supported in the belt

Matés

The gourd *(Lageneria vulgaris),* whose fruit is called maté, grows in the warm mountain valleys above the jungle and the coast. The size and shape of these gourds vary greatly, making it possible to create a wide range of utensils from them. In some regions the gourd has half of its growth inhibited while it is still soft, resulting in a pear-shaped receptacle used for the calcareous paste that, when mixed with coca and chewed, produces a druglike effect. It is conceivable that the ancient matés may have led the Peruvians to create the first clay vessels. Whatever the case, the making of matés dates back at least as far as the Neolithic period, and their use has been as widespread in Peru as it has been in other South American countries. Most interesting is the work done directly on the rind of the maté. The system of decoration and even the motifs vary throughout the regions, but in no other country can you find pieces of artistic merit comparable to those of Peru.

The gourd plant is sown in April, before which the soil must be turned and dampened, as it will not be watered again; the harvest is three to five months later. According to their size and use, matés are given different names. The large matés called *limetas* tend to be used for transporting water or *chicha;* the *lapa,* a wide but shallow gourd, is used as a bowl; another of the same species but not as broad, known by the generic name *maté,* is used throughout Peru as a plate to eat from.

In the departments of Piura, Lambayeque, and La Libertad the decoration of the matés is done by dyeing or burning with a solution of sulfuric, hydrochloric, or nitric acid. According to the strength of the liquid ap-

745

746

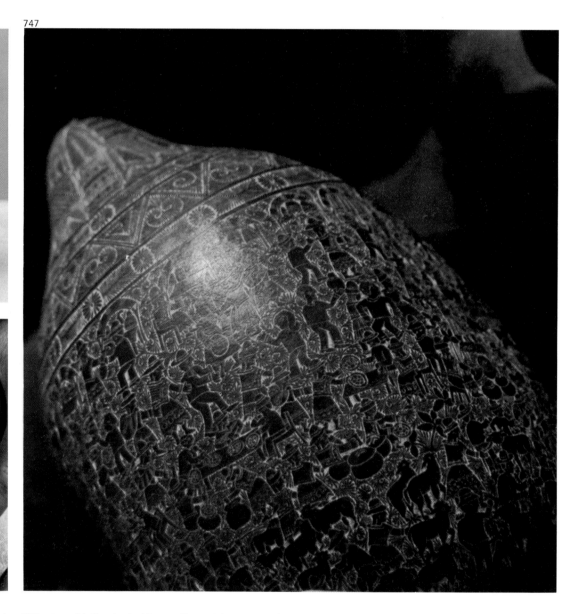

747

745 Matés with an acid-burned decoration of simple floral design commonly found on the north coast. Lambayeque

746 Engraving a maté requires a great deal of patience and precision; the work of hours can be lost in one slip. A small burin or a well-worn knife is the only tool used. Cochas Grande, Junín

747 A maté is first dyed with an aniline and then engraved. In this example scenes from daily life are represented. Cochas Grande, Junín

plied, a range of colors can be obtained, from ochre to dark brown. The decorations are simple and are based on flowers, geometric lines, and occasionally a verse or saying.

The finest maté engraving is done in the central mountains. The designs that cover the entire surface of the gourd require great ability and patience. Everyday aspects of peasant life are depicted in the designs, from work in the fields, such as farming and raising cattle, to the festive side of their life, with regional costume. If the maté maker, called a *matero*, has been on a journey he may also include the new things he has seen for the first, and possibly the last, time in his life. By studying the decorations on the matés it is possible to understand the way of life in the vast Peruvian mountain regions and the elements on which it is based. Even more than that, the inventive spirit of these artists leads them to create scenes of the nearby jungle, an interpretation of a totally different life-style about which they know only from hearsay. Hence their representations of tigers, lions, and other animals are of such proportions that they could come only from the imagination. The designs are also intermingled with borders clearly influenced by the Mudejars (Muslims who lived under Christian rule in Spain) and are of Spanish origin. There are other designs consisting of ancient symbols whose significance is generally not known.

Three types of finish are used in the decoration of the matés: *ayacuchana* consists of applying a black mixture of soot and fat to the incisions; *huanca* means scorching the maté with burning quinwal bark to pro-

748

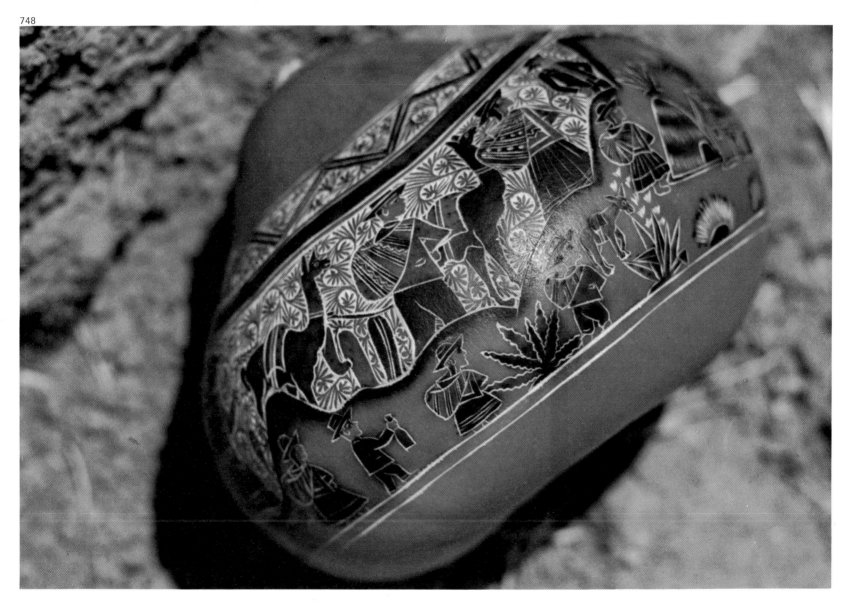

748 Shades of dark brown are obtained by burning the gourd with tree bark; this job requires special care as the final appearance is determined by it. Cochas Grande, Junín

duce various shades of dark gray and brown; in the third method the maté is submerged in boiling water mixed with an aniline dye of the desired color, generally dark fuchsia or green.

The tools used to work the designs are one fine burin and other thicker ones; two gouges to clear out the parts that have to stay under water; a steel tube to get rid of the endocarp of the pieces that are to be used as receptacles; a thin, sharp blade for splitting the maté or cutting a lid; and an ordinary knife for smoothing the cut. It is safe to say that the *materos* do not always use all these tools and may substitute in their place an old, well-worn, all-purpose knife.

The subjects of the designs of the matés made in Cochas Grande and Cochas Chico (villages where 50 percent of the inhabitants are *materos*) or in Huanta and Mayoc are very different from those of Ayacucho; the former depict rural life in the Andes; the Ayacucho matés show *señoritos* —young men dressed in festive clothes wooing young women. Taken as a whole matés give insight into the lives and customs of the mountain dwellers, and into the dreams they hold in their hearts.

749

750

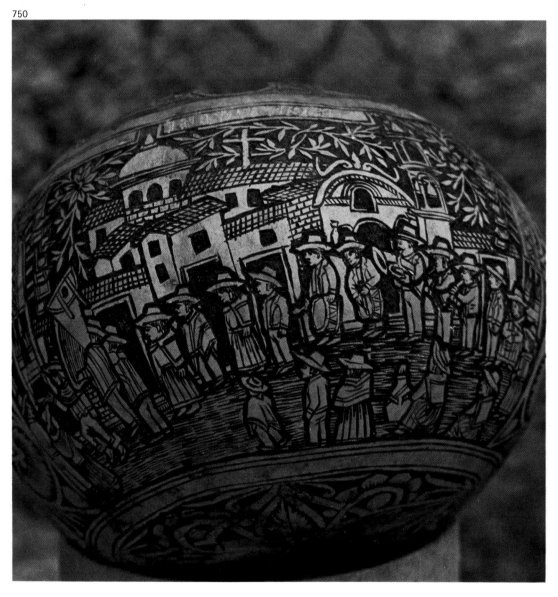

749 Matés are made by both men and women. Entire families dedicate themselves to this work. Cochas Grande, Junín

750 Sugar bowl showing a village festival; it is finished with a dark-colored bitumen that fills in the engraved lines, forming the design. Mayocc, Huancavélica

Some of the most characteristic creations of the Peruvian craftsworkers are the altars called *andas*, which are made in Ayacucho for Holy Week. A wooden structure is covered with a white cloth and adorned with silver-covered paper cut into geometric shapes. Hundreds of candles placed at all different levels, bouquets of flowers, ears of corn, and wax birds complete the sculpture. It is an inspiring sight to see the *andas* at night with all their candles lit. In Huaraz, capital of the province of Ancash, candles are made in different shapes, some of complex design, and are placed on an altar customarily made of sugarcane. The candles are in the shape of flowers, birds, bells, dancers, or even the national coat-of-arms. A very large cross frequently tops the structure.

The artisans of the San Blas district of Cuzco are experts in waxwork also. They make polychrome candles, decorated with incisings and motifs in relief, made on the spot in small molds. When *el pago de la pachamama* (a ceremony honoring the earth goddess) takes place, the occasion is often used to ask for special protection for some animal. The animal is molded in tallow (using the same process as for wax) and the image is destroyed during the celebration of the rite.

Waxwork

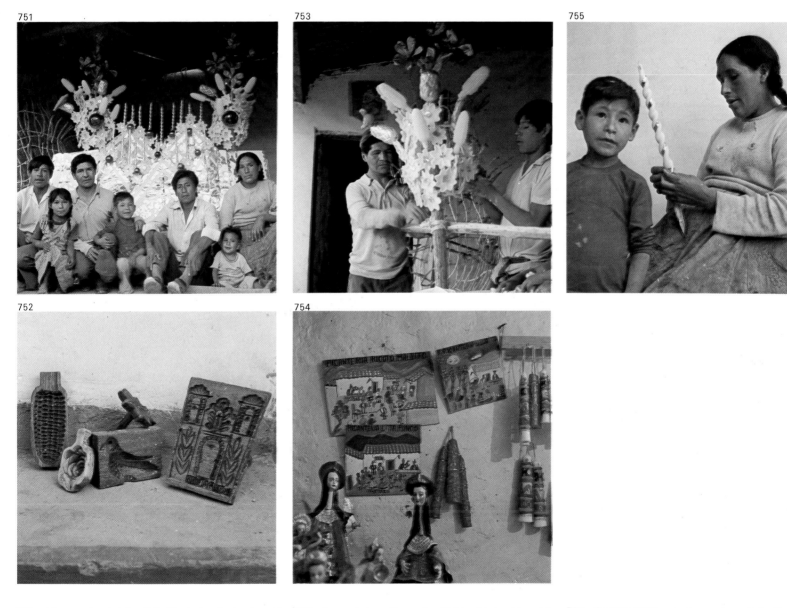

751 Altar constructed for Holy Week; hundreds of small candles have still to be added at different levels to the central section of the *anda*. Ayacucho

752 Wooden molds in which the wax altar decorations are made. Ayacucho

753 Bouquet of wax flowers to which is added a wide variety of molded figures, from corn to parrots, to obtain even more baroque compositions. Ayacucho

754 The polychrome candles that are made in Cuzco have different forms and decorations from those of Ayacucho

755 On holy days the candles are decorated with aluminum foil. Ayacucho

Imaginería and Masks

This section deals with the art of sculpting and molding sacred figures, or *imaginería*. Some of these figures are made on the occasion of a specific anniversary, others represent folkloric scenes, and still others are simply toys commemorating a fair or festival.

One of the most outstanding examples of the art of *imaginería* from Ayacucho is the shrine or votive carving that over the past thirty years has come to be known as a retablo. (Previously it was called "the chest of" followed by the name of the saint depicted in the retablo, the most common being the chest of San Marcos.) The chest is a pine cabinet some ten inches (25 cm) high and eight inches (20 cm) wide, crowned with a triangular spire; the obverse and reverse of its two open doors are decorated with floral motifs. The wood is stuccoed with plaster, then painted with aniline and egg tempera. Scenes of heaven are represented in the upper part and scenes of earth in the lower. The scenes have undergone changes according to the current religious beliefs or those of whoever commissioned the retablo. Muleteers used to carry these chests on their long journeys as protection by the saint against attack on the road. At times they carried more than one, to use as barter, although it was often thought that the muleteers carried them to give religious instruction to the shepherds.

Today the chest of San Marcos is made in many different sizes and the motifs used are very diverse. Some retablos are more than four feet tall and have five levels inside; others are small, only about six inches (15 cm) high, with a Nativity or folkloric scene inside.

756

757

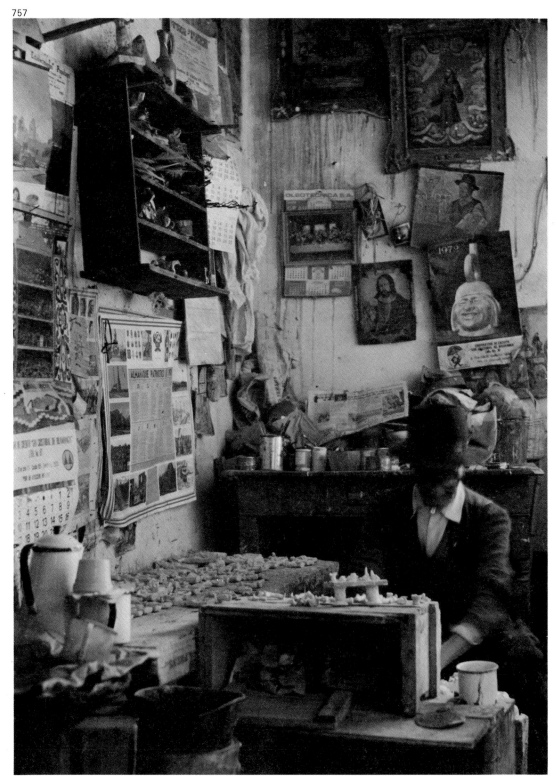

756 Painted clay folkloric figure representing a man with a cargo of matés. Mórrope, Lambayeque

757 Craftsman modeling small figures, made of plaster and potato paste, which will later be painted and placed in a retablo. Ayacucho

The figures are either molded or modeled by hand; each artist prepares a potato-based paste using his own particular ingredients. When the figure is dry, it is painted, varnished, and placed in the retablo to form part of a scene; on one shelf there may be more than fifty figures. Each craftsworker has his own explanation for the meaning of each level and for the number of figures it contains. Nevertheless, the main connection with the old retablos is that the top level still contains a divine or celestial scene.

With the same criteria and with the same mixture of religious and daily life, trunks are made in Ayacucho in which the scenes are composed of figures fixed to the inside of the lid. The wooden trunks are stuccoed with plaster and painted in the same manner as the retablos.

In Ayacucho other molded or modeled figures are made, such as the wall retablos. They are molded in plaster and retain the customary scenes of heaven at the top and earth at the bottom. Crosses of the Passion are also often made, which can be up to two and a half feet (77 cm) tall. Where the two arms of the cross meet the face of Christ is shown, enclosed and protected by a glass-front case. The finish is identical to the retablos and trunks.

In the San Blas district of Cuzco live the most expert sculptors and painters of religious figures. One of the traditional figures is the niño Manuelito, the infant Jesus, who is shown sumptuously dressed. Also made in this part of the country are kings, magicians, angels, dancers, soldiers, and Virgins. All the religious figures were once

758

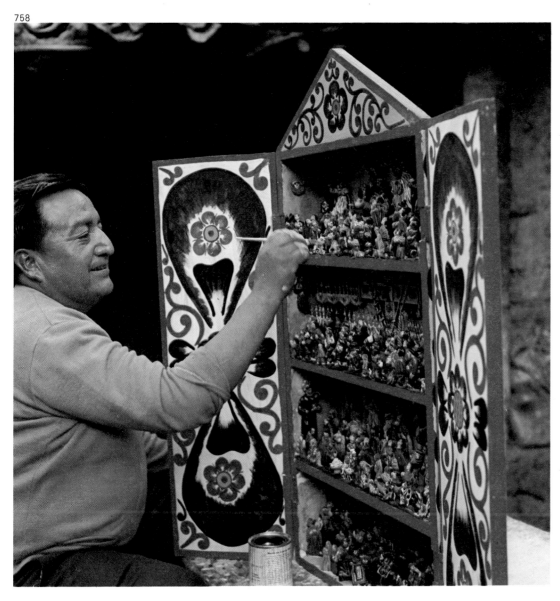

759

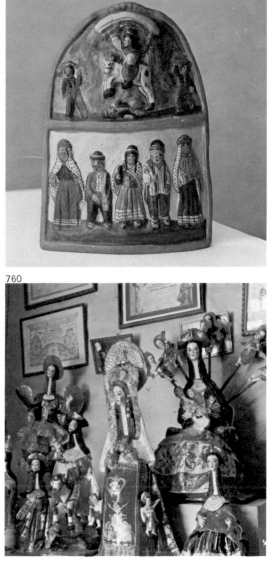

760

758 Four-level retablo to which the artist is giving the final touches of paint to hide the fixtures of his figures. Ayacucho

759 Wall retablo; in the upper part, Santiago the Indian killer overpowers the god Illapa; in the lower part are country people in traditional dress. Ayacucho

760 All the figures made by this craftsman have great creative force (see photo 761). They are made from a mixture of plaster and other ingredients; the clothes of the Virgins, saints, Magi, etc., are made of paper. Cuzco

decorated with real gold leaf, but now they are painted with bronze metal powder. In Cuzco, the cultural capital of Peru, there are artisans who have remained faithful to tradition and who continue to make the same works as those taught to them by their fathers, who in turn learned from their fathers. But the traditionalists coexist with artists who, while they maintain a clear connection with the old styles, vary their subjects and endeavor to show present-day reality.

In towns with a tradition of folklore, such as Paucartambo and Puno, many masks are produced for the popular festival days: in these, the ancient beliefs have mingled with those imposed by the conquistadors. Dances at the festivals are burlesque, ironic, or even parodies of public dignitaries. In all of these the folk imagination still expresses itself in the costumes and movements and, ultimately, the masks. Artisans who had once been dancers and who remember precisely the significance and the forms of the dances reproduce the main steps and demonstrate them using figures that are perfectly molded and richly dressed.

761

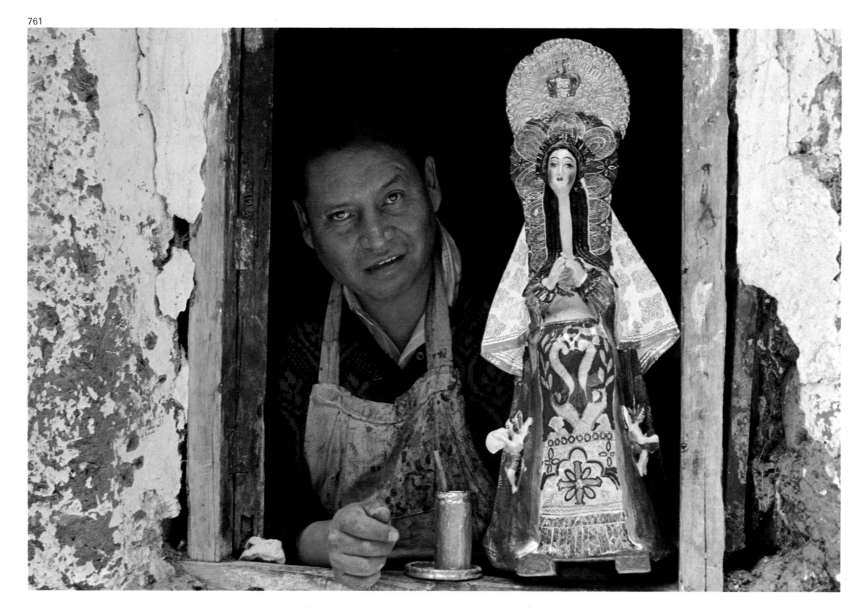

761 In a mixture of religions, this outstanding representation shows the pregnant Virgin Mary. All the figures of this artist have long necks inspired, it seems, by the llama

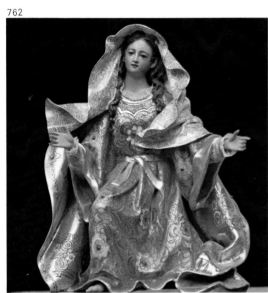
762

764

766

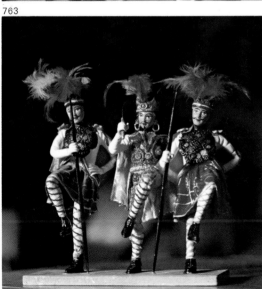
763

765

767

762 In the department of Cuzco there are many artists who make classical religious figures. These figures have glass eyes and sometimes their mantles and costumes have gold-leaf motifs. Cuzco

763 These three small figures reproduce exactly the costumes and one of the steps of the dance called *Chunchu Extranjero* (Indian Stranger from the Jungle). Cuzco

764–767 Masks are made from various materials, principally cardboard and plaster, tinplate, and wood. For the best overall effect, all types of material are used

Folk Painting

There are two important kinds of folk painting in Peru. The first is found in the mountains, where artists re-create the reality of their environment in an intuitive and naive style. Their subjects are religious festivals, processions, feasts for saints' days, weddings—in short, anything of folkloric value. The second kind of folk painting is found in the jungle, where various tribal groups paint their bodies for certain ceremonies and feasts. Body painting is representative of the unique concept of art of the Amazonian ethnic groups. They apply a love of art to their need for a constant relationship and communication with their gods by decorating their bodies, using the same figures and natural colors that they use for their fabric designs: a boa, the stars, the sun, the moon, lakes, etc., are combined in complex geometric patterns. When the men go hunting they protect themselves against insects with a mixture of anotta and resin.

In the department of Ayacucho it is traditional to give to a family who is building a new home a flat board divided into seven or eight different designs, with the sun and moon represented on the upper part, scenes from daily life lower down, and a Catholic image at the bottom; alternatively a symbiosis of different religions may be shown.

Another reason for the success of folk painting is the *pendones*, or banners, which have become public advertisements for the *chicherías* (taverns where chicha is sold) and *picanterías* (restaurants selling hot, spicy food). There are many popular *chicherías* and *picanterías* in Cuzco and Arequipa. Their banners usually contain

768

769

768 Craftsmen often work in primitive conditions. For this man, one of the finest banner painters, a rickety table suffices. Cuzco

769 Tribal groups always paint their bodies in private ceremonies. Nevertheless, the symbology is the same as that used on fabrics and ceramics. Shipibo group. Loreto

motifs related to the type of food sold there or the gaiety of the restaurant's clientele. The *pendones* are often adorned with a bouquet of flowers, a red cloth, even occasionally with lettuce or a chili pepper.

770 Painting of a scene showing the procession of Corpus Christi with image of Saint Sebastian. Cuzco

771 Painting of a scene from the procession of Christ of the Earthquakes. Cuzco

772 Typical banners advertising *picanterías* painted by a family of artisans who, besides specializing in a particular craft, are branching out into other fields. Cuzco

Catalogue

773 Cradle, *kirau*, made of wood and tied with vegetable fiber. Ayacucho

774 Traditional hat of Santiago de Pupuja, Puno

775 Sling, called a *waraka*, woven by hand without the aid of any tools. Ayacucho

776 Tapestry made with vegetable-dyed wool. Ayacucho

777 Distinctive designs of sashes from the altiplano

778 Shipibo purse with traditional designs. Loreto

779 Detail of a textile made from caraguata fiber. Loreto

780 The number of designs for Peruvian sashes is infinite

781 Horizontal ground loom. Taquile Island, Puno

782 Woolen saddle pad. San Pedro de Lloc, Lambayeque

783 Embroidering the dancers' costumes for La Diablada. Puno

784 Doll musicians with typical Puno costumes woven on small sticks. Puno

785 Frame of a mirror in hammered brass. Loreto

786 *Tupu* or woman's brooch. Sicuani, Ayacucho

787 Metal clasp. San Jerónimo de Tunán, Junín

788 Figure of a turkey worked in silver. San Jerónimo de Tunán, Junín

789 Filigree silver cigarette case. San Jerónimo de Tunán, Junín

790 Metal earrings. San Jerónimo de Tunán, Junín

791, 792 Combs with bamboo teeth braided with cotton. Loreto

793 Crown of toucan and macaw feathers. Loreto

794 Crown of macaw feathers. Loreto

795 Crown of toucan and macaw feathers. Cashibo group. Loreto

796, 797 Carved wooden stools. Loreto

798 Canoe made from a hollowed-out tree trunk

799 Carved-wood staircase. San Francisco Javier, Loreto

800 Carved wooden instrument used for face painting. Loreto

801 Representation of a farm, or *chacra*. Sicuani, Cuzco

802 *Illas*, carved-stone amulets. Cuzco

803 Scene from the dance of the *llamerada* (Llama men)

804 Polychrome figures of clay and plaster. Cuzco

789

793

797

801

790

794

798

802

791

795

799

803

792

796

800

804

805 Carved-wood figures, with details of dress to be completed. Cuzco

806 Virgin made of pottery and papier-mâché inlaid with a lamina of gold leaf. Cuzco

807 Folkloric figures used as toys. Ayacucho

808 Retablo with folkloric scene. Cuzco

809 Horse and rider in green varnished clay. Santiago de Pupuja, Puno

810 Reproduction of the Ayacuchan church

811 *Limitata,* a jug for serving liquor. Santiago de Pupuja, Puno

812 Bull from Pucara. Checcapupuja, Puno

813 Clay figures for ceremonial use. Acora, Puno

814 Whistle made up of celestial figures. Quinua, Ayacucho

815 Container for *chicha*. Quinua, Ayacucho

816 Traditional church of painted clay. Quinua, Ayacucho

817 Different pottery forms from Checcapupuja, Puno

818 Pitcher of traditional form. Quinua, Ayacucho

819 Clay candelabra with painted designs; in the central stem a typical Ayacuchan church is depicted. Quinua, Ayacucho

820 Clay pot and a man's hat. Santiago de Pupuja, Puno

805

806

807

808

809

810

811

812

813

814

815
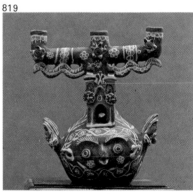

816
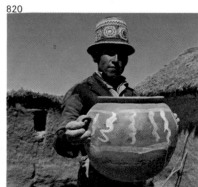

817
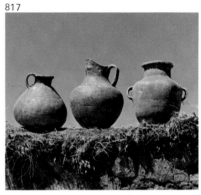

818
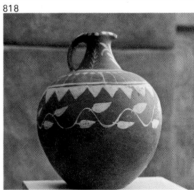

819

820

821 Jar with traditional design. San Marcos, Cajamarca

822 Clay pot with four protruding points on the rim. Sharanahua group. Loreto

823 Clay vessel with decoration carried out with natural pigments. Yarinacocha, Loreto

824 Unpainted pot for domestic use. Loreto

825 Anthropomorphic vessel with displaced opening. Shipibo group. Loreto

826 Detail of an anthropomorphic vessel. In the symbology of the Shipibo the designs represent the track of a serpent. Loreto

827, 828 Plate *mocahua*, in clay with decorations in natural pigments. Aguaruna group. Loreto

829 Painted clay vessel. Cocama group. Loreto

830 Large earthenware jars. Omagua group. Loreto

831 Anthropomorphic vessel with the face of a woman with earrings and a *tembeta* (lip adornment). Yarinacocha. Loreto

832 Anthropomorphic vessel. Shipibo group. Loreto

833 Plates, or *mocahuas*. Omagua group, Loreto

834 Vessel with floral designs. Omagua group. Loreto

835 Plate, or *mocahua*, of clay decorated with natural pigments. Aguaruna group. Loreto

836 Shipibo vessel and jug with tribal designs. San Francisco Javier, Loreto

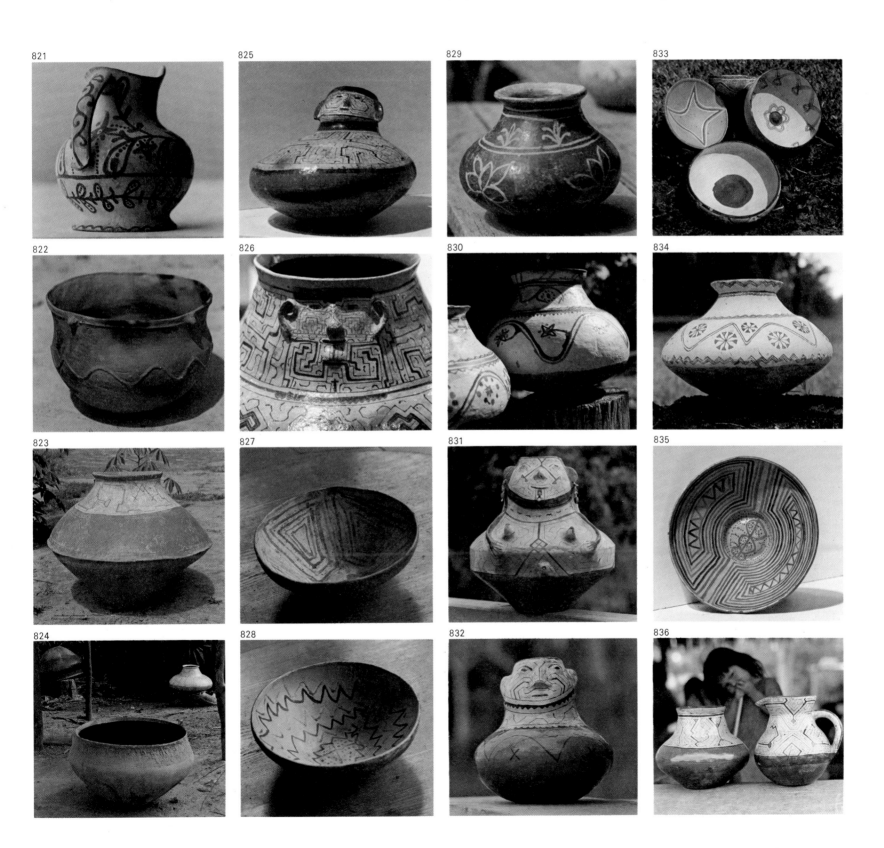

821

822

823

824

825

826

827

828

829

830

831

832

833

834

835

836

BOLIVIA

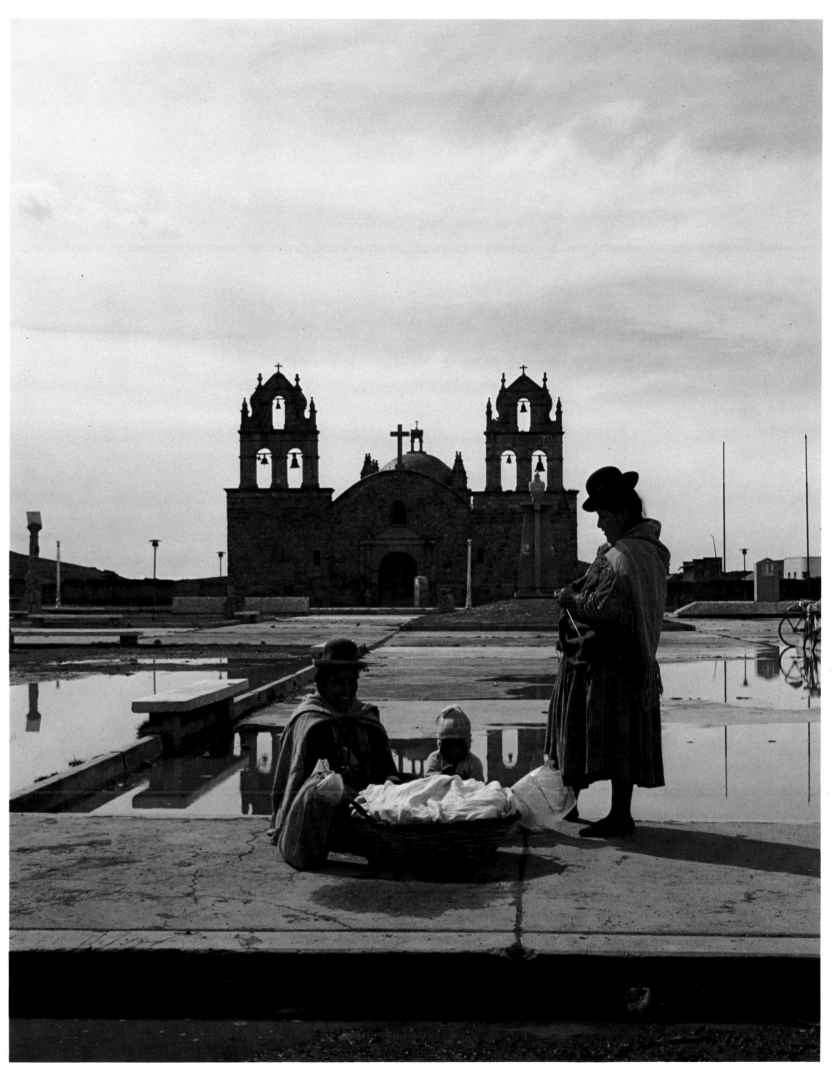

837 Eighteenth-century church in the city of Laja. La Paz

Introduction

... and among the other towns they conquered there was one called Tiahuanacu whose large and incredible buildings are worthy of mention. One of the amazing works to be seen in that place is an astonishingly high man-made hill. This was built upon an enormous stone foundation so that the heaped-up earth would not slide back, flattening the hill. No one understands the purpose of that edifice. ...

Inca Garcilaso de la Vega, *Book Three of the Royal Commentary of the Incas*, Chapter I

Although there are many hypotheses about the origins of the precolonial cultures of South America, there is still considerable uncertainty with respect to their historical beginnings, physical extension, political organization, and beliefs. This is certainly true of the early history of Bolivia, and it would be venturesome to attempt a detailed account of that period.

In general it is possible to distinguish two types of Incan culture: that of the coast-dwellers, who were more creative than warlike, and that of the empire builders who, originating in the highlands, moved downward toward the sea, in some instances exerting an influence on the culture of the coast-dwellers. With respect

838

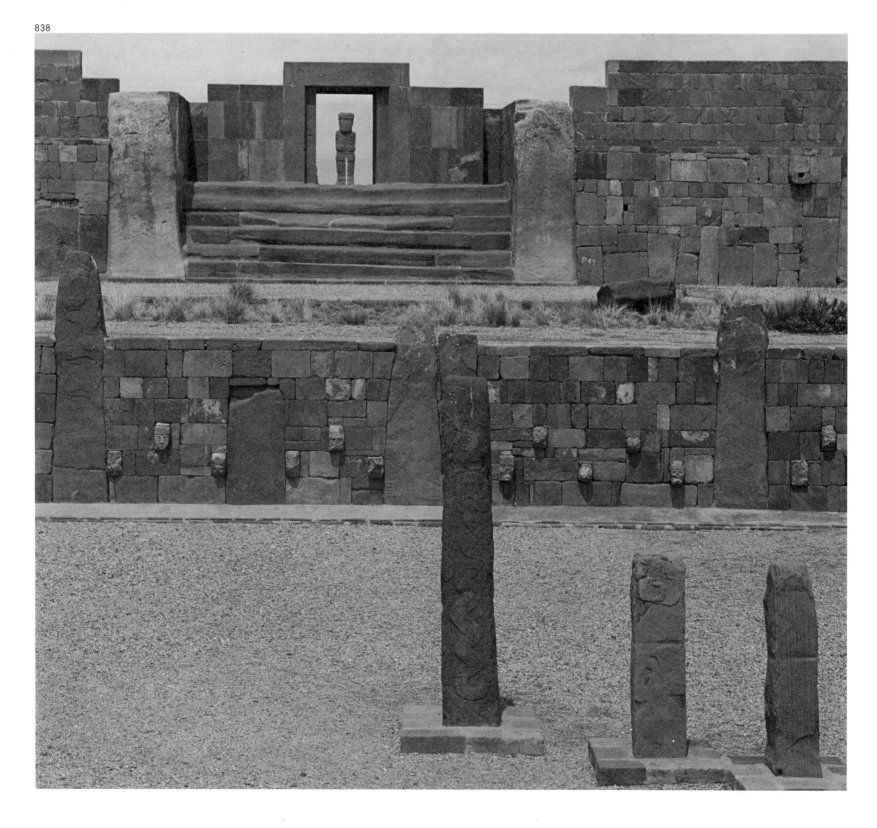

to Bolivia, the most important civilization known to date is that of Tiahuanaco (A.D. 200–1100), which apparently developed from a small settlement of Aymará Indians. The archeological center of this culture is located near Lake Titicaca. This deeply religious group erected an impressive temple called Kalasasaya that reveals a high level of skill in stonework. Also characteristic of this empire are the geometric designs used to decorate objects made of clay. Metalwork was done as well as work with various textile fibers.

The decline of the Tiahuanaco culture favored the consolidation of the new Inca Empire, which eventually dominated the entire coastal area from the present-day cities of Quito, Ecuador, to Santiago, Chile, and extended to Peru, Bolivia, and Argentina. Bolivia was a part of the Empire of the Sun up to the time of the Spanish Conquest.

After achieving independence from Spain, Bolivia had border problems with its neighbors. These conflicts, along with the exchange of land for rail lines that would link it to the capitals of other countries (a goal that was only partially realized), the ultimate loss of its passage to the sea, and the exhaustion resulting from several wars all contributed to keep the country in a state of economic underdevelopment.

There is a certain tendency to consider Bolivia an Andean nation although the altiplano comprises only 15 percent of land surface. Thirty-five percent of the population lives in this zone, in cities and towns situated at an altitude of thirteen thousand feet (4,000 m) or more above sea level. The descending slopes of the altiplano

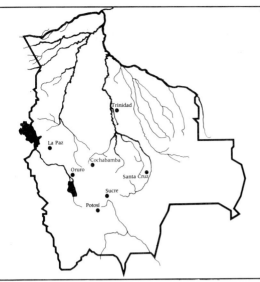

839

840

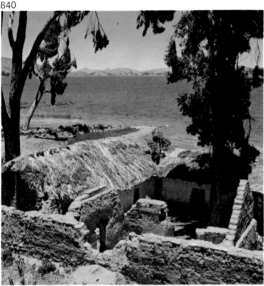

838 East side of the temple of Kalasasaya. Ruins of Tiahuanaco. La Paz

839 In addition to the large number of jewelry shops, there are vendors who sell silver objects, sometimes of ancient origin, that give testimony to the importance in earlier times of the mines of Potosí

840 Adobe dwellings with totora roofs on Suriki Island. Lake Titicaca, La Paz

263

are punctuated by *yungas,* or valleys of hot climate that extend down to the savannahs, or plains. These lowlands, equatorial in character, comprise 70 percent of the territory and extend as far as the Brazilian border. Bolivia's participation in the continent's three principal watersheds—Titicaca, the Amazon, and the Plata—completes the country's complex topography. The proper cultivation of its fertile lands and the exploitation of its mineral resources would enable Bolivia to achieve significant economic development.

The above-mentioned tendency to consider Bolivia an Andean nation is reenforced by the fact that La Paz, the capital of the country and therefore its principal point of communication with the exterior, is located in the middle of the altiplano. The influence that this zone exerts upon the observer stems both from its complex cultural history and from its location: the area is favored by its proximity to Lake Titicaca, highest navigable lake in the world, 12,350 feet (3,800 m) above sea level. The lake, incidentally, has given rise to a kind of culture—that of the Uro, or lake-dweller—that is unique to this region (see section on totora work).

The altiplano, inhabited by Aymará and Chipaya, is easily accessible and consequently quite well known. The Quechua and Chapayo live in the valleys of the temperate zone, and the plains and jungles of the lesser-known eastern zone are inhabited by small ethnic groups of varied characteristics such as the Mataco, Moxeño, Ayoréode, Guarayo, Guaraní, etc. These autochthonous groups comprise 52 percent of the total population. They have a common denominator, the *ayllu,* which is the most important organizational unit for the

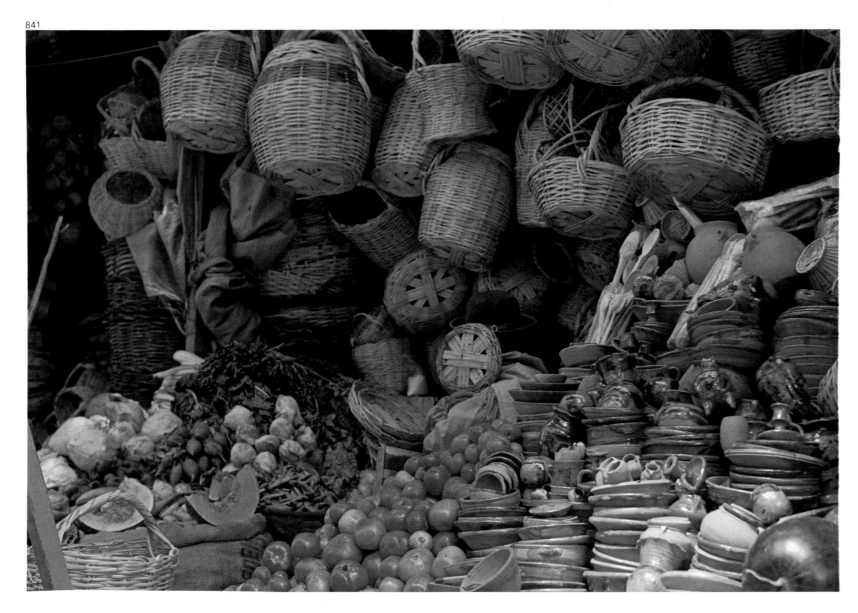

841 Merchant's stall in Camacho Market. La Paz

Quechua and the Aymará, as the *clan* is for the jungle-dwelling tribes of the east. These communities elect their representatives in a truly democratic manner; the most capable person is chosen to defend the interests of the community before the politico-administrative authority of the department. The *ayllu* is a mythical institution; it has been suggested that in pre-Incan times the chief of the *ayllus* represented the elite within the Aymará group and that out of this elite culture the Tiahuanaco civilization developed. At any rate the *ayllu* demonstrates that even in ancient cultures a certain type of democracy existed, and not only in Bolivia, since the same pattern appears, for example, in cultures like that of the Araucanians in Chile.

Present-day Bolivia is, then, a country of contrasts with a mixture of beliefs and with a wide variety of types of native artisanry resulting from the diversity of cultures that make up its population. All of this is evident in native markets, fiestas, and in daily life, which in rural areas follows the course it followed centuries ago. The difficulty in moving from one place to another in regions where means of transportation are scarce and slow, and where travelers traverse dirt roads that wind up and down through mountains of violent contrasts in altitude, has favored the conservation of folk traditions. Although means of communication are improving, country folk are cut off from the outside world and the advances of modern life are very slow to reach them. Young people must learn from their parents and from what they can observe in their immediate surroundings; they will become farmers, shepherds, or artisans according to family tradition.

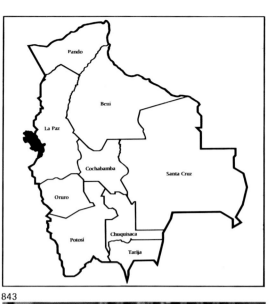

842

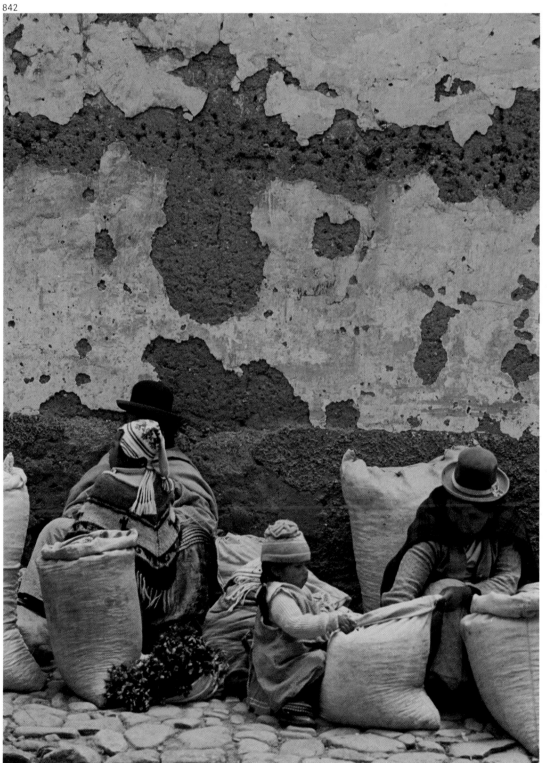

843

842 This young girl accompanies her mother, who will teach her all about selling, to the market. When the time comes for her to take her mother's place, the change will be made without difficulty

843 Women tending food stands traditionally wear white gowns that cover their clothing. Sucre, Chuquisaca

265

Pottery

Pottery first appeared in the Neolithic age in Bolivia. At the beginning the objects were crude and rudimentary, but archeological remains of the Mollo and Tiahuanaco cultures reveal that during several periods of the pre-Columbian age, new ways of polishing and finishing were discovered. Certain items from these periods stand out, including the *huaco-retratos* (painted pottery vessels found in burial mounds) and the *sahumerios* (incense burners) of the high plateau, and the large funeral urns of the east. A great number of the pieces were decorated with colors or finished with engobe prepared from a base of natural oxides. Following the conquest, the Spanish introduced the technique of making baked bricks for building houses, as well as the process of glazing, which was unknown in America until then. There are several important examples of colonial architecture in Bolivia that incorporate the use of *tejas* (curved roof tiles) and enameled bricks; these include the church at Caquingora and the Casa de los Condes (House of the Counts) at Arana, which are both eighteenth century, and the seventeenth-century church at Copacabana.

In contrast to other countries where the potter even has to pay rent for the use of a clay bed, there is no shortage of these natural resources in Bolivia and the potters tend to live near them, outside the center of town. As well as items for domestic use (plates, vessels, pots, etc.) other pieces are made for the brewing of chicha, a characteristic drink of the Indians based on fermented corn, which can reach quite a high alcoholic content. A corn flour mixture is boiled in a round earthenware jar with a wide opening and it is then poured into a

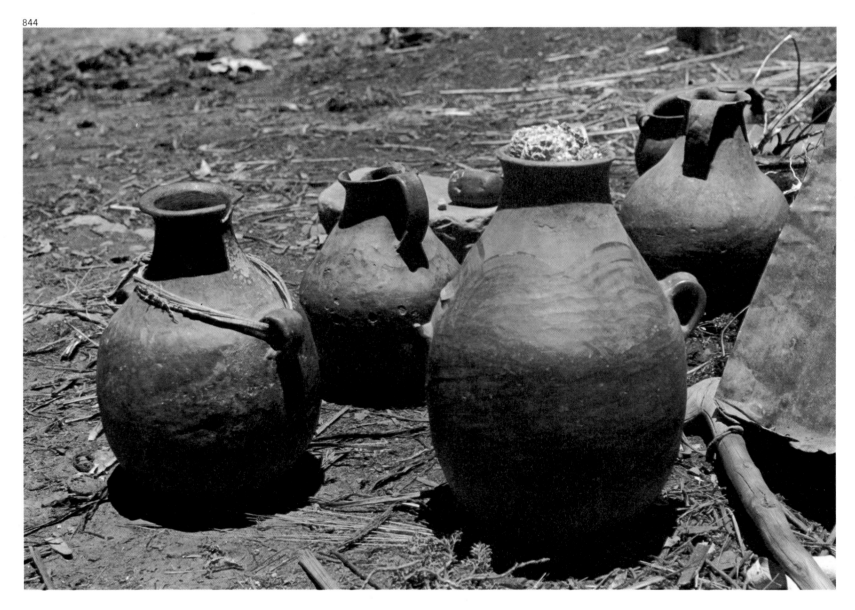

844 Pottery shop where traditional Aymará wares are produced. Lake Titicaca, Suriki Island

fermentation vessel, also globular in shape but having a small mouth. Smaller pitchers are used for distributing chicha, and others, smaller still, are used for selling it. Chicha is drunk from small household mugs made for this purpose. The decoration of the mugs varies from one department to another. Tarija mugs have a superimposed design, for example, while those of Cotoca in Santa Cruz are painted red and white. There are slight differences in jug designs as well; the shape of the mouth is determined by the individual artisan.

For transporting and storing water special pitchers are used whose shape varies from one region to another. The Moxeño of the department of El Beni make bird-shaped vessels that resemble the *pío* or American ostrich. The Mataco of the Pilcomayo River region make backstrap vessels—rounded jugs with an opening in the center for a rope that can be used for hanging the vessel on one's back when transporting water. The Ayoréode keep their water cool by using conical-based vessels that they half-bury in the earth.

One of the more spectacular techniques is the one used in rural areas to make large jugs. The base is made first from a plate of clay, and as this becomes firmer, the walls are made from additional layers of rolled clay. Sand is placed around the jug as if to cover it or to form a mold from top to bottom to prevent it from collapsing or breaking. When the clay is dry, the jugs are fired without moving them from the spot where they were made. A vegetable fuel is used, and the piece is completely covered; it is estimated that temperatures reach over 1600° F (900° C).

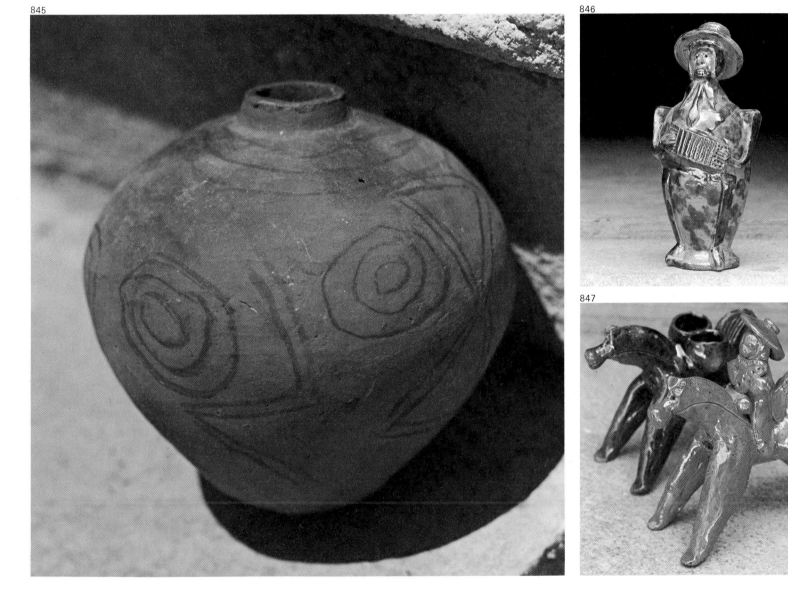

845

846

847

845 Conical water vessel decorated with symbols of the Ayoréode tribe. Santa Cruz

846 Glazed ceramic figurine made by Quechuas. Wayculí, Cochabamba

847 Small glazed ceramic horses. Wayculí, Cochabamba

Clay is also traditionally used for making toys and for modeling figures typical of a region. These are generally given a glaze containing powdered lead and offered for sale at annual fairs.

In several parts of the department of La Paz, an attempt is being made to redevelop ceramics of the Tiahuanaco style. Potters influenced by archeological discoveries made in the area are trying to find the natural products once used to make different colors and to rediscover the ancient techniques of polishing. While the modern replicas retain certain purity of form, they cannot match the quality of the originals; they reflect, however, a renewed interest in the history of this entire zone.

848

849

850

851

848 Country scene in glazed ceramic. Wayculí, Cochabamba

849 Anthropomorphic vessel in glazed ceramic. Wayculí, Cochabamba

850 Artisan draws decorative motifs on a Tiahuanaco-style vessel. Khonko Liqui Liqui. Jesús de Machaca, La Paz

851 Potter near his kiln displays a ceremonial vessel. Throughout this region pottery making is influenced by artifacts of the Tiahuanaco culture discovered here. Jesús de Machaca, La Paz

Weaving

In autochthonous settlements cloth is often hand woven for making garments for everyday use. This activity is ordinarily done by women who combine it with their work in the fields. In rural areas a horizontal ground loom is often used. For this type of loom all that is needed is a small area of level ground and four stakes with which to maintain the tension of the warp. Since it is such a simple device, country women often carry it with them so that they can continue to work while their animals are grazing. They spin wool and cotton using equipment that is similarly transportable: the spindle takes up little space and is not heavy. With the skill of their ancestors, women go on spinning while they are walking, waiting, chatting, etc.

The vertical loom is also commonly used; with both looms, the horizontal and the vertical, warp face textiles can be produced in which the weft disappears. A factor favoring the development of the art of weaving is the ease of construction and negligible cost of weaving implements; the frame of a good loom can be made with nothing more than a few pieces of wood. The treadle loom is found less frequently, but there are families that manufacture textiles for trade; these families generally have more than one loom.

The variety of ethnic groups within Bolivia's population has been a decided asset in the development of this craft; the desire of these groups to retain a distinctive identity has motivated artisans to invent new systems of weaving and to create more and more complicated designs. In the textile centers of each department the typical textiles produced reflect the imagination and creativity of local artisans. Decorative motifs express memories

852

853

854

852 Traditional costume of rural Bolivia. The short pants are made of baize. The mantles and ponchos of this area have colored stripes. Sucre, Chuquisaca

853 Aymará woman compacting, or beating, a piece of weaving on a ground loom with the help of a *wichuña*, an instrument generally made of the tibia of a llama. Suriki Island, Lake Titicaca

854 Aymará woman spinning wool. Suriki Island, Lake Titicaca

of ancient religious beliefs as well as a view of present-day surroundings. Both mythological and terrestrial events are interpreted in an almost interminable series of elaborate designs.

It is impossible to give a detailed account of all of the areas that produce textiles. One of the most typical, however, is Charazani in the department of La Paz. Weavers in this area use horizontal looms to produce textiles with multicolored fringes. After the wool has been spun and twisted on a spinning wheel, it is dyed with aniline (previously, vegetable and mineral coloring agents were used).

Before starting to work, the weaver must arrange the threads on the loom that will comprise the warp. These fabrics have decorative motifs, of from two to four pairs of warp threads (permitting the making of reversible designs), which may be broken-line geometric figures, figures of religious symbology, or, more frequently, animal designs. Potolo, in the department of Chuquisaca, is another important center. Weaving from this area is characterized by the diagonal arrangement of decorative figures, usually vermilion in color, although sometimes green, against a dark background. Figures may be stylized birds in strange positions or, occasionally, mythological animals.

Until now, Potolo has remained somewhat out of the mainstream because of its relative inaccessibility. The weavers of Ravelo have taken the lead and produce textiles of high quality. Although there are no major differences between the technique used in Charazani and that of Potolo, the weavers of Potolo use a vertical

855

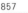

856

857

855　Caraguata plant. Three stages are shown: the plant in its natural state; combed fibers ready for spinning; spun fibers ready for weaving

856　Caraguata-fiber pouch. Ayoréode tribe. Santa Cruz

857　Needlework with caraguata fiber. Ayoréode tribe. Santa Cruz

858　Traditional weaving of Potolo: diagonal animal designs carried out in warp-face technique, making the piece reversible. Chuquisaca

loom, a wooden frame that rests against a wall when in use. In the entire area surrounding Macha in the department of Potosí, weaving is done with the complementary warp technique in two or three colors. The result is a very compact, fine-textured textile with V- or S-shaped geometric designs in earth tones.

This area is inhabited by Quechua. Within this group it is customary for the women, who use a rudimentary horizontal loom, to weave cloth of very complicated designs, while the men, who use a treadle loom, weave a smooth cloth called *bayeta de tierra*, a coarse woolen cloth used for making pants, vests, and shirts. A cashmerelike cloth used in making men's clothing is also frequently produced by this group.

The entire altiplano produces certain characteristic items of women's apparel that reflect the skill of weavers. These are the *ajsu*, skirt; the *lliclla*, mantle; the *chuspa*, coca bag; the *chumpi*, sash; and the *wayaka*, a kind of sack. Other garments are made of baize. Men usually wear European dress, although they occasionally use the *chuspa*, the *chumpi*, and the *chullo* or knitted cap.

In the forests of the east, home of the jungle-dwellers, weaving is done with vegetable fibers. The most common fiber used is that of the caraguata, a relative of the century plant; very attractive effects are achieved with both crochet hooks and knitting needles. Both natural-color fibers and fibers dyed with natural dyes are used in this region.

858

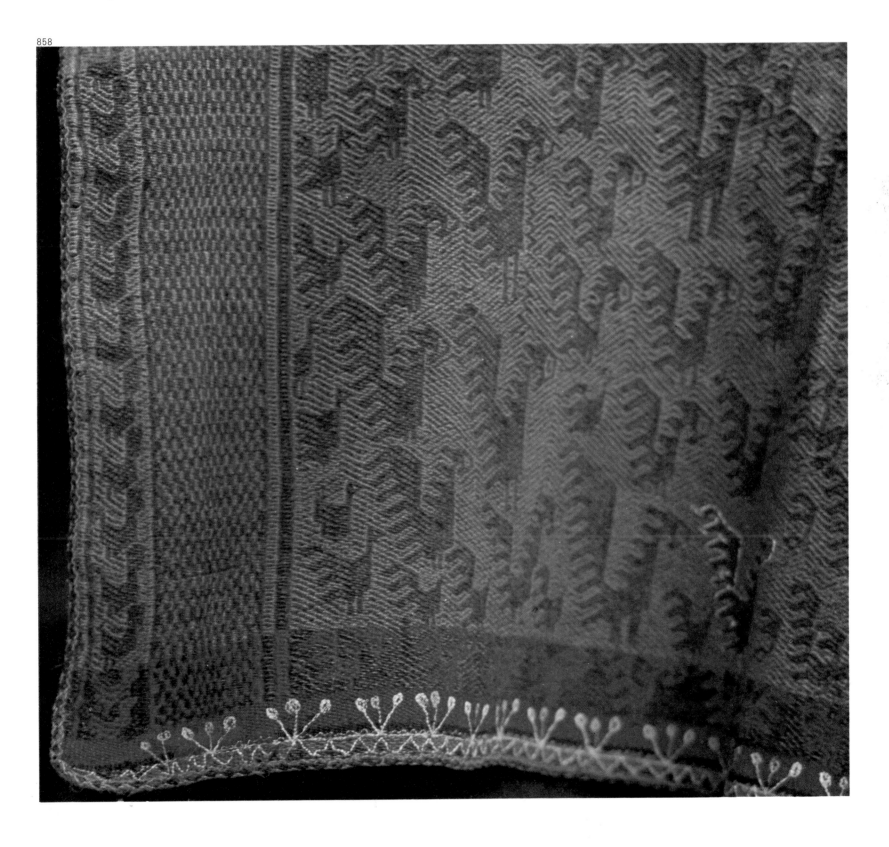

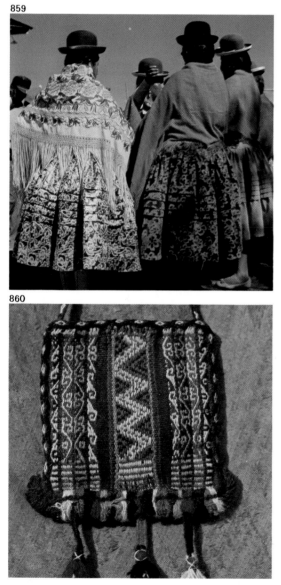

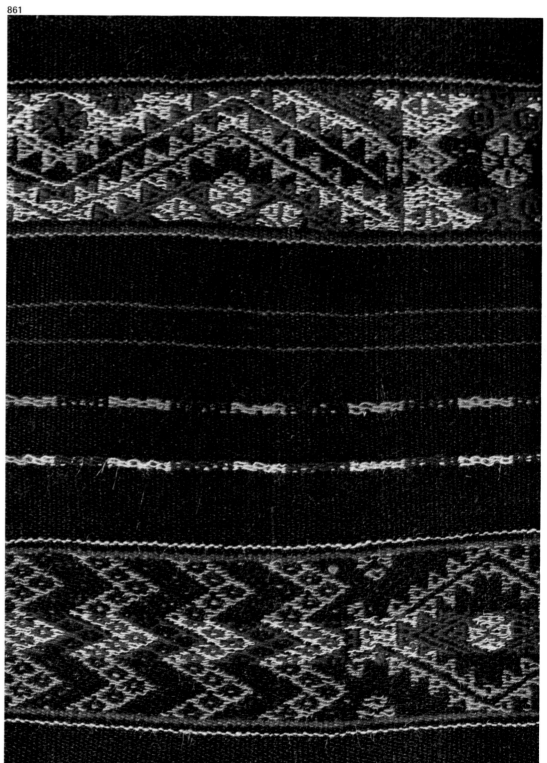

859 Aymará women in traditional holiday skirts. Taraco, La Paz

860 *Chuspa*, coca bag, sometimes used for carrying money and amulets. Macha, Potosí

861 *Ajsu*, detail of a woman's skirt. Macha, Potosí

862 Shop where derby hats are made and sold. La Paz

Hatmaking

In rural areas a hat is an object of prestige. Furthermore, a hat indicates the region or area where its wearer lives. Because of the geographic variety of its territory, Bolivia has developed a large number of different hat designs. Sometimes the differences among these are minimal, but they suffice to indicate the transition from one region to another. In markets where buyers and sellers from a variety of localities come together, one notices the large number of styles, and, above all, the pains taken by the women to protect their hats. If it is a rainy day the women will cover their hats with plastic. Some women even put an older hat on top of the one they are wearing. In cold areas of the altiplano men wear a *chullo* with a hat on top; the *chullo* is the traditional cap, but during the colonial era and later European migration, native tradition suffered under the influence of new styles of dress and particularly of new types of headgear. An example of the ingenuity and creativity of Bolivian artisans is the Tarabuqueño hat, a perfect adaptation of the Spanish soldier's helmet. The Tarabuqueño model is made of felt and cardboard worked in such a way as to produce an extremely stiff material.

Felt for the hats of the altiplano is made of sheep, alpaca, or vicuña wool; sometimes final touches are done with vizcacha fur. In the valleys and planes a lighter hat is worn; its function is not to keep one warm but to protect the head from the hot rays of the sun. As elsewhere, hats are also worn here as decorative or identifying garments.

In large cities shops featuring the same handicrafts tend to be clustered together along certain streets.

862

To some extent the same thing happens in local markets: vendors of medications, musical instruments, clothing, pottery, etc., are grouped according to specialty, making it relatively easy for shoppers to locate the item they are interested in buying. The market in La Paz, for example, has an entire street dedicated to the making and selling of hats.

Another feature common to the various crafts is family participation in the production process. Tasks are divided according to difficulty among all the members of the family, providing children with a continuous apprenticeship from an early age. In hatmakers' shops the hierarchical organization of work is very clear: the most difficult and demanding task, that of fulling the fabric, is done by the husband, who runs the workshop and who also does the forming and finishing of the hats; the wife washes hides and shears and combs wool; the oldest son selects colors and cards wool.

Making a hat is a long, slow process, some phases of which require considerable experience. First of all the materials must be prepared; hides are cleaned by being immersed in water and beaten until they become dirt-free.

Once the hide has dried, the wool is combed so that it can then be separated from the skin with a knife. This stage of the process ends with the carding of the wool, which is done with a bunch of teasels or thistles. This is followed by the preparation of the *fuste,* or material of which the hat will be made. A cardboard pattern

863

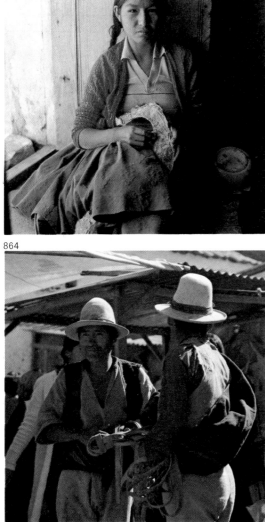

864

865

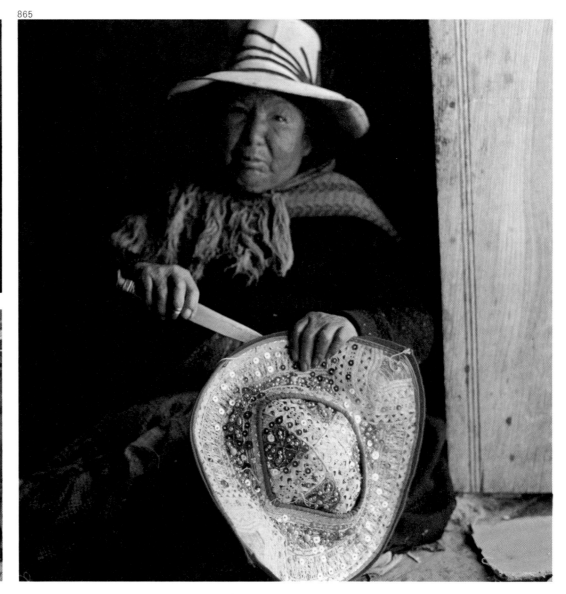

863 Girl applies resin to a hat form to give it additional stiffness. Sucre, Chuquisaca

864 Hats made of sheep's wool felt: every individual decorates his hat with ribbons or strips of cloth according to taste. Chuquisaca

865 Artisan making a woman's festival hat; trimming is made of silver spangles and small woolen flowers that resemble *kankuta,* the national flower of Bolivia. Sucre, Chuquisaca

is used that is covered with wool and then with a cloth. Now the fulling process begins; the iron must be kept very hot and the water must be poured in an uninterrupted stream to produce the steady supply of steam needed to make a *fuste* of good quality. Next the latter is removed from the pattern and goes back to the fuller to acquire additional stiffness. This time it is placed on a form and given its final shape. The brim is molded with the aid of an iron and a damp cloth. All that is needed to complete the hat is the band and other decorative elements.

This is the process used in making the type of derby used throughout the altiplano. Other models are made through modifications in the finishing process. For example, the Tarabuqueño hat becomes hard and water-proof with the addition of a coating of resin.

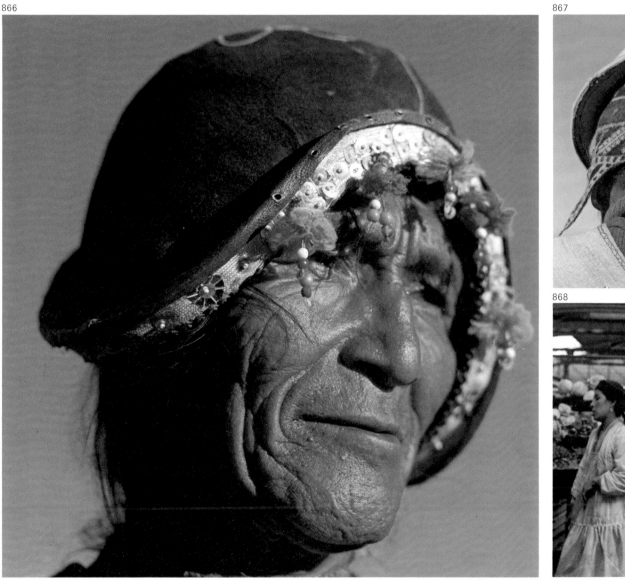

866 Man's hat inspired by the helmet of the conquistadors. Tarabuco, Chuquisaca

867 The practicality of the *chullo* in cold regions is unsurpassed. This man has decided to wear two types of hats: a traditional *chullo* and a European-style one

868 Lightweight, broad-brimmed hat that provides protection from the sun. Cochabamba

Totora Work

The totora is a plant of the typhaceous or cattail family that grows in wet, swampy regions. People who live on the shores of Lake Titicaca use it for a variety of purposes: they thatch their houses with it; they use it in making extra furniture; they make rafts of it; and when it is young and tender, they eat it in salads. The most important of these uses is raftmaking. Although these raftmakers are becoming scarce, it is still possible to find people who ply this craft among the Aymará who live on the small islands of the lake. Raftmaking is a slow process that requires great skill. A man must work steadily for an entire month to build a raft that will last only a year. Because of this people have begun to use small motor- and sailboats which, although more expensive to acquire and maintain, give longer service.

The process of making a totora raft begins with the construction of the shell, or outside layer of the rolls that give the raft its shape. The best totora stalks—all of medium thickness—are used in making the shell. These are joined by being interwoven and then tied with straw twine. The heap of totora is arranged lengthwise and held in place with temporary ties; the process is continued until an entire roll is covered. Once the two main rolls are finished, a third one is made that will form the connection between the other two; this joining is done with braided straw twine; the tying is done in the form of a spiral. In the very center of the third roll an opening is left for drainage. The bow and the stern are constructed with the aid of a support; other supports are used to form the ascending curves needed at each end of the raft.

869

870

869 Stool woven of totora. Suriki Island, Lake Titicaca

870 Floating islands of totora inhabited by the Uros. Lake Titicaca

At this point the cord-tightening process is completed: while the totora is kept moist, the cord is tightened again and again; during the process, the surface of the raft is pounded with a stone to maintain overall uniformity. This is the most important phase of all and the success of the work depends on its being done well. Finally, two small lateral rolls called *atajos* (dividers) are made; these are fastened to the base and create the inner hollow of the raft.

Another point of interest with regard to Lake Titicaca is the way of life of the lake-dwellers, or Uros, who up until a few years ago had virtually no contact with the shore-dwellers. The Uros were not considered human; they were thought to have black blood, to be immune to dampness and cold, and to be exempt from death by drowning. They have now begun to intermarry with the Aymará, but they preserve their traditional way of life on floating islands made of totora. The Uros have been included in this chapter, even though they live on the territorial waters of Peru, because of their extensive use of totora.

The largest totora beds are located in shallow water—no more than 12–15 inches (30–40 cm) in depth. The Uros build their islands (approachable by channels known only to the Uros) upon such beds, laying down successive layers of totora stalks until the heaps rise above the water level; new stalks are added to the surface as the submerged portion gradually rots away. The totora added is anchored to growing stalks to prevent the island from moving out of position, although storms or variations in water level sometimes uproot an island.

871

872

873

871 Totora beds. Lake Titicaca

872 The totora roll that forms the gunwale of the raft is formed as it is being fastened to the base. Suriki Island, Lake Titicaca

873 Finishing the bow and the stern of the raft. The ends of the rolls are cut and trimmed with a knife. Suriki Island, Lake Titicaca

As a rule each island is occupied by only one family. The dwelling, simple in construction, is made of large mats woven of totora and supported with stakes. The roof, also of totora, is like the inverted hull of a ship.

The totora work done in the Lake Titicaca area is a craft phenomenon as creative as it is rare in the rest of South America. In this connection we ought to mention the small totora raft-boats called *caballitos* (little horses) made on the Peruvian coast near the ruins of Chan Chan, ancient capital of the Mochica; these small vessels are used for fishing in the Pacific.

In any case it is interesting to note the similarity in form between the totora raft and the papyrus rafts made near Lake Chad in Central Africa.

874

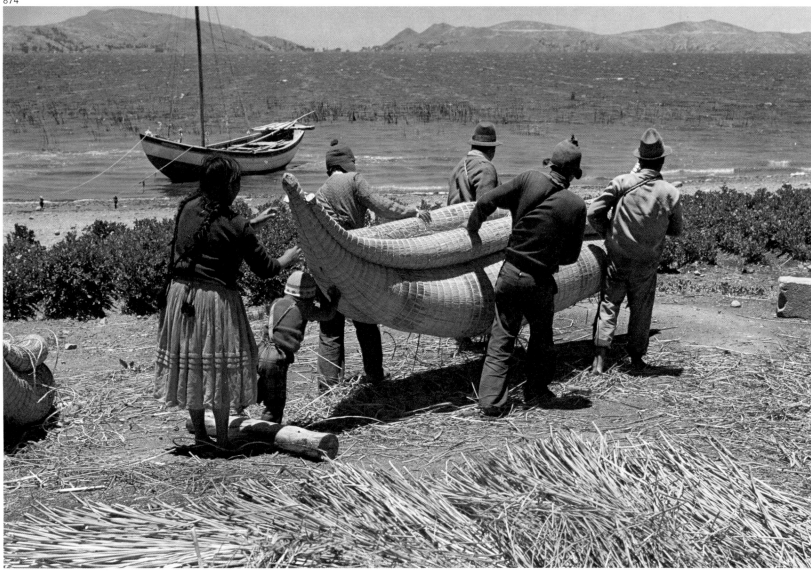

874 Once an artisan has finished a raft, it is carried down to the water. Rafts are fairly heavy and several people are needed to carry one. Suriki Island, Lake Titicaca

875

876

875 Although laborious to make, rafts like these can still be seen near the shores of Lake Titicaca.

876 Adobe structures, nearly leaning against one another, with waterproof totora roofs are the traditional dwellings of the Aymará in the region of Lake Titicaca

Masks

From prehistoric times man has covered his face in order to play the part of a deity or an animal or to caricature a contemporary. The shaman, witch doctor, or priest also makes use of masks as a means of achieving a trance-like state in the culmination of a ritual. Such acts enhance the religious identity of the community and grant the priest figure a certain ascendancy within the group. But the use of masks extends beyond the magic rituals and festivals of tribal groups; in many areas masks are still used in the performance of traditional folk dances. In some of these there is a blending of the most ancient traditions with those introduced after the conquest. This reminiscence of earlier times allows for the rediscovery of dances falling into oblivion; revitalized, these become part of present tradition. Folk dances are based on a wide variety of themes. An important category is the satirical dance alluding to foreigners. One dance, for example, called "the dance of the blacks," ridicules the movements of the slaves; the mask, grotesque in character, has an enlarged mouth that seems to be panting, a face that symbolizes the silent protest of a people against the exploitation of their fellows.

Another type of dance portrays customs. Masks are used to represent the faces of jungle-dwellers, or *chunchus,* or of shepherds, called *llameros.* The masks that represent animal heads (pumas, roosters, cats, etc.) are used in the dance called *misti sicuris;* the dancers wear costumes that recall the dress of bullfighters.

The Moxeño of eastern Bolivia carve wooden masks with a variety of motifs: the sun, the moon, and various types of animals. The most important of these masks are those representing the *achus* or most elderly

877

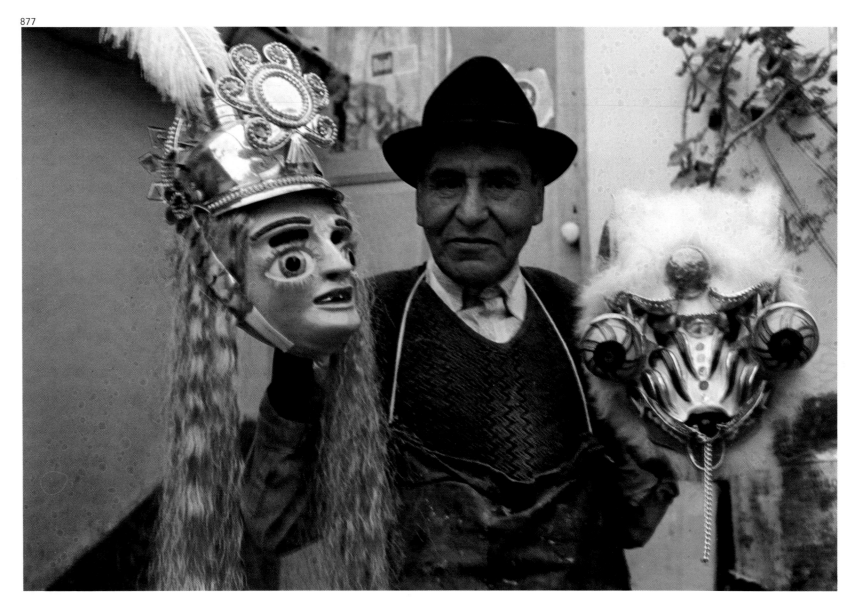

877 Artisan showing two of his creations: the mask of Archangel Michael and that of the bear, both from La Diablada dance. La Paz

members of the tribal group. But the most imaginative and creative dance is one called the *diablada*. Many different personages take part in this dance which explicitly reflects the juxtaposing of religious beliefs of a tribe that has been influenced by numerous denominations. The "evil angel" represents the devil; the *sarja* is evil; the *supay* is a diabolical being originating among the natives themselves; the *china supay* is a female devil. Intermingled with these are masked figures representing Lucifer, the bear, the condor, and other animals. This is a complex dance having a variety of steps; it even includes dragons arising from the cultural influence of Asia.

The making of the principal *diablada* mask begins with the modeling in plaster of a series of elements that will become essential parts of the finished mask. The base of the mask is the part that the dancer puts over his head. The inside is formed of felt; ears and other features are affixed to this base with glue. The nose, mouth, and eyes are generally molded by hand from a paste made of flour, plaster, and glue. The horns are cone-shaped woolen bags filled with sand; the spiral twist is achieved by means of a wire inside the bag and is solidified by an application of glue mixed with soot. Eyebrows, eyes, and other features may be made of discarded items (electric bulbs, resistors, pieces of tin, etc.). The winged dragons, with their enormous feet and claws, are similarly formed of superimposed parts and have a markedly mythological character. Once the entire mask has been put together, it is given a coating of paste to provide a smooth surface that can be painted in warm tones of enamel with touches of blue and green. Finally, the piece is decorated with stones from costume jewelry.

878

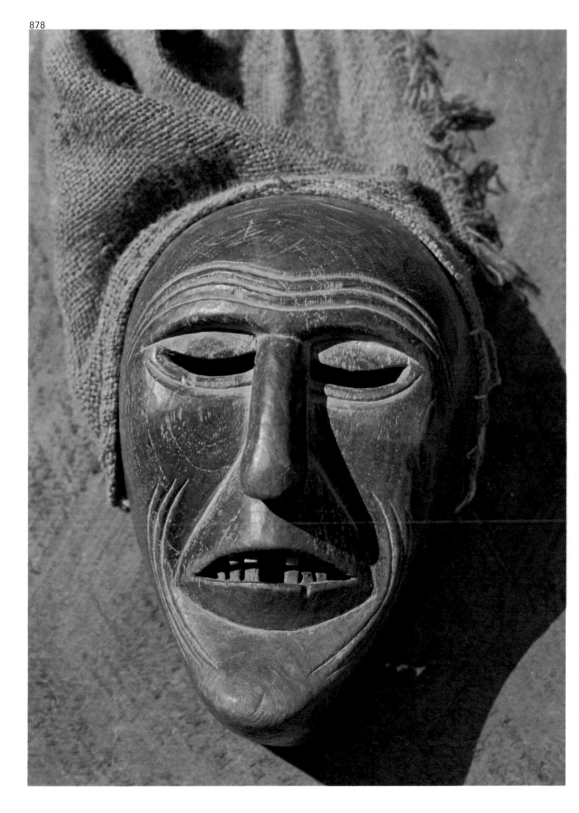

879

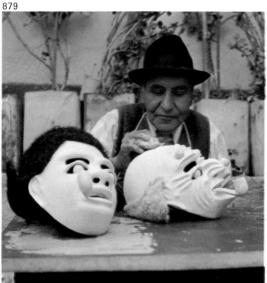

880

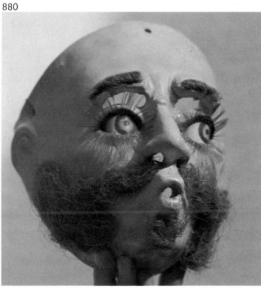

878 Wooden mask of an *achu* or elderly person. Moxo group. Beni

879 Once the plaster base of the mask is dry, the surface must be polished so that paint can be applied for a perfectly smooth finish. Mask of a black man and of *wapfuri*

880 Mask of a *chunchu*, or inhabitant of the rain forest, used in a dance in which the Aymarás mimic the inhabitants of the eastern zone

Embroidery

One of Bolivia's most important crafts is embroidery. In La Paz, Potosí, Oruro, etc., there are entire streets of craft shops that work full time producing costumes for dances, the most significant expression of Bolivian folklore. Dance troops are formed by people who work in the same neighborhood or who live in the same country village. They meet to prepare for special patronal or regional festivals for which there exist an enormous number of dances that have been performed, with slight variations, for several centuries. Here again the dance signifies a symbiosis of different cultures and religions that in one way or another have left an imprint on the country's heritage and that remain alive in the various celebrations. The decorative motifs of the costumes have undergone a continuous evolution. In the last thirty years we have seen a change from elements of Andean symbolism to figures clearly reflecting Tiahuanaco influence. Oriental designs are also increasingly important.

Most of the costumes produced are for the *diablada* and *morenada* dances. Various types of stitches are used in creating embroidered designs. There are several stages common to most of the embroidery techniques used. The artisan sketches on cardboard the design to be embroidered and then cuts out the silhouette. A frame is used to keep the heavy cotton cloth taut. The cardboard figure is applied to the base fabric and is used as a pattern. The most common stitches are the chain stitch, the satin stitch, and the feather stitch, all of which use different combinations of thread and different techniques for linking stitches.

Once the embroidered design is finished, the figure is cut out and sewed to the appropriate place on

881

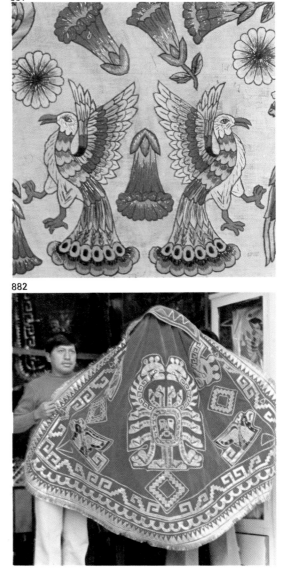

882

883

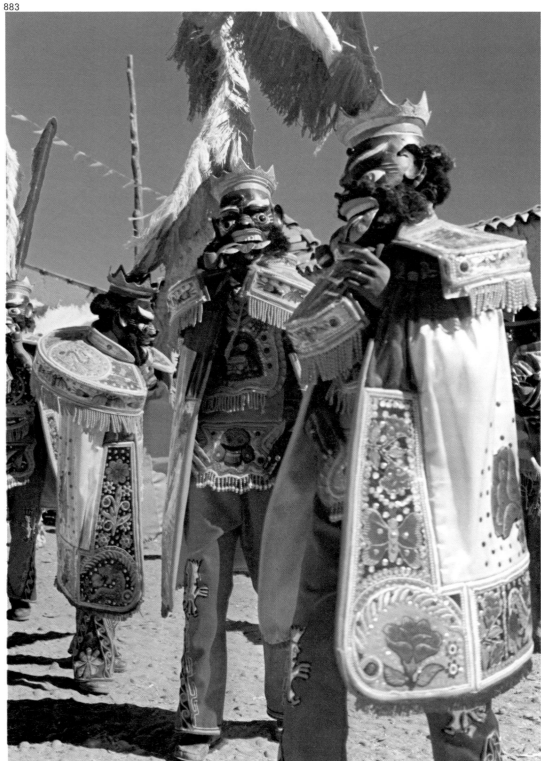

881 Detail from an embroidered costume from the *kullaguadas* or spinners' dance. La Paz

882 Cape from the dance of the Incas; designs, inspired by Tiahuanaco motifs, on velvet using the *tormaneado* technique. La Paz

883 Folk festival in Taraco. Dancers wearing *morenada* costumes. La Paz

the costume. The artisan may decide to give the figure greater relief by tucking small tufts of cotton or wool between the embroidered piece and the cloth of the costume, which is usually of velvet. This technique lends a three-dimensional quality to designs such as serpents or dragons.

The process of putting the costumes together is complicated and requires a great deal of patience. When a costume has an unusual feature because of the figure it represents, as often occurs, a cardboard form is sometimes molded which is then covered with the costume fabric. Once the entire costume has been put together, pearls and rhinestones from costume jewelry are added, creating an exaggerated, baroque effect.

In general, artisans give free rein to their imagination in designing motifs, varying them at will, retaining only the general shape of figures. This results in the creation of a great variety of designs that are further enriched by the use of metallic threads and other brilliantly colored materials.

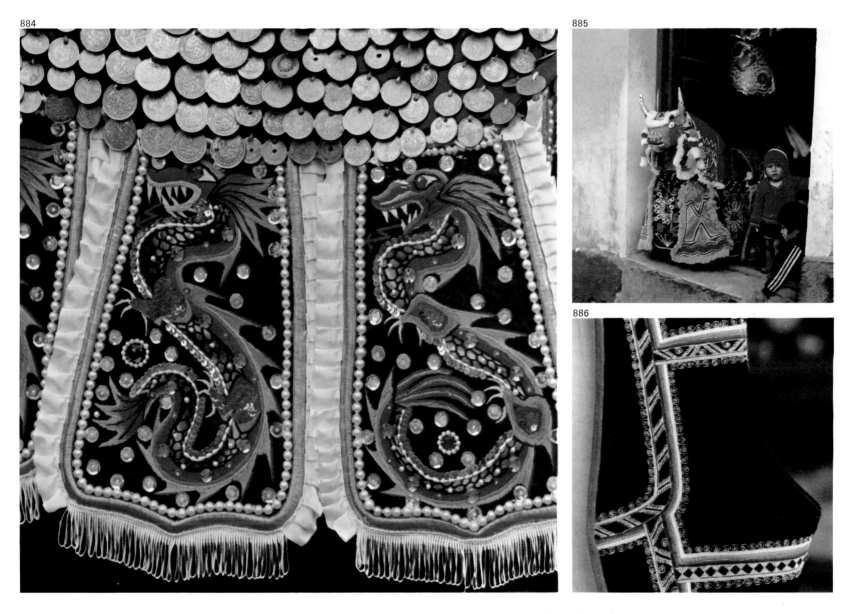

884 Peplum sections and coin-decorated sash of the devil's costume embroidered in chain stitch; the dragon is done in feather stitch. La Paz

885 Embroidery workshop. The costume displayed in the doorway as a sales sample is designed for the bull in the *waka waka* dance. It is worked in the *tormaneado* technique. La Paz

886 Machine-embroidered vest with designs typical of San Lucas. San Pedro Buenavista

Catalogue

887 Multicolored straw airplane. Copacabana. La Paz

888 Multicolored basket or sewing kit. Copacabana, La Paz

889 Basket for storing cotton. Moxo group. Beni

890 Straw basket, or *chilliwa,* used for gathering potatoes. Aymará group. Altiplano

891 Bundle of *garabatá* fibers used to extract honey from storage vessel. Ayoréode group. Santa Cruz

892, 893 Bags or *chuspas* used for carrying coca. Macha, Potosí

894 Hat and embroidered sash for festivals. Tarabuco, Chuquisaca

895 Embroidery detail from the edge of Lucifer's cape, worked in feather and chain stitch

896 Embroidery detail from the pants worn in the weavers' dance, worked in the *tormaneado* technique. La Paz

897 Leather belt with pockets and inlay work. Tarabuco, Chuquisaca

898 Headdress of parrot and macaw feathers. Chacobo group. Beni

899 Headdress of macaw feathers. Moxo group. Beni

900 Headdress with feathers and strip of jaguar skin. Ayoréode group. Santa Cruz

901 Feathered headdress called *mañenohibé.* Ayoréode group. Santa Cruz

902 "Mosquito" dolls. Copper thread and silk. Sucre, Chuquisaca

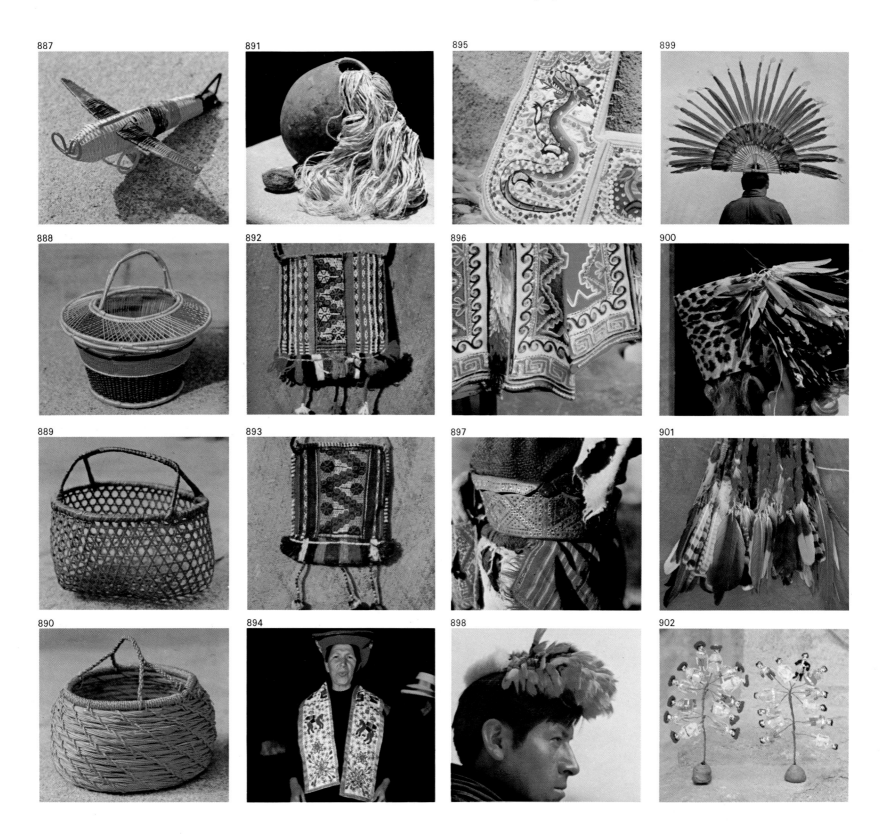

887

888

889

890

891

892

893

894

895

896

897

898

899

900

901

902

903 Dancing figures made of straw and horsehair. Aymará group. Copacabana, La Paz

904 Miniature made of bread dough, about an inch high. Padilla, Chuquisaca

905, 906 Bread-dough dolls. Padilla, Chuquisaca

907 God of Plenty, or *ekheko*. Aymará group. La Paz

908 Maraca of the type traditionally used in festivals of the altiplano. Taraco, La Paz

909 *Bajón,* bassoonlike instrument made of leaves of the *cusi* palm tree. Moxo group. Beni

910 *Chapaco,* violin used in rural festivals. Tarija

911 Charango made of an armadillo shell

912 *Rollano,* a wind instrument. Calcheño group. Potosí

913 *Potha.* Wooden whistle with shell ornaments for ceremonial use. Ayoréode group. Santa Cruz

914 Man trying out a panpipe, or *zampoña,* consisting of two sets of reed pipes. Altiplano

915 *Jojoavidie,* an idiophonic rattle made of a turtleshell with a bone clapper. Ayoréode group. Santa Cruz

916 Orangewood egg and dishes, turned on a lathe. The egg is one inch high. La Paz

917 Miniature orangewood table service, turned on a lathe. The diameter of the tray is one inch. La Paz

918 Everyday objects of tin. Sucre, Chuquisaca

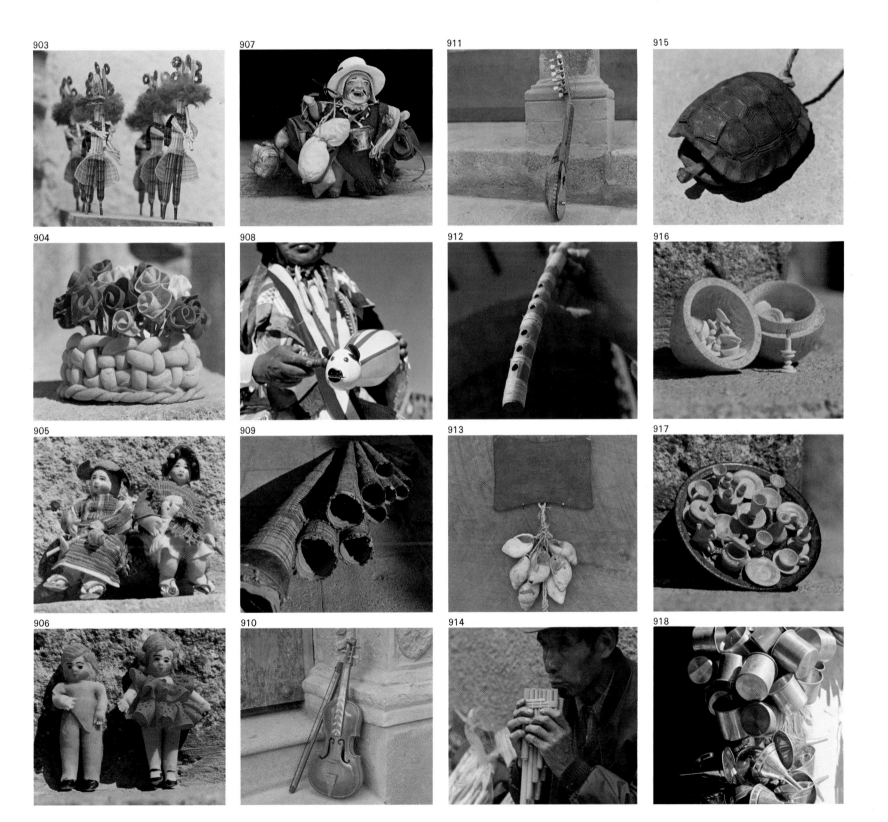

903
904
905
906
907
908
909
910
911
912
913
914
915
916
917
918

CHILE

919 The success of Chilean agriculture can be seen in its fruit production, a major factor encouraging the country's economic expansion. Linares

Introduction

Chile, fertile province
renowned in the legendary Antarctic,
respected by distant nations
for its strength, leadership, and power.
Its people are so remarkable,
so proud, bold, and warlike
that no king has ever ruled them
nor foreign power ever bent them to its sway.

Alonso de Ercilla, *The Araucaniad*, "Chile and the Araucanians." Canto I. 1569

The Atacameño, Diaguita, El Molle, and Araucanian were ancient tribes who once inhabited Chile; of these only the Araucanians still preserve a certain identity. Their deeds have distinguished them as true defenders of Chile and have been remembered in poetry throughout the country. Their ability as warriors and their courage made invasions as difficult for the Inca as for the Spanish a century later. Chile has never been completely colonized; the first expedition, led by Diego de Almagro, failed, and it was Pedro de Valdivia who conquered the Araucanians and made them retreat south of the Maule River. However, despite the five Spanish cities founded in this area, including Concepción, the hostility of the native people continued. Valdivia died in 1553, four years after defeating the Araucanians for the first time.

Today the city of Temuco could be considered the most important Araucanian center, with some twenty thousand of them living in small villages on the outskirts. The Araucanians have retained their ethnic characteristics and have kept many of their customs, which are related as much to their political organization as to their daily tasks and crafts. Intermingled with other inhabitants across the country are another one hundred fifty thousand Araucanians, who are leaving traditional ways behind and keeping their language only to use bilingually with Spanish. The Araucanians of Temuco and vicinity speak only Mapuche, principally because they live farther from urban centers.

Mapuche, meaning "people of the land," is the name they were given as a people. In the past the Araucanians consisted of several tribes unified by the same customs, the same language, and one system of government. The names of the tribes varied according to their location within the country; thus there were Moluche (people of the west), Picuche (people of the north), Pehuenches (people of the pine land), Huilliche (people of the south), and the Mapuche.

Although Temuco is not the residential center for the Araucanians, it is the commercial center of the region. On market days the Mapuche go to the city from their villages, traveling the mile or so by public transport, on their beasts of burden, or on foot with their products on their back. Multitudes of Araucanians converge on Temuco and set up their own market in the vicinity of what could be considered the "official" market.

920

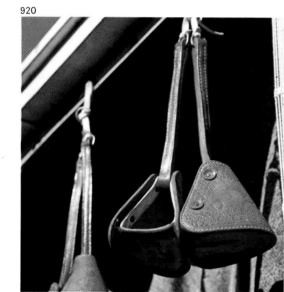

921

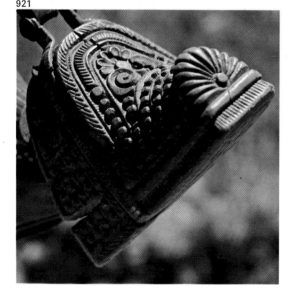

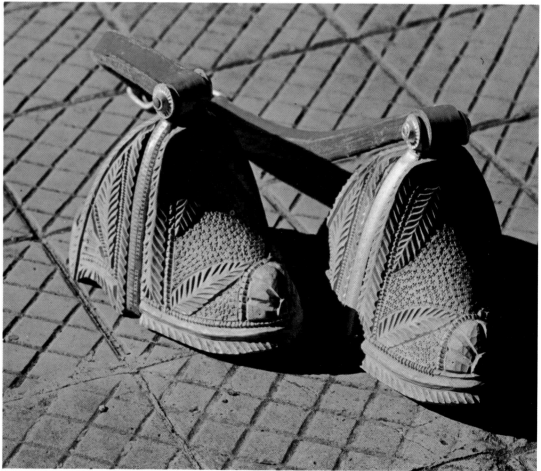
922

920 Stirrups in repoussé leatherwork are very common in the cattle-raising area of the country. Chillán, Ñuble

921, 922 Carved-wood cowboy stirrups. One can appreciate the different details in the manufacture of the two models. Today they are not made with the precision as were the old ones. Ñuble

Poultry, cattle, farm produce, textiles, crafts, etc., are all mixed together indiscriminately and the color and gaiety of the scene are added to by the typical Mapuche costume.

The women, even if they have on nylon stockings and silk handkerchiefs, are wearing the characteristic black poncho with a green or red border; often it is worn as a shawl covering the shoulders and kept in place with a silver pin. Silk handkerchiefs have replaced the dark-colored cotton ones, but the way they are worn on the head has not changed. Chile is one of the few countries in the Andes where women do not wear men's style hats. The men tend to sport a felt or vegetable-fiber hat, and they mostly wear European clothes. Very few wear a poncho, which for them is woven in soft-colored shades of brown wool, generally undyed.

For the most part, Araucanian craft products fulfill utilitarian functions. The Mapuche weave fabrics and make pottery for their own use, and are almost completely self-sufficient. Their pottery is seen only in their own markets and then only a few examples. The state organization for the promotion of crafts is now forcing some textiles onto the tourist trade. As happens all over the world, the repeated production of such craft pieces as a response to the increasing demands of tourism and the greater buying power of the native people could lead to the use of artificial products that diminish the beauty and quality of traditional crafts.

Silverwork, one of the most important arts, and one that is specifically Araucanian, has almost completely disappeared because of the high price and subsequent shortage of the raw material. Nevertheless, all

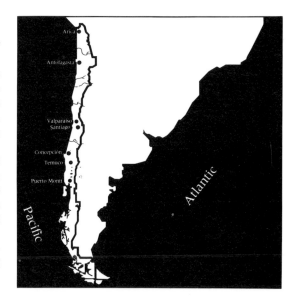

923

923 Ground pepper is sold in bulk in most of the markets. Note that one of the measures is an ox horn. Chillán market, Ñuble

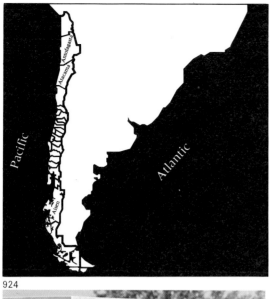

the characteristic pieces of jewelry are reproduced industrially, including the *siquel* (a breast pendant), the *punzón* (a breast pin), and the *prendedor* (a breast piece), whose styles and designs have also been adapted to jewelry of a wider use, such as bracelets and necklaces.

The Araucanians are not the sole exponents of Chilean crafts, but there is a basic difference between the Mapuche and other craftsworkers. Mapuche objects are almost entirely utilitarian; they are made to fulfill already existing functions and, as such, there is an obvious reason why they are made in an already determined style, although to some extent they are being altered to resemble modern objects. The majority of crafts found in the rest of the country are purely decorative: the horsehair work in Rari and Panimávida; objects of inlaid wood; shell objects of Valparaíso; and the painted pottery figures of Talagante.

924

925

924　The market in Chillán is one of the best attended in Chile, and all the products of the central area of the country can be found there. As the climate is warmer than in the south, the ponchos are lighter weight than those of Temuco and the surrounding areas

925　This advertisement for a Chilean fish market is a magnificent example of folk painting. Chillán, Ñuble

Black Pottery

Pomaire and Quinchamalí are towns well known in Chile for their black pottery. There are several differences between their products. Perhaps the major difference is that the pottery of Pomaire is subject to greater outside influences, since Pomaire is more of a tourist town than Quinchamalí. Another difference is that the Quinchamalí potters decorate their pieces, whereas the pottery of Pomaire is left plain.

In Quinchamalí, a village of small farms sheltered under large fruit trees, the women work the clay while the men concern themselves with tasks appropriate to a predominantly agricultural area. Besides making pieces for domestic use, the women make an endless number of pottery models such as women with children; a wide variety of animal figures, including roosters; perhaps the most popular, the guitar player. For the most part these figures are used as moneyboxes.

The first task is to prepare the clay, which is mixed with sand to give it porousness and to prevent it from cracking while it is being baked. The potter uses two equal lumps of clay that, after kneading, will be formed into bowllike shapes, depending on the figure being made; these two parts are joined together and the seam is polished, first with the fingers and later with a scrap of wood called a *paleta*, to give the final touch. This hollow ball, which will be the base or body of the figure, is left to dry for a couple of hours, after which arms, legs, head, tail, etc., are added. The clay is dampened as it is being worked and the parts are affixed with a little pressure and a slight twist. Once the piece is complete it is left to dry, to be polished later with a smooth pebble.

926 The beginning of the process; after kneading the clay, the potter separates the parts that will make up the body

927 The hemispheric shape is obtained with the help of a scrap of gourd rind with which the lump of clay is smoothed and thinned out

928 Once modeled, the two pieces will be put together to make the body

929 With an odd-shaped wooden blade, the seam is polished until the two pieces are as one

930 A couple of hours later it is possible to start adding the other parts of the figure

931 With the utmost care, since a wrong movement could destroy the work, the modeling of the face, arms, guitar, etc., is started

The finishing process requires patience. Polishing consists of glazing the piece all over with *cola-colorada*, a sticky sand dissolved in water, and then rubbing it until the clay acquires a reddish color; following this, the piece is submerged in oil and polished again with a stone until it shines. Finally the potter engraves the design, which is usually floral, using an old phonograph needle fastened to a small stick.

The object is now ready to be baked. In winter the first drying is done by suspending the pieces over a fire; in summer the heat of the sun suffices. (The object of this phase is to avoid the cracking that would result if the pieces were put directly into the fire.) The pieces are then baked without a kiln, in an open fire that is fueled with straw and, when that has burned away, ox or horse dung, which covers the pieces and gives them their popular black color. Last, the etched lines are filled in with white clay.

932

934

936

933

935

937

932 This figure of a pig has also been made by the method explained above; the craftswoman is applying *cola-colorada* to polish and shine the piece

933 Etching the decoration on the body of a guitar player with a phonograph needle

934 Figure of a guitar player. Quinchamalí, Ñuble

935 Figure of a goat. Quinchamalí, Ñuble

936 Figure of a turkey. Quinchamalí, Ñuble

937 Figure of a woman with a child. Quinchamalí, Ñuble

Horsehair

One of the most unusual crafts in Chile is the creation of beautiful objects from braided horsehair. The craft is confined to a very small area, virtually to a single village called Rari, but it is famous all over the country. Its popularity comes, in part, from Rari being situated only a small distance from the spa Panimávida, which many people patronize for its hot springs.

Horsehair is soaked for twenty-four hours, then washed in detergent, bleached with industrial products, and boiled in a solution of dyes and salt so the sun will not fade or discolor it. In general hair from horses' tails is used because the creation of complicated figures requires hair that is more than six inches in length.

In the past, root fiber from the poplar tree was used, the fiber being dyed with natural products; when it was replaced by horsehair, artificial dyes were substituted.

938

939

940

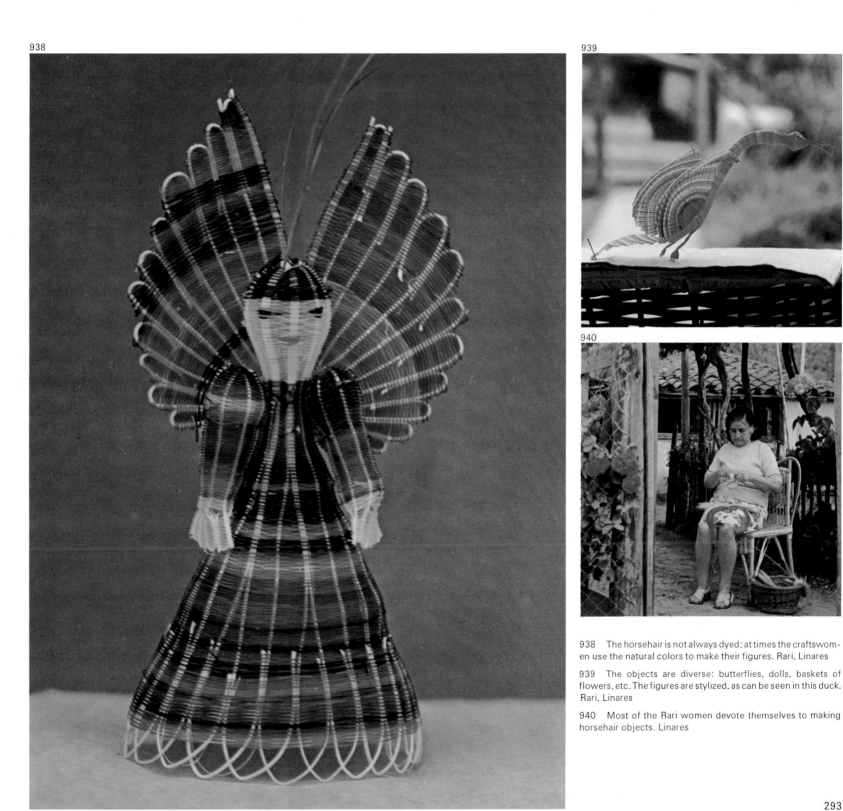

938 The horsehair is not always dyed; at times the craftswomen use the natural colors to make their figures. Rari, Linares

939 The objects are diverse: butterflies, dolls, baskets of flowers, etc. The figures are stylized, as can be seen in this duck. Rari, Linares

940 Most of the Rari women devote themselves to making horsehair objects. Linares

Basketry

The cities of Chile have a specialized craft. Chimbarongo is a very important center of basketry where there are weavers, predominantly men, in nearly every house. Wicker is one of the most frequently used materials. It is gathered in June while it is still green and then submerged in water for four months, at the end of which the bark or rind has loosened. After cutting the cane in four pieces with a cleaver, each piece is split lengthwise with a knife and thus thin strips for braiding are obtained. Naturally, this process is not always necessary, as uncut canes are sometimes used to make the framework for furniture or something of greater durability. Large baskets, chairs, and lamps are the most common objects.

It should be noted that wicker is not the only vegetable fiber used in basketry; stems of rice, wild oats, wheat, agave, rattan, etc., are often used to make objects. Outstanding, perhaps, are the small boxes made of wheat stems that are produced all over the country; those from La Manga and Melipilla are particularly worthy of mention.

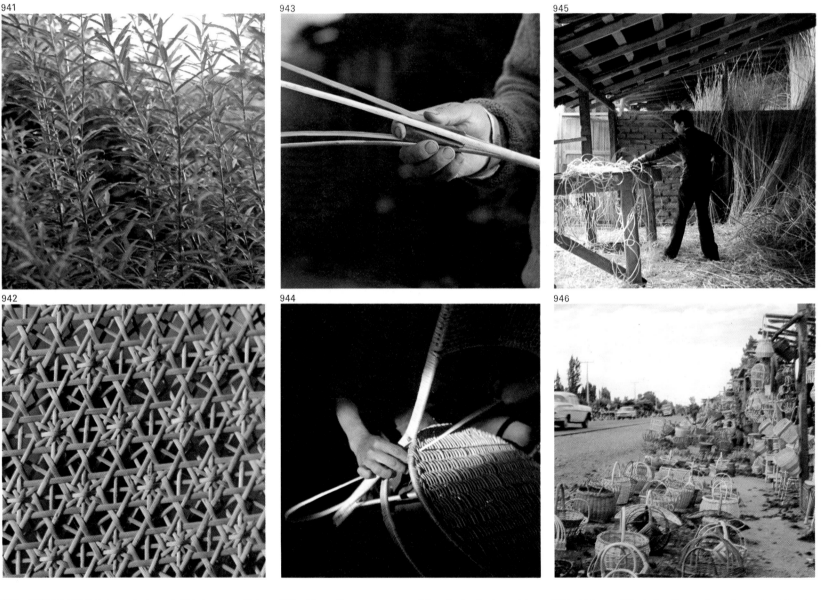

941 Willows still too green to be cut. Chimbarongo, Colchagua

942 Detail of the back and seat of an easy chair woven in a star pattern. Chimbarongo, Colchagua

943 The willow canes are cut lengthwise in four strips. Chimbarongo, Colchagua

944 The design of the weaving goes from complicated patterns to a simple wicker cross. Chimbarongo, Colchagua

945 Using a thin knife, the craftsworker cuts strips for making braided objects. Note the length of the stored willow canes. Chimbarongo, Colchagua

946 View of the highway between Chimbarongo and San Fernando, along which assemble most of the basketweavers of the area. Colchagua

Mapuche Craftswork

Although the Mapuche are beginning to adapt objects of European origin to their daily tasks, they are one of the ethnic subgroups that have predominantly kept their traditions. They go to the market in Temuco to sell their products and buy what they need, many of the women still wearing the traditional costume and their complex and beautiful jewelry. The social organization, based on the clan, dictates the form of their villages. The houses are grouped around that of the *ayllu* to make up small communities (see chapter on Bolivia). The dwellings are made of wooden boards covered with vegetation; the floor plan is rectangular, with a semicircular space like an apse. At the point where the sloping roof of the "apse" meets the main part of the building, there is a gap that acts as a chimney. The simple rural life of the Mapuche allows them to continue making most of their traditional crafts. The women weave ponchos for the men, in natural-colored wool with geometric designs about whose significance they are reluctant to speak; the poncho for women is enormous and colored black with a red or green border, and most of the time it is used as a shawl that hangs from the shoulders.

The making of jewelry containing silver has almost died out because the raw material is now so scarce and expensive, but many styles are still worn: the *siquel*, a breast pendant fastened with a *tupu*, a pin with a large head; the *trarilongo*, a necklace of linked circular pieces; the *prendedor* and *trapelacucha*, both breast pieces that give their names to their respective designs; the *trarikue*, a small ornamental chain; the *quilkay* and *kintuchape*, similar to the *trarilongo* but shorter and with the pieces farther apart.

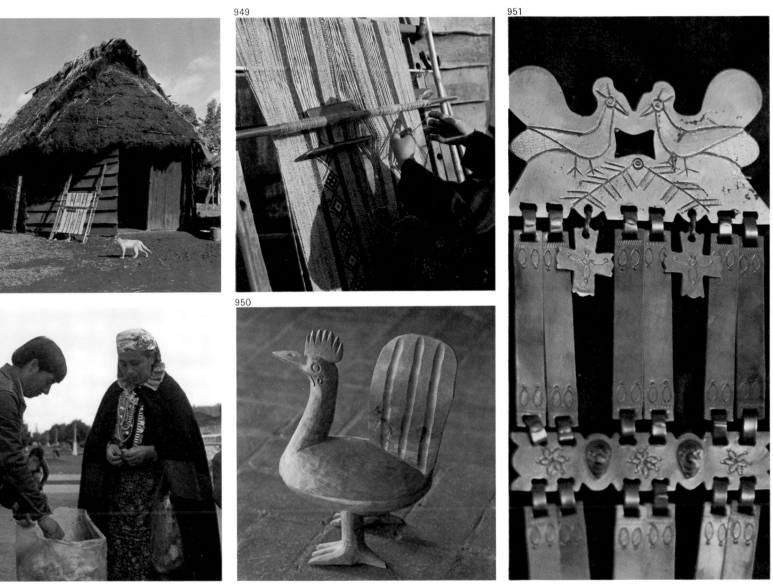

947

948

949

950

951

947 Mapuche dwelling in the village of Tres Cerros. Cautín

948 Mapuche woman wearing a *trarilongo* and a *trarikue*, a necklace and small ornamental chain respectively. The printed head scarf was originally black. Temuco, Cautín

949 Making a man's poncho. The Mapuche use applewood to make the vertical loom. Tres Cerros, Cautín

950 Handcarved wood rooster shows the skill of the Mapuche craftsmen. Cautín

951 Detail of a silver *prendedor*. Temuco, Cautín

PARAGUAY

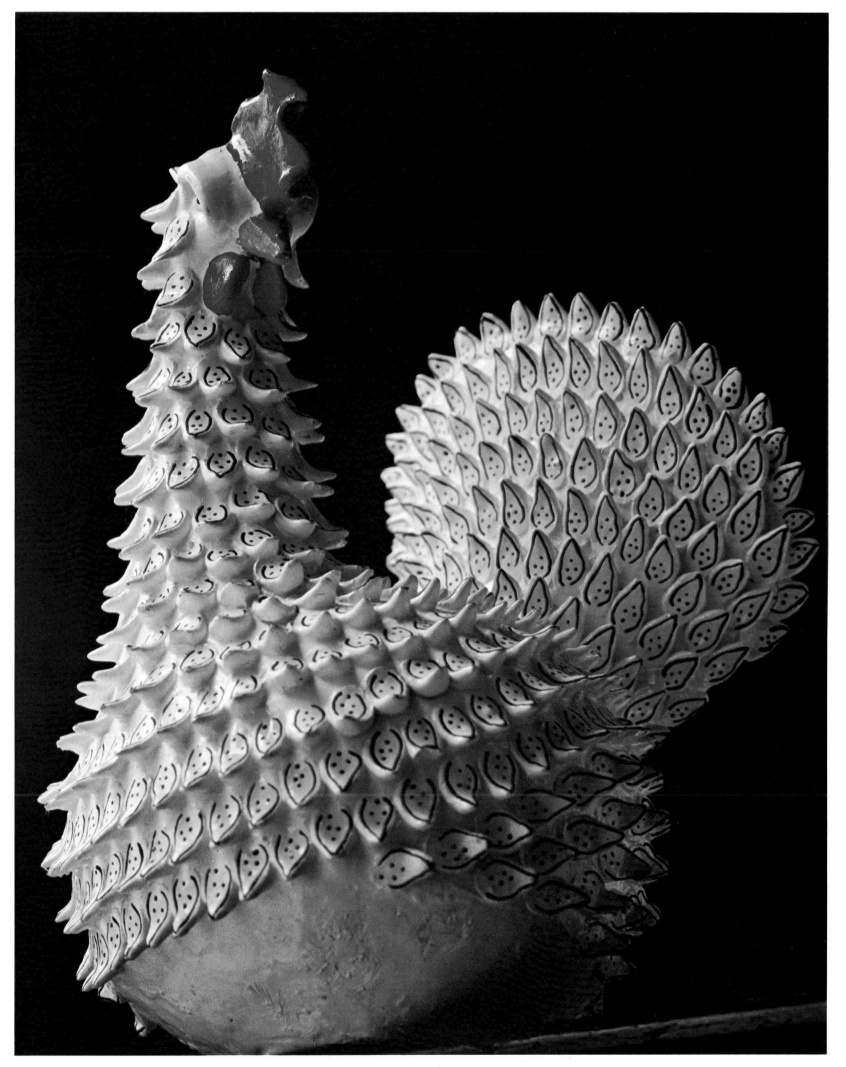

952 Lucky hens, called *pichai*, which are usually painted
black or white. Itá, Central

Paraguay is divided by the river of the same name into two regions of markedly different geography, vegetation, and people. In the latter respect the inhabitants of the Chaco, the west of Paraguay (Toba, Lengua, Mataco, Maká, etc.), are still a wild people, keeping to themselves, little disposed to communication and trade. In the east, on the other hand, the Guaraní are much more friendly; it was their blood that mixed with that of the conquistadors to form the basis of the modern Paraguayan population. When the Spanish first encountered the Guaraní they were a seminomadic group who lived by hunting and fishing. They also practiced a nomadic agriculture by settling in one place long enough for one harvest and afterward moving on in search of new land. The Guaraní took a leading part, with the Jesuits, in one of the most unusual experiments in social development.

After several attempts to settle the vicinity of the Río de la Plata a fort was built in 1537 and named Nuestra Señora de la Asunción, flourishing under the first governor, Domingo Martínez de Irala. The site was chosen for the favorable natural characteristics of the area, above all for its great fertility, and for the friendliness of the indigenous people. Asunción, which was to become the future capital of Paraguay, was made into the southern capital of the conquest and a center for the Spanish expeditions into the Andes, more specifically into Peru. In 1588 the Jesuits arrived with orders from the king to civilize the Indians. They organized centers called *reducciones* all over the region, including the present-day territory of Argentina; each center consisted of some three thousand Indians under the direction of two or three Jesuits who, as well as converting them to Christianity,

953

954

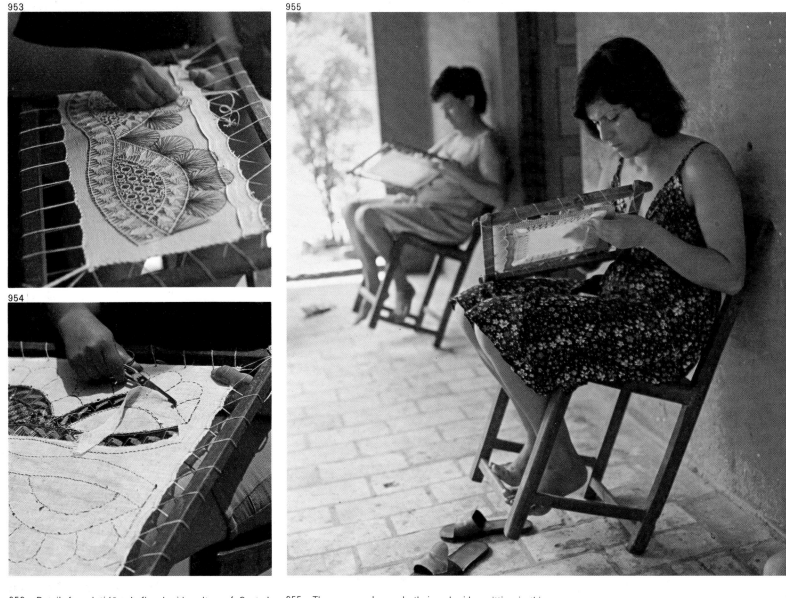

955

953 Detail of nanduti (*ñandutí*) embroidery. Itauguá, Central

954 Trimming the fabric once the embroidery is finished. Itauguá, Central

955 The women always do their embroidery sitting in this curious position—the chair balanced on two legs and leaning against a wall. Itauguá, Central

taught them agriculture, cattle raising, masonry, and other trades. Possessions were held communally and certain experts are of the opinion that the *reducciones* were the first examples of a communist society.

At the same time *encomiendas* were granted to Spanish colonists by royal decree. These were enormous estates exploited by the Spanish and the sons of their unions with the Guaraní, the mestizos, into whose service was pressed the indigenous population. The civil and administrative organization was envious of the success of the Jesuits and denounced their type of society in order to destroy it. In 1767 the Jesuits were accused of creating an empire within an empire and were expelled from the country, the inhabitants of the *reducciones* returning to their old way of life.

Two other important historic events that also helped determine Uruguay's demography were the wars of the Triple Alliance and the Chaco, in 1865–1870 and 1932–1935 respectively. Both brought about an alarming reduction in the male population, which left the country without manual labor and with its economic activity reliant, for the most part, on women.

The majority of the population live in the eastern part of the country, in 40 percent of its total area; the capital, Asunción, contains nearly 20 percent of the country's approximately two and a half million inhabitants. The eastern region is extremely fertile, with luxuriant vegetation and large expanses of orchards and land devoted to vegetable produce. The Chaco, by contrast, is an area of grassland, swampy in the rainy season because

956

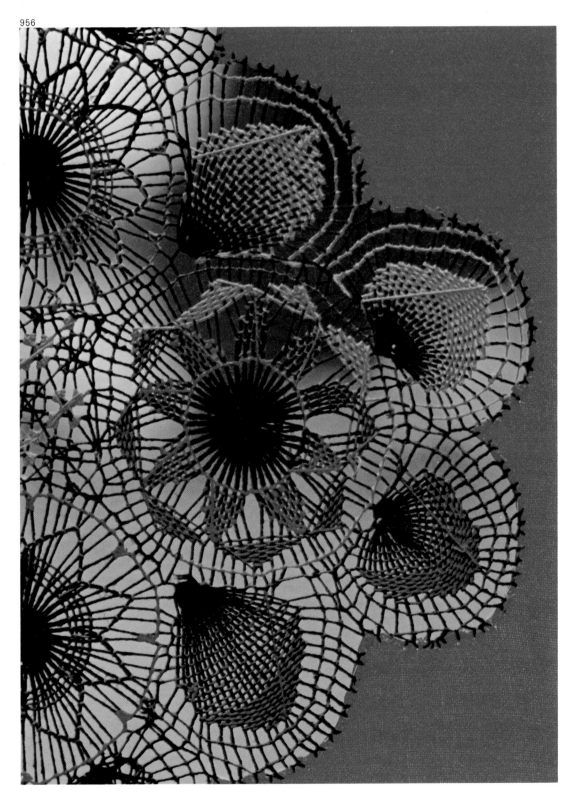

957

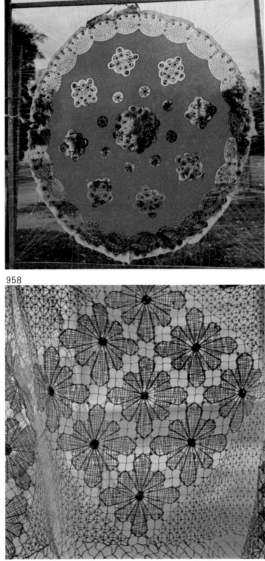

958

956 Detail of completed nanduti. Itauguá, Central

957 When the work is of large dimensions, the finished and trimmed pieces of nanduti are placed on the ground fabric. Itauguá, Central

958 Traditional cotton lace in crossed threads made by the women of Villarrica. Guairá

299

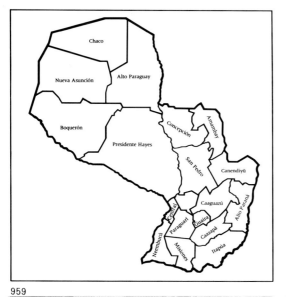

of the impermeability of the topsoil, but suitable for cattle raising, for which the government gives economic incentives. Despite some palm groves and wooded areas, the vegetation disappears almost completely toward the west of the Chaco. The Pilcomayo River, the natural boundary between Argentina and Paraguay, is the only oasis of water in that area. The density of population in the Chaco is approximately three persons per square mile.

The panorama of Paraguayan crafts is dominated by the making of nanduti (*ñandutí*), or lace on fabric. The Spanish introduced the technique of embroidery, but folk imagination has created innumerable stories connected with the invention of nanduti, almost all of them concerning its resemblance to a spider's web. The first stage of making nanduti is designing the motif, which is generally circular, on cotton fabric stretched in an embroidery frame. Then, with infinite patience, the design is embroidered over, following the imaginary spokes of the circle; over this are embroidered two smaller concentric circles. Having finished these basics, the craftswomen give free rein to their imagination in finishing off the work. The designs are varied and more than one hundred different patterns have been counted. Once the embroidery is finished, the piece trimmed, the beauty of the work can be fully appreciated. Nanduti is done with differently colored threads and a plain-colored fabric. It is never embroidered directly onto the ground fabric, but is fixed onto it in the center or around the border.

Aho-poi, the cotton lace made in Villarrica, is also highly regarded. Outstanding in weaving throughout the country are the woolen sashes of the Chaco, and the hammocks of Pirayú.

959

961

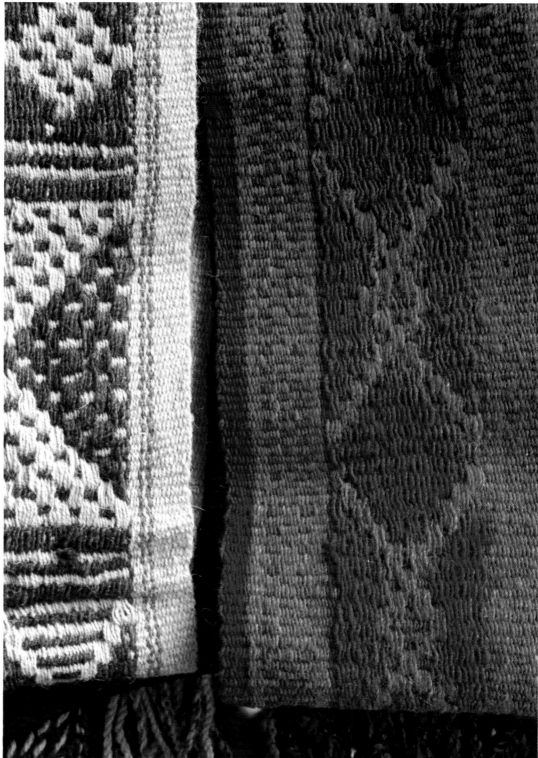

960

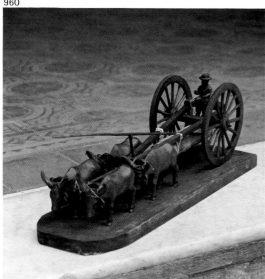

959 Collection of carved wooden figures painted in oils. Tobatí, Cordilleras

960 Carved wooden ox cart, traditional in the rural areas of Paraguay. Tobatí, Cordilleras

961 Wool sashes. Chulupí group. Boquerón

Woodcarving is very widespread, and that of the santeros is best known. Almost all the pieces of their abundant production show scenes from the lives of the saints along one side, and this has been extended to include designs based on the theme of death or of the conquistadors.

The "lucky hens," called *gallinas de suerte* or *pichai* in Guaraní, are outstanding in the field of pottery. They are made in many different sizes and their raised plumage is made of many tiny clay feathers that are attached by hand. In addition to a certain amount of pottery produced for domestic use, there is an abundant manufacture of figures in black clay that represent scenes of daily life.

Despite the tourist connotations, one must not forget to mention the group of Maká who live on a government reservation in the vicinity of Asunción on the right bank of the Paraguay River. The Maká, a group of the Chaco, received this land as a reward for their collaboration in the war of "The Thirty-Three." A large part of their economy is based on the manufacture of glass-bead necklaces and the reproduction of their old weapons. Nevertheless, it seems that the young Maká men are not adjusting to this contemplative life and they are moving back to their old homes.

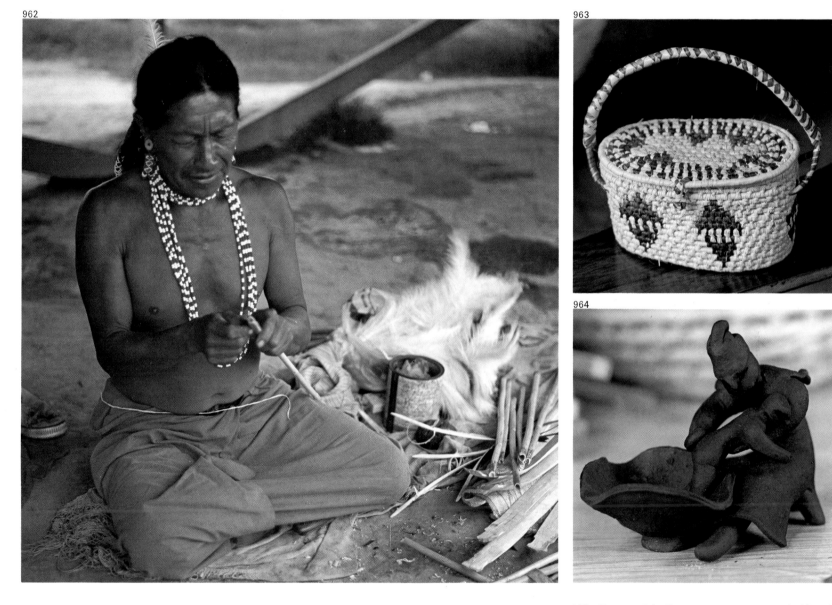

962 The chief of the Maká reservation making arrows to sell to tourists. Asunción, Central

963 The men of the Chamacoco group are expert braiders of pounded roots, with which they make fine baskets

964 Pottery figures darkened by baking. Itá, Central

ARGENTINA

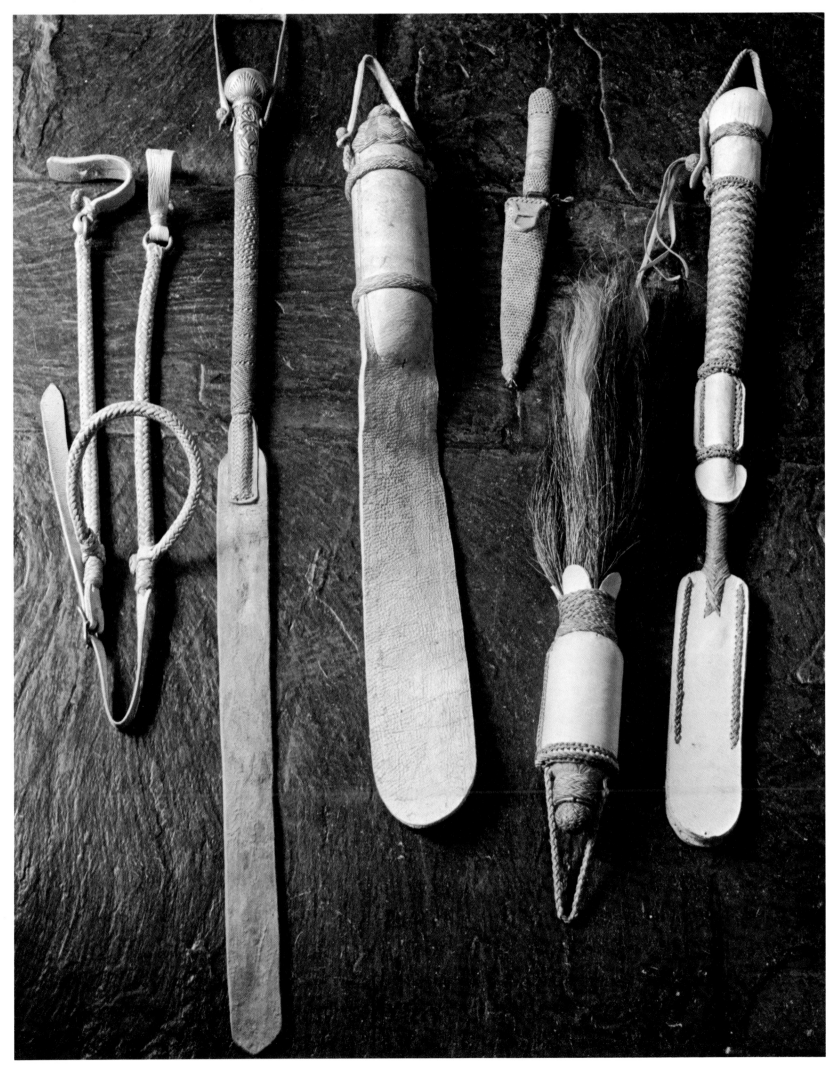

965 Various tools for leather. Note the braiding and fine
leather finish on some handles. Entre Ríos

Introduction

Throughout Latin America there were three distinct responses of the native peoples to the Spanish Conquest. The first is that of the great cultures such as the Aztec, Maya, and Inca. Their complex social organizations changed, certain fundamental beliefs were replaced, and they eventually adapted to the culture of the conquistador, even though this meant the end of their cultures. The second response is that represented by the Arauc (see chapter on Chile), who were impervious to Spanish influence, either cultural or military. The third is that of the less-developed cultures, the seminomadic groups of hunters and fishermen who practiced only rudimentary agriculture. These groups, whose social organization was tribal, were either wiped out or forced to flee into the enormous expanses of the jungle or steppes of the subcontinent. In Argentina, the latter response of the Mapuche and Ona of the south, and the Mataco, Toba, Chaguanco, and Chané of the north, has today resulted in only minimal contact with modern civilization. This dispersal was encouraged, at least in Argentina, by the wide range of territory and varied orographic characteristics. It is the second largest country in area in South America, and its surface area is equal to 29 percent of Europe's.

At the time of the conquest, despite the relative political importance of the Río de la Plata region, supremacy came for Spain only in Argentina, within the South American context, when the Pampas, under the control of the gauchos, were converted into an enormously important cattle-raising area. (The Pampas are vast, treeless, fertile plains over which gauchos —herdsmen or cowboys —roamed.) The Spanish had been much more

966

968

966 While Mataco mothers paint clay objects, their children rest nearby. Campo Durán, Salta

967 Chahuanco woman of the Chané group ("look at my hands, my love/furrowed by each winter," Patricio Man, *Song of America*), tanned by the sun, of undefinable age. The clay pieces are her work. Aguaray, Salta

968 Detail of a hide drying in the sun. The hide is prevented from touching the ground by being stretched over the stakes. Ojo de Agua, Santiago del Estero

interested in settling Peru, and their initial intention of opening a way through to the Inca Empire in the south was quickly abandoned because of the difficulties involved. On one hand, there were troubles with the Indians who, among other things, forced the Spanish to abandon Santa María de Buenos Aires (1541) while it was being built; on the other, the harsh topographical features of the area made exploration into the interior impossible.

The first horses and cattle to appear on the Argentine Pampas were those left by fleeing Spanish colonists. The Indians quickly learned to take advantage of them and turned them into a basic part of their daily life. Thus, the gaucho appeared. With Indian and European blood in his veins, he became a symbol of the vast Pampas: contemptuous of city ways and people, independent, adventurous, a man to whom the words "law and order" suggested oppression and slavery and whose first rule was to live by his own effort. Land that had once been of no value when the Spaniards arrived soon became a major economic asset for its cattle-raising capacities. By the end of the nineteenth century products from the Pampas were being taken to the port in Buenos Aires and from there shipped to Europe. A massive emigration of Spanish and Italians, attracted by the opportunities in Argentina, began; this last wave of hard-working immigrants had a decisive impact and caused the boom in the economic development of the Pampas, The Argentine ranchers considered agriculture—work in the fields— beneath them so that the Italians were able to take advantage of virgin territory, which they put to use by growing corn, wheat, and other cereals. In the north a sugar industry developed, thanks to the railroads. This economic boom produced limitless optimism that soon degenerated into high inflation with consequent successive economic disasters and bankruptcies. Despite this, extensive cultivation of cereals and production of cattle and sheep led to Argentina's recovery, and by the start of the twentieth century it was the leading economic power in Latin America.

Argentina's surface area of 1,072,067 square miles (2,776,641 sq km) can be divided into four distinctly different geographic regions. The first is the Andes, its icy fingers reaching almost to the Atlantic, as well as extending into the Bolivian high plateau; all major cities built by the Spanish, including Salta, Jujuy, Tucamán, and Catamarca, are in the more populated northern area at the foot of the Andes. The second is that part of Argentina called the Chaco, a natural region that also occupies part of Bolivia and Paraguay, leading to the alluvial plain of Argentina, called Mesopotamia, bounded by the rivers Paraná and Uruguay. The third region is the Pampas, an area in excess of 260,000 square miles (673,400 sq km) divided into one dry part, another humid and rainy part, with the latter making the greater contribution to the country's economic development. The fourth and last is Patagonia, where marine winds blow constantly.

970

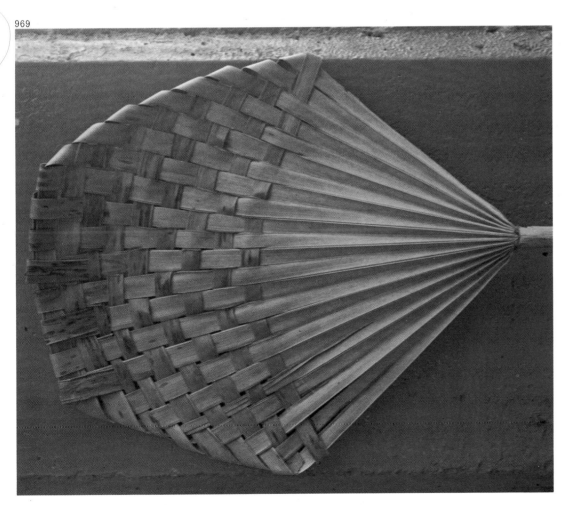

969

969 Las Termas de Río Hondo is one of the most important centers for basketry in north Argentina. This fire fan is made from a single leaf of caraguata

970 Detail of a saddle pad woven from dyed sheep's wool. Ojo de Agua, Santiago del Estero

Masks

The function of masks is similar everywhere: they cover the real face and emulate another in a religious, festive, or satiric ceremony. In the chapters on Mexico and Bolivia this aspect is explained more fully and illustrated with examples of the ornate art produced by those sophisticated cultures in which masks are made. The masks of Argentina, however, combine a forceful artistic effect with great simplicity of line.

The Chané and the Mataco of the north are expert in carving masks from the wood of the *palo borracho* (vegetable silk tree). This work is done by the men while they are resting from their labors in the fields or the forests. The most common images represented are heads of animals, but the imagination and creativity of the craftsmen produce continuous variations on one theme. Even today the head of a conquistador is still represented, decorated with a large frontal piece in the shape of a helmet. The masks are painted with the same mixture of colored clays used on pottery objects.

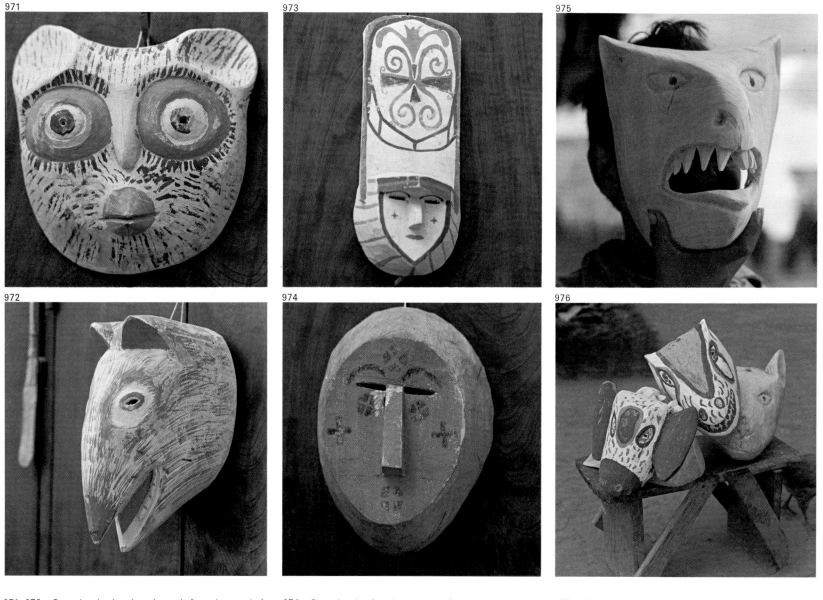

971–973 Carved and painted masks made from the wood of the *palo borracho* (vegetable silk tree). Chiriguano group. Chaco Salteño

974 Carved and painted mask made from the wood of the *palo borracho*. Chahuanco group

975 Chahuanco boy covers his face with an unfinished wooden mask that represents an attacking animal. Aguaray, Salta

976 Group of animal masks. Chahuanco group. Aguaray, Salta

Weaving

The making of textiles is less widespread today than it was in the past, but centers of weaving can still be found in nearly all regions. As in the rest of the subcontinent, textiles are made on traditional vertical looms, horizontal looms, backstrap looms, and on the pedal looms introduced by Europeans. One of the more curious historical facts about textiles is that they were used as money, even as late as the sixteenth century. In Paraguay, Argentina, and Chile, the peasants used cotton cloth to pay their taxes to the state, their tithes to the church, or rent for their land. Several governors of the viceroyalty of the Río de la Plata collected their fees in this kind; perhaps the presence of a cotton grower on the coat-of-arms of Catamarca is owed to this.

The techniques of carding, dyeing, and weaving are similar to those of other countries (see Peru, for example). Nevertheless, there are some differences: Argentine weavers revolve the spindle very skillfully while keeping their arm aloft and do not spin with a distaff; a combination of the horizontal and European pedal looms is used on which the warp is stretched, rather than rolled; as the piece is being woven, the warp, which is fastened, showing the full length, to strong, secure stakes, is loosened.

The Mataco and Chané textiles deserve special mention. These are made from caraguata fiber with a bone needle, and their designs represent the skin of the viper.

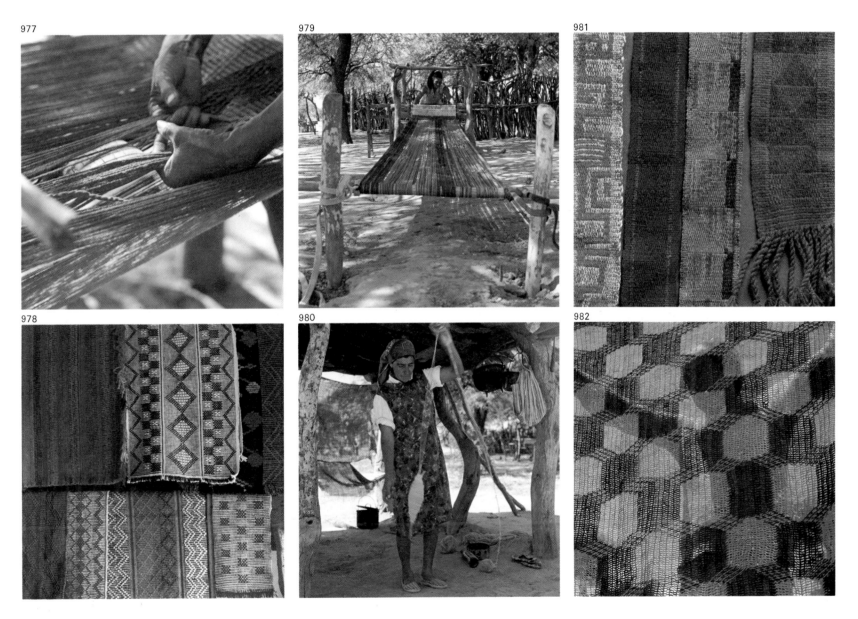

977 The craftswoman works with great patience, separating the warp threads in combinations to create various patterns in the weave. Brea Pozo, Santiago del Estero

978 In Brea Pozo, several cooperatives gather together to sell craftwork. Santiago del Estero

979 Combination of two types of looms: a rudimentary treadle and horizontal loom, with the warp fastened to stakes. Brea Pozo, Santiago del Estero

980 Spinning the wool. Brea Pozo, Santiago del Estere

981 Double-faced or reversible sashes woven of wool dyed with vegetable products. Toba group. Formosa

982 Fabric of caraguata fiber woven with a needle. Mataco group

Leathercraft

The introduction of cattle and horses into Argentina by the conquistadors led to the art of working in leather. Although from ancient times the Indians had used animal skins to protect themselves against the cold, and animal scrota to make bags and other containers, it was the Spanish who taught them to prepare hides for making saddles, reins, and other pieces of harness, even awnings and covers for wagons. Uncured leather is used for bindings; the elasticity of leather when it is damp and its rigidity when it dries again mean that wooden joints can be tightly fastened with it.

Leather is prepared in several ways: uncured, *sobado*, and *redomón*, the difference between the latter two being their relevant amounts of elasticity, depending on the length of time each has been treated. *Redomón* is treated for the longer period and is used to make twisted lariats and thin strips of leather for braiding. *Sobado* leather is used for halters, reins, girths, the hunting slings called *bolas*, etc. One of the more unusual objects made from uncured colt's skin was a pair of boots that was dried and made rigid using the owner's foot as a last.

Every stage of leatherwork is important to the craftsmen, who start by selecting the live animal. The thickness of the hide is different in each type of animal; in some breeds it is more uniform, but in others it is fatter and can be kneaded more easily. The younger the animal is, the finer the leather, and the more visible its veins the better.

Tanning is the process of converting hide to leather. There are tanners who demand that the animal be

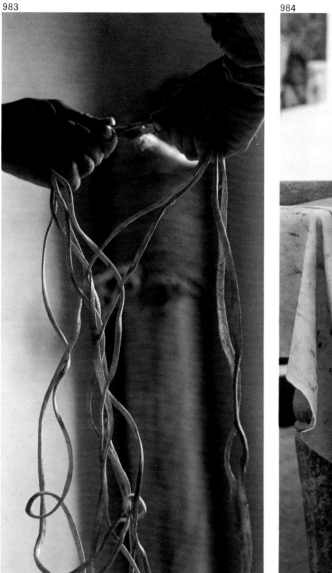

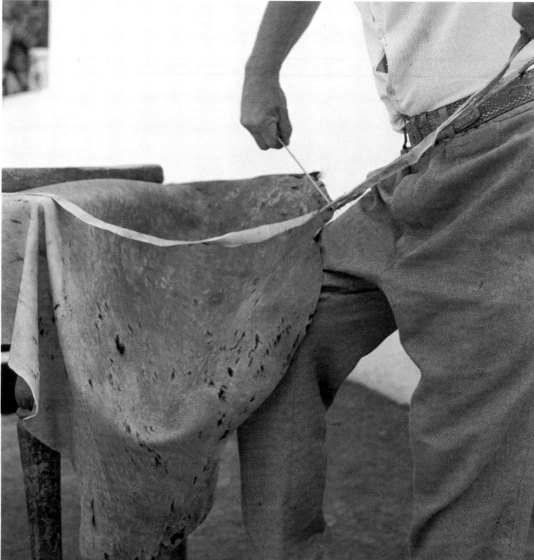

983 Braiding a rope of eight strips. To stretch it, the craftsman fastens one end of the rope to a post and wraps the other end around his body to hold taut the braiding. Ojo de Agua, Santiago del Estero

984 The strip is cut following the outline of the skin, in an irregular spiral. Ojo de Agua, Santiago del Estero

killed standing up so that the skin is unblemished. The methods vary: there are tanners who sprinkle the skin with ashes or a type of sand to get rid of the hair; others scrape it immediately; and some wait until the hide is staked out—that is to say, fixed on stakes and dried in the sun. Recently lime has been used as a way to get the hair off the skin.

The technique of kneading the leather, called *sobado,* is done in several ways. The preferred method is kneading by hand, using the fist to beat the leather. Another method is to put the hide through a ring once it has been cut into strips, and pull hard on both ends. Yet another consists of rolling the skin with the hair toward the inside and beating it with a hammer or mallet.

The leather is cut into straps or strips according to width. The strips are used as they are, but the straps are kneaded to give them a wrinkled texture. Both of these are used to make innumerable items; note, for example, the great variety in the types of braiding, such as flat, round, square, with several surfaces, etc. The greater the number of strips used, the more complicated and highly valued the work will be.

The craft of leatherwork has developed above all in the Pampas and there are still magnificent works by local craftsmen to be found; there is no doubt that this occupation is declining and has lost its variety, but the gauchos still continue to love these fine pieces of leatherwork and show them off.

985

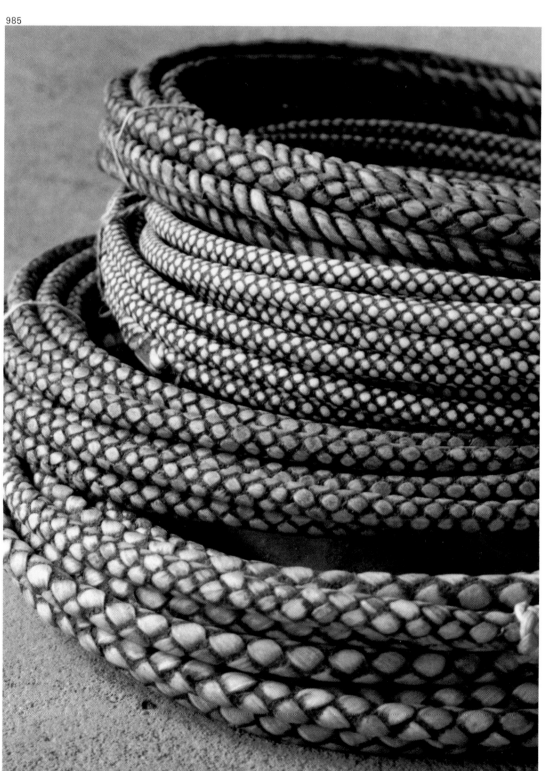

986

987

985 Ropes of different numbers of strips; the second from the top is not braided but twisted. Santiago del Estero

986 Strips before they are braided. The craftsman protects his back from friction of the braiding as he holds it taut. Ojo de Agua, Santiago del Estero

987 Braided rope coiled around a post. Ojo de Agua, Santiago del Estero

Pottery

The best pottery objects are found in the tribal communities of the Toba, Chané, and Mataco, all of whom are skilled in making a range of clay objects, from small zoomorphic figures to large earthenware jars for use in the home. Jugs, plates, pots, etc., are decorated with floral designs and are sold to tourists from outside the potters' homes.

Here, pottery making is almost always a job done by women; it is safe to say that hardly a single man is to be seen in the Indian villages by day as they are all in the forests or the fields. The women select and prepare the clay, as well as the mixtures with which they will later decorate their products. They do not use a potter's wheel. Their tools are mollusc shells, round stones, and bark scraps for smoothing and tapering the walls of their pieces.

One of the more beautiful objects is a large jug that is split or grooved laterally along its most convex part; this serves to stop the cord between the two handles from slipping and so makes the piece easier to carry; it is a traditional piece of Mataco pottery. Among pottery of rural origin, that of Minas Clavero should be mentioned. Here stylized zoomorphic figures are made using a method of baking similar to that used in Quinchamalí in Chile that results in a very dark color.

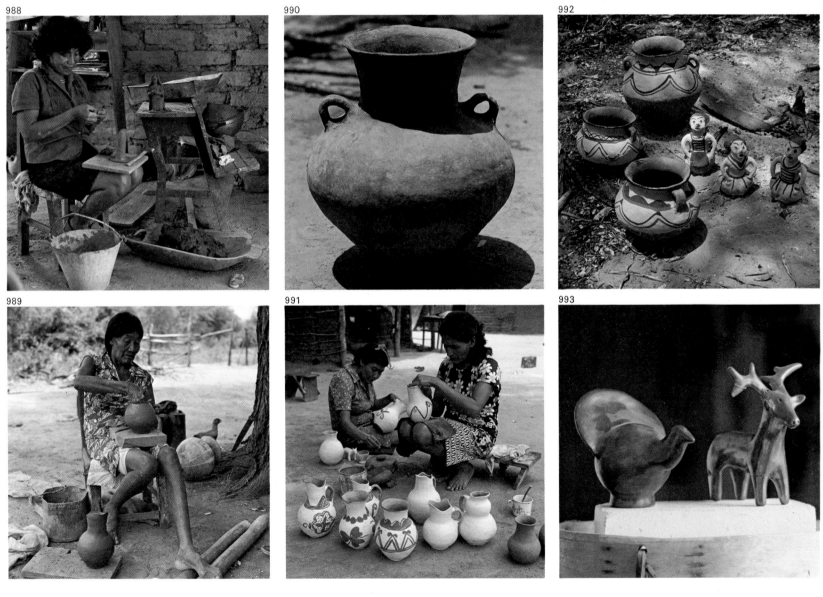

988 Chané woman modeling her figures starting with a cylindrical roll. Note the carved wooden bowl that holds the clay. Aguaray, Salta

989 Mataco woman smoothing the body of a jug with a scrap of bark. Campo Durán, Salta

990 Magnificent Chané pot made by the method of working rolls of clay in spirals. The baking is done by the heat of the sun's rays, without a kiln. Aguaray, Salta

991 Once the clay is dry, a layer of white clay is applied on which decorative motifs are painted; later the piece is baked. Campo Durán, Salta

992 Examples of Chané pottery. Aguaray, Salta

993 Clay pieces blackened by baking with ox dung. Minas Claveros, Córdoba

994 Painted clay jugs. Chané group

995 Zoomorphic figures, painted clay. Chané group

996 Pitcher in the shape of a rooster, and a frog. Chané group

997 Jar for storing water; both convex parts were made separately and joined together at the ends. Mataco group. Gran Chaco

998 Jar for carrying water; it is over 30 inches (70 cm) high. Mataco group. Gran Chaco

999 Tobacco pouch made from an armadillo's tail. Mataco group. Gran Chaco

1000 Mortar carved from lignum vitae or carob wood; it is common in the north

1001 Musical instruments. The bass drum is traditional in Santiago del Estero; the drum or tabor in the north; and the violin and *charango* (a kind of guitar) in Puna and Jujuy.

1002 Natural-colored blanket. Catamarca, Belén

1003 Sashes of natural, undyed wool. Mataco group. Gran Chaco

1004 Bag woven from vegetable fiber. Mataco group. Gran Chaco

1005 Bag woven from caraguata fiber. Mataco group. Gran Chaco.

1006 Although their designs are rooted in tradition, the Matacos make these belts to answer the tourist demand. Gran Chaco

1007 Blanket woven in natural wool dyed with cochineal obtained from the insect of the same name, which is a cactus parasite. Santiago del Estero

1008 Sashes of natural wool. Mataco group

1009 This blanket of natural wool is called *pelero* and is used to protect a horse's back. Santiago del Estero

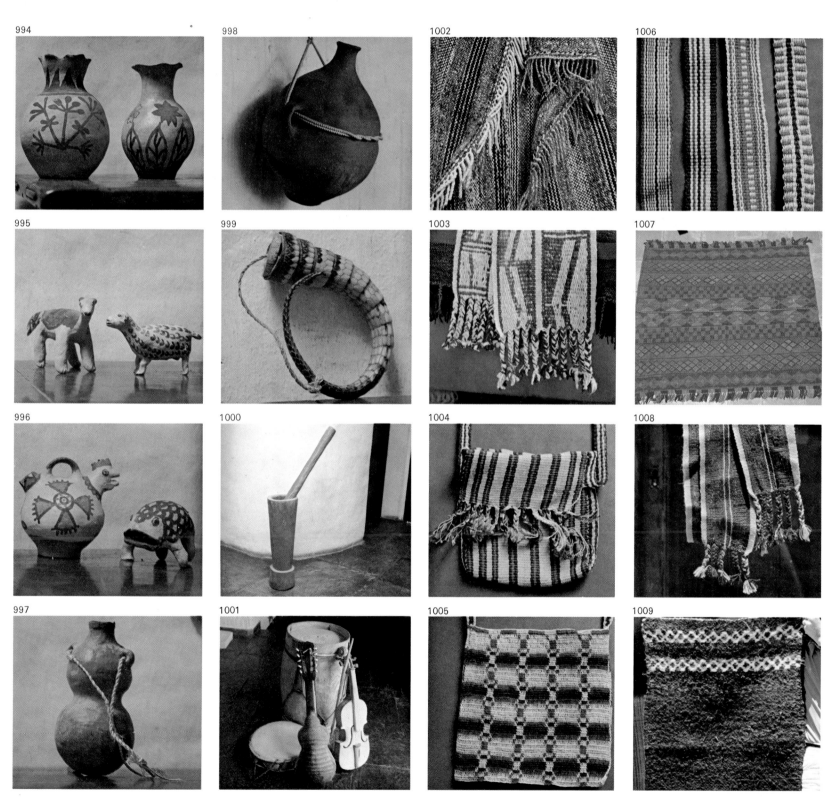

994

995

996

997

998

999

1000

1001

1002

1003

1004

1005

1006

1007

1008

1009

URUGUAY

1010 Detail of a sheet of agate, in its natural color. Note its
transparency. Montevideo

The number of indigenous people in Uruguay is quite small; only the fierce Charrúa, who killed Juan Díaz de Solís, the first explorer to enter the territory of Uruguay, will be mentioned. His murder somewhat slowed down the exploration of the country, which at that time was only part of what would later become the viceroyalty of the Río de la Plata. In 1680 Colonia, the first Uruguayan city, was founded on the eastern shore of the Uruguay River's estuary, that site being chosen to compete with Buenos Aires, which was located on the opposite bank. In 1724 Montevideo was founded.

Bounded by the two colossi of the subcontinent, Argentina and Brazil, Uruguay was territory coveted by them both. From the first years of the nineteenth century to 1825, the year it proclaimed independence, Uruguay's history was a continuous struggle between Brazil and Argentina for the so-called Left Bank of the Río de la Plata.

The social changes that most affected Uruguay were the reforms introduced during the two presidential terms of José Batlle y Ordóñez (1903–07 and 1911–15). These included nationalization of the electric companies, water distribution companies, the railway lines, and other communication systems, and partial governmental control of the production and distribution of the most important products. Accompanying all this were social reforms of a democratic nature. Batlle's greatest dream was to do away with the presidency and create a council of nine people who would direct the political life of the country, to be put into effect after his death. Nev-

1011

1013

1010 Detail of a sheet of agate, in its natural color. Note its transparency. Montevideo

1011 Detail of a magnificent sculpture in bronze, by José Belloni, representing a scene from the civil war. Montevideo

1012 Rough agates; their size and cut determine the future uses of the stones. Montevideo.

1013 Once dyed, cut, and polished, the agates are used to make necklaces, bracelets, and other jewelry. Montevideo

ertheless, for varying reasons but basically because of the difficulty nine people had in agreeing on political decisions, it did not take long to return to the old presidential structure. It is important to understand, however, that from the 1920s to the 1960s Uruguay was considered the most socially and politically advanced country in South America.

Uruguay has a very agreeable climate, without extremes of temperature; its orography is characterized by rolling hills, called *cuchillas*, none of which is higher than 2,000 feet (700 m). Between these rolling hills run numerous small streams that are good for the grasslands, considered to be some of the finest in the American continent. For this reason Uruguay is obviously ideal for cattle raising. Its cattle, which have been crossed with European breeds, are highly valued and constitute one of the basic factors of the country's economy. Suffice to say that grasslands make up 76 percent of the total surface area of the country and only 10 percent of them are under cultivation.

The craft tradition is based on the use and development of products that are plentiful in the country: work in agate and amethyst is done in Montevideo; items are made from shark's vertebrae in Punta del Diablo; and horn and bone carving are widespread throughout Uruguay.

Two facts should be mentioned which, in one way or another, have an effect on Uruguayan craftswork. First, the official organization that, in its way, promotes Uruguayan crafts is more concerned with their com-

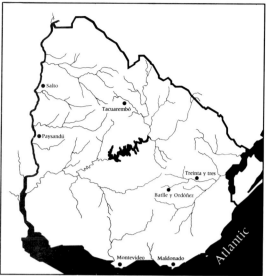

1014

1015

1016

1014 Pile of cattle horns; from these will come items from sculptures to bracelets or rings, according to the way they are cut. Montevideo

1015 Figure of a bird carved in cattle horn. Montevideo

1016 Necklace made of carved cattle horn

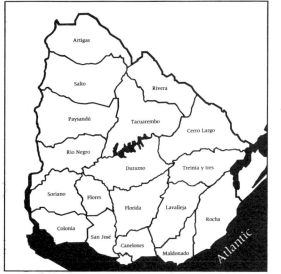

mercial and tourist potential than the need to promote art and protect manual labor. Second, and at the other extreme ideologically, the Annual Book and Craft Fair not only promotes the country's new writers, it also sets up a jury to award certificates of quality to pure craft products; at this fair, craftsworkers in the traditional meaning of the word are accepted as readily as those who have left other professions to work in the crafts field.

Agates and amethysts are relatively abundant in the subsoil of Uruguay and some craft activity is derived from them. Machinery is now being used in the technical process to make these semiprecious stones into all kinds of items, from small beads for necklaces and bracelets to large, heavy ashtrays. According to the judgment of the craftsworker, stones can be left their natural color or they can be dyed.

Cattle-horn carving is one of the crafts that arose out of its environment and was encouraged by cattle raising. In this craft, also, hand work is starting to be accompanied by some mechanical apparatus, such as polishers and saws. The manual skill of the carver is still, however, the most important aspect in making these sculptures. Small beads of all kinds, on the other hand, are made with a machine.

One must also mention the experiment carried out by a group of artists in Batlle y Ordóñez, a city in the interior. Here an old weaving center still existed that had fallen into disuse through lack of a commercial outlet. A new workshop was set up following the traditional ways of weaving and producing natural woolen ponchos in the old style, which had once made the area famous. The economic success of the center, precarious from

1017

1018

1019

1020

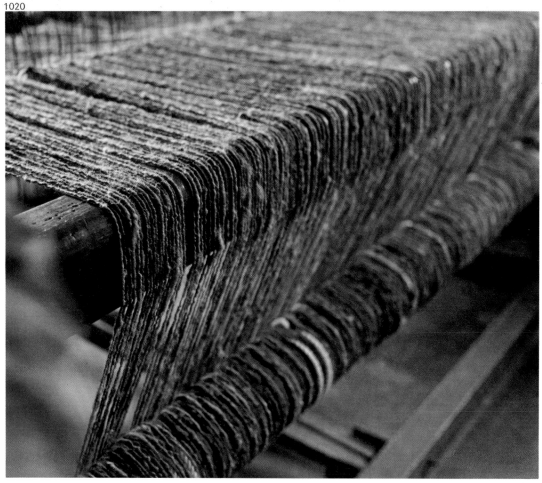

1017 In the weaving center of Batlle y Ordóñez a craftswoman learns to spin wool using an old sewing machine adapted to its present-day use. Florida

1018 The wool must be washed at least once to get rid of impurities. Batlle y Ordóñez, Florida

1019 Poncho in natural wool dyed with vegetable products. Tacuarembó

1020 Detail of a warp of natural wool on a pedal loom. Batlle y Ordóñez, Florida

the start, is helped by the making of other more marketable woven items. Young craftsworkers are instructed in the technique of weaving. The organization is cooperative and therefore the efforts and rewards are distributed equally.

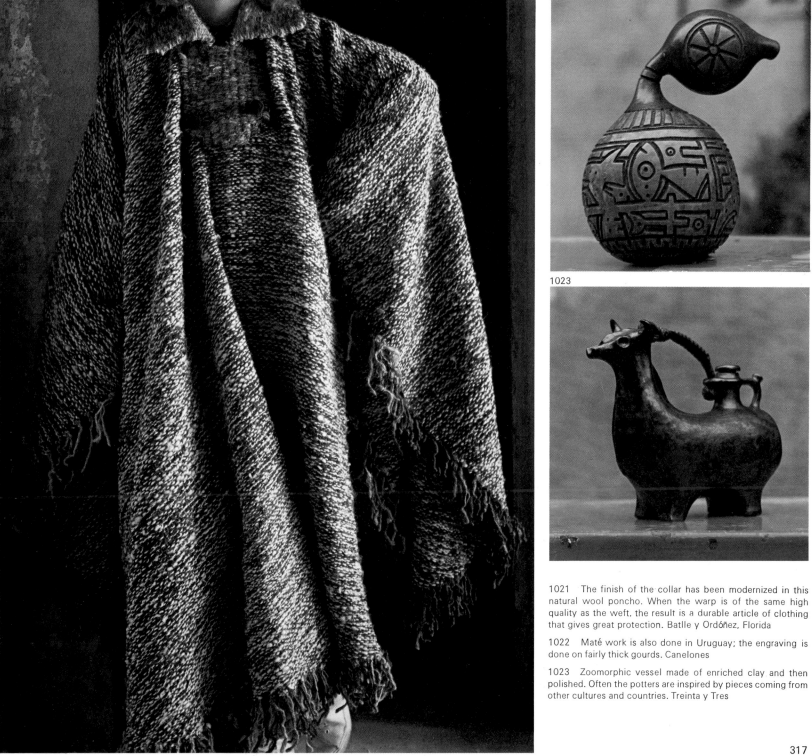

1021 The finish of the collar has been modernized in this natural wool poncho. When the warp is of the same high quality as the weft, the result is a durable article of clothing that gives great protection. Batlle y Ordóñez, Florida

1022 Maté work is also done in Uruguay; the engraving is done on fairly thick gourds. Canelones

1023 Zoomorphic vessel made of enriched clay and then polished. Often the potters are inspired by pieces coming from other cultures and countries. Treinta y Tres

amautik: jacket worn by Canadian Indian women, who often carry their babies in the hood

altiplano: high plateau or tableland

ayllu: most important organizational unit for the Quechua and Aymará Indians

backstrap loom: simple horizontal loom on which warp tension is maintained between a stationary object, such as a tree, and the body or waist of the weaver

bobbin lace: form of lace worked with several individual threads each wrapped around a spool or bobbin

bread babies or *guaguas de pan* (Quechua): small, decorated figures of people or animals made of bread dough

bulto: fully rounded image of a saint; of carved and painted wood

canasto: flat basket without handles

carding: process of separating and partially aligning loose fibers in preparation for spinning

chicha: characteristic Indian drink made in Central and South America of fermented corn

chullo: traditional knitted cap with earflaps worn by men of the altiplano

chunchu (Quechua) or chuncho: uncivilized jungle or forest dweller

chumpi: woven sash or belt worn by Indians

chuspa: pouch often woven of vegetable fiber and used to carry coca

comales: pottery plates or griddles for cooking tortillas

engobe: colored, prepared slip (clay in liquid suspension) that is between a glaze and a clay

Fraktur: ornate handwriting that developed in the sixteenth century featuring decorative motifs such as tulips, scrolls, and birds; was used by Pennsylvania Germans

frame loom: any simple square, circular, or rectangular loom, usually without harnesses or a beater

horizontal ground loom: loom with fixed support at both ends of the warp. One type uses four stakes driven into a flat area of ground

huipil: one-piece blouse or skirt, usually hand-embroidered and woven, worn by women of Central America

ikat: process of resist-dyeing portions of a warp or weft before weaving to create a pattern

imaginaría: the art of sculpting or molding sacred or religious figures

jaspeado. See ikat

jícaras: gourds and gourdlike fruits that are often decorated and used as bowls or cups for cocoa drinks

limner: self-taught itinerant painter who produced decorative flat portraits or scenes

lliclla: traditional shawl or mantle worn by women of the Andes

majolica: earthenware covered with a soft tin-lead glaze. The ware originally came from Spain and got its name from the island of Majorca

maté: fruit of the gourd plant (*Lageneria vulgaris*). It is often hollowed, engraved, and then used for domestic purposes or decoration

metate: concave stone used for grinding corn

mola: reverse appliqué, done by Cuna Indian women in Panama, in which brightly colored fabrics are laid one on top of the other and are then cut and sewn to form designs, figures, and symbols

nanduti: intricately patterned lace made from cotton or other fine vegetable fibers

petate: all-purpose mat woven from plants

plumaria: the art of decorating or embroidering with feathers

pulque: fermented drink made in Mexico from the juice of the aguave or maguey plant

quesquemetl: shoulder garment of Guatemala and Mexico, usually handwoven and embroidered, that is made of two rectangles to form a square

retablo or retable: votive offering, painted and/or carved on a wooden panel, made in the form of a religious picture typically portraying saints

santo: literally "saint." Painted or carved wooden image usually found in New Mexico; its creator is called a santero

sgraffito: decoration achieved by scratching through a colored slip to show the contrasting body color beneath

shigra: cylindrical bag woven of plant fiber with a needle

slip. *See* engobe

Talavera ware: style of decorated pottery which was brought to Mexico from Spain and which retains Spanish and Asian influences

tostadora: shallow pottery bowl used to toast barley or corn

warp: set of yarns that are parallel to one another and to the selvedge or longer dimension of a woven fabric

weft: set of yarns or other material perpendicular to the selvedge or longer dimension of a woven fabric

Bibliography

American University Foreign Area Studies. Area Handbook Series. Washington, D.C.: U.S. Government Printing Office. Argentina, 1974; Boliva, 1974; Brazil, 1975; Chile, 1969; Colombia, 1977; Costa Rica, 1970; Dominican Republic, 1973; Ecuador, 1973; El Salvador, 1971; Honduras, 1971; Mexico, 1975; Panama, 1972; Paraguay, 1972; Peru, 1972; Uruguay, 1971; Venezuela, 1977.

Ames, K. L. *Beyond Necessity: Art in the Folk Tradition.* New York: W. W. Norton, 1978.

Anderson, M. *Guatemalan Textiles Today.* New York: Watson-Guptill, 1978.

Auld, R. L. *Molas.* New York: Van Nostrand Reinhold, 1977.

Barney Cabrera, E. *Historia del Arte Colombiana.* Bogotá: Salvat Editores, 1975.

Barret, S. A. *The Capaya Indians of Ecuador.* New York: Museum of the American Indian, Heye Foundation, 1925.

Bennett, W. C., and Bird, J. B. *Andean Culture History.* New York: American Museum of Natural History; Handbook Series No. 15, 1949.

—. *Ancient Art of the Andes.* 2nd ed. New York: Museum of Modern Art, 1966.

Birnbaum, Steven, ed. *Get 'Em and Go Travel Guide: South America.* New York: Diversion Books, 1981.

Bishop, R. *Folk Painters of America.* New York: E. P. Dutton, 1979.

Bjerregaard, L. *Techniques of Guatemalan Weaving.* New York: Van Nostrand Reinhold, 1977.

Briggs, Ch. "To Talk in Different Tongues. The Discovery and Encouragement of Hispano Woodcarvers by Santa Fe Patrons, 1919–1945." *Hispanic Crafts of the Southwest: An Exhibition.* William Wroth, ed. Colorado Springs: Colorado Springs Fine Arts Center, 1977.

Brooks, J., ed. *The South American Handbook.* Bath, Engand: Trade and Travel Publications, Ltd., 1978.

Carvalho-Neto, P. *Diccionario del folklore-ecuatoriano.* Quito: Casa de la Cultura Ecuatoriana, 1964.

Cason, M., and Cahlander, A. *The Art of Bolivian Highland Weaving.* New York: Watson-Guptill, 1976.

Creekmore, B.B. *Traditional American Crafts: A Practical Guide to 300 Years of Methods and Materials.* Great Neck, New York: Hearthside Press, 1968.

Dickey, R. *New Mexico Village Arts.* Albuquerque: University of New Mexico Press, 1970.

Dockstader, F. J. *Indian Art of South America.* Boston: New York Graphic Society, 1967.

Drucker, P. *Cultures of the North Pacific Coast.* San Francisco: Chandler Publishing, 1965.

Duff, W. *The Indian History of British Columbia.* Vol.1. Victoria: Victoria Provincial Museum of British Columbia, 1965.

Espejel, Carlos. *Mexican Folk Crafts.* New York: Universe Books, 1978.

Espejel, C., and Català Roca, F. *Mexican Folk Pottery.* New York: Universe Books, 1976.

Espinosa, C. G. *Tin Craft in New Mexico.* Copmiled by the departments of Education and Industty of New Mexico, 1937.

Fortun, J. E. *La danza de los diablos.* La Paz: Ministerio de Educación y Bellas Artes, Oficialía Mayor de Cultura Nacional, 1961.

Fowke, E. *Folklore of Canada.* Toronto: McClelland and Stewart, Ltd., 1976.

Frank, L., and Harlow, F. *Historic Pottery of the Pueblo Indians.* Boston: New York Graphic Society, 1975.

Gisbert y Cia. *Catálogo de las voces usuales de aymara.* La Paz: Gisbert y Cia, 1977.

Grabun, Nelson H. H., ed. *Ethnic and Tourist Arts: Cultural Expressions from the Fourth World.* Berkeley: University of California Press, 1976.

Gregor, T. Mehinaku. *The Drama of Daily Life in a Brazilian Indian Village.* Chicago: University of Chicago Press, 1977.

Holanda, S. de. *Raízes do Brasil.* Río de Janeiro: Livraria José Olympio Editora, 1969.

Holstein, J. *The Pieced Quilt: A North American Design Tradition.* Toronto: McClellan and Stewart, Ltd., 1973.

Horowitz, E. L. *Mountain People, Mountain Crafts.* Philadelphia: Lippincott, 1974.

Instituto Azuayo de Folklore. *Recopilación de investigaciones sobre artesanía.* Cuenca, Ecuador: Casa de la Cultura Ecuatoriana, Núcleo del Azuay, 1975.

Jaramillo, J. "Rio Grande Weaving: A Continuing Tradition." *Hispanic Crafts of the Southwest: An Exhibition,* William Wroth, ed. Colorado Springs: Colorado Springs Fine Arts Center, 1977.

Jongh Osborne, L. *Indian Crafts of Guatemala and El Salvador.* Norman: University of Oklahoma Press, 1965.

Kelly, P., and Orr, C. *Sarayacu Quechua Pottery.* Dallas: Museum of Anthropology, 1976.

Kelsey, V., and Osborne, L. J. *Four Keys to Guatemala.* Rev. ed. New York: Funk and Wagnalls, 1961.

Kent, K. P. "Pueblo and Navajo Weaving Traditions and the Western World." *Ethnic and Tourist Arts: Cultural Expressions from the Fourth World.* Nelson H. H. Graburn, ed. Berkeley: University of California Press, 1976.

Kent, K. P. *The Story of Navajo Weaving.* Phoenix, Arizona: Heard Museum of Anthropology and Primitive Art, 1961.

Lago, T. *Arte popular chileno.* Santiago: Editorial Universitaria, 1971.

Lima, E. de. "Os indios waurá. Observaçòes gerais. A Cerâmica." Rio de Janeiro: Boletín del Museo Nacional, *Antropología no. 9,* 1950.

Lipman, Jean, and Winchester, Alice. *The Flowering of American Folk Art, 1776–1876.* New York: Viking Press, 1974.

Litto, G. *South American Folk Pottery.* New York: Watson-Guptill, 1976.

McGee, H. F. *The Native Peoples of Atlantic Canada.* Toronto: The Carelton Library No. 72, McClelland and Stewart, Ltd., 1974.

McNaught, K. *The Pelican History of Canada.* New York: Penguin Books, 1976.

Mason, O. T. *Aboriginal American Basketry.* U.S. National Museum Annual Report for 1902. Glorieta, New Mexico: Rio Grande Press, 1970.

Miles, C., and Boris, P. *American Indian and Eskimo Basketry.* New York: Bonanza, 1969.

Parker, A., and Neal, A. *Molas: Folk Art of the Cuna Indians.* Barre, Massachusetts: Barre Publishers, 1977.

Reichel-Dolmatoff, G. *Amazonian Cosmos: The Sexual and Religious Symbolism of the Tukano Indians.* Chicago: University of Chicago Press, 1971.

Reina, R., and Robert, M. *The Traditional Pottery of Guatemala.* Austin: University of Texas Press, 1978.

Roth, L. H. *Studies in Primitive Looms.* Halifax: Scott Brothers, Ltd., 1950.

Rowe, A. P. *Warp-Patterned Weaves of the Andes.* Washington, D.C.: The Textile Museum, 1977.

Rubín de la Borbolla, D., y Rivas, P. *Honduras: Monumentos históricos y arqueológicos.* Mexico, D.F.: Instituto Panamericano de Geografía y Historia, 1953.

Salomon, F. "Weavers of Otavalo." *Peoples and Cultures of Native South America,* Daniel Gross, ed. Garden City, New York: Doubleday, 1973.

Salvat, J., and Crespo, E. *Historia del arte-ecuatoriano.* Barcelona: Salvat Editores, 1977.

Simard, C. *Artisanat Québécois: Indiens et Esquimaux.* Montreal: Les Editions de L'Homme Lteé, 1977.

Spahni, J. C. *Los mates decorados del Perú.* Lima: Peruano Suiza S.A., 1969.

Steward, Julian H., ed. *Handbook of South American Indians.* 7 vols. Reprint. New York: Cooper Square, 1957.

Stoller, M. L. "Traditional Hispanic Arts and Crafts in the San Luis Valley of Colorado." *Hispanic Crafts of the Southwest: An Exhibition.* William Wroth, ed. Colorado Springs: Colorado Springs Fine Arts Center, 1977.

Stonequist, E. *The Marginal Man.* New York: Charles Scribner's Sons, 1937.

Turner, L. W. "Beadwork from the Northeast to the Western Plains." Unpublished manuscript. Vancouver: University of British Columbia.

Turner, V. *The Forest of Symbols. Aspects of Ndembu Ritual.* Ithaca, New York: Cornell University Press, 1967.

Ubbelohde-Doering, H. *The Art of Ancient Peru.* New York: Frederick Praeger, 1952.

Underhill, R. M. *Red Man's America.* Chicago: University of Chicago Press, 1953.

Wilder, M. A., and Brietenbach, E. *Santos: The Religious Art of New Mexico.* New York: Hacker Art Books, 1976.

Zeballos Miranda, L. *Artesanía boliviana.* La Paz: Instituto Boliviano de Cultura, 1975.

322

Gualjoco (Honduras), 133
Gualupita (Mexico), 69
Guanajuato (Mexico), 79
Guaraní Indians, 298, 299, 301
Guatajiagua (El Salvador), 139
Guatemala City, 116
Guayakí Indians, 201
Guayami Indians, 162
Guiana, Venezuelan, 189–90
guitars, 118–19

H

Haida Indians, 20
hammocks: cabuya-fiber, 147, 149;
 cotton, 142, *fig. 432;* 193–94,
 fig. 566; 210, *figs. 611–13;* 300
handiwork, *see* needlework
hats (and hatmaking): Bolivia, 273–
 75, figs. *862–68;* Colombia, 175–
 77, *fig. 483,* figs. *499, 502, 503;*
 Ecuador, 218, *fig. 657;* El Salvador,
 143; Guatemala, 115; Honduras,
 133–35, *figs. 409, 410,* figs. *412–
 14;* Nicaragua, 147, 149
hijiaduras (added palm strips in hat-
 making), 134, *fig. 412*
Hispanic-American culture, 44–45
Hispaniola, 94–95
Holy Week, 249
hooking rugs, 42, 53
horn carvings, 79, *figs. 209, 210;* 315,
 316, *figs. 1014–16*
horsehair, 293, *figs. 938–40*
horses, 305, 308
Hoyade San Juan (Colombia), 169
huaco-retratos (painted pottery from
 burial mounds), 266
huanca (scorching of maté), 247–48
Huanta (Peru), 248
Huaraz (Peru), 249
Huatusco (Mexico), 86
Huautla de Jiménez (Mexico), 69
Huehuetenango (Guatemala), 109
Huejutla de Reyes (Mexico), 77
hueso (bone used as spindle), 120
huipil, 120–21, *fig. 323,* figs. *358–60,*
 figs. *362, 363, fig. 367, fig. 370*
hunting, *see* decoys

I

idols, carved, 164, *fig. 475*
Ikaluit Cooperative, 29
ikat weaving, 222; see also *jaspeado*
illuminated calligraphy, 60
imaginería (sculpting and molding of
 religious figures), 250–52, *figs.
 757–62; see also* retablos
Inca, 181, 216, 234–35, 262–63,
 288, 304, 305
indigo, 124, 138, 142, 148
inkuña (shawl), 243–44
Inuit, 20, 21, 26, 27–28, 29, 32
iraca palm, 175
ironwork, 16, 48, 157, *fig. 458; see
 also* wrought iron
Isla Mujeres (Mexico), 79
Italian immigrants, 305
ivory rings and jewelry, 29, *figs. 46, 47*
ixcaco (undyed brown cotton), 120
Ixcatlán (Mexico), 69
Ixmiquilpan (Mexico), 86
Ixtaltepec (Mexico), 76
Ixtapán de la Sal (Mexico), 77
Iza (Colombia), 169
Izalco (El Salvador), 141

J

Jalisco (Mexico), 75, 77, 86
jaspeado (dyeing process), 121–22
Jatunpamba (Ecuador), 225–26
Javahé Indians, 206
Jesuits, 298–99
jewelry: ivory and soapstone, 29, *figs.
 45, 46, 47;* silver, 289–90, 295,
 figs. 948, 951; stone, 78–79, 316;

see also necklaces
jícaras (gourd cups or bowls), 148–
 49, *figs. 443–45*
Jinotega (Nicaragua), 147, 150
"Jipi" hat, *see* palmetto straw hat
Jipijapa (Ecuador), 175, 218
Jocotán (Guatemala), 116
Jocotenango (Guatemala), 114
José de Colorico (Venezuela), 191
Joyabaj (Guatemala), 114
Juárez City (Mexico), 73
Juayua (El Salvador), 141
"Judas" figures, 84
junco (rush), 115

K

Kaa Indians, 208
Kadiwéu Indians, 207
Kalasasaya, temple of (Bolivia), 263,
 fig. 838
kaperrai (shawl), 122
Kekchi Indians, 113, 120
kiln, 170, 171–72, *fig. 495;* 225,
 238–39, *fig. 725*
kintuchape (silver necklace), 295
knitting, 27, 31; of caraguata fiber, 271

L

La Arada (Honduras), 133
La Campa (Honduras), 132
La Ceibita (Honduras), 133
La Jagua (Colombia), 169
La Manga (Chile), 294
La Paz (Bolivia), 264, 274, 282
La Paz (Mexico), 79
La Paz Central (Nicaragua), 148, 150
La Victoria (Ecuador), 223
lace, *see* cotton lace; lace edging;
 nanduti
lace edging, 211, *figs. 617, 618*
lacquer technique, for decorating *jí-
 caras,* 148–49
lacquerware, 70–72, *figs. 188–94*
ladles, *see* spoons and ladles
ladinos, 108
Lagoa Santa (Brazil), 198
lake-dwellers (Uros), 264, 277
Lambayeque (Peru), 241, 243
languages, Amerindian, 15
Langue (Honduras), 132
lapa (maté), 246
Las Minas (El Salvador), 139
lathe, 16; see also wood, turned
leather musical instruments, 100–1,
 figs. *319–22*
leathercraft, 98, *figs. 307–10;* 149,
 figs. *449, 450;* 169, 308–9, *fig. 965,*
 figs. *983–87*
Lenca Indians, 133, 138, 139
León (Nicaragua), 148, 149, 150, 151
lignum vitae wood, 182
limetas (matés), 246
limners, portraits by, 41, 60, *fig. 146*
litxokó figures, 206, *fig. 599*
llama hat, 133
llameros masks, 280
llicIla (shawl), 243–44, 271
Llobasco (El Salvador), 139, 140–41
logwood, 124
looms, types of, 11: horizontal (ground
 loom), 242, *fig. 734;* 269, 270, 271,
 fig. 853; vertical (upright loom), 30,
 fig. 50; 39, 51, *fig. 88;* 193, *fig.
 562;* 242, 269, 270–71; *see also*
 backstrap loom; treadle loom
Los Anices (Honduras), 133
Los Cocos (Nicaragua), 148
Los Filuos (Venezuela), 193
"lucky hens," 301, *fig. 952*

M

macana (stole), 222, *fig. 665*
machetes, 82, 182; horn handles of,
 79, *fig. 209*
Machu Picchu (Peru), 235, *fig. 719*

macque (lacquer technique), 148–49
Macro-ge Indians, 208, 209
Magdalena River, 168, 169
magic rituals, *see* rituals
mahogany, 133, 164
majolica, 110, 132
Maká Indians, 301, *fig. 962*
malacate (spindle for cotton), 120
malachite, 78
Malinche, 112
manioc (cassava), 203
Mapuche, 288–90, 295, 304
Maraxco (Guatemala), 109
marimbas, 150
markets, 150, 274, 288–89
Masatepe (Nicaragua), 149
Masaya (Nicaragua), 148, 149, 150
masks: Argentina, 306, *figs. 971–76;*
 Bolivia, 280–81, *figs. 877–80;* Gua-
 temala, 112–14, *figs. 341–46;* Ni-
 caragua, 151; Peru, 252, *figs. 764–
 67; see also* cardboard masks and
 figures
Mataco Indians, 264, 267, 304, 306,
 307, 310
matés, 246–48, *figs. 745–50*
mats: embroidered wool, 222, *fig. 666;*
 palmetto straw, 175, *figs. 501, 504;*
 palm-stalk bark, 219, *fig. 660;* rush,
 115, 116–17, 142, 149, *figs. 347,
 350;* totora, 219, *fig. 659*
Maxeño Indians, 122
Maya, 68, 104–6, 132, 138, 168, 304
Mayapán league, 68, 104
Mayoc (Peru), 248
Mehinacú Indians, 207
Melipilla (Chile), 294
Mennonites, 20, 42
Mérida (Venezuela), 191
mestizaje, 14
mestizos, 13, 146, 154, 169, 237, 299
metallic leaf, *see* gold and silver leaf
metallurgy, 13, 216
metalwork, 48, *figs. 107–9;* 80–83,
 figs. *214–21;* 97, *figs. 297–99;*
 see also goldwork; ironwork; silver-
 work
Metapán (El Salvador), 138
metate (stone for grinding corn), 78,
 fig. 213
Metepec (Mexico), 74, 75
Mexico City (Mexico), 17, 82, 83,
 84–85
Michoacán (Mexico), 80
Micmac Indians, 22
Minas Clavero (Argentina), 310
miniatures, 86; *see also* clay toys and
 miniatures
Misquito Indians, 155
misti sicuris dance, 280
mitts, beaded, 26, *fig. 36*
Mixtec, 67
model churches, pottery, 240, *fig. 728*
Mohawk Indians, 25, 26
mokoshan (Naskapi feast), 23
molas (designs of layered fabric),
 163–64, *figs. 478–80*
molcajete (stone mortar), 78, *fig. 213*
molds, use of, 13
Momostenango (Guatemala), 124
Mompós (Colombia), 169
moneyboxes, 291
Monimbó (Nicaragua), 149
Monterrey (Mexico), 73
Montevideo (Uruguay), 314, 315
mopa-mopa bush, 178
Moravians, 42
morenada dance, costumes for, 282,
 fig. 883
Morgan, Henry, 160
morros (gourds), 140
mortars, stone, 78, *fig. 213*
Motilone Indians, 169
Moxeño Indians, 264, 267, 280
Moya (Peru), 240

Acknowledgments

This work would not have been possible without the invaluable collaboration, direct and indirect, of numerous craftsworkers who made their time, their work, and their knowledge available to us. Although the majority of them remain anonymous, the names of certain others are listed below. To all, our sincere appreciation.

Canada:
Eric Baker. British Columbia
Johnny Blueboy. Moose Factory, Ontario
Serge Bourdon. St.-Jean-Port-Joli, Quebec
Helen Burning. Six Nation Reservation, Ontario
Mike Donnelly. Londdn, Ontario
Brenda Gosselin. Sardis, British Columbia
Richard Hunt. Victoria, British Columbia
Pitseola Jayko. Frobisher Bay, Northwest Territory
John Joseph. Vancouver, British Columbia
Marie-Claire Levasseur. St. Lambert, Quebec
Dave Mendel. Vancouver, British Columbia
Freda Nahanee. Vancouver, British Columbia
Tim Paul. Vancouver Isle. British Columbia
Marie-Andrée Plinius. St. Lambert, Quebec
Anabel Stewart. Sardis, British Columbia

U.S.A.
Teresa Archuleta Sagel. Española, New Mexico
Noël Bennet. Corrales, New Mexico
Marie Cash de Romero. Santa Fe, New Mexico
Gloria López Córdova. Cordova, New Mexico
Carnation Lockwood. San Juan Pueblo, New Mexico
José Benjamín López. Española, New Mexico
Irene López. Española, New Mexico
Anna Marie Lovato. Tesuque, New Mexico
John Maxwell. Cookeville, Tennessee
Gabrielita Nave. San Juan Pueblo, New Mexico
Ortega Family. Chimayo, New Mexico
Emilio and Senaida Romero. Santa Fe, New Mexico
Anita Romero. Santa Fe, New Mexico
Anacita Salazar. San Juan Pueblo, New Mexico
Isable Talachy. Taos, New Mexico
Luis E. Tapia. Santa Fe, New Mexico
Star Tapia. Santa Fe, New Mexico
Garnett Webb. Corrales, New Mexico

Mexico:
Dámaso Ayala. Olinalá, Guerrero
Margarito Ayala. Olinalá, Guerrero
Teodora Blanca. Atzompa, Oaxaca
Angel Carranza. Tlaquepaque, Jalisco
Francisco Cornoel. Olinalá, Guerrero
Auerlio Flores. Izúcar de Matamoros, Puebla
Amado Galván, Tonála, Jalisco
Adrián Luis Gonzlález. Metpec, Mexico
Gorki González. Guanajuato
Antonio Hernández. Patambán, Michoacán
Antonio Herández. Chiapa de Corzo, Chiapas
Casto León Romero. Metpec, Mexico
Petra López. Putla, Oaxaca
Pedro and Ignacio López. Celaya, Guanaiuato
Herón Martínez Mendoza. Acatlán, Puebla
Emilio Molinero. Tintzuntzan, Michoacán
Saulo Moreno. Oaxaca
Luis Núñez. Tlaquepaque, Jalisco
Guadalupe Panduro. Tlaquepaque, Jalisco
Natividad Peña. Tintzuntzan, Michoacán
Julio Pérez. Tecali, Puebla
Luis Ruiz. San Blas Atempa, Oaxaca
Guadalupe Valdez. Olinalá, Guerrero
Jorge Wilmot. Tonalá, Jalisco
Miguel Zaco Soto. Santa Clara, Michoacán

Haiti:
Patrick Lafontant. Port au Prince
Georges Liautaud. Croix des Bouquets
Loulou Scherival. Port au Prince

Puerto Rico:
Carmelo Martell. Utuado
Carlos Vázquez. Ciales

Guatemala:
Pascuala Appof. Totonicapán
Angel Remigio Cogüox Poroj. Momostenango, Totonicapán
Juana Benita Poncia. Totonicapán
Hector Gabriel Pérez. Totonicapán

El Salvador:
Oscar Domingo Molina. San Sebastián
Marta de Solis. Ilobasco

Costa Rica:
Eloy Alfaro Corrales. Sarchi, Alajuela

Panamá:
Máximo Lara. El Valle

Venezuela:
Juan Montes, Quibor, Lara

Brazil:
José Alves Ferreira. Boqueirao, Paraiba
Ño Cabloco. Recife, Pernambuco
Antonio Poteiro. Goiania, Goiás
Quincas. Brasilia, Goiás
Maria Madalena S. Reinbolt, Bahía
José Valentim Rosa. Belo Horizonte, Minas Gerais
José Antonio da Silva. São Paulo

Ecuador:
Miguel Andrago. Agato, Imbabura
Luis y Cenaida Benegas. Pulcay, Azuay
Antonio Espinoza. Pomasqui, Pichincha
Alberto Muinala. Peguche, Imbabura
Amable Olmos. Pujilí, Cotopaxi
Antonio Supleuichi. Gualaceo, Azuay
Cecilia Trujillo. Calderón, Pichincha
Hugo Vaca. La Victoria, Cotopaxi
Luis Villa. Chordeleg, Azuay

Peru:
Agustín Alarcón. Ayacucho
Pascual Apacachambi. Checca, Puno
Emilio Condori. Checca, Puno
Flaviano González. Molinos, Junín
José López Antay. Ayacucho
Mardonio López Quispe. Ayacucho
Georgina Mendivil. Cuzco
Edilberto Mérida. Cuzco
Antonio Olave. Cuzco
Familia Ozores. Cochas Chico, Junín
Maxi Palomino. Cuzco
Cesáreo Poma. Cochas Chico, Junín
Delia Poma. Cochas Grande, Junín
Antonio Prada. Ayacucho
Santiago Rojas. Cuzco
Alfonso Sulca. Ayacucho
Leoncio Veli. Cochas Chico, Junín

Bolivia:
Luis Quisbert Ramos. La Paz
Antonio Viscarra Morales. La Paz

Chile:
Riola Castro. Quinchamalí, Ñuble
Mariano Coliqueo. Temuco, Cautín
Melania Sepúlveda. Rari, Linares
Seferino Torrealba. Chimbarongo, Colchagua

Paraguay:
Teófilo Pedroso Itaguá. Central

Argentina:
Nazarena Alarcón. Brea Pozo, Santiago del Estero
Laura Centeno. Aguaray, Salta
Felipe Leiva. Ojo de Agua, Santiago del Estero

Uruguay:
Casa Artigas. Montevideo
Tomás Cacheiro. Treinta y Tres
Julio César Hernández. Solimar, Canelones
Silvio Larguero. Montevideo
Amaris de Villafán. Batlla y Ordóñez, Florida
Carlos Villalba. Montevideo.

We would also like to acknowledge the patience and care with which Isabel Baños and María Dolores Delgado have given to typing several versions of each author's texts as well as the numerous lists of numbers of the illustrations that were necessary before the work took definitive form; we should also like to mention the dedication of Montserrat Gràs of the Català Roca Photo Lab, who classified and put in order the original photographic documentation.

327

Photograph Credits

We should like to acknowledge the extraordinary courtesy extended to us by folk artists from all parts of the Americas who allowed us to photograph examples of folk art that were their personal property.

Canada: Lucy W. Turner 29, 30, 33, 36, 38, 79, 81

U.S.A. Ricardo Muratorio 154, 168

Mexico: Museo Nacional de Arte y Industrias Populares of Mexico City 195–98, 243, 252, 279–88, 291

Dominican Republic: Fundación para el Desarrollo del Hombre Dominicano 311–20

Guatemala: Museo Nacional de Artes e Industrias Populares of Guatemala City 323, 331, 338, 341, 358, 359, 362, 363, 367, 376–78, 380, 382–88, 391, 395, 397, 398, 400–406, 408

Colombia: Museo de Artes y Tradiciones 511, 516, 530, 543, 545, 548

Brazil: Museo Nacional 589; Celia Coelho 600, 601, 627, 629, 631, 632, 635, 637, 638, 641–44, 649–51; Berta G. Ribeiro 588, 591, 592, 599, 600, 602–07, 610, 620–26, 628, 630, 633, 634, 639, 640, 645–47; Galerie Urubamba (Paris) 582, 608, 609

Peru: Roberto Villegas 775, 786, 787, 791, 793, 794, 796, 797, 800

Bolivia: Museo de Etnografía y Folklore 845–48, 855–57, 860, 861, 876, 880, 887–93, 898–907, 909–13, 915–17

Argentina: Pilar Bardin 965, 971–73, 993, 998, 1001; Carlos Bardin 970, 974, 981, 982, 994–97, 999, 1000, 1002–1007, 1009

Uruguay: Comité Organizador de la Feria del Libro y de la Artesanía 1019, 1022, 1024

Additional photographs for the United States chapter were obtained from the following sources; 92: Courtesy National Gallery of Art, Washington, D.C.; 93, 94: Courtesy Angus J. Bruce, Furniture Designer, New York City; 95: *Josephine* by Whit Kent. Courtesy Julie, Artisan's Gallery, New York City; 96: *Mosaic Cats* by Mimi Vang Olsen. Courtesy the artist; 97, 106: Courtesy Thos. Moser, Cabinetmaker. New Gloucester, Maine; 103, 105, 125: Courtesy Museum of American Folk Art, New York City; 124: Courtesy Mr. and Mrs. J. W. Titelman, Hollidaysburg, Pennsylvania; 126: *True Romance* by Chris Bobbin. Courtesy Julie, Artisan's Gallery, New York City; 131: From *American Denim*. Crochet by Kay Chellman Miller, Addison, New York. Photograph by Gerald Miller. Courtesy Levi's Denim Art Contest; 132, 133: From *American Denim*. Embroidery by Julie Elliott, Indian Wells, California. Photograph by John W. Carson. Courtesy Levi's Denim Art Contest; 144: *Our First and Last Leaders of the Truth*, 1977, by Rev. Howard Finster. Collection Museum of International Folk Art Santa Fe, New Mexico. Courtesy Phyllis Kind Gallery, New York City; 145: By permission of the Pogrebin Family. Mimi Vang Olsen; 146: *Pau de Wanderlaer*. Courtesy Albany Institute of History and Art; 147: Sculpture by Miles Carpenter. Courtesy Victor Faccinto, Wake Forest University, Winston-Salem, North Carolina.